FIVE HUNDRED

BUILDINGS OF

PARIS

FIVE HUNDRED
BUILDINGS OF
PARIS

PHOTOGRAPHY BY JORG BROCKMANN AND JAMES DRISCOLL

TEXT BY KATHY BORRUS

BLACK DOG
& LEVENTHAL
PUBLISHERS
NEW YORK

Contents

Author's Note

"Five hundred buildings?" my architect friend asked. "How can I get an assignment like that?"

Other friends also salivated at the idea of writing about five hundred Paris buildings and immediately began offering resources and suggestions.

Armed with everyone's recommendations and my own passion for art and architecture, I traipsed off to Paris with a different perspective: looking up, while simultaneously watching my step. (Parisians love their dogs as much as their buildings.)

Creating a list and wading through layers of architecture and history to write about that many buildings inevitably required the assistance of many people along the way. First and foremost, I cannot find enough superlatives to describe the immeasurable ways Gaël Lesterlin contributed to this book. His expertise, guidance, research, fact-checking, list review, encouragement, and tireless efforts were invaluable. As an architect and Ph.D. candidate in the history of architecture, his passion for exploring the history behind the façades was contagious and affected me in ways I could not anticipate. I appreciate his insight, dedication, friendship, and good humor in cheering me on and seeing this project to conclusion. Thanks to Florence Lloyd, Claude Baudez, and Basile Baudez whose cumulative recommendations led me to Gaël.

Next, Thirza Vallois, author of the *Around and About Paris* guides and *Romantic Paris*, deserves special mention for her initial interest and her expert knowledge of the city, along with my thanks for wandering the Parisian streets with me. Her guides, chock full of history, are among the many sources I consulted for information.

My thanks also go to Karyn Marcus. Her sustained enthusiasm and early background work on the book were essential to its success. Her numerous suggestions, contacts, translations, and organizational ability aided me in creating and researching the initial list. Our walks through the city knew no bounds and increased our camaraderie. And I'd like to extend our mutual thanks to Jean Connehaye for his support of the project and list review. He lent his time and expertise, as well as his valuable research books; chief among these was the excellent *Dictionnaire Historique des rues de Paris* by Jacques Hillairet. For all of Mr. Connehaye's efforts, I am sincerely grateful. Our additional thanks for consultation go to Julia Trilling and Olivier Amat.

Ultimately, the text drew inspiration from the photographic artistry of Jorg Brockmann and James Driscoll. Adept at finding frequently difficult addresses and weaving their way through narrow streets, they brought their creative vision to each of the five hundred buildings in the book.

To all of my family and friends at home, thanks for your encouragement and patience while I disappeared to explore Paris. My special thanks and love to my son, Josh, who helped research literary references when needed and reviewed numerous paragraphs before I submitted them.

Finally, my appreciation extends to J.P. Leventhal for his faith in me and the opportunity to contribute to this book, as well as to Laura Ross for her editorial guidance, encouragement, and gentle pressure throughout the writing process. My thanks also to the staff and freelancers of Black Dog & Leventhal for their efforts, especially Dara Lazar, Sheila Hart, Iris Bass, True Sims, and Magali Veillon.

<div align="right">KATHY BORRUS</div>

Photographers' Notes

I'd like to dedicate this book to the memory of Alain Colomb, my father-in-law, a man of great courage and integrity, and to Aline; to my wife Celine, my kids Leo and Sasha, my grandmother Oma Lisa, and above all, to my parents, who moved to Paris in 1970, as a young couple, and brought us up there. They are responsible for my love of the city.

After spending the last decade in New York, I was able to approach Paris with a fresh eye. I was eager to rediscover a city that I had known from a comfortable, day-to-day perspective: the traffic hassles, the noise, the agitation. (I had found that when I shot the photographs for One Thousand New York Buildings I wanted to reduce these extraneous factors to a minimum to allow readers to concentrate on the essence of each building.) I will never forget the weekend when the center of the city was closed to traffic. Walking through the streets without the fear of getting run over, and the unusual quietness, afforded me a unique perspective.

I did not approach Paris with an idealized, romantic vision. The work remains first and foremost a factual record. And yet, through choices of perspective, framing, and the time of day that I took the shot, each photograph takes on a mood or quality of its own. When photographing restaurants, it often seemed more interesting to portray the interior, where the history of the place had unfolded.

For those interested in the technical side of things, all of the photographs in this book were shot with a Sinar F2 4 x 5 camera shooting Agfa APX 100 film.

I would like to extend my thanks, first, to my collaborator, James Driscoll; to my assistants, Fanny Dupont and Matteo Venet; and to Nicolas Spuhler of the Geneva-based lab Actinic, for their hard work and enthusiasm. I am grateful to Maryvonne Deleau at the Mairie of Paris for helping me get access to certain sites; to Catherine and Michel Devos and Francoise and Philip Proust for lodging, and to Marie Françoise Deslandes, Alain Bled, and Jean Connehaye for their help. Congratulations to Kathy Borrus for her thorough research and writing job. My gratitude also goes to the whole team at Black Dog and Leventhal, especially to J.P. Leventhal, for giving me the opportunity to take on this project. Thanks to Laura Ross, my editor, for her strong (moral and practical) support, and to True Sims and Dara Lazar for their painstaking efforts on this complex undertaking. Thanks also to Thomas Palmer, a master separator, and to Sheila Hart for completing the design equivalent of the Rubik's Cube with great style and good cheer.

Dear reader, enjoy this walk through Paris!

JORG BROCKMANN

The year 2002 was an interesting one in my life: it was the year that I became the archetypal "American in Paris." I'm sure I'll look back on it later in life with much joy and humor.

My journey to shoot this book was the first time this "New York Boy" had ever left the USA, and I have to admit that I had my reservations. I tend to have a bad attitude about places other than the five boroughs of New York City—but being in France turned out to be a very enlightening experience.

After living and working in Paris for four months, I can say that most of the stereotypes about the city and its residents are untrue. Sure, I ran into some rudeness but what city is free of it? What I did find was a beautiful city that is rich with history, pride, and old-world ways of life. I believe that the buildings and structures of Paris reflect the pride that Parisians have always felt about their city. It was this quality that I tried to capture in my photographs.

My work on this book was completed with the assistance and support of many people. I begin by thanking my family for all the encouragement they have given my photography over the years. I must offer grateful thanks to friend and photographer Mike Falco, who first put a camera in my hands and was always there with advice and support when I needed it most. Deep thanks to fellow photographer Jorg Brockmann for seeing in me what I now see—it was his eye and ability that inspired me throughout this project. Thanks to Ursula Jaroszewicz, for her years of help and love. A humongous thanks must go to J.P Leventhal, Laura Ross, True Sims, and Dara Lazar of Black Dog & Leventhal, who dreamed up this book and supported our work on it. Thanks to the people at Fotocare in New York City, Le Grand Format in Paris, and Arnie Duren of Brooklyn Camera Exchange for their help on the technical side. Thanks to our Paris assistants, Fanny Dupont and Matteo Venet, for their invaluable help in navigating the streets of Paris and for being my two best friends during my time in Paris, and gratitude to the Devos family for allowing me to use their apartment as a base of operations during my stay. Author Kathy Borrus, designer Sheila Hart, and separator Thomas Palmer must be commended for the skill and creativity they have brought to the project.

Last and certainly not least, I would like to thank my wife-to-be, Stacy Lucas, for the time she took out of her life to take care of mine, and for being my main inspiration on this wonderful project. Without her love and support, my work on it would not have been possible.

JAMES DRISCOLL

ÎLE DE LA CITÉ

Two hundred and fifty years before Julius Caesar pulled up to shore and camped on Île de la Cité in 53 B.C., a Celtic tribe known as Parisii (boat people) occupied the island and the land on both its banks, and cruised the waters of the Seine in lucrative trading. They called the land Lutetia, which meant "boatyard on the water." Caesar expanded his empire by crushing a Parisii rebellion, and the Romans renamed their settlement Lutetia Parisiorum. They rebuilt the town, walled it off, and constructed a temple to Jupiter and Caesar on the site of the future Notre-Dame cathedral. They also built bridges to connect the banks, and the city spread outward from Île de la Cité through centuries of struggle and warfare, bombardment and occupation. Christianity intervened, then the Franks invaded, and Charlemagne ruled benevolently from afar but encouraged trade and commerce. Enter the Vikings in the ninth century. Their repeated sackings caused a retreat to the island as the outlying areas were not defensible. In the twelfth century, the Knights Templer assumed control and Bishop Maurice de Sully began construction on Notre-Dame.

The French monarchy developed and took command in reaction to the repeated Viking incursions and the lack of effective action by the foreign rulers: Governor Hugh Capet ascended the throne and made Paris his capital; Île de la Cité became the site of his home, where now stands the Palais de Justice. Philip II occupied the medieval palace complex that today includes Sainte-Chapelle. He developed Paris into being the center of what was considered Europe during the Middle Ages, and expanded the old Roman wall around the island and beyond. Medieval life on Île de la Cité was a tangled web of streets and markets and buildings. By the mid–nineteenth century, when Napoléon III named George Haussmann his prefect of Paris and placed him in charge of urban renewal, life on the island had deteriorated: Streets were narrow, twisted, and filthy—crowded and squalid. Haussmann engineered new routes, widening streets and razing old buildings. The result of his tinkering left Notre-Dame with breathing room, while opening the door to a twentieth-century maze of tourist buses. Essentially, he created modern Paris. Though its actual administration was divided into the first and fourth arrondissements, Île de la Cité is its heart.

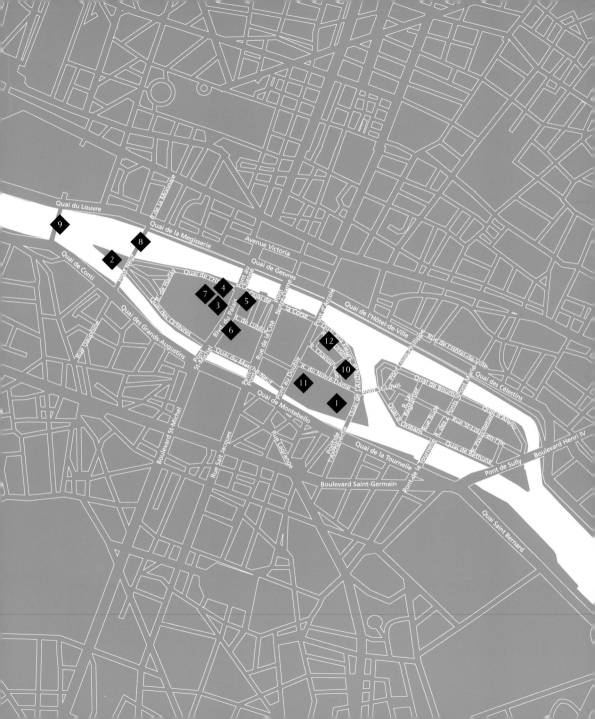

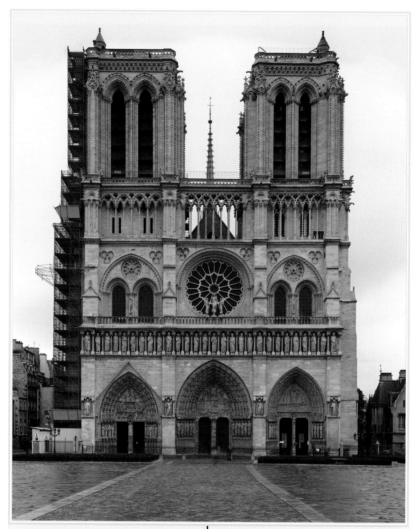

1

Notre-Dame de Paris

PLACE DU PARVIS—NOTRE-DAME

C.1160, ORIGINAL ARCHITECTS UNKNOWN; C.1250—58, JEAN DE CHELLES; SECOND HALF OF THIRTEENTH CENTURY,
PIERRE DE MONTREUIL; 1296—1325, PIERRE DE CHELLES AND JEAN RAVY; 1699—1715, ROBERT DE COTTE,
CHOIR DECORATION; 1728—29, GERMAIN BOFFRAND, CROSSING VAULT REBUILT AND RESTORATION;
1841—64, RESTORATION OVERSIGHT BY JEAN-BAPTISTE LASSUS AND EUGÈNE VIOLLET-LE-DUC

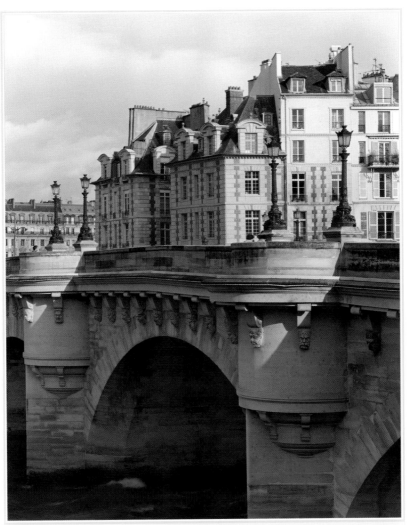

2

Place Dauphine

WEST TIP OF ÎLE DE LA CITÉ

1607—19, ATTRIBUTED TO LOUIS MÉTEZEAU

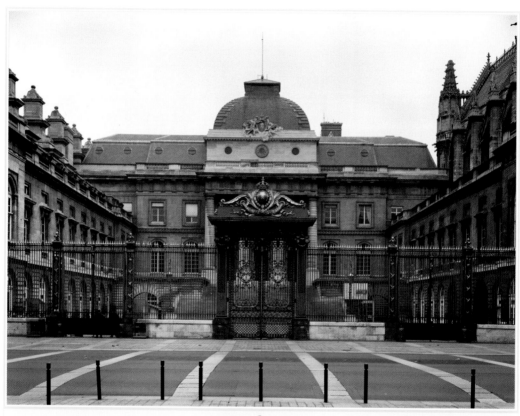

3

Palais de Justice

4, BOULEVARD DU PALAIS

1776–83, JOSEPH-ABEL COUTURE, PIERRE DESMAISONS, JACQUES-DENIS ANTOINE, COUR DU MAI SIDE

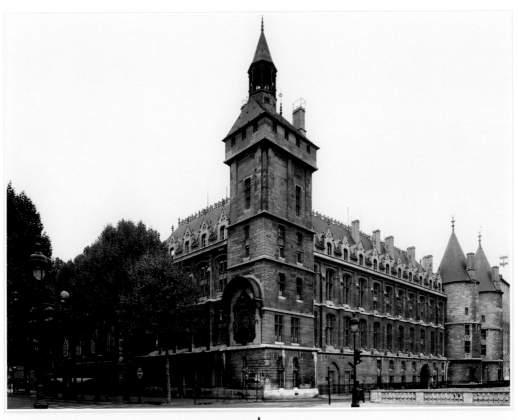

4

La Conciergerie

1, QUAI DE LA CORSE

1296–1313, ENGUERRAND DE MARGINY

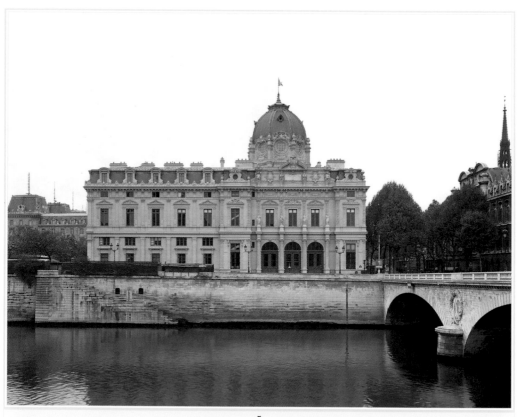

5

Tribunal de Commerce

3, QUAI DE LA CORSE

1860–65, ANTOINE-NICHOLAS BAILLY

6

Préfecture de Police

7, BOULEVARD DU PALAIS AT RUE DE LUTÈCE

1862–65, VICTOR CALLIAT

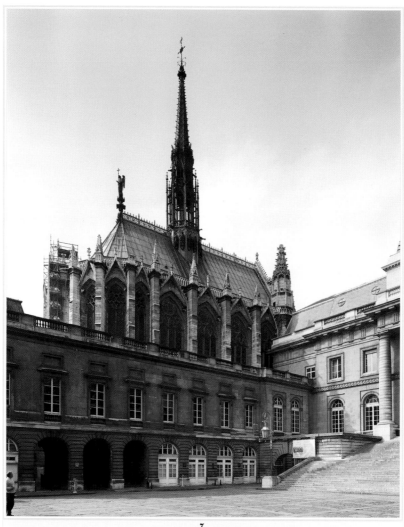

7

Sainte-Chapelle

4, BOULEVARD DU PALAIS

1241—48, ATTRIBUTED TO PIERRE DE MONTREUIL, THOMAS DE CORMONT, OR ROBERT DE LUZARCHES

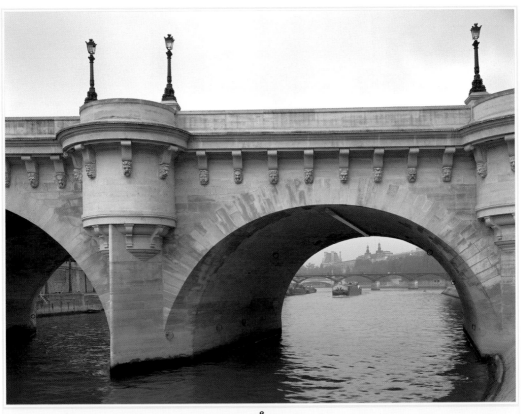

8
Pont-Neuf

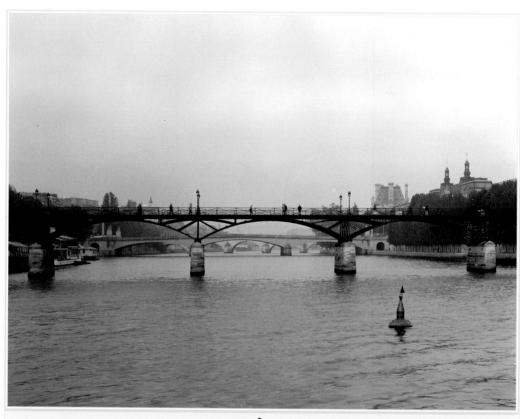

9

Pont des Arts

10

One, rue des Chantres

<small>AT 1–3, RUE DES URSINS</small>

<small>1958, FERNAND POUILLON</small>

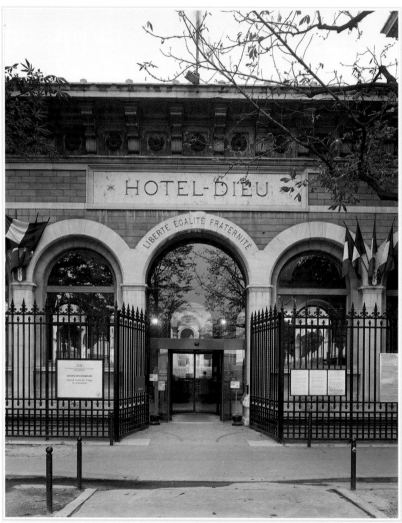

11

Hôtel-Dieu

1, PLACE DU PARVIS NOTRE-DAME

1864–74, JACQUES GILBERT; 1874–77, STANISLAS DIET

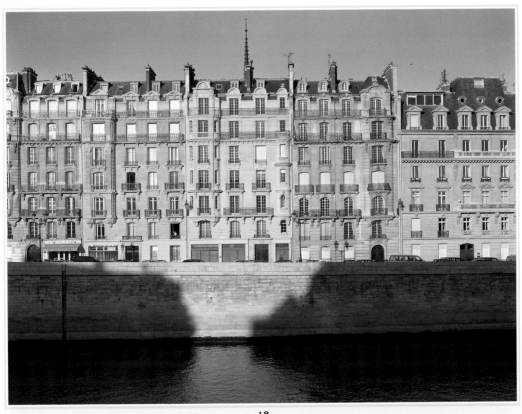

12

Buildings on quai aux Fleurs

1769, Pierre-Louis Moreau

1ST ARRONDISSEMENT

Grand squares, ancient buildings, and modern additions all shape this royal arrondissement. The sweeping vista of water, sky, and greenery includes Pont-Neuf and place Dauphine on the tip of Île de la Cité, and extends north from the Seine, encompassing the Jardin des Tuileries and the Louvre. World-renowned since its twelfth-century origins through I. M. Pei's bold, twentieth-century glass pyramid addition, the Louvre was a royal residence long before it evolved into a museum. Nearby, the revitalized gardens of Palais-Royal — former private home of Cardinal Richelieu—also represent the area's regal heritage, as well as its common roots as a place of revelry. At the eastern edge of the first arrondissement, Forum des Halles—a subterranean shopping mall—replaced Paris's medieval food market, Les Halles, razed in 1969, and is a modern reminder of those rousing days and nights.

Running straight through the old city, rue de Rivoli became an elegant nineteenth-century showcase for both its homogenous frontage and the arcaded galleries behind the façades. To its north, on the western end, the elegant place Vendôme remains true to its pre-Revolutionary, aristocratic origins with stately architecture. Haute couture houses developed here and around the royal square of place des Victoires and on rue Saint-Honoré, catering to the needs of the nobility. Today, upscale fashion houses still reign here.

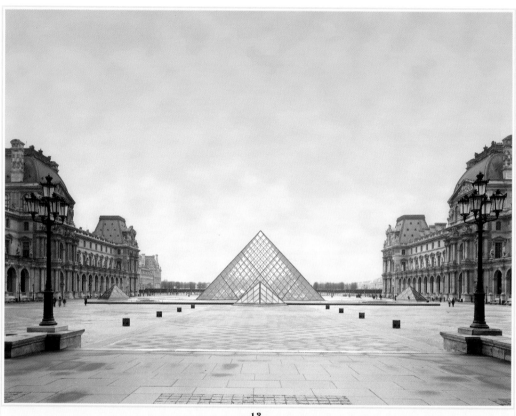

13

Louvre

BETWEEN RUE DE RIVOLI AND QUAI DU LOUVRE, ENTRANCE COUR NAPOLÉON

1190, CONSTRUCTION; 1528, PIERRE LESCOT AND JEAN GOUJON, PALACE (COUR CARRÉE); 1624, JACQUES LEMERCIER, ADDITIONS; 1654, LOUIS LE VAU, ADDITIONAL WORK; 1668, CLAUDE PERRAULT, COLONNADE; 1804–48, CHARLES PERCIER AND PIERRE-FRANÇOIS-LÉONARD FONTAINE; 1852–53, LOUIS-TULLIUS-JOACHIM VISCONTI; 1853–80, HECTOR-MARTIN LEFUEL; 1984–93, IEOH MING PEI, PYRAMID

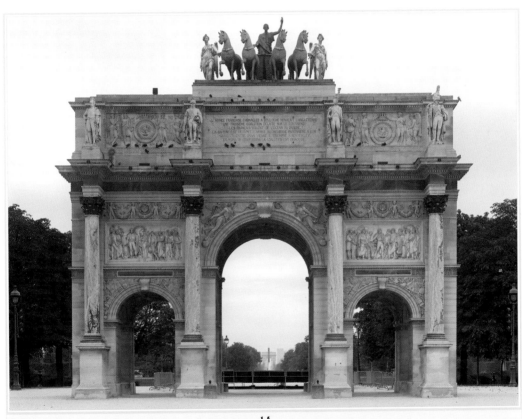

14

Arc de Triomphe du Carrousel

PLACE DU CARROUSEL, BETWEEN LOUVRE AND TUILERIES GARDENS

1806–08, CHARLES PERCIER AND PIERRE-FRANÇOIS-LÉONARD FONTAINE

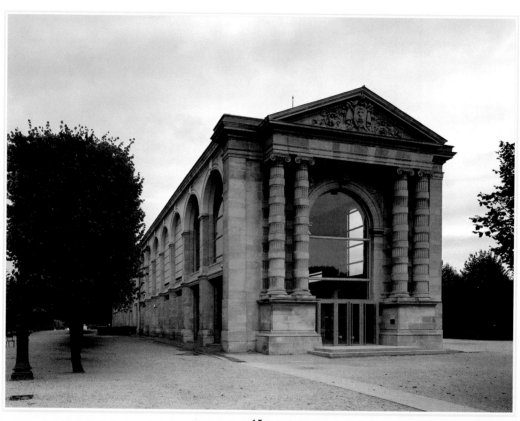

15

Musée du Jeu de Paume

TUILERIES GARDENS, RUE DE RIVOLI SIDE AT RUE DE RIVOLI

1861, 1991, ANTOINE STINCO, RENOVATION

16

Fontaine de la Croix-du-Trahoir

111, RUE SAINT-HONORÉ, CORNER OF RUE DE L'ARBRE-SEC

1776, JACQUES-GERMAIN SOUFFLOT

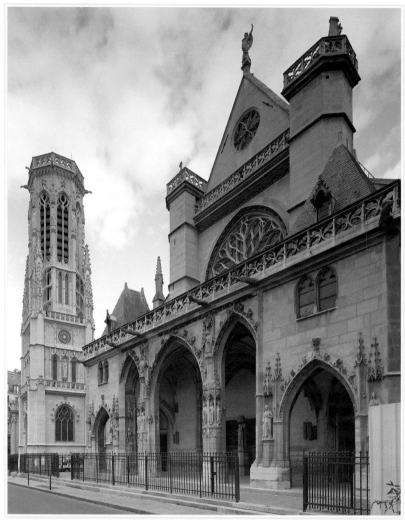

17

Saint-Germain-l'Auxerrois

2, PLACE DU LOUVRE AT RUE DE L'ARBRE

TWELFTH—SIXTEENTH CENTURIES, 1754, CLAUDE BACCARIT, INSIDE TRANSFORMATIONS
1838–55, JEAN-BAPTISTE LASSUS AND VICTOR BALTARD, RESTORATION

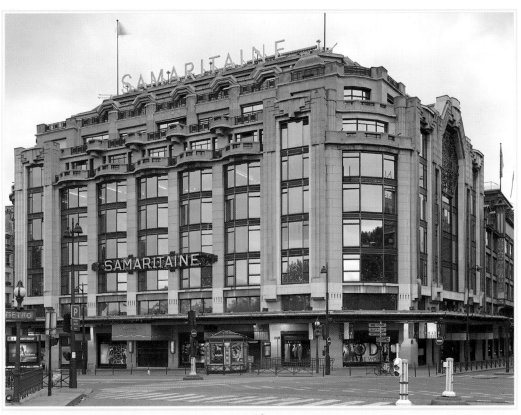

18

La Samaritaine Department Store

75, RUE DE RIVOLI, BETWEEN RUE DE LA MONNAIE AND RUE DE L'ARBRE

1905, FRANTZ JOURDAIN, 1926—28, FRANTZ JOURDAIN AND HENRI SAUVAGE, EXTENTION

19

15, rue du Louvre

AT RUE SAINT-HONORÉ

1889, HENRI BLONDEL

20

32, rue du Louvre and 112, rue Saint-Honoré

c. 1900

21
Oratoire du Louvre

4, RUE DE L'ORATOIRE

1621–30, CLÉMENT MÉTEZEAU II & JACQUES LEMERCIER

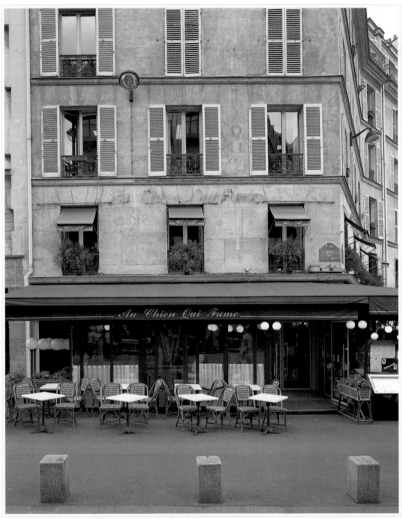

22

Au Chien qui Fume

33, RUE DU PONT-NEUF AT RUE SAINT-HONORÉ

1854

23
Saint-Leu-Saint-Gilles

92, RUE SAINT-DENIS AT BOULEVARD SÉBASTOPOL

1319, NAVE; 1611, SIDE AISLES AND CHOIR; 1858–61, REWORKED BY VICTOR BALTARD

24

Théâtre du Chatelet

1, PLACE DU CHÂTELET AT AVENUE VICTORIA

1860–62, GABRIEL DAVIOUD

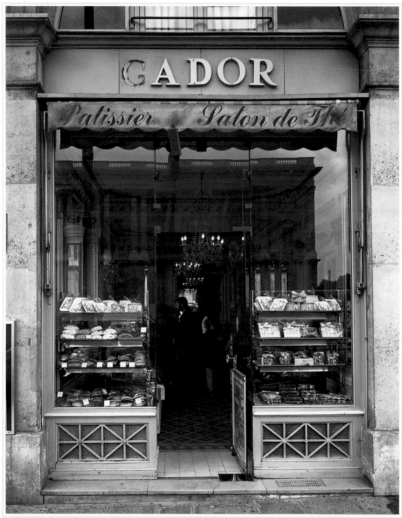

25

Cador

2, RUE DE L'ADMIRAL DE COLIGNY AT 30, QUAI DE LOUVRE

1853

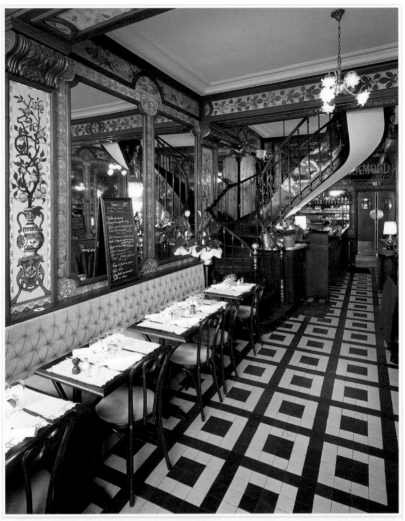

26

Pharamond

24, RUE DE LA GRANDE TRUANDERIE AT RUE PIERRE LESCOT

1879; C. 1900, PICARD AND CIE, INTERIOR REDECORATION

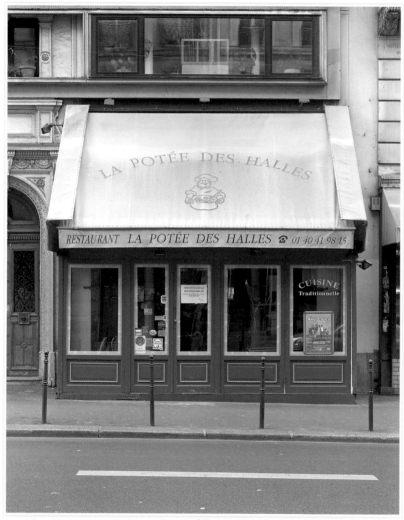

27

La Potée des Halles

3, RUE ETIENNE-MARCEL AT BOULEVARD DE SÉBASTOPOL

c. 1900

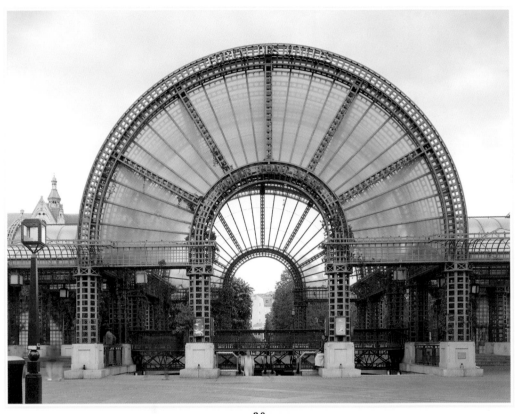

28

Forum des Halles

RUE PIERRE-LESCOT, BETWEEN RUE BERGER AND RUE RAMBUTEAU

1853–74, VICTOR BALTARD, LES HALLES; 1835, ADDITIONS; 1979–88, C. VASCONI AND G. PENCRÉACH, FORUM DES HALLES; C. AND F.-X. LALANNE, GARDENS; 1985, PAUL CHEMETOV, INTERIOR OF PLACE CARRÉE AND EQUIPMENT

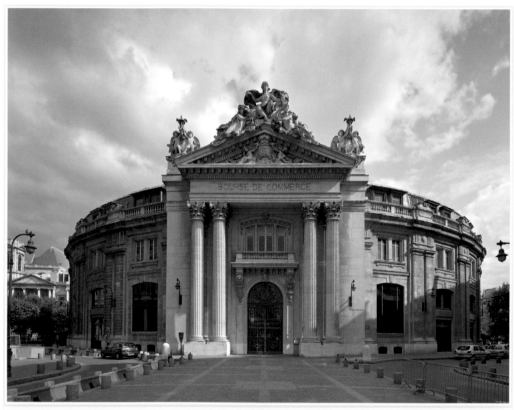

29
Bourse de Commerce

2, RUE DE VIARMES AT RUE DU LOUVRE

1574, JEAN BULLANT, COLUMN; 1765–68, NICOLAS LE CAMUS DE MÉZIÈRES, GRAIN MARKET; 1782–83, JACQUES-GUILLAUME LEGRAND AND JACQUES MOLINOS, FIRST WOOD DOME; 1809, FRANÇOIS-JOSEPH BÉLANGER, SECOND IRON DOME; 1885–89, HENRI BLONDEL, BOURSE DE COMMERCE

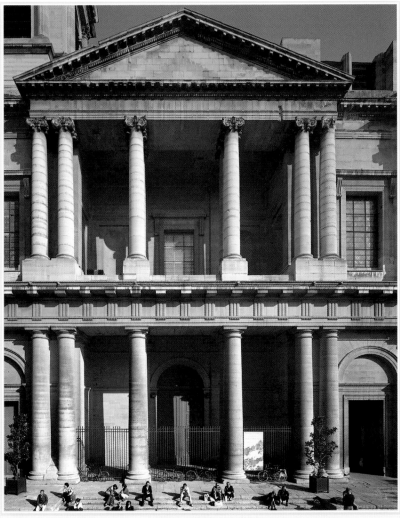

30
Saint-Eustache

1, RUE DU JOUR

1532–1640, JEAN DELAMARRE OR PIERRE LE MERCIER; 1754, JEAN HARDOUIN-MANSART DE JOUY, FAÇADE,
THEN PIERRE-LOUIS MOREAU; 1844, VICTOR BALTARD, FEW RESTORATIONS

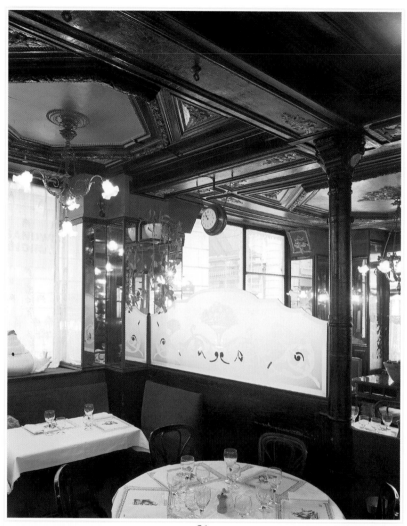

31

L'Escargot Montorgueil

38, RUE MONTORGUEIL AT RUE ETIENNE-MARCEL

1875, RESTAURANT

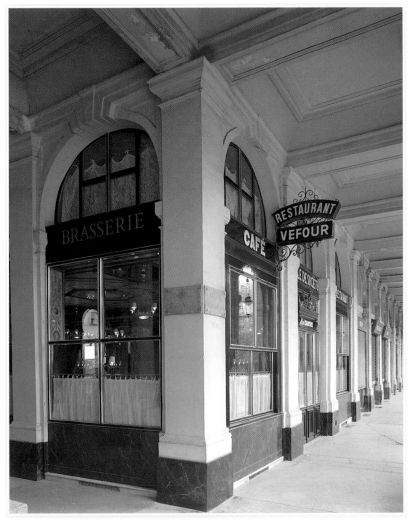

32

Le Grand Véfour

17, RUE DE BEAUJOLAIS, BETWEEN RUE DE VALOIS AND MONTPENSIER

1820, PURCHASED BY JEAN VÉFOUR

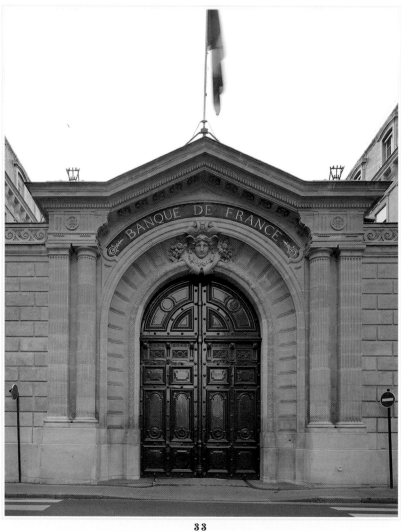

33

Banque de France (former Hôtel de la Vrillière, then Hôtel de Toulouse)

One rue de la Vrillière at rue Croix des Petits-Champs

1635–40, François Mansart; 1713, Robert de Cotte;
1853–65, Gabriel Crétin; 1870–74, Charles Quesnel

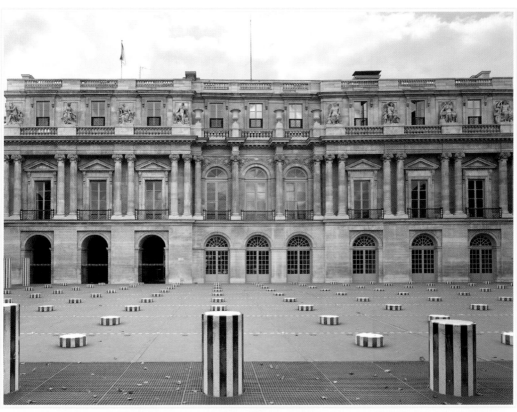

34

Palais-Royal

PLACE DU PALAIS-ROYAL, BETWEEN RUE DE VALOIS AND RUE DE MONTPENSIER

1620, MARIN DE LA VALLÉE AND JEAN THIRIOT; 1625–39, JACQUES LEMERCIER; 1766–70, PIERRE-LOUIS MOREAU AND CONTANT D'IVRY,
PARTIAL REBUILDING; 1781–84 AND 1786–90, VICTOR LOUIS, ADDITIONAL BUILDINGS; 1817, PIERRE-FRANÇOIS FONTAINE, ADDITIONAL BUILDING;
1849–75, PROSPER CHABROL; 1986, DANIEL BUREN, INSTALLATION IN THE COURTYARD

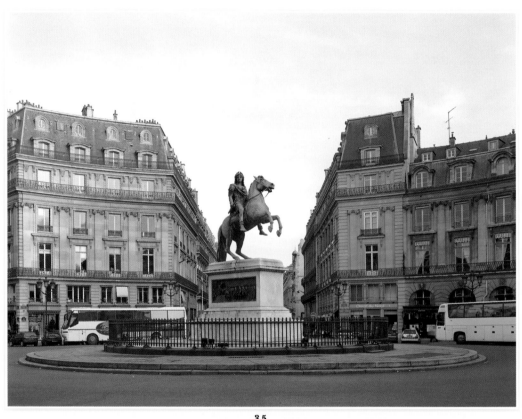

35

Place des Victoires

At rue de la Feuillade, rue Etienne-Marcel, rue Notre-Dames des Victoires, and rue Croix des Petits Champs

At the boundary of the first and second arrondissements, 1685–86, Jules Hardouin-Mansart

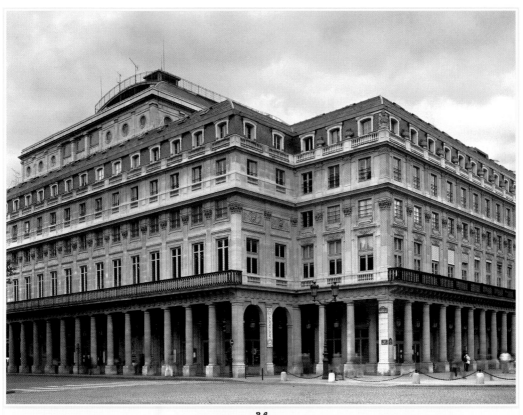

36

Comédie-Française

2, RUE DE RICHELIEU AT AVENUE DE L'OPÉRA

1786—90, VICTOR LOUIS; 1861, PROSPER CHABROL, SOUTH FAÇADE; 1900, REBUILT PARTIALLY

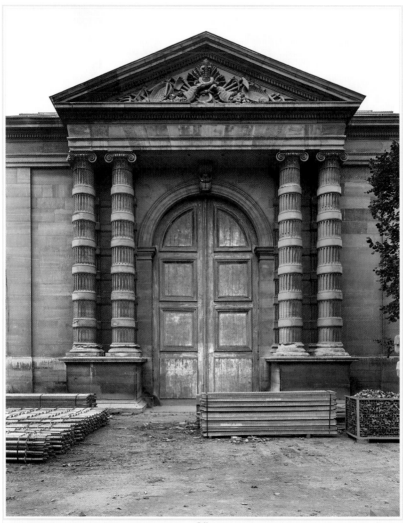

37

Musée de l'Orangerie

TUILERIES GARDENS, SEINE SIDE AT QUAI DES TUILERIES

1664, ANDRÉ LE NÔTRE, REDESIGN OF GARDENS; 1853 L'ORANGERIE;
1991, PASCAL CRIBIER AND LOUIS BÉNECH, REFURBISHMENT, TUILERIES

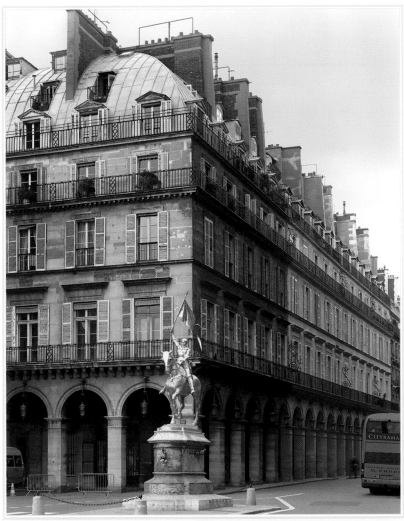

38
Sloped Apartments

PLACE DE LA PYRAMIDES AT RUE DE RIVOLI AND RUE DE LA PYRAMIDES

1802, CHARLES PERCIER AND PIERRE FONTAINE, FAÇADES; 1874, EMMANUEL FRÉMIET, STATUE OF JOAN OF ARC

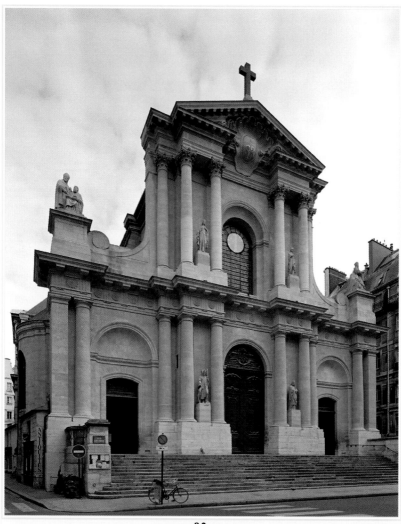

39
Église Saint-Roch

298, RUE SAINT-HONORÉ

1653, JACQUES LE MERCIER; 1705–39, JULES HARDOUIN-MANSART, ROBERT DE COTTE, FAÇADE; 1754, ETIENNE-LOUIS BOULÉE,
CHAPEL DU CLAVAIRE (DAMAGED) AND ETIENNE - MAURICE FALCONET, DECORATION IN THE VIGIN CHAPEL

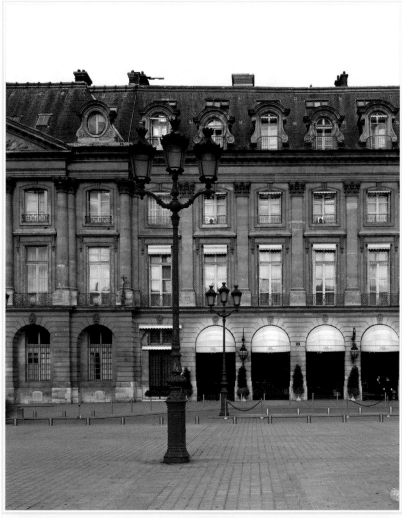

40

Hôtel Ritz

15, PLACE VENDÔME AT RUE DE LA PAIX

1705, FIRST ARISTOCRATIC HOME; 1896, CHARLES MEWÉS, TRANSFORMATION AS AN HOTEL FOR TRAVELERS

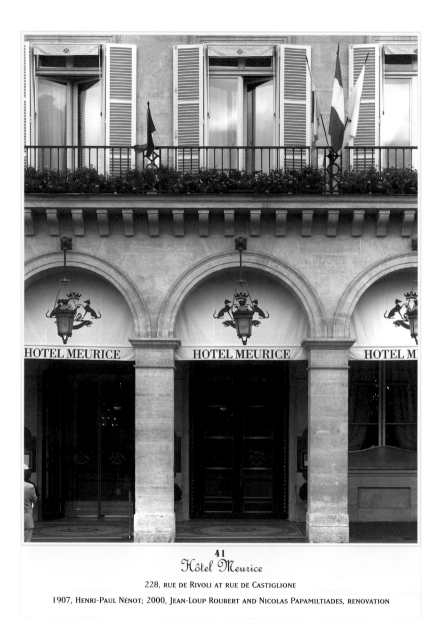

41
Hôtel Meurice

228, RUE DE RIVOLI AT RUE DE CASTIGLIONE

1907, HENRI-PAUL NÉNOT; 2000, JEAN-LOUP ROUBERT AND NICOLAS PAPAMILTIADES, RENOVATION

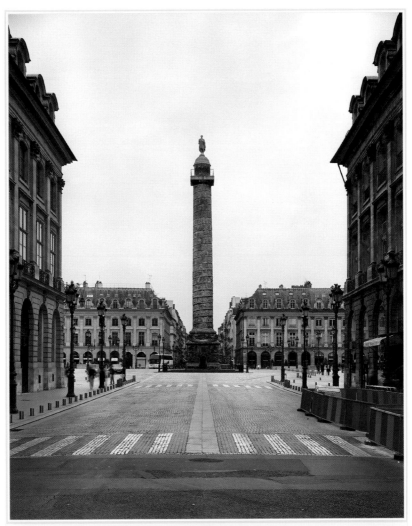

42

Place Vendôme

BETWEEN RUE DE CASTIGLIONE AND RUE DE LA PAIX

1699–1720, JULES HARDOUIN-MANSART

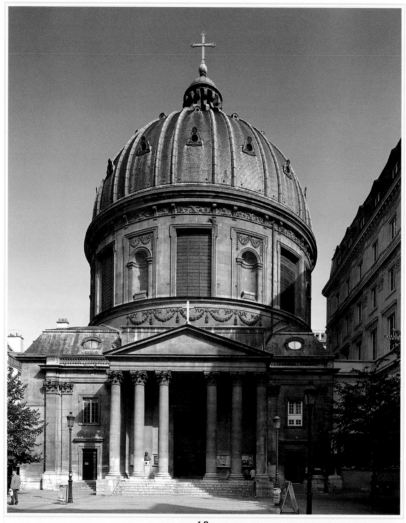

43

Notre-Dame-de-l'Assomption

263 BIS, RUE SAINT-HONORÉ AT RUE CAMBON AND RUE DUPHOT

1670–76, CHARLES ERRARD

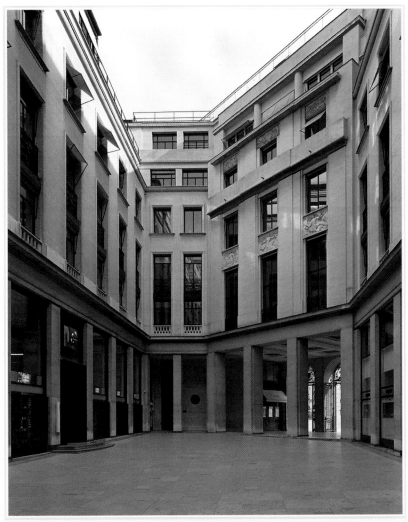

44

Cour Vendôme

BETWEEN PLACE VENDÔME AND RUE SAINT-HONORÉ

1934

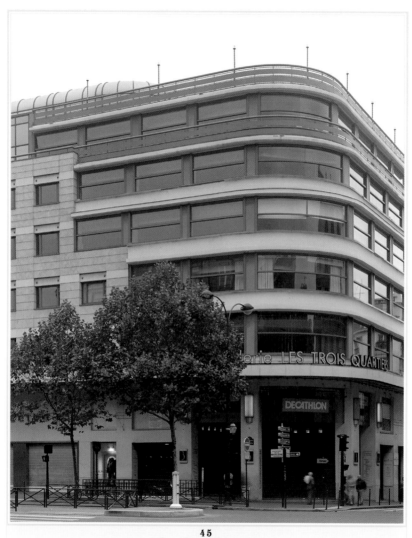

45

Aux Trois Quartiers

17, BOULEVARD DE LA MADELEINE AT RUE DUPHOT

1932, LOUIS FAURE-DUJARRIC

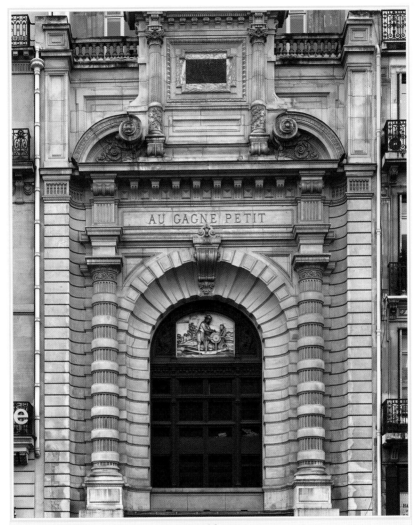

46

Au Gagne Petit

23, AVENUE DE L'OPÉRA AT RUE SAINT-ROCH

1878

2ND ARRONDISSEMENT

From the French Revolution in 1789 through the end of the Belle Epoque in 1914, Paris was arguably the capital of Europe—and, the second arrondissement, the crossroads between the capital and the rest of the world. Driving this hub of international activity, the Paris stock exchange and the media defined the business character of this district. Capitalism swept into Paris via La Bourse, the Greek temple to finance initiated by Napoléon I but opened in 1825, ten years after his removal from power. Close by, in the Sentier area, the textile industry took root and supplied the country with clothes and fashion. Having made their fortune in commerce and the stock market, the rising middle class replaced the aristocracy in the neighborhood, sparking a need for entertainment. The theaters and restaurants that lined the Grands Boulevards, along the old northern fortification border, provided amusement, as did the prostitution that developed along rue Saint-Denis on the eastern side. The Revolution also gave rise to freedom of the press—journalists, though periodically stifled, established a presence in the second arrondissement and reported on the political progress of France, often instigating progressive reforms. Thus, the district still resonates to the sounds of money, communications, and entertainment.

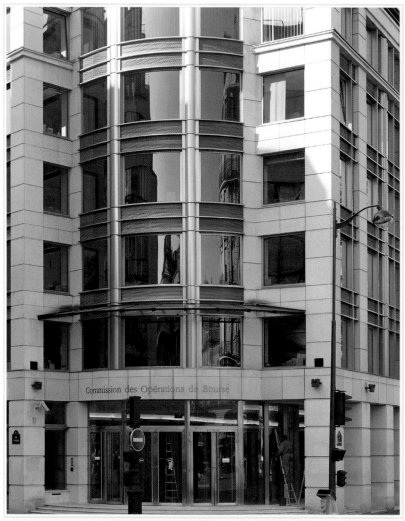

47

Commission des Opérations de Bourse

17, PLACE DE LA BOURSE AT RUE VIVIENNE

c. 1990

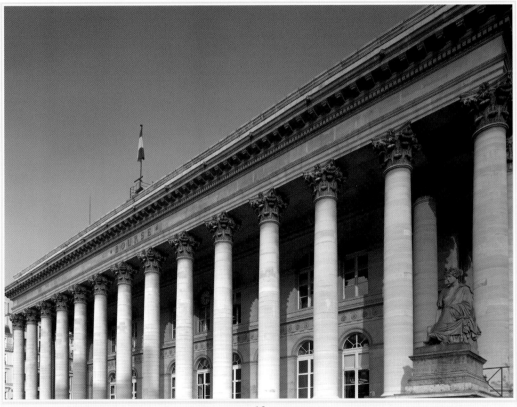

48

Bourse

PLACE DE LA BOURSE, BETWEEN RUE NOTRE-DAMES-DES-VICTOIRES AND RUE VIVIENNE

1809–26, ALEXANDRE-THÉODORE BRONGNIART, ORIGINAL BUILDING; 1813–26, ELOI LABARRE;
1902–07, JEAN-BAPTISTE-FRÉDÉRIC CAVEL, EXPANSION

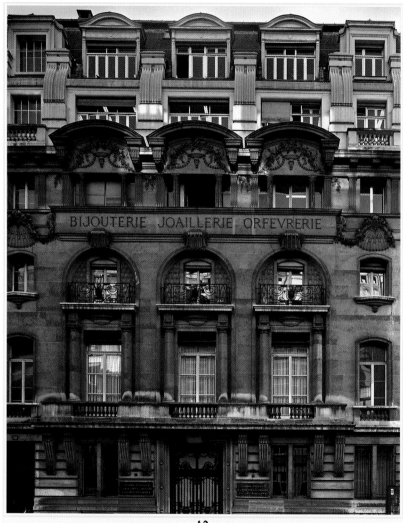

49

Chambre syndicale de la Bijouterie

58, RUE DU LOUVRE AT RUE D'ARGOUT

C. 1900; C. 1930, ADDITION OF TWO STORIES

50

Ministère de la Culture et de la Communication (Administration Centrale)

4, RUE DE LA BANQUE AT RUE DES PETITS-PÈRES

1905, PIERRE-HENRY NENOT

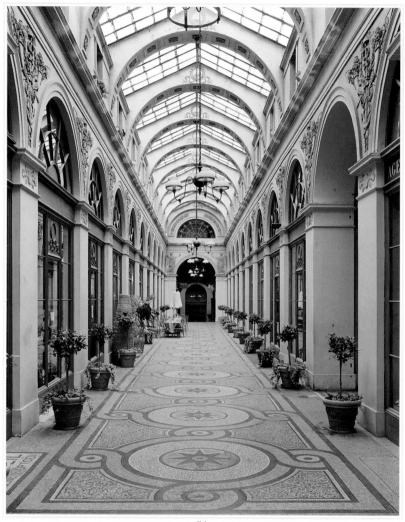

51

Galerie (Passage) Vivienne

4, RUE DES PETITS-CHAMPS, 5, RUE DE LA BANQUE AND 6, RUE VIVIENNE
BETWEEN PLACE DES VICTOIRES AND BIBLIOTHÈQUE NATIONALE

1823–26, FRANÇOIS-JACQUES DELANNOY

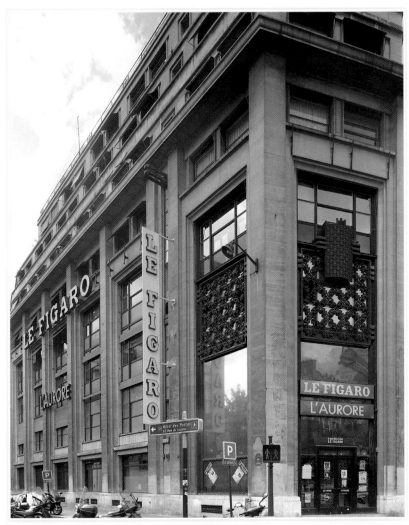

52

Le Figaro

37, rue du Louvre and 25, rue d'Aboukir at rue Montmartre

1936, F. Leroy and J. Cury

53
Hôtel

2 BIS, RUE DE LA JUSSIENNE AT 40, RUE ETIENNE-MARCEL

1752, DENIS QUIROT

54

Société Générale

132-134, RUE RÉAUMUR; 1901, JACQUES HERMANT

55

40-42 rue d'Argout

At rue du Louvre, number 40 c. early 18th century; number 42 1830-40

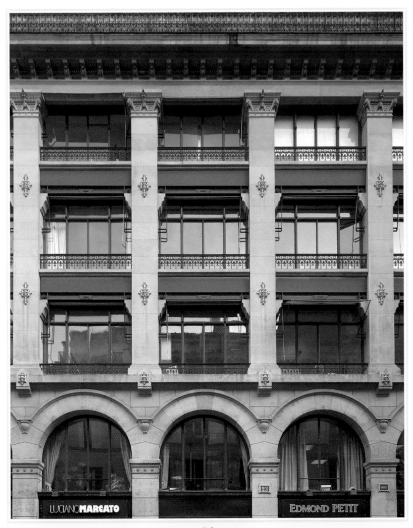

5 6

23, rue du mail

BETWEEN RUE MONTMARTRE AND PLACE DES VICTOIRES

c.1880

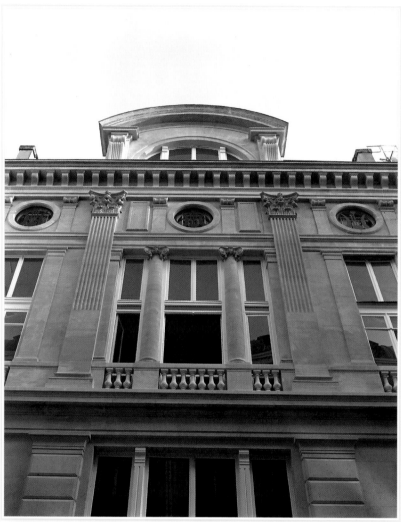

57

Ancienne salle de concert

11, RUE PAUL LELONG, BETWEEN RUE MONTMARTRE AND RUE NOTRE-DAMES-DES-VICTOIRES

c. 1844

58

Hôtel de Rambouillet

2—4, RUE VIDE-GOUSSET AND 3—4, RUE D'ABOUKIR AT PLACE DES VICTOIRES

1634

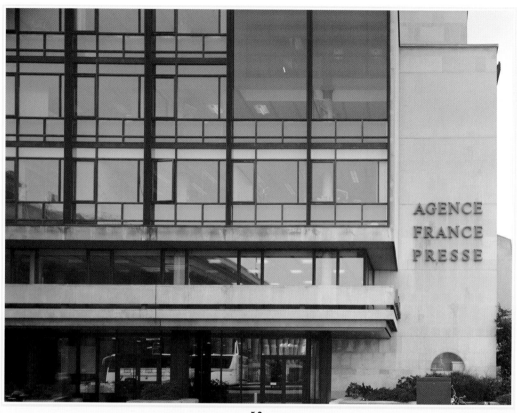

59

Agence France Presse

11–15, PLACE DE LA BOURSE, BETWEEN RUE VIVIENNE AND RUE DE LA BANQUE

1961, ROBERT CAMELOT AND JEAN-CLAUDE ROCHETTE

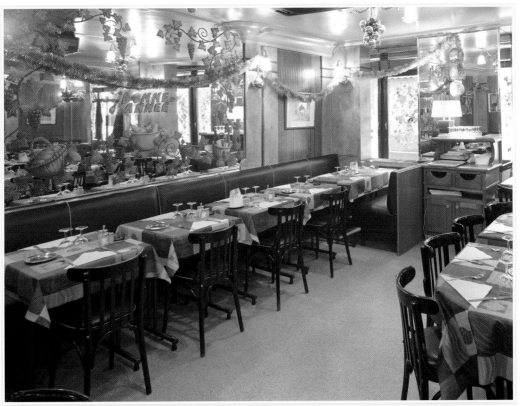

60

Café le Croissant

146, RUE MONTMARTRE AT RUE DU CROISSANT

1850

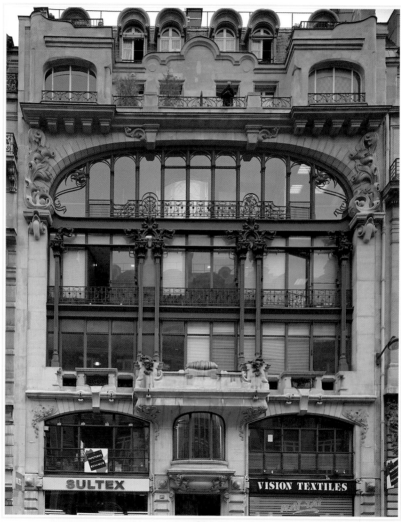

61

118, rue de Réaumur

AT RUE MONTMARTRE AND RUE DU SENTIER

1900, CHARLES DE MONTARNAL

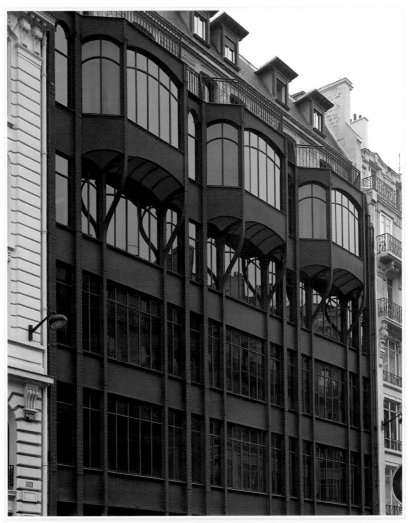

62

124, rue de Réaumur

At rue Montmartre and rue du Sentier

1904–05, Georges Chédanne

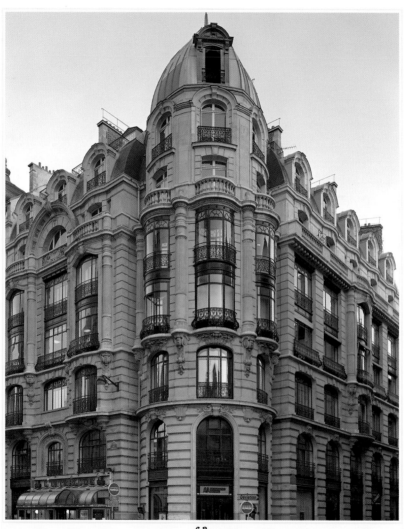

63

121, rue de Réaumur

AT RUE NOTRE-DAME-DES-VICTOIRES

1900, CHARLES RUZÉ

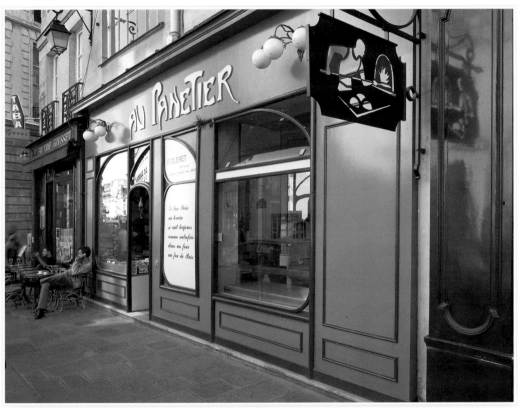

64

Au Panetier

10, PLACE DES PETITS-PÈRES ACROSS FROM NOTRE-DAME-DES-VICTOIRES

c. 1900

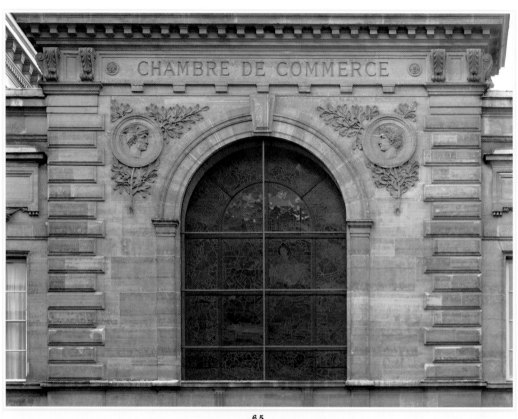

65

Chambre De Commerce

21, RUE NOTRE-DAME-DES-VICTOIRES AT PLACE DE LA BOURSE

1833, FÉLIX CALLET; 1891, JULES LISCH, EXTENSION

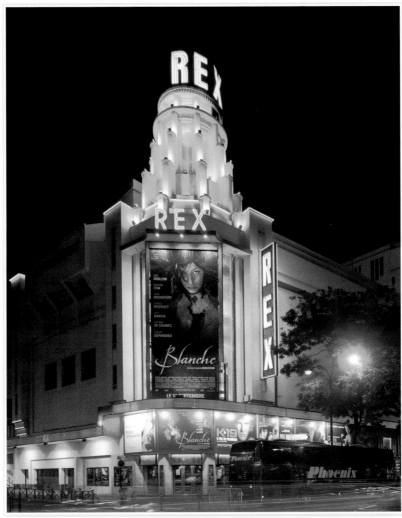

6 6

Le Rex

1-5, BOULEVARD POISSONIÈRE

1931, ANDRE BLUYSEN AND JOHN EBERSON

67

13 &15–17, rue d'Uzès

BETWEEN RUE MONTMARTRE AND RUE SAINT-FIACRE

NUMBER 13, 1885–86, GUSTAVE RAULIN; NUMBERS 15–17, 1887, ETIENNE SOTY

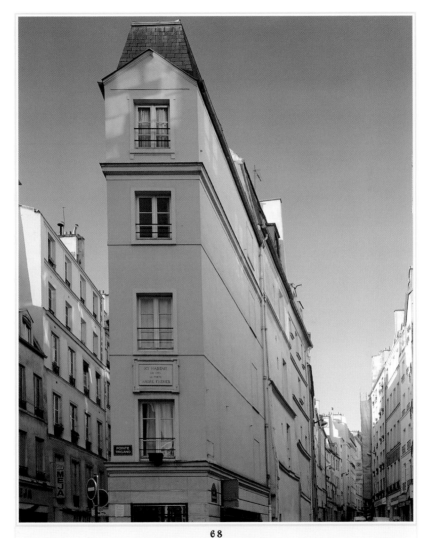

68

House of André Chénier

9, RUE CHÉNIER AT CORNER OF RUE DU BEAUREGARD AND RUE DE CLÉRY

C. EIGHTEENTH CENTURY

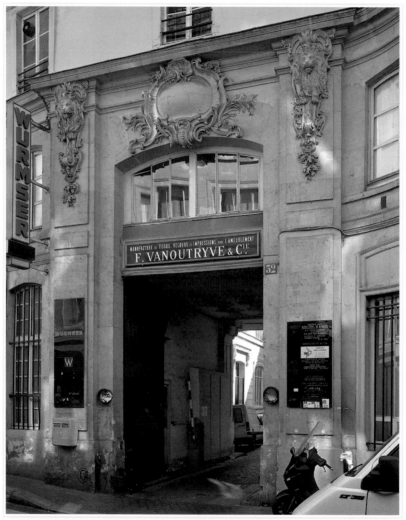

69

Ancien Hôtel Masson de Meslay

32, RUE DU SENTIER AT BOULEVARD POISSONNIÈRE

c. 1700

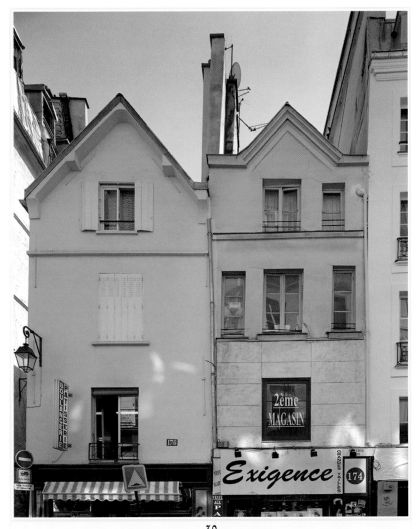

70

174 & 176, rue Saint-Denis *(Maisons a pignon)*

AT RUE RÉAUMUR

C. SIXTEENTH CENTURY

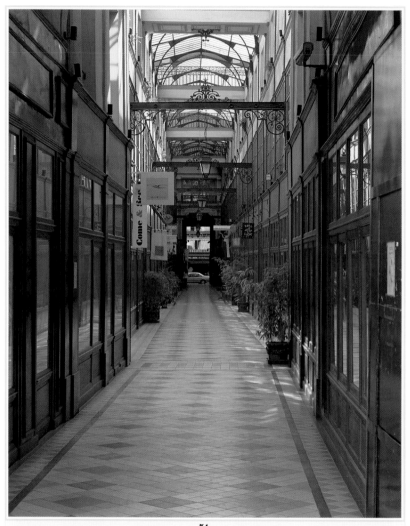

71

Passage du Grand-Cerf

10, RUE DUSSOUBS AND 145, RUE SAINT-DENIS

1825–35, CONSTRUCTION; 1989, RESTORATION

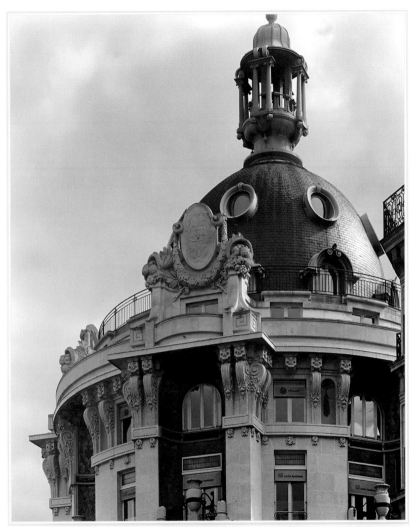

72

51, rue Réaumur

At boulevard de Sébastopol

1910, Charles Henry-Camille Le Maresquier

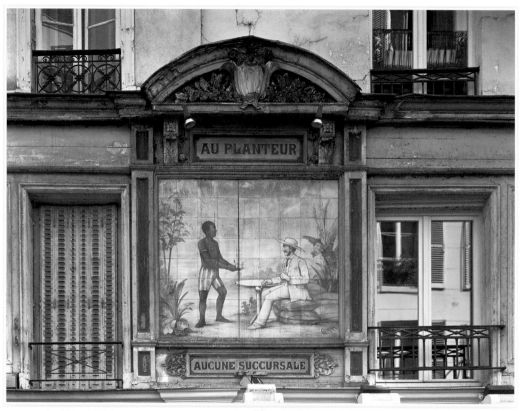

73

10–12, rue des Petits-Carreaux

AT RUE BELLAN

C. EARLY NINETEENTH CENTURY

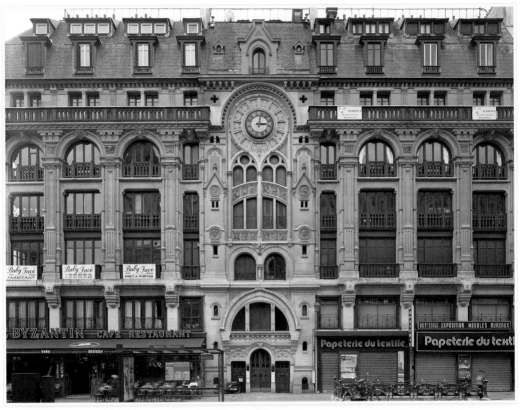

74

61–63, rue Réaumur

AT RUE SAINT-DENIS

C. 1900, G. SIRGERY AND P. JOUANNIN

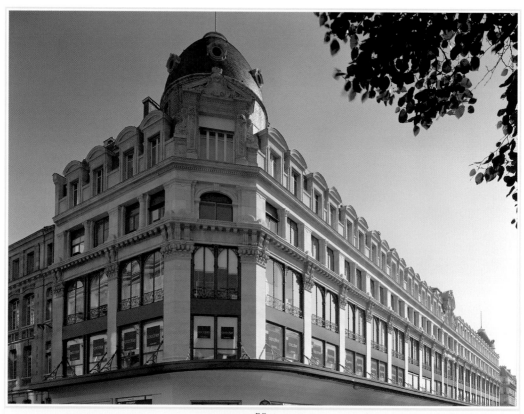

75

82–92, rue Réaumur

At rue Saint-Denis

1897, F. Constant-Bernard

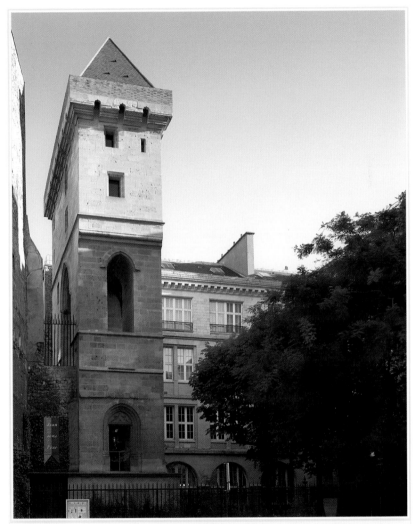

76

Tour de Jean-Sans-Peur

20, RUE ETIENNE-MARCEL AT RUE DE TURBIGO

1409–11, ROBERT DE HELBUTERNE

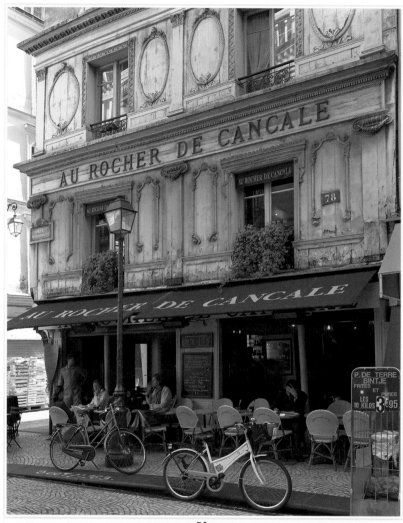

79

Au Rocher de Cancale

78, RUE MONTORGUEIL AT RUE GRENETA

1850

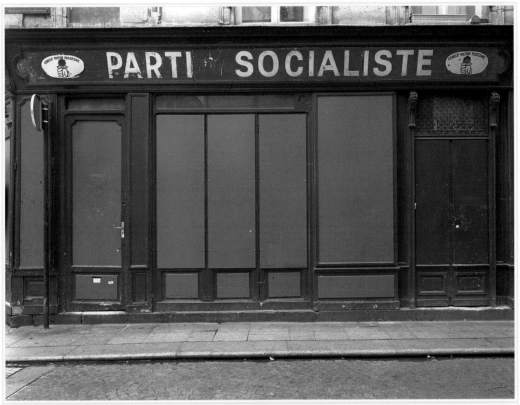

80

Parti Socialiste

73, RUE MONTORGUEIL, CORNER OF RUE LÉOPOLD-BELLAN AND RUE MONTORGUEIL

C. 1720

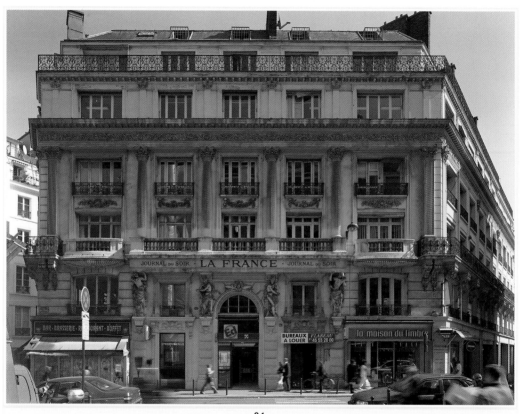

81

La France

142, RUE MONTMARTRE AT RUE RÉAUMUR

1885, FERDINAND BAL

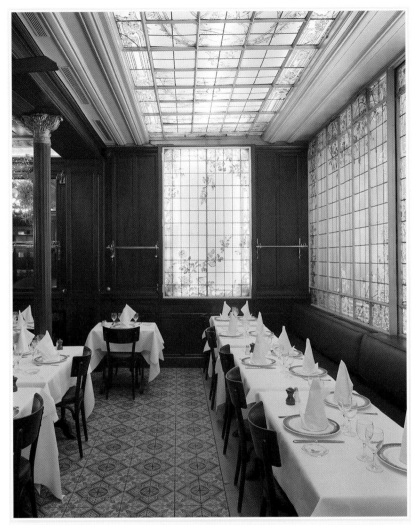

82

Galopin

40, RUE NOTRE-DAME-DES-VICTOIRES AT PLACE DE LA BOURSE

1876

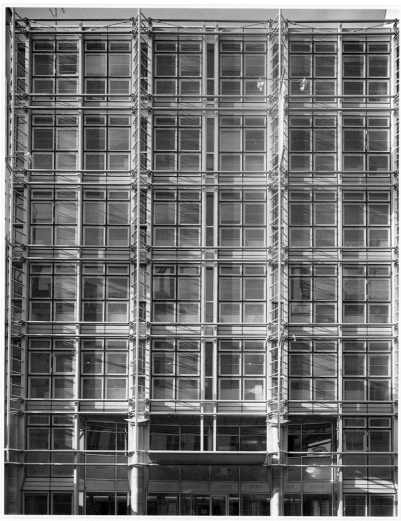

83

La Tribune

46, RUE NOTRE-DAME-DES-VICTOIRES, AT PLACE DE LA BOURSE

1991, JEAN-JACQUES ORY

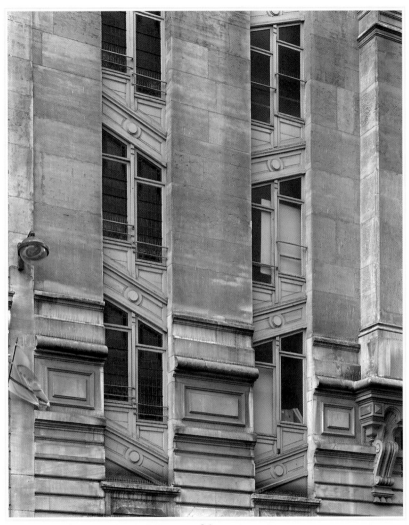

84

One, rue Leon Cladel

AT 111 RUE MONTMARTRE

C. 1890

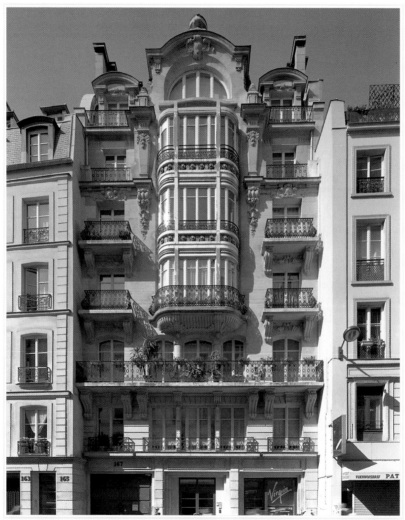

85

167, rue Montmartre

AT RUE D'UZÈS

1909, VICTOR BLAVETTE

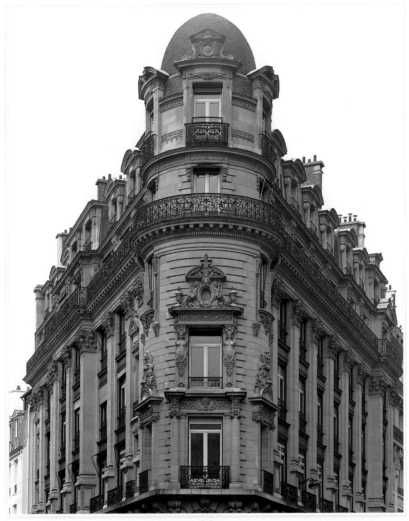

86

101, rue Réaumur

AT RUE DE CLÉRY

1895, ALBERT WALWEIN

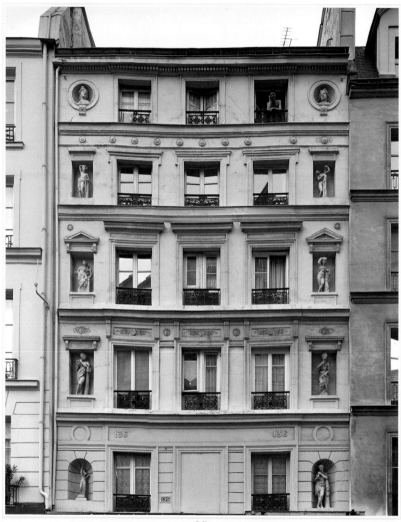

87

Hôtel de Mantoue

136, RUE MONTMARTRE, BETWEEN RUE RÉAUMUR AND RUE LÉON CLADEL

1820–30

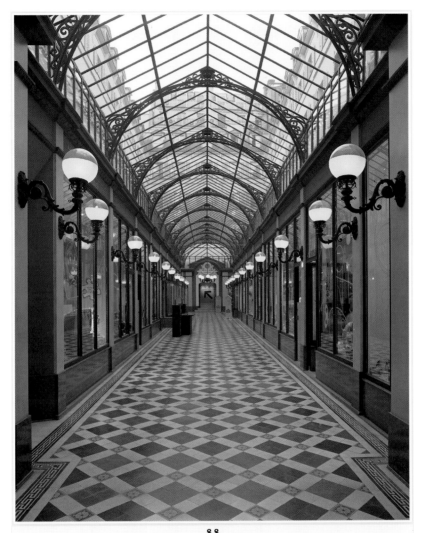

88

Passage des Princes

5, BOULEVARD DES ITALIENS AND 97–99, RUE DE RICHELIEU

1860; 1990–94, RESTORED

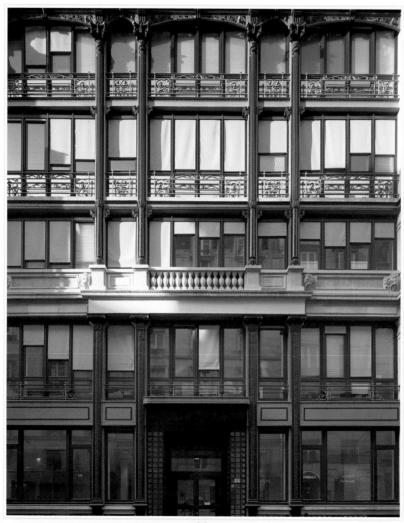

89

Commercial Building

24, RUE SAINT-MARC AT RUE VIVIENNE

1894, LOUIS THALHEIMER

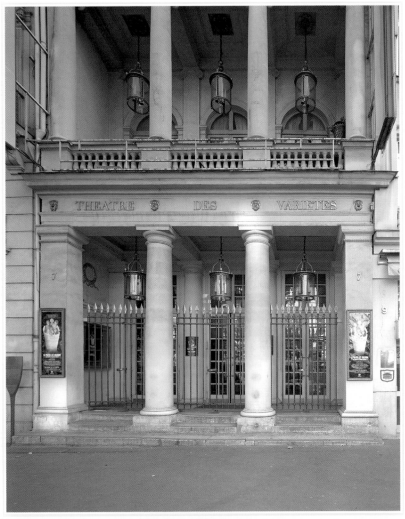

90

Théâtre des Variétés

7, BOULEVARD MONTMARTRE AT RUE MONTMARTRE

1806–07, JACQUES CELLERIER

91

38–40 & 47–49, avenue de l'Opéra

AT RUE DU QUARTRE SEPTEMBRE AND RUE DE LA PAIX

1873, HENRY BLONDEL

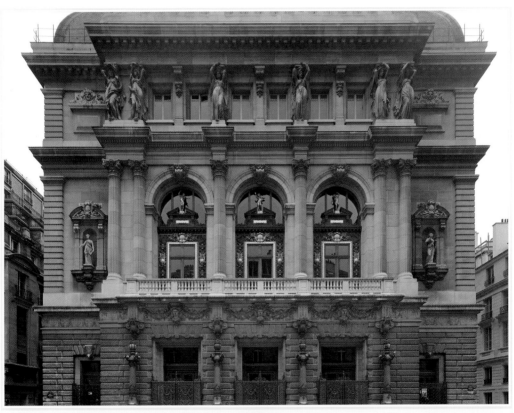

92

Opéra-Comique

ONE, PLACE BOÏELDIEU BETWEEN RUE FAVART AND RUE MARIVAUX

1894–98, LOUIS BERNIER

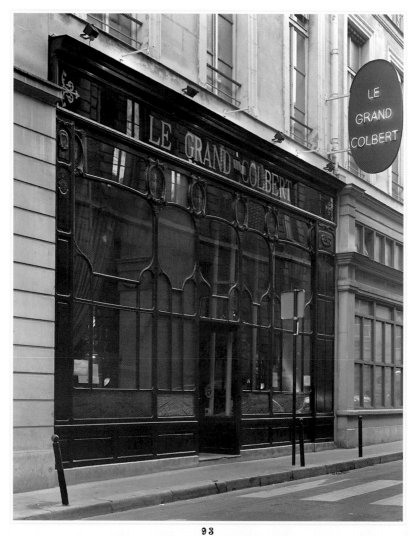

93

Le Grand Colbert

2, RUE VIVIENNE AT RUE DES PETITS-CHAMPS AND GALERIE COLBERT

1826, J. BILLAUD, THE GALERIE COLBERT, BUILDING

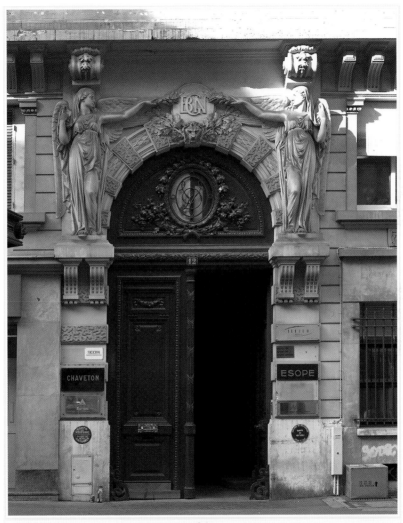

94

4–12, rue du Quatre-Septembre

Between rue de la Bourse and rue Feydeau

1793, Louis-Joseph Bernard, altered later by Nicolas-Jacques-Antoine Vestier

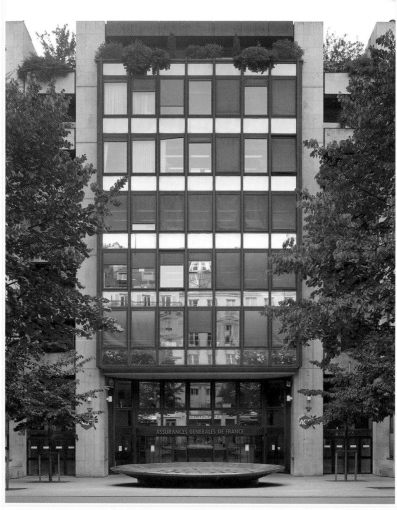

9 5

Siège des Assurances générales de France (AGF)

87, RUE DE RICHELIEU BETWEEN RUE SAINT-MARC AND RUE FEYDEAU

1979, JOSEPH BELMONT AND PIERRE-PAUL HECKLY

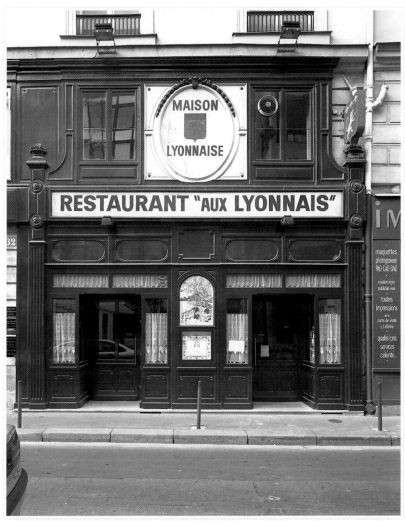

96

Aux Lyonnais

32, RUE SAINT-MARC

1890

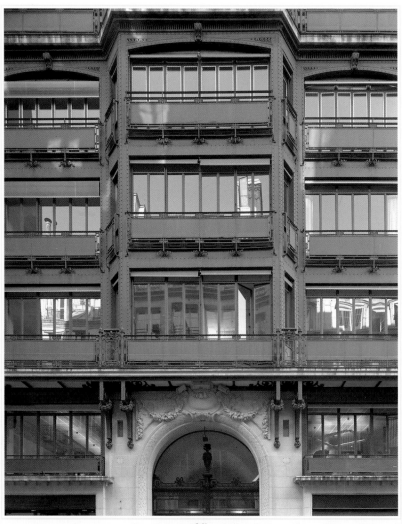

97

12, rue Gaillon at place Gaillon

1913, Jacques Hermant

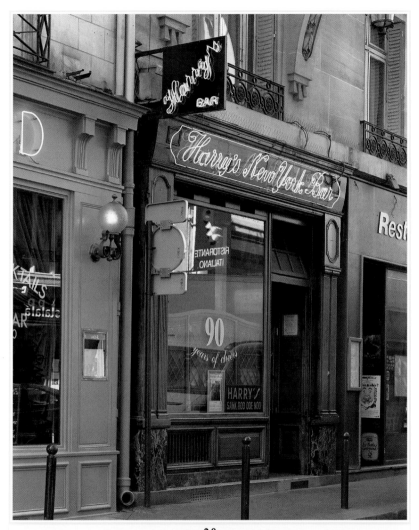

98

Harry's New York Bar

5, RUE DAUNOU AT AVENUE DE L'OPÉRA

1911

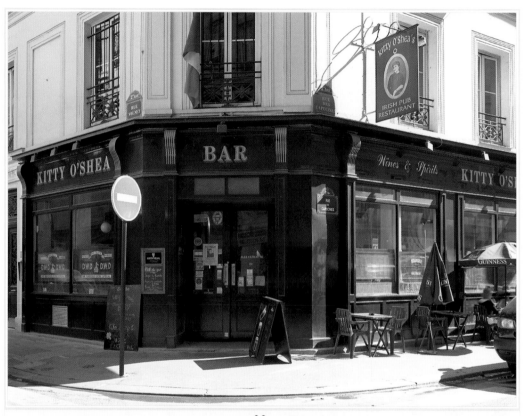

99
Kitty O'Shea's
10, RUE DES CAPUCINES AT RUE VOLNEY

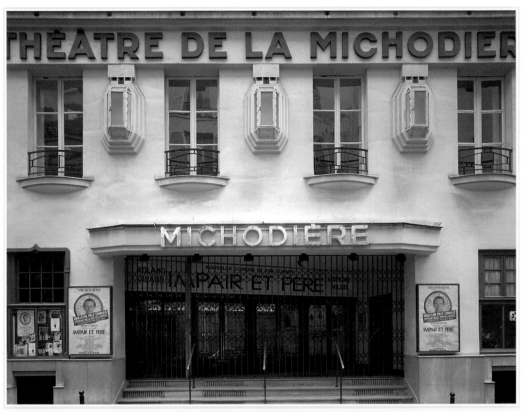

Théâtre de La Michodière

4 BIS, RUE DE LA MICHODIÈRE AT RUE SAINT-AUGUSTIN

1923, AUGUSTE BLUYSEN

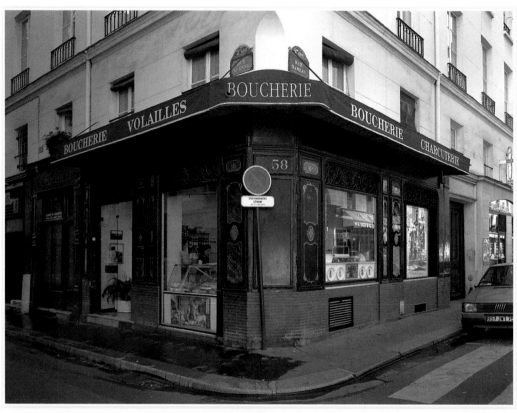

101

Boucherie

58, RUE SAINTE-ANNE, CORNER OF RUE SAINTE-ANNE AND RAMEAU

C. NINETEENTH CENTURY

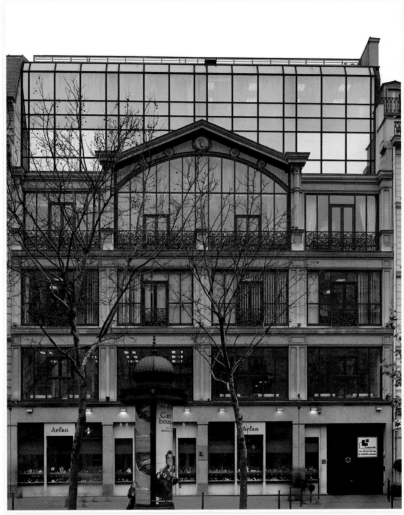

102

Atelier Nadar

35, boulevard des Capucines at rue Daunou

1860, Etienne Soty; 1993, transformations

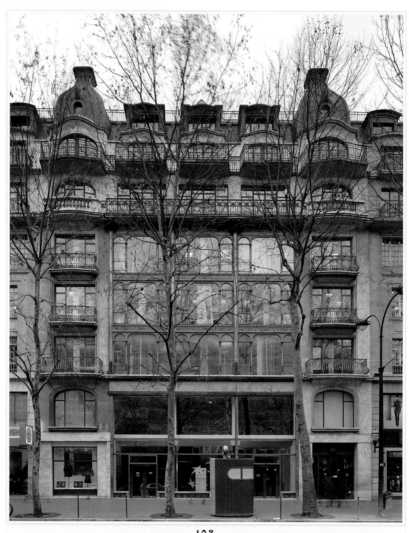

103

Ancienne Samaritaine de Capucines

27, BOULEVARD DES CAPUCINES AT RUE DAUNOU AND RUE SCRIBE

1914—17, FRANTZ JOURDAIN

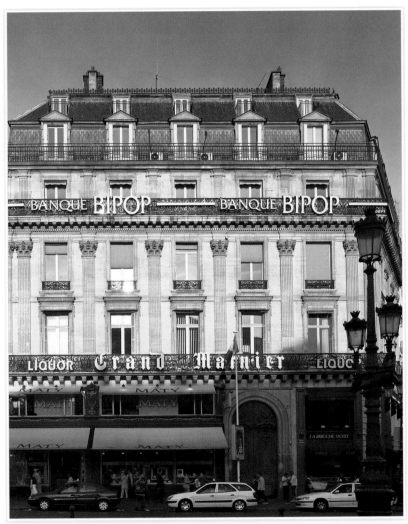

104

Bijouterie Maty

4, PLACE DE L'OPÉRA AT AVENUE DE L'OPÉRA

1875

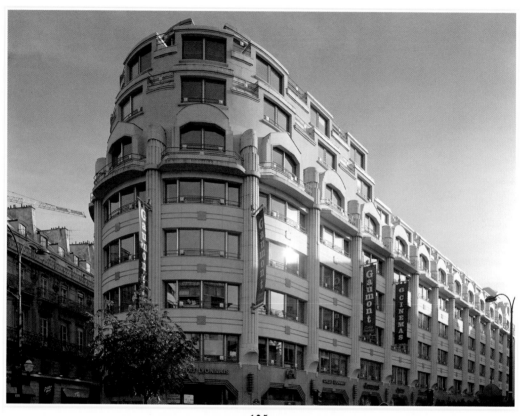

105

Palais du Hanovre

31–33, BOULEVARD DES ITALIENS AT 26, RUE LOUIS-LE-GRAND

1932, CHARLES LEMARESQUIER AND VICTOR LALOUX

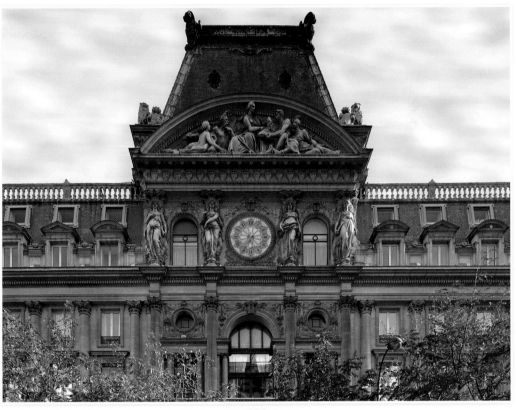

106

Crédit Lyonnais

19, boulevard des Italiens between rue de Choiseul, rue de Gramont, and rue du Quatre Septembre

1876–78, William Bouwens Van der Boijen

107

4–6, rue Gaillon

BETWEEN AVENUE DE L'OPÉRA AND RUE SAINT-AUGUSTIN

1730

3ʳᵈ Arrondissement

In the thirteenth century, the Knights Templar drained the remaining swampland here and settled into what is now the northern portion of the historic Marais (literally, "marsh"). They were followed by the French aristocracy, who erected private mansions in the neighborhood and remained until the mid-seventeenth century when the royal court moved to Versailles. Largely ignored through the nineteenth century and first part of the twentieth, the third arrondissement next attracted an influx of poor Jewish immigrants from Eastern Europe, and many of the former aristocratic homes were converted to workshops and tenements. By the 1960s, the area was an infested slum and in danger of mass demolition. Saved by then Minister of Culture, André Malraux, the Marais became a protected historic site and many of the magnificent private mansions, known as *hôtel particuliers*, were restored and became museums.

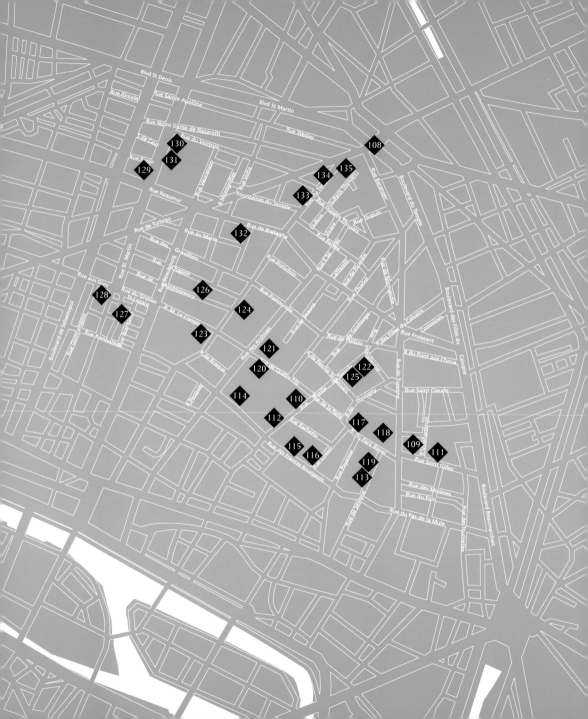

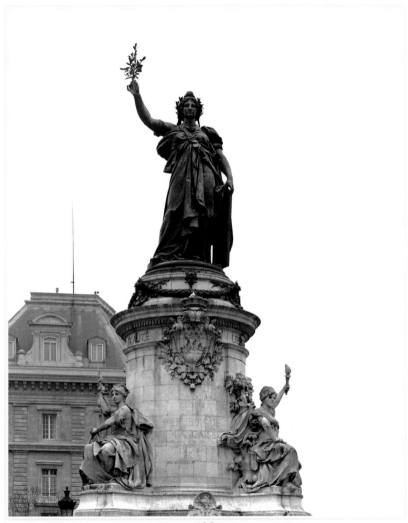

108

Place de la République

At the boundary of the 3rd, 10th and 11th arrondissements

1854–59, A. Legrom, Vérines Barracks; 1866, Gabriel Davioud, Magasins Réunis;
1883, Léopold and Charles Morice, sculptors of Statue of the République

109

Hôtel de Montrésor

110
Hôtel de Rohan

87, RUE VIEILLE-DU-TEMPLE AT RUE BARBETTE

1705–08, PIERRE-ALEXIS DELAMAIR

111

7, rue Saint-Gilles

BETWEEN RUE DE TURENNE AND RUE DES TOURNELLES

1987, DOMINIQUE HERTENBERGER AND JACQUES VITRY

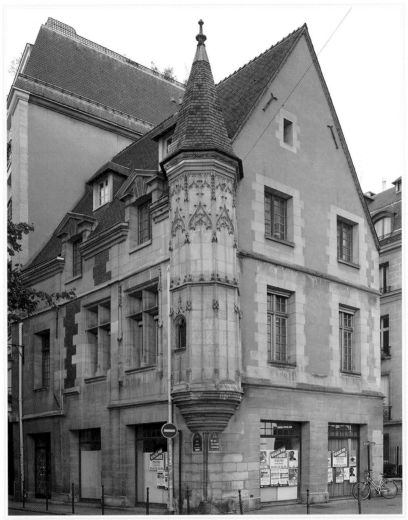

112

Hôtel d'Héroët

54, RUE VIEILLE-DU-TEMPLE AT RUE DES FRANCS-BOURGEOIS

1500—20

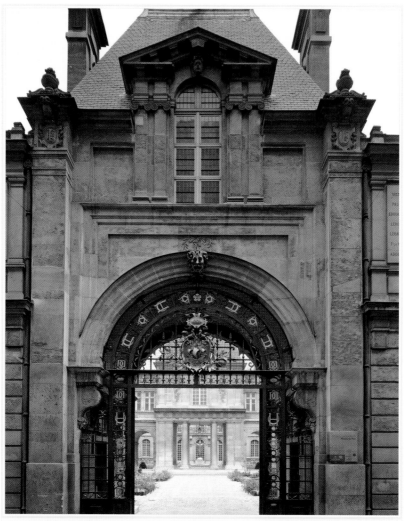

113

Musée Carnavalet

23, RUE DE SÉVIGNÉ AT RUE DES FRANCS BOURGEOIS

1547—49, NICHOLAS DUPUIS, MASON; DESIGN ATTRIBUTED TO PIERRE LESCOT;
c. 1660, FRANÇOIS MANSART, EXTERIOR RESTORATION

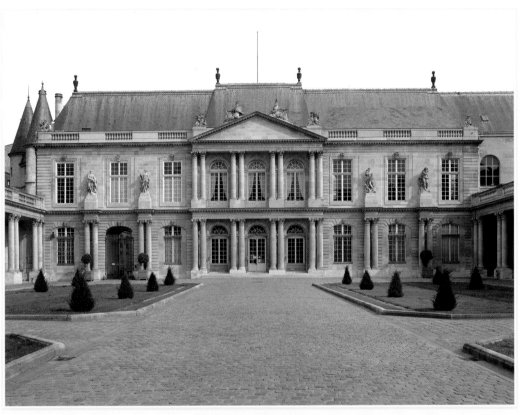

114

Hôtel de Soubise

60, RUE DES FRANCS-BOURGEOIS AND 58, RUE DES ARCHIVES

1705–09, PIERRE-ALEXIS DELAMAIR; 1735, GERMAIN BOFFRAND

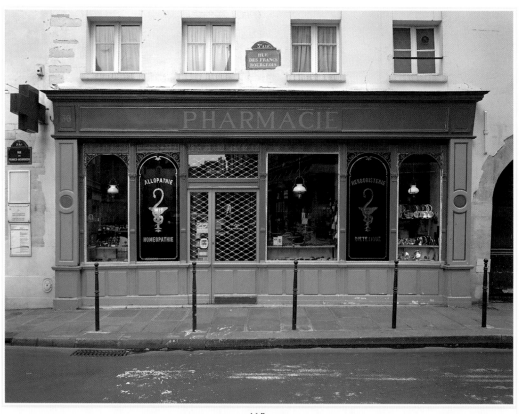

115

Pharmacie des Francs Bourgeois

36, RUE DES FRANCS-BOURGEOIS

C. SEVENTEENTH CENTURY

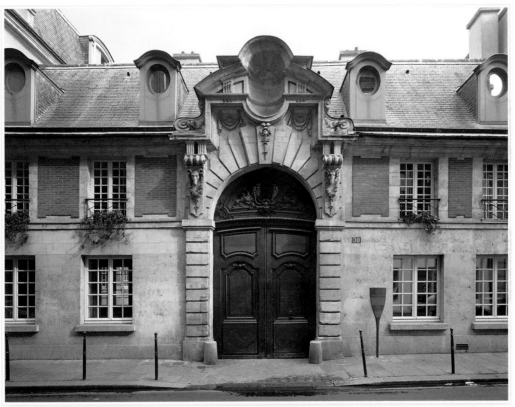

116

Hôtel d'Alméras

<small>30, RUE DES FRANCS-BOURGEOIS AT RUE ELZÉVIR</small>

<small>1611, LOUIS MÉTEZEAU; 1981—83, RESTORATION</small>

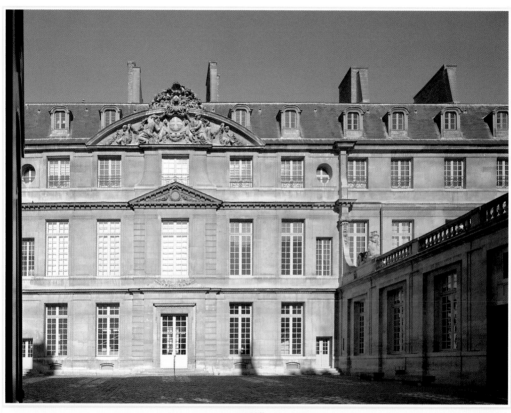

117

Hôtel Salé (Musée Picasso)

5, RUE THORIGNY

1656–59, JEAN BOULLIER DE BOURGES; 1974–84, BERNARD VITRY AND BERNARD FONQUERNIE, EXTERIOR RESTORATION;
1976, ROLAND SIMOUNET, INTERIOR RESTORATION

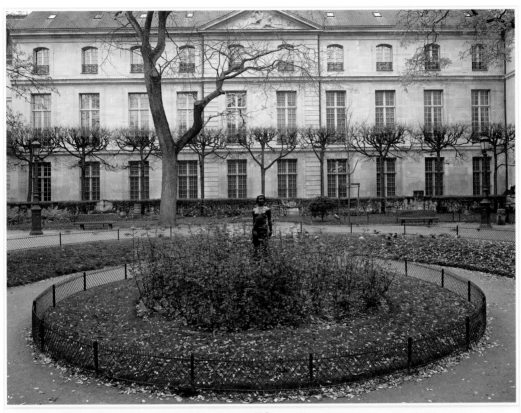

118
Hôtels Particuliers (Private Mansions)

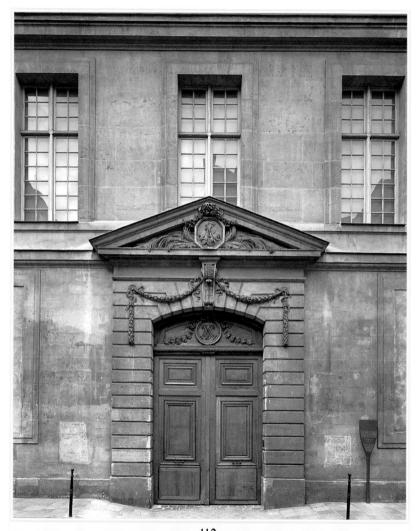

119

Hôtel Le Peletier de Saint-Fargeau

29, RUE DE SÉVIGNÉ BETWEEN RUE DES FRANCS BOURGEOIS AND RUE DU PARC ROYAL

1686–90, PIERRE BULLET

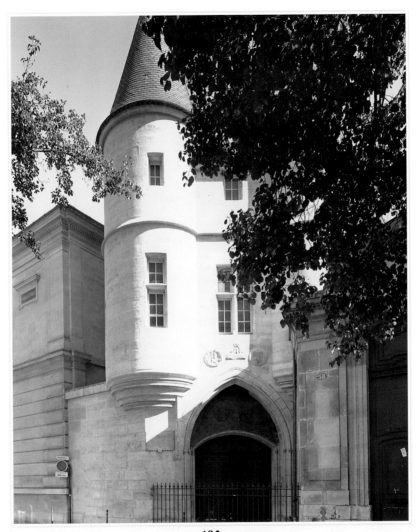

120

Hôtel de Clisson

58, RUE DES ARCHIVES AT RUE DES QUATRE-FILS

c. 1375

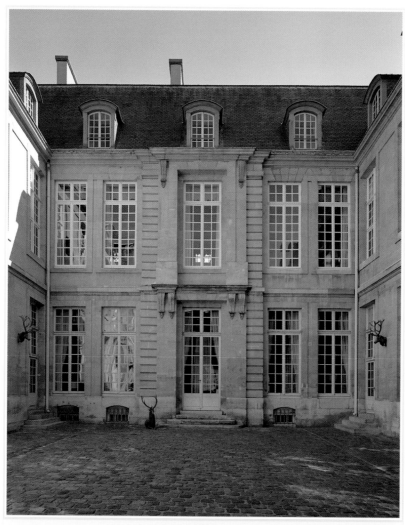

121

Hôtel de Guénégaud (Musée de la Chasse et de la Nature)

60, RUE DES ARCHIVES AT RUE DES QUATRE-FILS

1653–55, FRANÇOIS MANSART

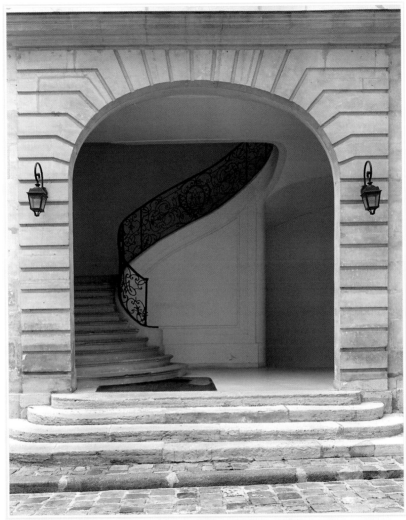

122
Hôtel d'Hozier

110, RUE VIEILLE-DU-TEMPLE AT RUE DE DEBELLEYME

1623, JEAN THIRIOT; 1731, MODIFIED BY DENIS QUIROT

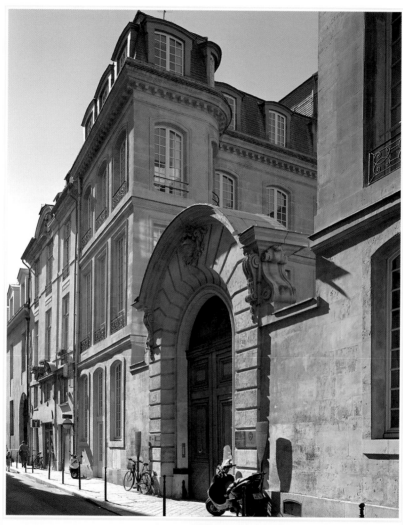

123

Hôtel de Montmort

79, RUE DU TEMPLE AT RUE DE BRAQUE

C. 1623, GIRARD GIPPON; 1752–54, REBUILT, PIERRE-ETIENNE DE BEAUMONT

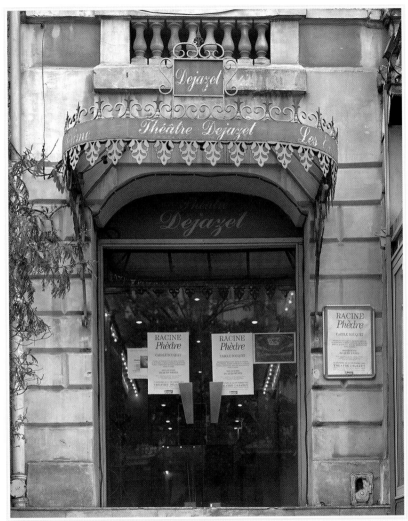

124

Théâtre Libertaire de Paris Déjazet

41, BOULEVARD DU TEMPLE

1786, FRANÇOIS-JOSEPH BELANGER

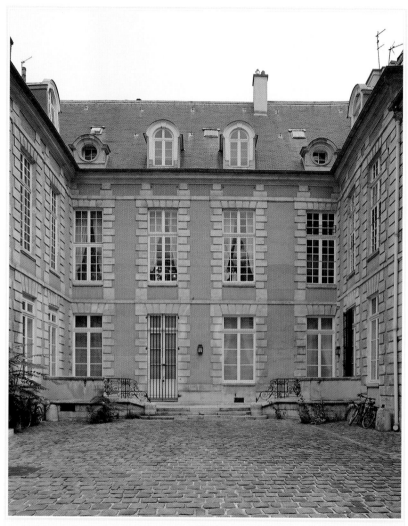

125

Hôtel Mégret de Sérilly

106, RUE VIEILLE-DU-TEMPLE AT RUE DE THORIGNY

1620–21, JEAN THIRIOT; 1686, JEAN COURTONNE

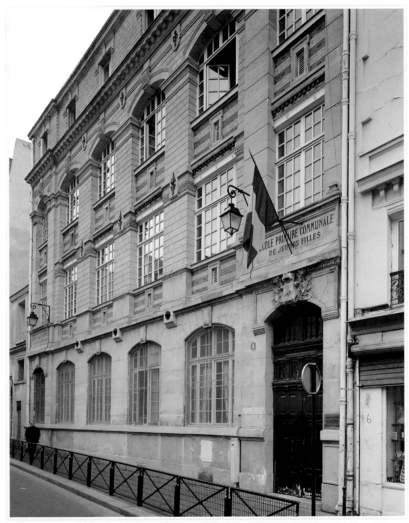

126

Ecole Primaire Communale de Jeunes Filles

8, RUE DE MONTMORENCY

c.1881

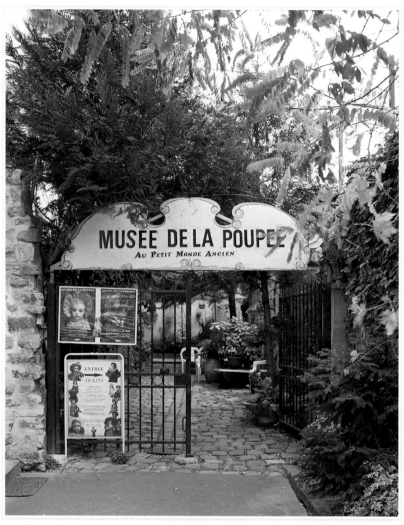

127
Musée de la Poupée

IMPASSE BERTHAUD

1994

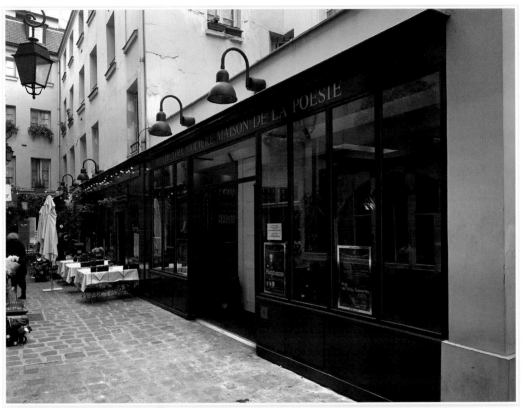

128

Théâtre Molière Maison de la Poésie

PASSAGE MOLIÈRE 1 AT 57 RUE SAINT-MARTIN

1791; 1993–95, REBUILT

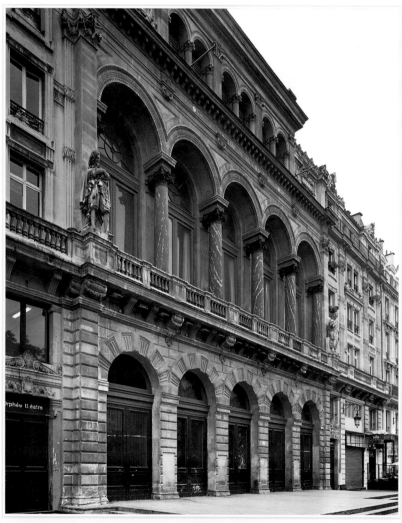

129

Théâtre de la Gaîté-Lyrique

3-5, RUE PAPIN OPPOSITE SQUARE ÉMILE-CHAUTEMPS

1861–62, ALPHONSE CUSIN

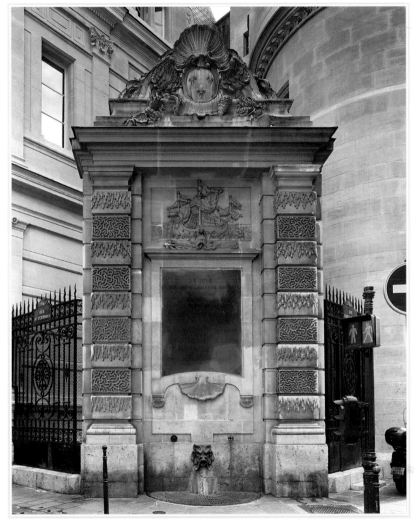

130

Fontaine de Vertbois

CORNER OF RUE SAINT-MARTIN AND RUE DU VERTBOIS

1712; 1882, RESTORED

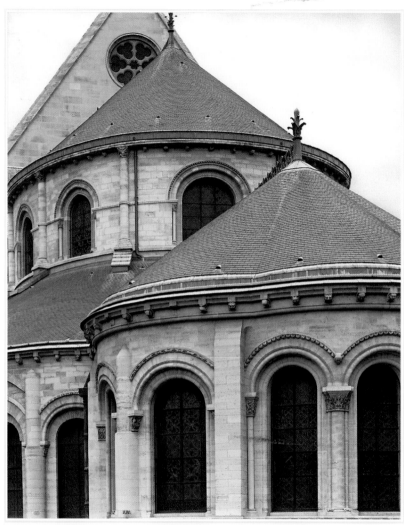

131

Conservatoire National des Arts et Métiers

270-292, RUE SAINT-MARTIN AT RUE DU VERTBOIS

1060—67, PRIORY AND FIRST CHURCH; C. TWELFTH CENTURY, FIRST NAVE AND CHOIR; C. MID—THIRTEENTH CENTURY,
REFECTORY AND REBUILT NAVE; 1794, CONSERVATOIRE ESTABLISHED; 1845—96, LÉON VAUDOYER AND GABRIEL-AUGUSTE
ANCELET, NEW BUILDINGS; 1885, CHURCH FAÇADE

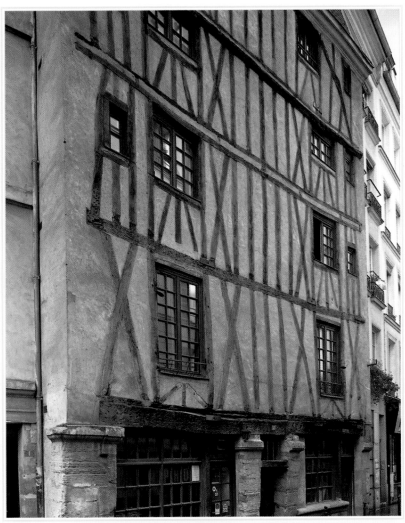

132
Timber House

3, RUE VOLTA AT RUE AU MAIRE

C. SEVENTEENTH CENTURY

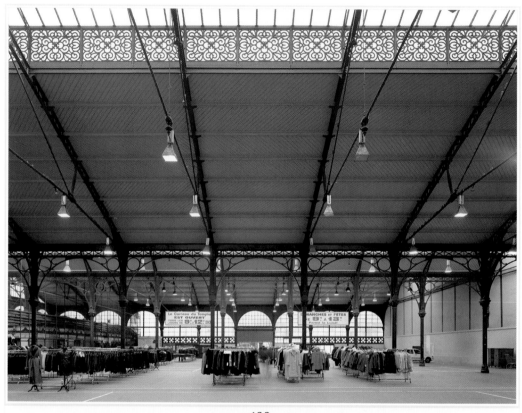

133

Marché du Temple

AT RUES PICARDIE, PERRÉE, EUGÈNE-SPULLER, AND DUPETIT-THOUARS

1808, MOLINOS; 1863, JULES DE MÉRINDOL AND ERNEST LEGRAND

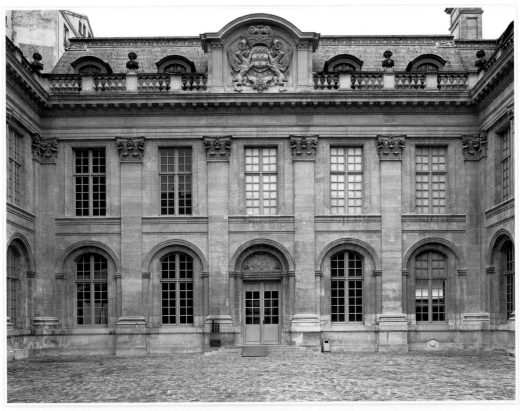

134

Musée d'Art et d'Histoire du Judaïsme (Hôtel de Saint-Aignan/Hôtel d'Avaux)

71, RUE DU TEMPLE AT PASSAGE SAINT-AVOIE

1644, PIERRE LE MUET, HÔTEL DE SAINT-AIGNAN

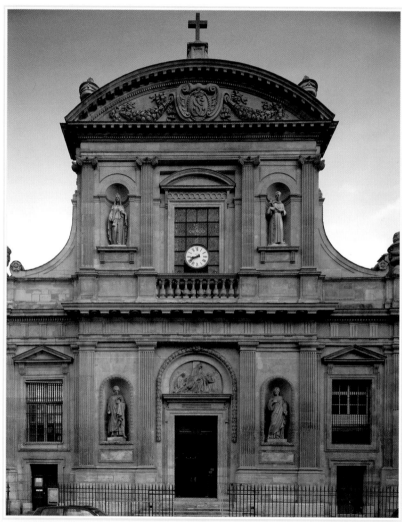

135

Église Sainte-Elisabeth

195, RUE DU TEMPLE AT RUE DE TURBIGO

1628; 1643, MICHEL VILLEDO; 1830, E. H. GODDE, ONLY THE CHANCEL

4TH ARRONDISSEMENT

In 1605, When Henri IV claimed the southern marshland of the Marais and created the first royal square, place des Vosges, he ignited an aristocratic building boom of private mansions called *hôtel particuliers.* Defined by royal legacy and working-class immigration, the neighborhood of the fourth arrondissement comprises the historic districts of the Marais and Beaubourg, the city hall known as Hôtel de Ville, and a symbol of postmodern Paris, the Centre Pompidou. Today, it's also home to art galleries, fashion outlets, funky boutiques, gay bars, and kosher delis.

Place des Vosges, where royalty romped until the Revolution, dominates the district's northern edge; restaurants and galleries now hold forth under its regal arches. Nearby, the old Jewish quarter thrives around rue des Rosiers. The Seine forms the southern border, where Hôtel de Ville commands a civil but bureaucratic presence. The Centre Pompidou provides a museum and cultural entertainment at the fourth's eastern quarter, known as Beaubourg. Derisively nicknamed the "beautiful burg," this area was in fact once a dumping ground for refuse. Lively and cultural and historic, this arrondissement also claims both the little island, Île Saint Louis, with its seventeenth-century architecture, and a slice of Île de la Cité, including Notre-Dame Cathedral.

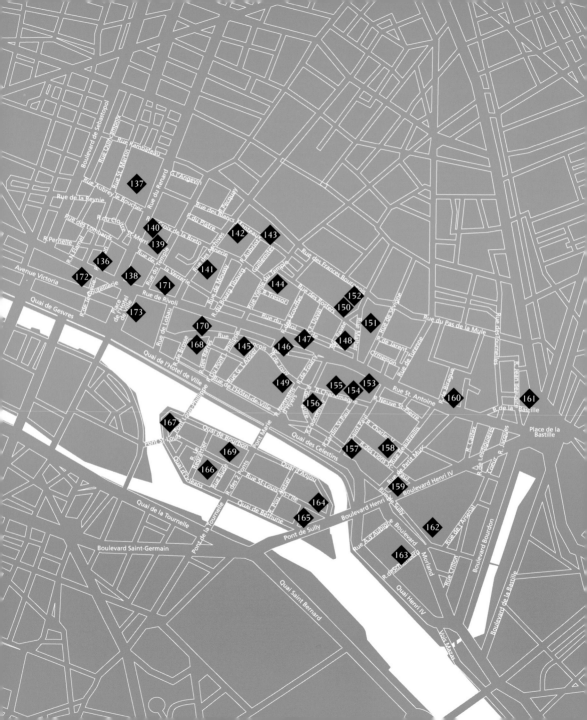

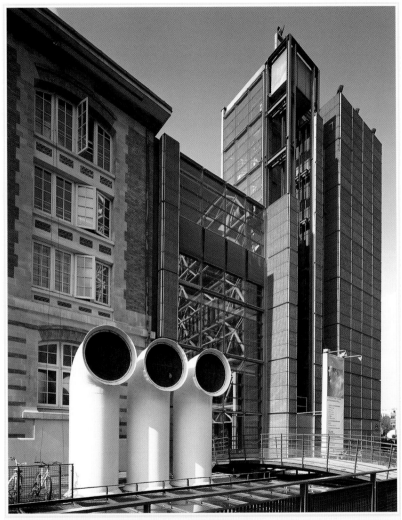

136

I R C A M (Institut de Recherche et de Coordination Acoustique-Musique)

1, PLACE IGOR STRAVINSKY AT PLACE GEORGES-POMPIDOU

1989, RENZO PIANO

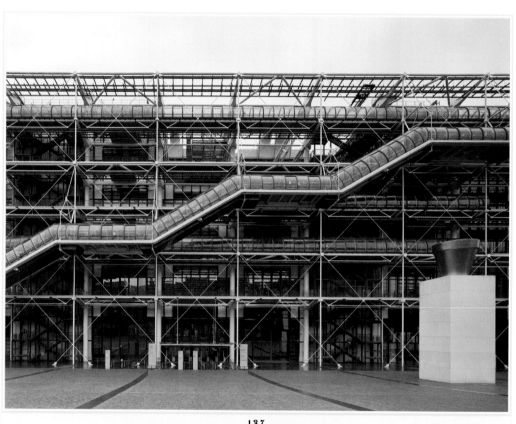

137

Centre Georges-Pompidou

PLACE GEORGES-POMPIDOU AT RUE DU RENARD

1971, RICHARD ROGERS AND RENZO PIANO

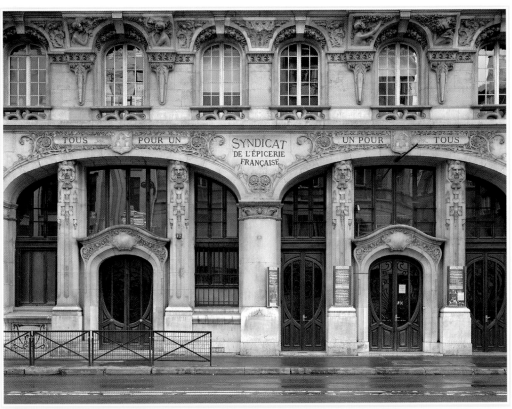

138

Syndicat de l'Épicerie et de l'Alimentation Générale

12, RUE DU RENARD

1901, RAYMOND BARBAUD AND EDOUARD BAUHAIN; SCULPTURES BY JULES-LOUIS RISPAL

139

Hôtel de Berlize

41, RUE DU TEMPLE AT RUE SIMON LE FRANC

C. EARLY SEVENTEENTH CENTURY; 1640, ENLARGED

140
Hôtel Le Rebours

12, RUE SAINT-MERRI AT RUE DU RENARD

C. SIXTEENTH CENTURY, FIRST BUILDING; 1624–25, CLAUDE MONNARD;
1738, ATTRIBUTED TO VICTOR-THIERRY DAILLY, MAIN FAÇADE

141

Cloître des Billettes

24, RUE DES ARCHIVES BETWEEN RUE DE LA VERRERIE AND RUE SAINTE-CROIX DE LA BRETONNERIE

1755–58, DOMINICAN BROTHER CLAUDE, PRESENT CHURCH

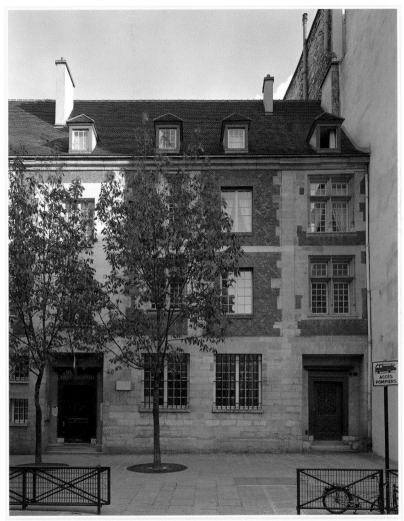

142

École Maternelle (House for the family of Jacques-Coeur)

40, RUE DES ARCHIVES

C. LATE FIFTEENTH CENTURY

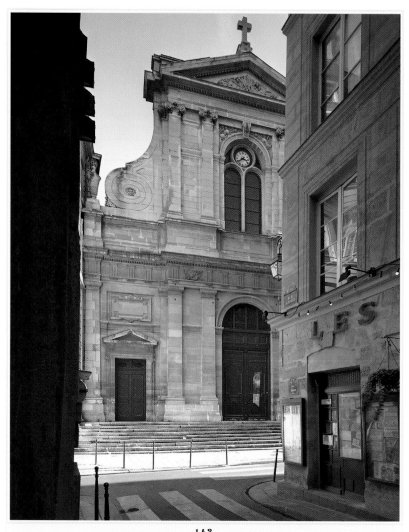

143

Notre-Dame-des-Blancs-Manteaux

12, RUE DES BLANCS-MANTEAUX AND 53, RUE DES FRANCS-BOURGEOIS

1685–1720, CHARLES DUVAL; 1703, JEAN-SYLVAIN CARTAUD, FAÇADE ;
1863, REBUILT BY VICTOR BALTARD

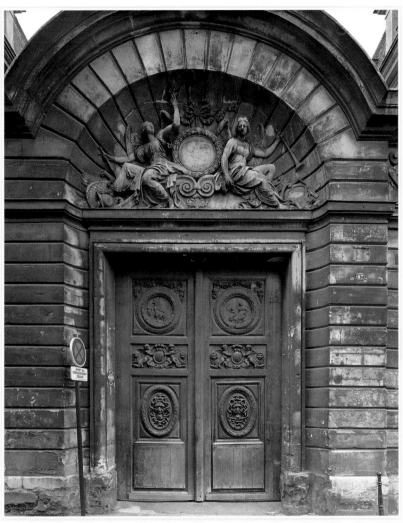

144

Hôtel Amelot de Bisseuil

47, RUE VIEILLE DU TEMPLE

1657–60, PIERRE COTTARD

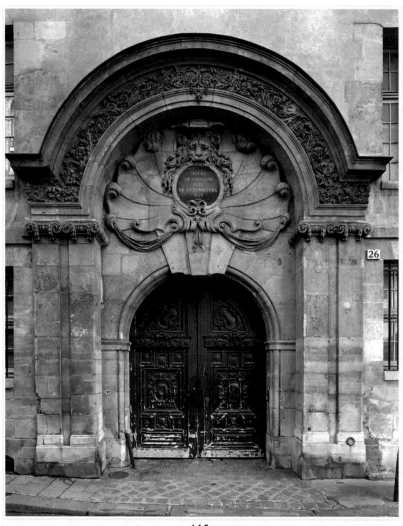

145

Hôtel de Châlon-Luxembourg

26, RUE GEOFFROY-L'ASNIER

C. 1625

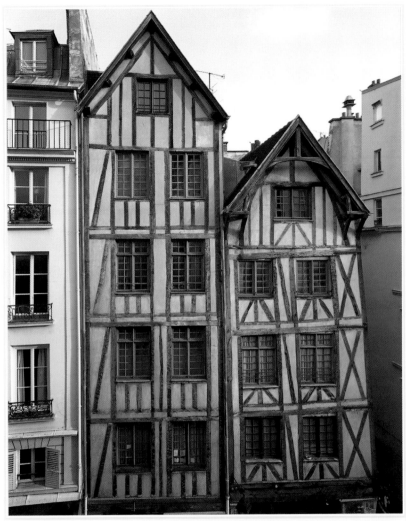

146

11–13, rue François-Miron

AT RUE CLOCHE PERCE

C. FOURTEENTH TO SEVENTEENTH CENTURIES; 1967, RESTORATION AND INVENTIONS

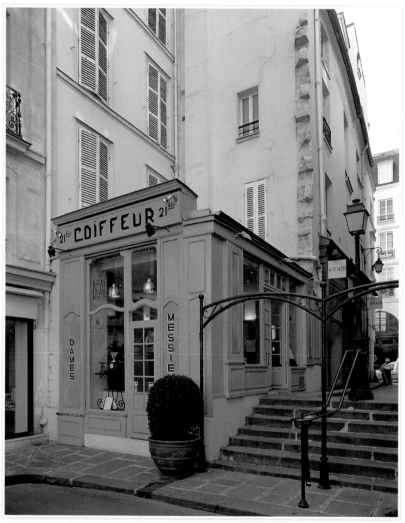

147

Hair shop

21 BIS, RUE DE RIVOLI AT RUE CLOCHE PERCE

C. 1880

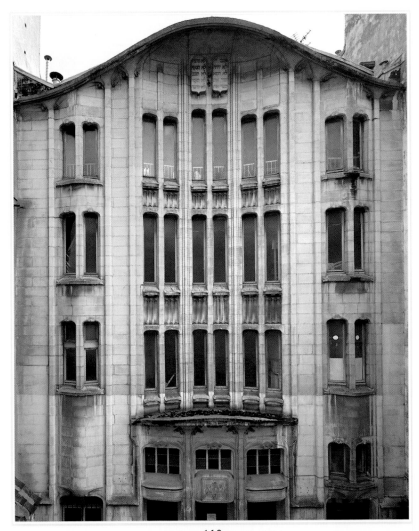

148

Synagogue

10, RUE PAVÉE BETWEEN RUE DES ROSIERS AND RUE DU ROI DE SICILE

1913, HECTOR GUIMARD

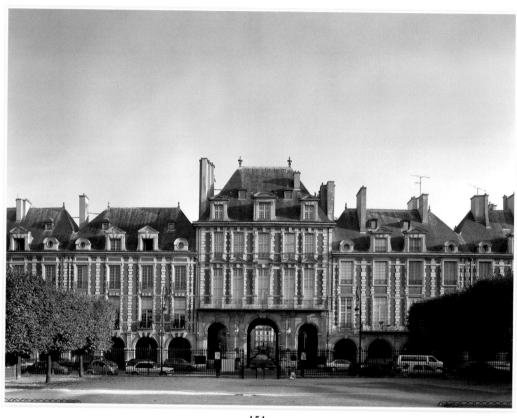

151

Place des Vosges

NORTH AND SOUTH SIDES OF PLACE DES VOSGES, BETWEEN RUE SAINT-ANTOINE AND RUE DES FRANCS BOURGEOIS

1605, ATTRIBUTED TO LOUIS OR CLÉMENT MÉTEZEAU, OR JACQUES II ANDROUET DU CERCEAU, OR CLAUDE CHASTILLON;
1818, JEAN-PIERRE CORTOT AND LOUIS-MARIE DUPATY, REPLACEMENT STATUE OF LOUIS XIII

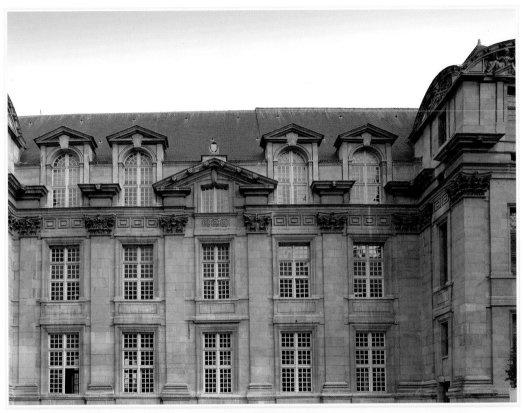

152
Hôtel de Lamoignon

24, RUE PAVÉE CORNER OF RUE DES FRANCS-BOURGEOIS

C. 1610, POSSIBLY THIBAULT MÉTEZEAU

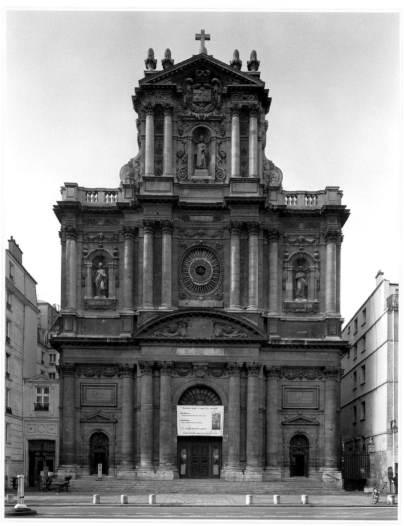

153
Saint-Paul–Saint-Louis

99, RUE SAINT-ANTOINE AT RUE SÉVIGNÉ

1627–41, FRÈRE MARTELLANGE, PLAN; PÈRE DERAND, FAÇADE AND CUPOLA; FRÈRE TURMEL, INTERIOR

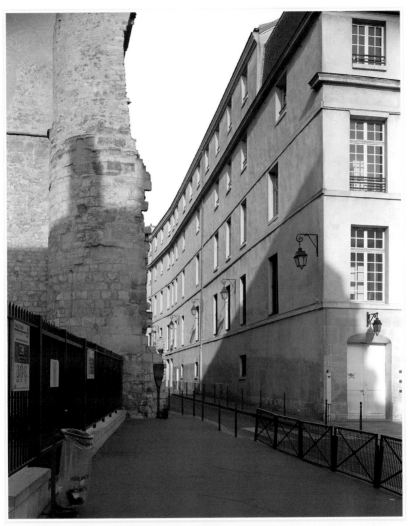

154
Wall fragment of Philippe Auguste
ANNEX OF LYCÉE CHARLEMAGNE AT RUE DES JARDINS-SAINT-PAUL

1190

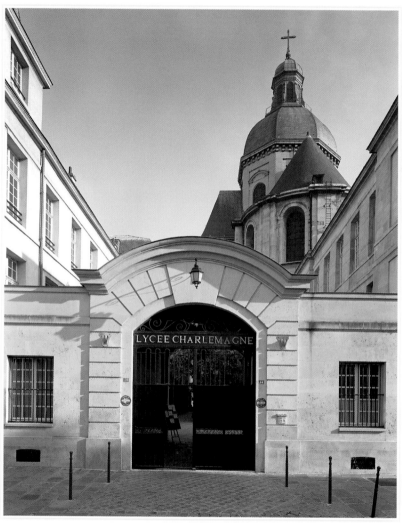

155

Lycée Charlemagne

14, RUE CHARLEMAGNE AT RUE DU FAUCONNIER

C. 1622, FRÈRE TURMEL

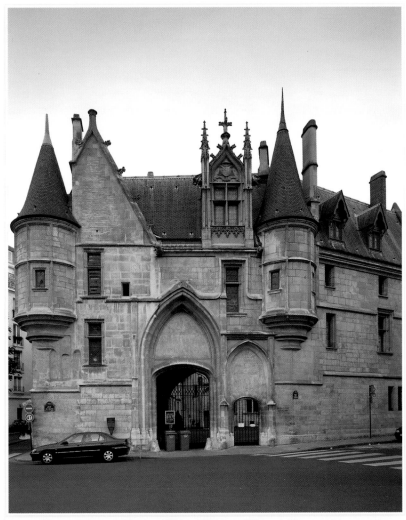

156

Hôtel de Sens (Bibliothèque-Mediathèque Forney)

1, RUE DU FIGUIER AT RUE DU FAUCONNIER

1475–1507, TRANSFORMATION OF THE FIRST HÔTEL; 1843, L. BÉNOUVILLE, RESTORATION;
1934–60, CHARLES HALLEY, RESTORATION

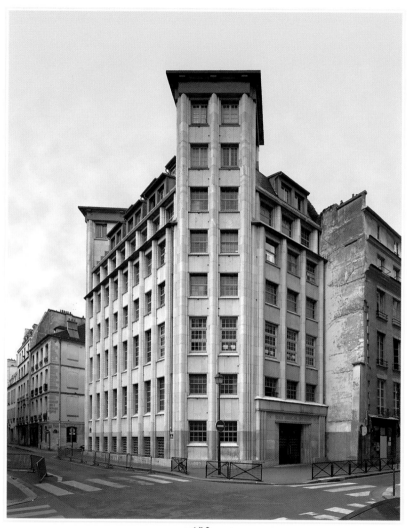

159

Ecole Massillon (Gratry annex)

9, RUE DU PETIT-MUSC AT RUE BEAUTREILLIS

1935–36, GASTON BOUZY AND JEAN GIRAUD

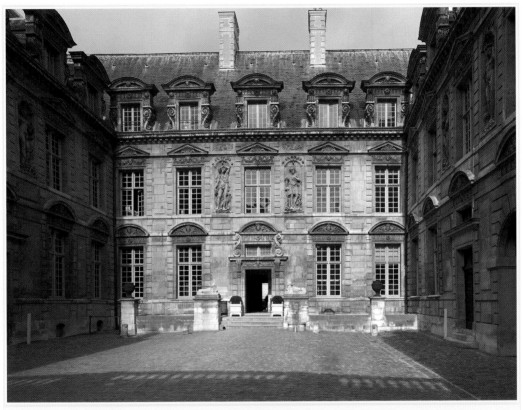

160
Hôtel de Sully

62, RUE SAINT-ANTOINE AT RUE DE BIRAGUE

1624–30, JEAN 1ST ANDROUET DU CERCEAU; 1651, FRANÇOIS LE VAU, INSIDE LEFT WING COURTYARD;
1660, PIERRE LAMBERT, RIGHT WING GARDEN

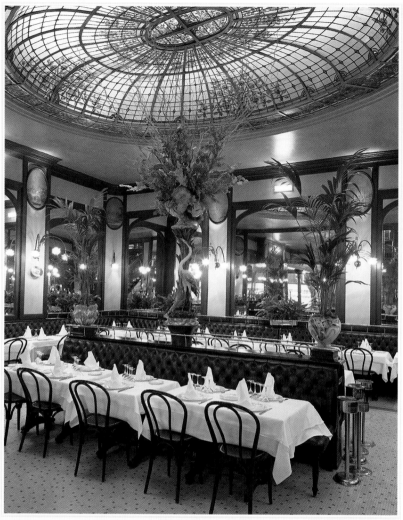

161

Brasserie Bofinger

3, RUE DE LA BASTILLE AT PLACE DE LA BASTILLE

1864

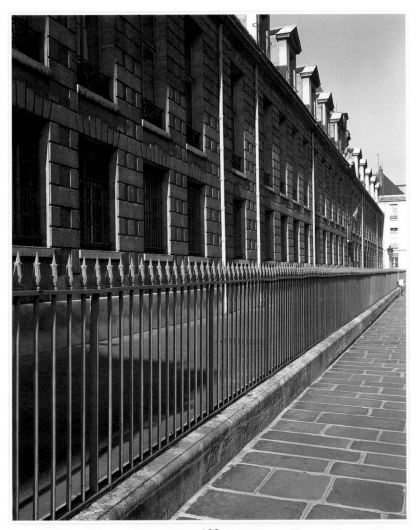

162

Bibliothèque de l'Arsenal

1, RUE DE SULLY AT RUE MORNAY

1715—25, GERMAIN BOFFRAND;
1745, ANTOINE-NICOLAS DAUPHIN, INTERIOR

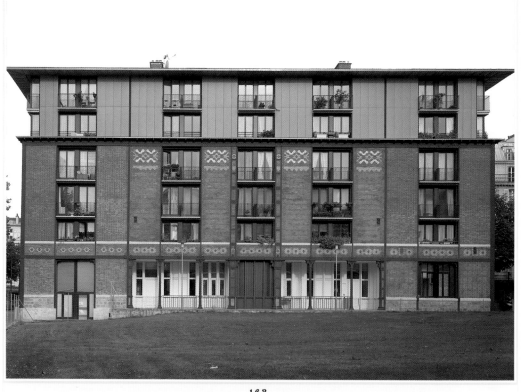

163

Housing for Republican Guard

2, RUE DE SCHOMBERG

1883, JOSEPH BOUVARD; 1998, YVES LION, RESTORATION AND EXTENSION
1703, GEORGES MAURISSART EXTENSION

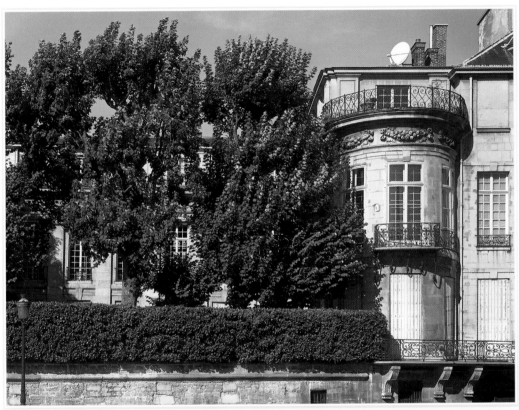

164

Hôtel Bretonvilliers

2, RUE SAINT-LOUIS-EN-L'ᵈLE AT QUAI D'ANJOU

1640–44, LOUIS LE VAU, BUILDING; EUSTACHE LE SUEUR, CHARLES LE BRUN,
AND FRANÇOIS PERRIER, INTERIOR DECORATION

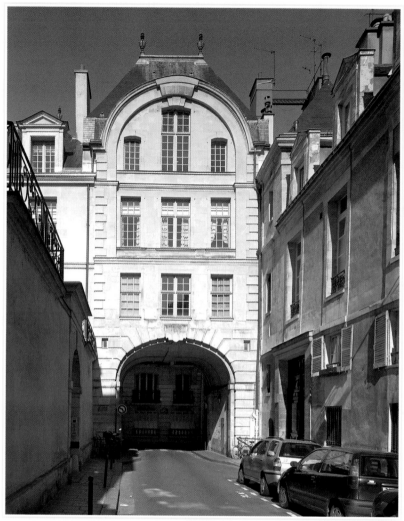

165

Arch

At entrance to rue de Bretonvilliers and rue Saint-Louis-en-l'île

1637–42, Jean Androuet Du Cerceau; 1643, Simon Vouet, decoration;
1663, Sébastien Bourdon, gallery décor; 1840, hotel destroyed

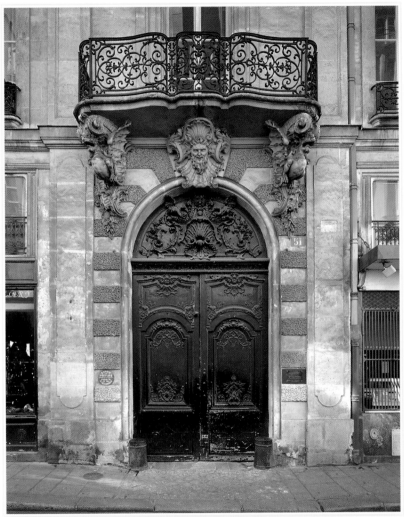

166

Hôtel de Chenizot

51, RUE SAINT-LOUIS-EN-L'ÎLE, BETWEEN RUE LE REGRATTIER AND RUE BUDÉ

C. FIRST PART OF THE SEVENTEENTH CENTURY;
1719, PIERRE VIGNÉ DE VIGNY, STREET BLOCK

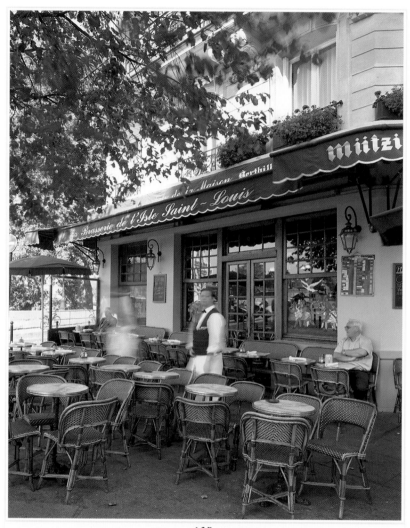

167

Brasserie de l'Isle Saint-Louis

55, QUAI DE BOURBON ON THE WESTERN TIP OF L'ÎLE ST.-LOUIS

C. 1870

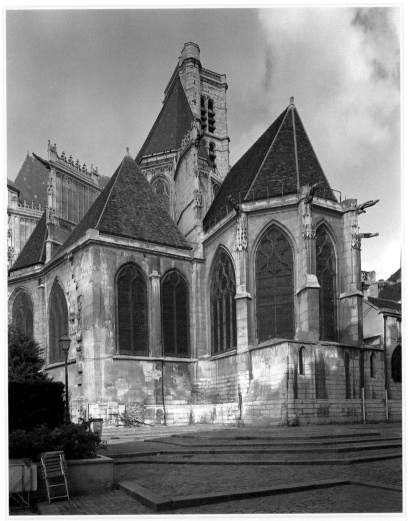

168

Église Saint-Gervais-Saint-Protais

PLACE SAINT-GERVAIS AT RUE DE BROSSE AND FRANÇOIS-MIRON

C. THIRTEENTH CENTURY, BASE OF BELL TOWER; 1494–1540, CONSTRUCTION FROM THE CHOIR TO THE TRANSEPT;
1616–21, SALMON DE BROSSE ARCHITECT, FAÇADE

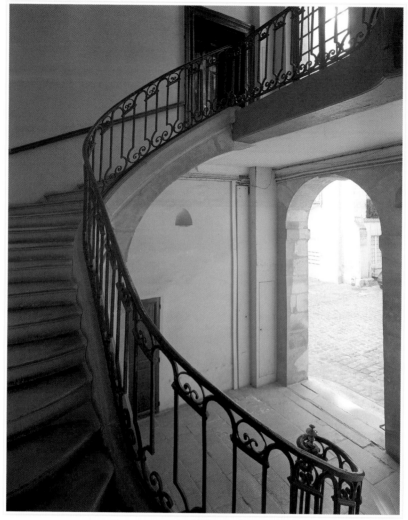

169

Hôtel de Charron, Hôtel de Jassaud

15–19, QUAI DE BOURBON ON L'ÎLE SAINT-LOUIS

¢15, HÔTEL DE CHARRON, 1637–40, SÉBASTIEN BRUAND;
¢19, HÔTEL DE JASSAUD C. 1635, ARCHITECT UNKNOWN

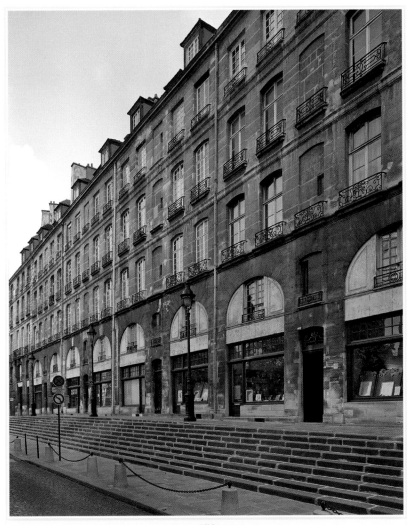

170

2-12, rue François-Miron

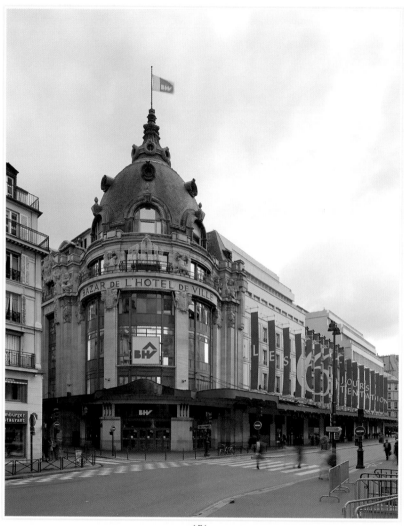

171

\mathcal{BHV} *(Bazar de l'Hôtel de Ville)*

52—64 RUE DE RIVOLI AT RUES DU TEMPLE, DE LA VERRERIE AND DES ARCHIVES

1902—04, GRANON AND ROGER; 1912—13, AUGUSTE ROY

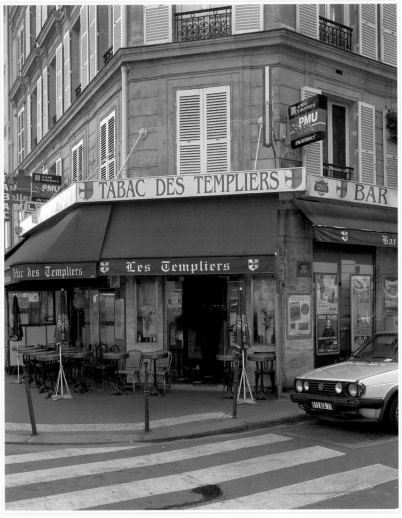

172

Tabac des Templiers

35, RUE DE RIVOLI AT RUE DE LA TACHERIE

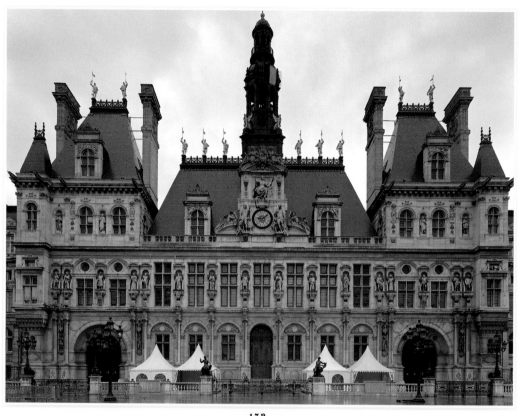

173

Hôtel de Ville

Place de l'Hôtel de Ville, between quai de l'Hôtel de Ville and rue de Rivoli

1533, Domenico da Cortona (aka Le Boccador), original building; 1836–50, Etienne-Hippolyte Godde and J.-B. Ciceron Lesueur, additions; 1873, Théodore Ballu and Edouard Deperthes, current building

5ᵀᴴ Arrondissement

In May 1968, rioting students shattered the scholarly environment of the 5th arrondissement with massive demonstrations that culminated in tear gassing, crushed cars, and general political upheaval. This was a far cry from the days when students sat quietly outdoors, at their teachers' feet, soaking up words of wisdom taught in Latin (which is what gave the quarter its name). For many tourists, the Latin Quarter and the dome of the Sorbonne chapel are synonymous, representing the embodiment of learning. Long home to students, professors, and left-leaning intellectuals and politicians, the Latin Quarter revolves around the Sorbonne, founded in 1253, as well as other Grandes Ecoles, cultural institutes, medieval churches, cafés, and bookstores. From the Seine, where the Institute du Monde Arabe and Jardin des Plantes are situated, to the Roman ruins of the Cluny baths, the Panthéon, and Val-de-Grâce at the southern edge, the buildings all bear evidence of the 5th arrondissement's illustrious roots. Although fast-food joints and cheap clothing chains now vie for attention with bookstores, galleries, and art house cinemas on the boulevards Saint-Michel and Saint-Germain, the neighborhood still retains its historic and academic charm.

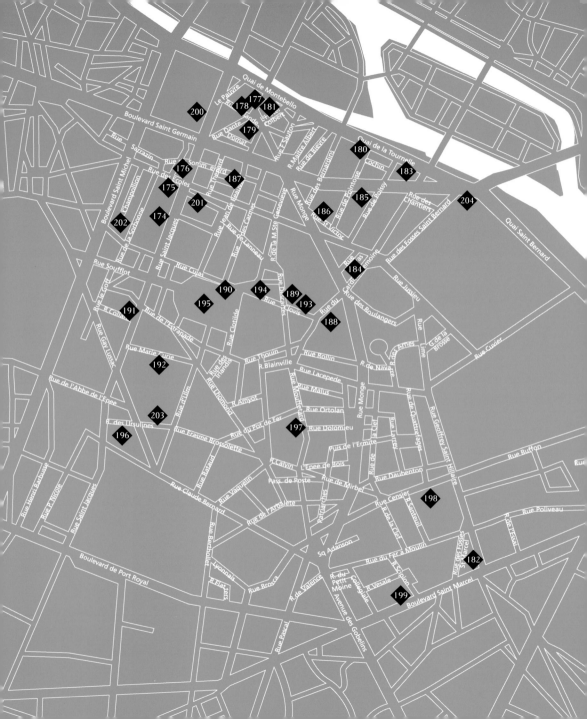

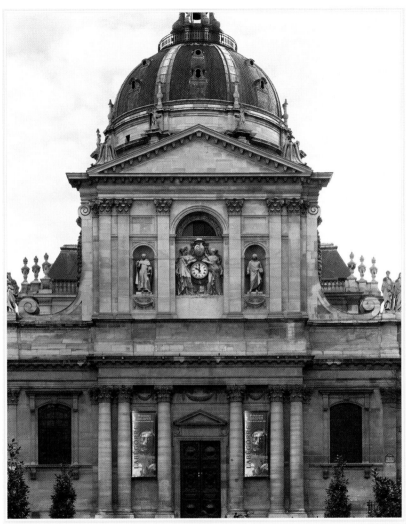

174

Sorbonne Chapel

PLACE DE LA SORBONNE, BETWEEN RUE DE LA SORBONNE,
RUE DES ECOLES, RUE CUJASAND, AND RUE SAINT-JACQUES

1253, FOUNDED; 1635–42, JACQUES LEMERCIER; 1881–1901, HENRI-PAUL NÉNOT

175

Ecole élémentaire

28, RUE SAINT-JACQUES AT RUE PARCHEMINERIE

c.1880

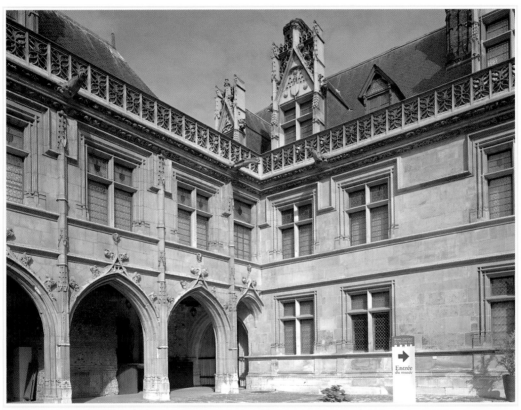

176
Hôtel and Musée de Cluny

6, PLACE PAUL-PAINLEVÉ AT RUE DU SOMMERARD

1485–1510, CONSTRUCTION; 1843–56, ALBERT LENOIR, REMODELED AND ENLARGED

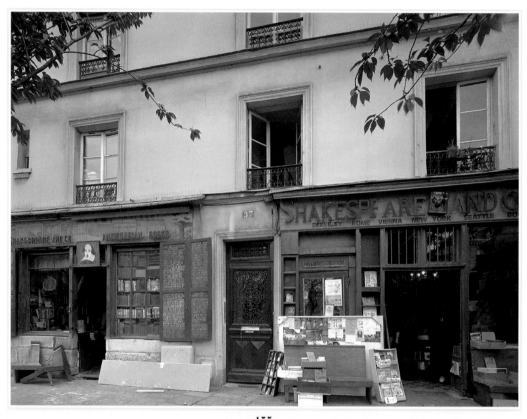

177

Shakespeare & Co.

37, RUE DE LA BÛCHERIE AT SQUARE RENÉ VIVIANI AND QUAI DE MONTEBELLO

c.1600

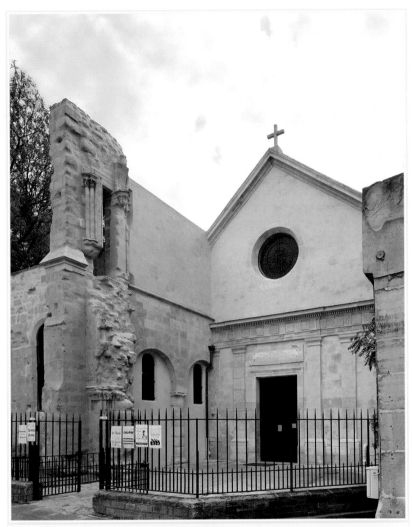

178

Église Saint-Julien-le-Pauvre

1, RUE SAINT-JULIEN-LE-PAUVRE AT RUE GALLANDE AND RUE SAINT-JACQUES

c. 1165–1220, LONGPONT BENEDICTINE MONKS; c. SEVENTEENTH CENTURY, BERNARD ROCHE, FAÇADE;
1826, GAU AND HUVÉ, RESTORATION

179

27-39, rue Galande

BETWEEN RUE DANTE AND RUE LAGRANGE

1202, STREET; C. SIXTEENTH—SEVENTEENTH CENTURIES, HOUSES

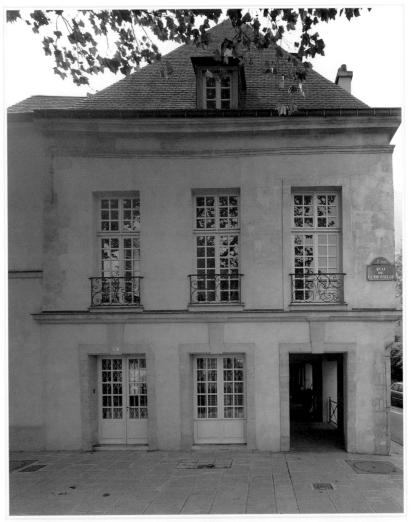

180

Hôtel de Nesmond

57, QUAI DE LA TOURNELLE AT RUE DES BERNARDINS

C. SEVENTEENTH CENTURY

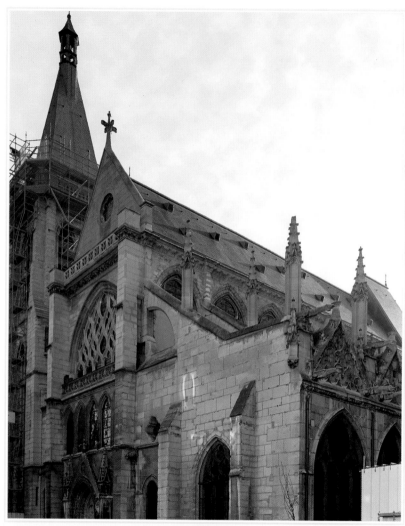

181
Saint-Sevérin

Rue des Prêtres-Saint-Sevérin at rue Saint- Sevérin

c. thirteenth—fourteenth centuries; c. late fifteenth century, reconstruction;
1489–1520, apse and ossuary, side chapels; 1673, Jules Hardouin-Mansart, communion chapel

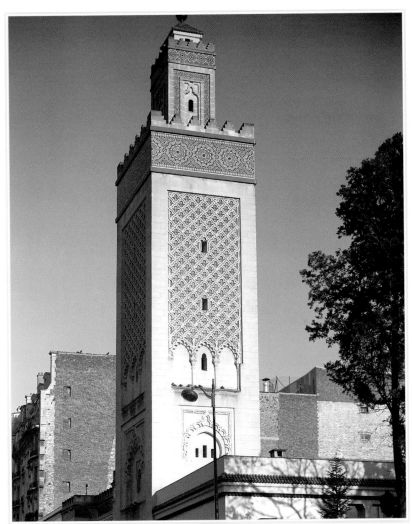

182
Paris Mosque

Place du Puits-de-l'Ermite at rue Geoffroy

1922–26, M. Tranchant de Lunel, C. Heubès, R. Fournez, and M. Mantout

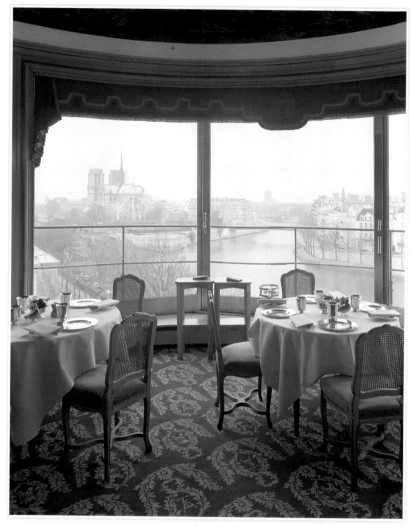

183

La Tour d'Argent

15, QUAI DE LA TOURNELLE AT RUE DU CARDINAL LEMOINE

C. 1870; 1937, ADDITION FOR EXTRA HEIGHT

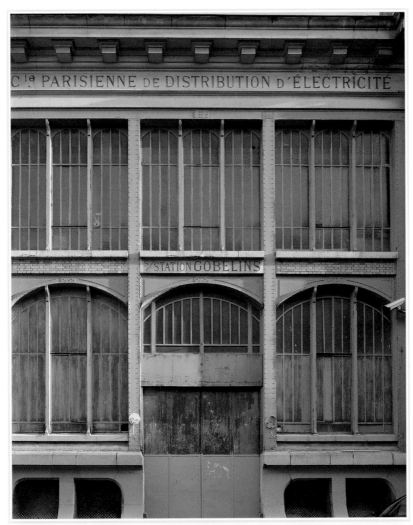

184

Parisienne de Distribution d'Électricité

5, RUE VÉSALE BETWEEN RUE SCIPION AND RUE DE LA COLLÉGIALE

c. 1910

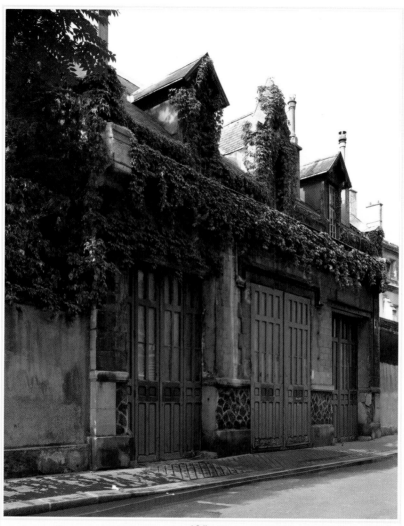

185

Refectory of the Bernardine Monks

18-24, RUE DE POISSY AT BOULEVARD SAINT-GERMAIN

1246, FOUNDATION OF THE COLLEGE; 1336, RENOVATION; 1338, CHURCH (DESTROYED);
1806–55, PARTIALLY DESTROYED

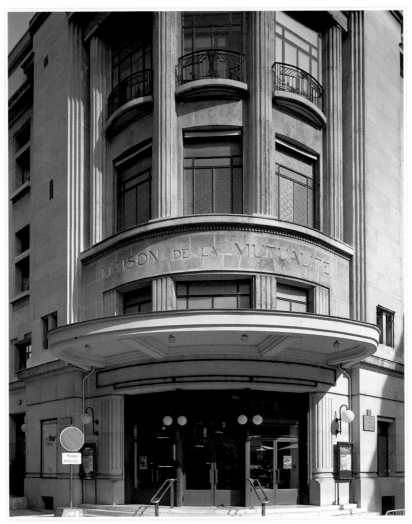

186

Maison de la Mutualité

24, RUE SAINT-VICTOR AT SQUARE DE LA MUTUALITÉ AND RUE MONGE

1928–31 BY ROBERT LESAGE AND CHARLES MILTGEN

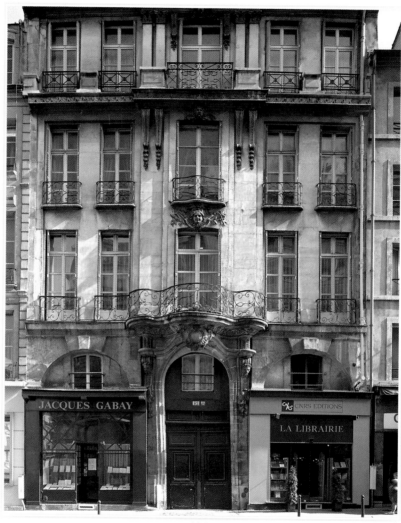

191

House of Lepas-Dubuisson

151 BIS, RUE SAINT-JACQUES

1718, CLAUDE-NICOLAS LEPAS-DUBUISSON; 1727, BALCONY

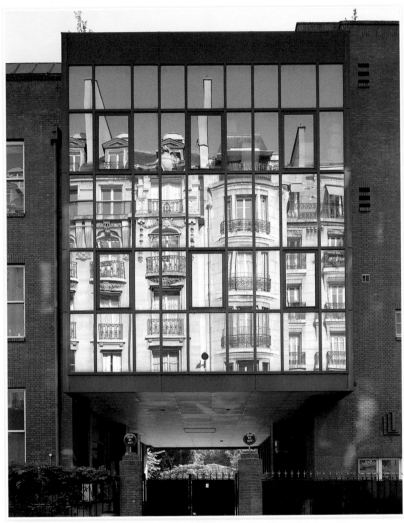

192

Institut de Biologie

13, RUE PIERRE-ET-MARIE-CURIE, BETWEEN RUE SAINT-JACQUES AND RUE D'ULM

1930, GERMAIN DERBRÉ AND NICOLAS KRISTY

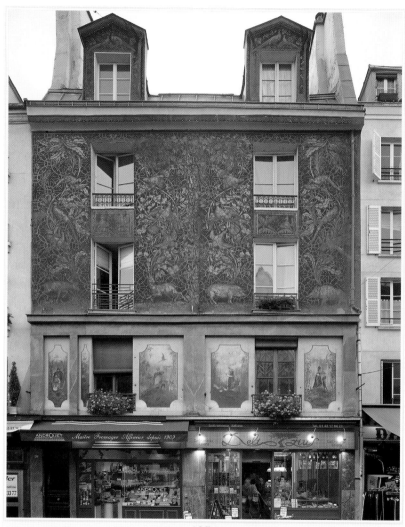

197

Maison de Facchetti

134, RUE MOUFFETARD AT RUE EDOUARD QUÉNU

1929, ELDI GUERI, FAÇADE PAINTING

198

33-35, Rue Censier

AT RUE MONGE

C. 1960

199

8, rue Scipion

BETWEEN RUE DU FER À MOULIN AND BOULEVARD SAINT-MARCEL

C. END OF THE 19TH CENTURY BUILDING, TRANSFORMED

200

The Abbey Bookshop

29, RUE DE LA PARCHEMINERIE, BETWEEN RUE SAINT-JACQUES AND RUE DE LA HARPE

1736

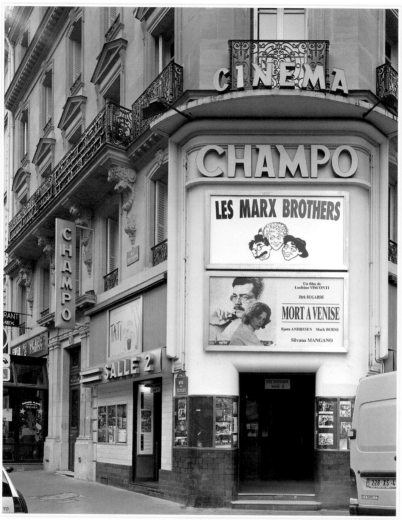

201

Le Champo

51, RUE DES ECOLES AT RUE SAINT-JACQUES

1939

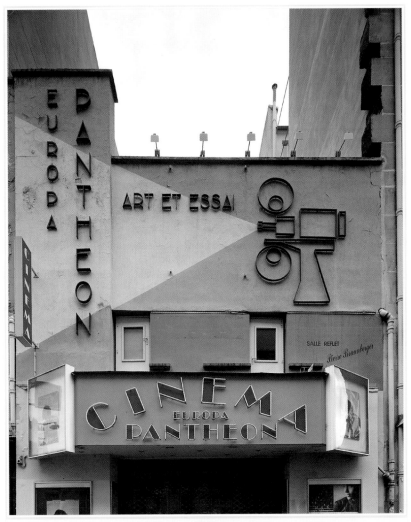

202

Le Cinéma du Panthéon

13, RUE VICTOR-COUSIN

1907

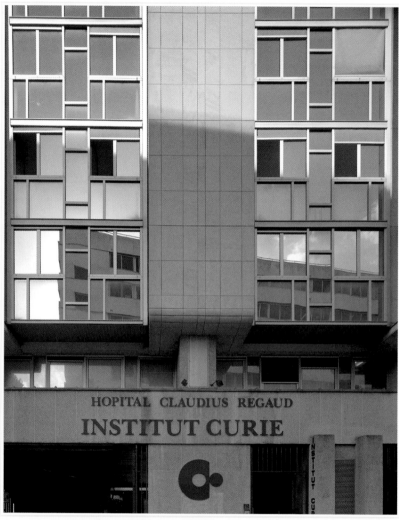

203

Institut Curie

26, RUE D'ULM AND 8, RUE LOUIS THUILLIER, BETWEEN RUE GAY LUSSAC AND RUE D'ULM

1988-1992, JEAN BALLADUR

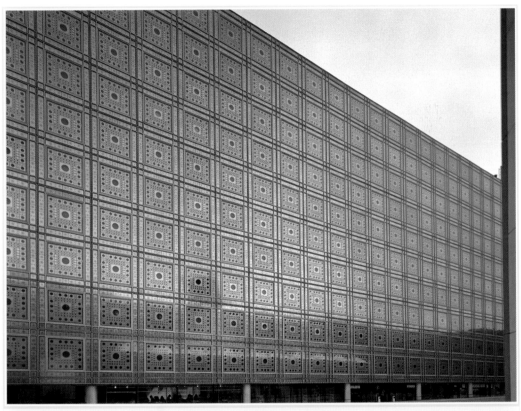

204

Institut du Monde Arabe

23, QUAI SAINT-BERNARD AT SAINT-GERMAIN

1982–87, JEAN NOUVEL, HENRI BERNARD, PIERRE SORIA, AND GILBERT LEZÈNES

6ᵀᴴ Arrondissement

The Benedictine monks of the Abbey of Saint-Germain-des-Près knew a good thing when they saw it. They owned most of this neighborhood in the Middle Ages, when they initiated the Saint-Germain Fair. Shopping and entertainment still thrive here today, along with the best people-watching park in Paris, Jardin du Luxembourg. *Uber*-chic and sophisticated, the district is the personification of the Left Bank (Rive Gauche). Whether you are a tourist, an academic, a shopper, an art lover, a cinema buff, or simply a *flâneur* (wanderer), this arrondissement offers many pleasures.

Often referred to as Saint-Germain-des-Près or Saint-Germain, this is the Paris of legendary cafés, street markets, cinemas, fashionable digs, swank boutiques, art galleries, theaters, gardens, artistic haunts, and literary walks. This is the Paris of Hemingway and Gertrude Stein, of Sartre and Simone de Beauvoir, of nightclubs playing hot jazz, of the celebrated Café de Flore, Les Deux Magots, and Brasserie Lipp. The birthplace of Existentialism, the 6ᵗʰ arrondissement still thrives on its proximity to the Latin Quarter to the east, Montparnasse to the south, and the Seine at the north, where the Institut de France guards the French language under its noble, seventeenth-century dome. Art galleries line rue de Seine, rue Bonaparte, and rue Mazarine; and stylish clothing stores emanate from the vicinity of Saint-Sulpice.

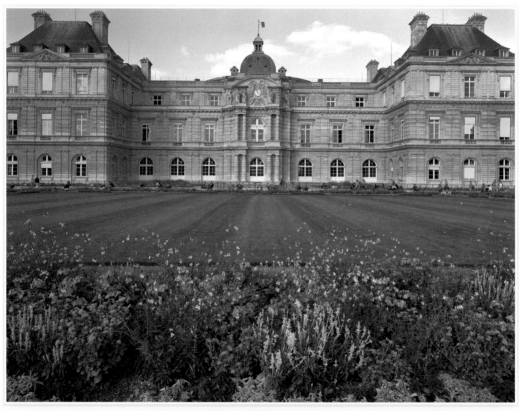

205
Palais du Luxembourg

15, RUE DE VAUGIRARD, BETWEEN RUE GUYNEMER AND RUE MÉDICIS

1616–24, SALOMON DE BROSSE; 1624–30, JACQUES LEMERCIER; 1799–1804, JEAN-FRANÇOIS-THÉRÈSE CHALGRIN, TRANSFORMATIONS;
1835, ALPHONSE DE GISORS, EXTENSIONS

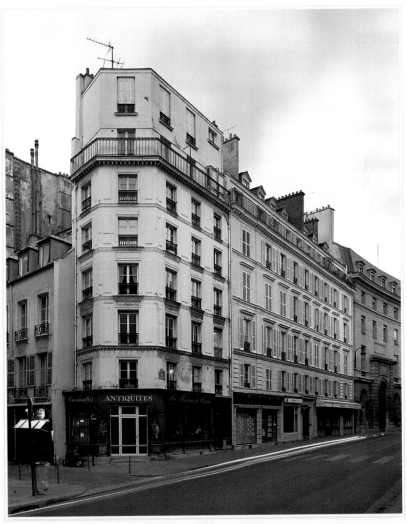

206

La Maison de Poupée

40, RUE VAUGIRARD AT RUE SERVANDONI

c. 1840

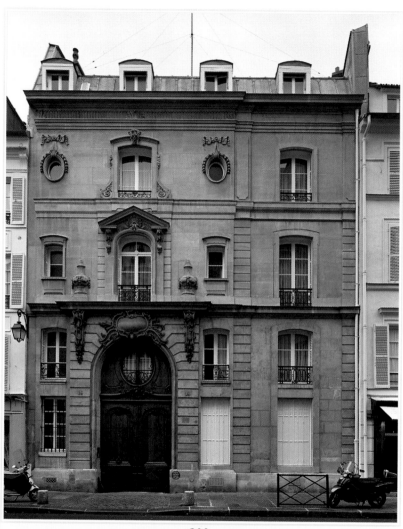

Hôtel de Marsilly

18, RUE DU CHERCHE MIDI AT RUE D'ASSAS

1738, CLAUDE BONNEAU

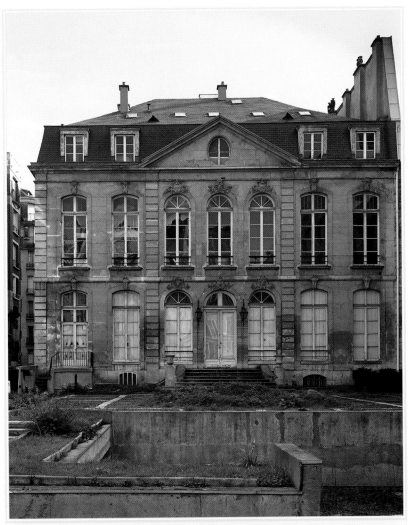

210

Hôtel de Choiseul-Praslin

2–4, RUE SAINT-ROMAIN AND 111, RUE DE SÈVRES

1732, SULPICE GAUBIER

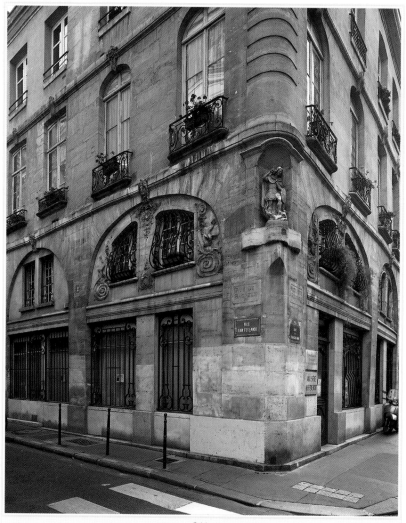

211

Musée Hébert

85, RUE DU CHERCHE-MIDI AT 2, RUE J. FERRANDI

1743, ADDITIONS OF SEVERAL EXISTING HOUSES

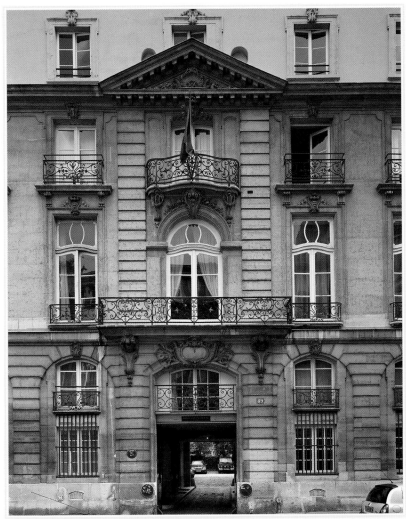

212

Embassy of Mali

89, RUE DE CHERCHE-MIDI AT RUE J. FERRANDI

1757, CLAUDE LE CHAUVE

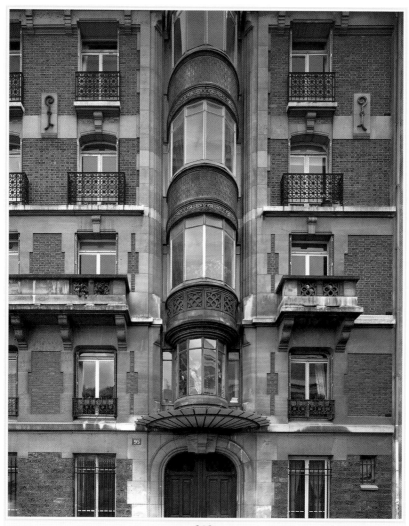

213

95, rue Vaugirard

BETWEEN RUE LITTRÉ AND ALLÉE MAINTENON

1891, FERNAND GLAIZE

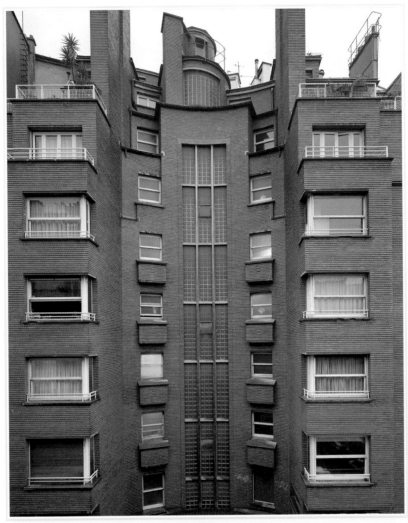

214

96, rue Notre-Dame-des-Champs

AT BOULEVARD MONTPARNASSE

1939, LÉON-JOSEPH MADELINE

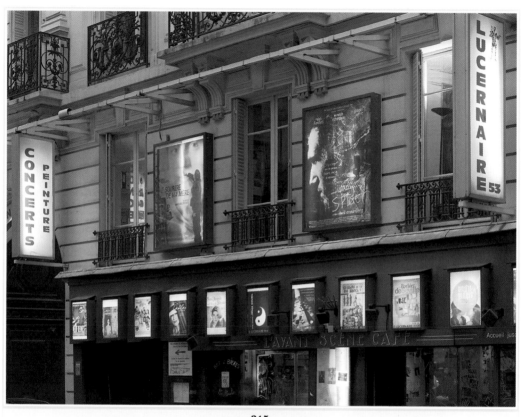

217

Lucernaire Forum

53, RUE NOTRE-DAME-DES-CHAMPS AT RUE VAVIN

1968, FORUM FOUNDED

218

Mairie

78, RUE BONAPARTE BETWEEN PLACE SAINT-SULPICE, RUE DE MADAME AND RUE MEZIÈRES

1848, ROLLAND AND LE VICOMTE; 1886, LÉON GINAIN

219

Newsstand

ONE, RUE DU FOUR AT RUE DE MONTFAUCON

c. 1960

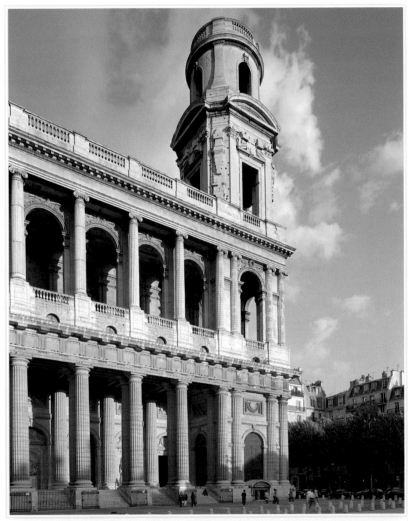

220

Église Saint-Sulpice

<small>Place Saint-Sulpice at rue Mabillon, rue Saint-Sulpice, and rue Palatine</small>

<small>c. twelfth century, first church; 1646–49, Christophe Gamard, transformations; 1660–86, Daniel Gittard; 1719–45, Gilles-Marie Oppenord, and Giovani Servandoini; 1774, Charles De Wailly, chapel decoration; 1777–80, Jean-François Chalgrin, balustrade and left tower</small>

223

Hôtel de Beaumarchais

26, RUE DE CONDÉ BETWEEN RUE SAINT-SULPICE AND RUE DE VAUGIRARD

C. MID—SEVENTEENTH CENTURY

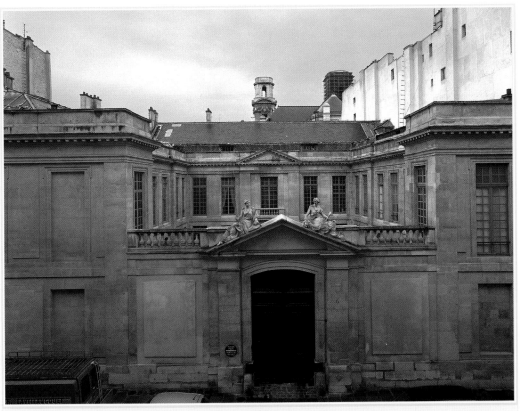

224

Hôtel de Brancas

6, RUE DE TOURNON AT RUE SAINT-SULPICE

C.1706–10, PIERRE BULLET

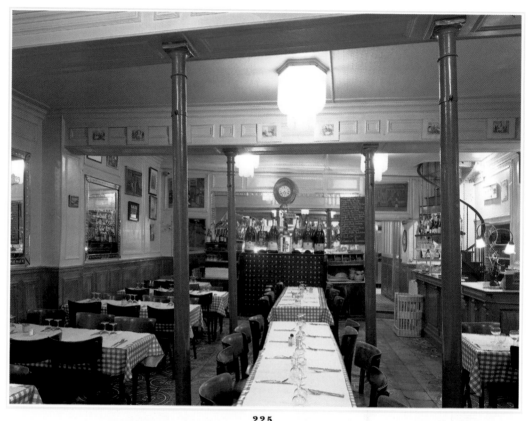

225

Polidor

41, RUE MONSIEUR-LE-PRINCE AT RUE RACINE

1845

226

Institut National du Patrimoine (Ancien cercle des Libraires)

117, BOULEVARD SAINT-GERMAIN AT RUE GRÉGOIRE DE TOURS

1877–79, CHARLES GARNIER; 1992, REMODELING

227
Marché Saint-Germain

BORDERED BY RUE MABILLON, RUE CLÉMENT, RUE FÉLIBIEN, AND RUE LOBINEAU

1813–18, JEAN-BAPTISTE BLONDEL AND AUGUSTE LUSSON;
1994–96, OLIVIER-CLÉMENT CACOUB, RECONSTRUCTION AND ALTERATIONS

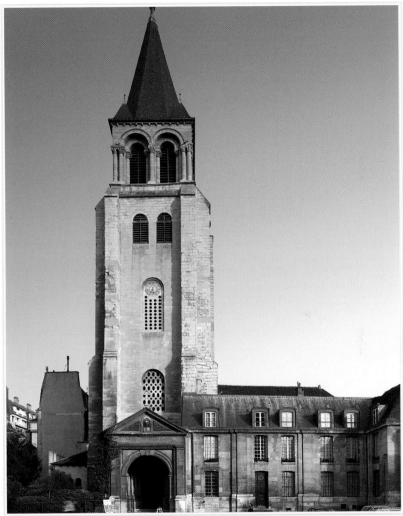

228

Église Saint-Germain-des-Prés
3, PLACE SAINT-GERMAIN-DES-PRÉS

542–59, FIRST CHURCH; 990–1014, RECONSTRUCTION (TOWER PORCH AND PROBABLY TWO TOWERS AT THE CHOIR);
1025–30, NAVE; 1145–60, CHOIR REBUILT; 1163, CHURCH OPENED, DEDICATED BY POPE ALEXANDRE III;
1607–08, MARCEL LEROY, PORTAL; 1644–46, CHRISTOPHE GAMARD, NAVE REMODELING;
1819–25, ETIENNE-HIPPOLYTE GODDE, RESTORATION; 1850, VICTOR BALTARD, RESTORATION

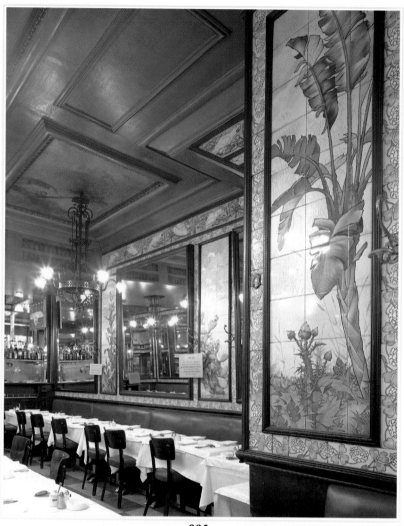

229

Brasserie Lipp

151, BOULEVARD SAINT-GERMAIN AT RUE SAINT-BENOÎT

1880, CREATION OF THE BRASSERIE

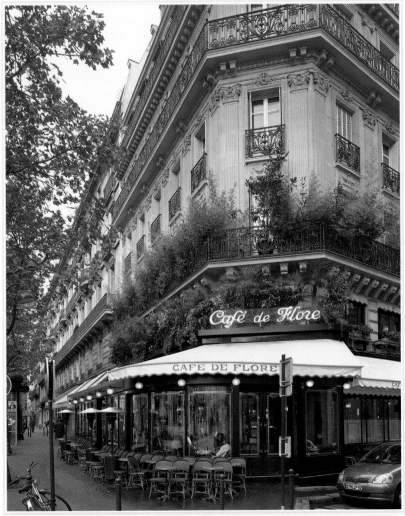

230

Café de Flore

172, BOULEVARD SAINT-GERMAIN AT RUE SAINT BENOÎT

1887

231
Hôtel Bel Ami

7–9, RUE SAINT-BENOÎT AT RUE JACOB

C. EIGHTEENTH CENTURY, FIRST BUILDING; C. 1890, SECOND BUILDING

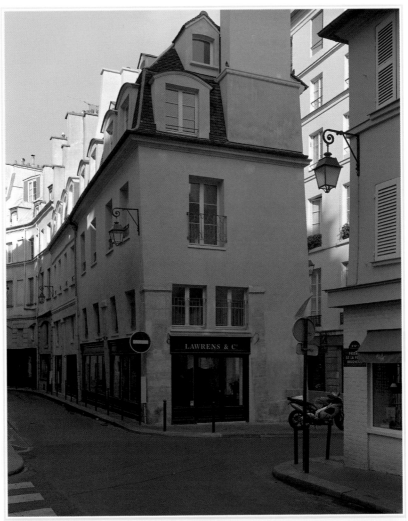

232
rue de l'Abbaye

At rue Cardinale and Passage de la Petite-Boucherie

c. 1800

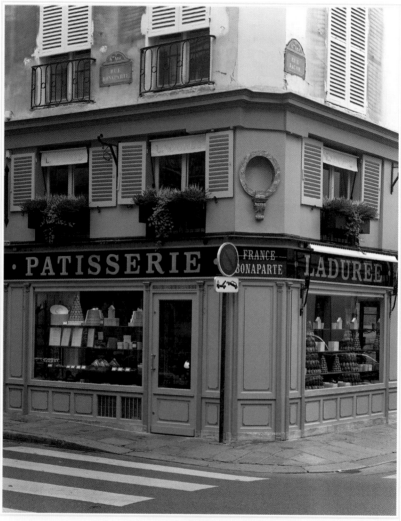

233
Ladurée

21, RUE BONAPARTE BETWEEN RUE JACOB AND RUE VISCONTI

C. 1700; 2000, INTERIOR DÉCOR, ROXANNE RODRIGUEZ

234

Grande Masse des Beaux-Arts

1, RUE JACQUES CALLOT AT RUE MAZARINE

1933, ROGER-HENRI EXPERT

235

22, Passage Dauphine

AT RUE MAZARINE

C. 1850 ARCHITECT UNKNOWN

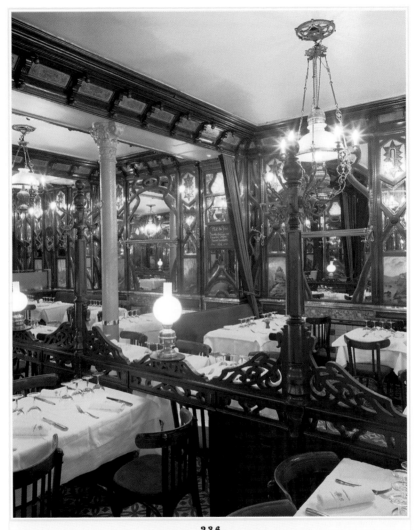

236

Restaurant Vagenende

142, BOULEVARD SAINT-GERMAIN AT ST RUE GRÉGOIRE DE TOURS

1878, BUILDING; 1904, RESTAURANT

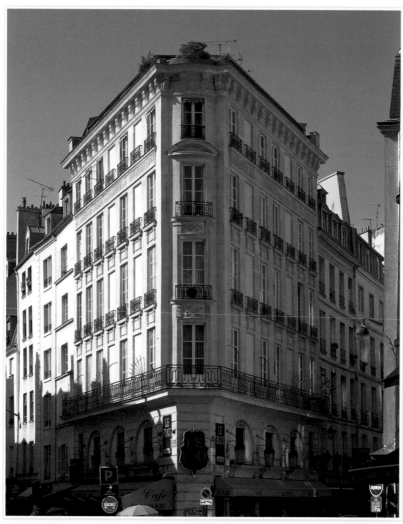

237

Le Buci

CARREFOUR DE BUCY ANGLE 52, RUE DAUPHINE AT RUE MAZARINE

1771, PIERRE DESMAISONS

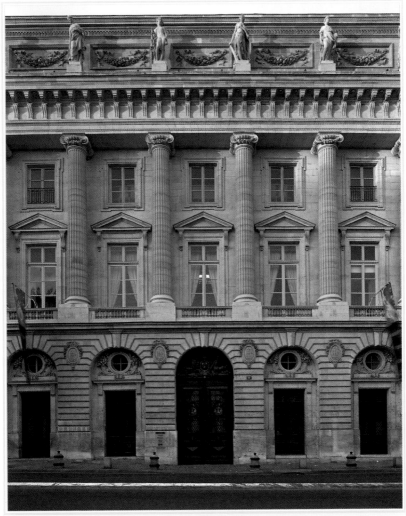

238

Monnaie de Paris

11, QUAI DE CONTI AT PONT-NEUF AND RUE GUÉNÉGAUD

1771–75, JACQUES-DENIS ANTOINE

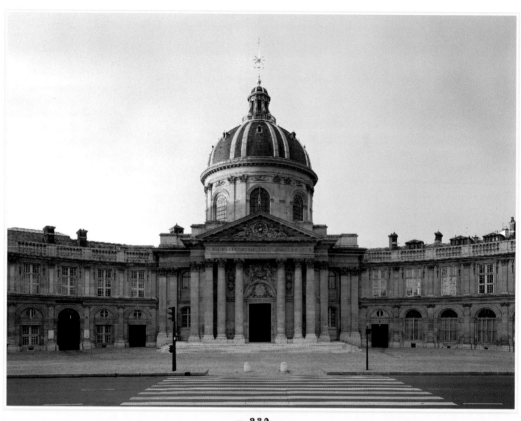

239

Institut de France

23, QUAI DE CONTI AT RUE DE LA SEINE AND QUAI MALAQUAIS

1663–70, LOUIS LE VAU; 1670–74, FRANÇOIS D'ORBAY II, COMPLETED AFTER LE VAU'S DEATH

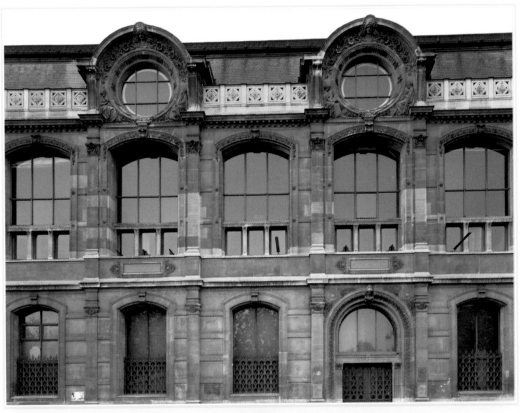

240
École des Beaux-Arts

14, RUE BONAPARTE AT 11–17, QUAI MALAQUAIS

1608–17, CHURCH AND CLOISTER; 1740–56, FRANÇOIS DEBIAS-AUBRY, HÔTEL DE CHIMAY; 1820–29, FRANÇOIS DEBRET, LOGES;
1832–72, FÉLIX DUBAN, CONTINUATION, AND PALAIS DES ETUDES, BUILDING ON QUAI MALAQUAIS; 1945, AUGUSTE PERRET, ADDITIONS

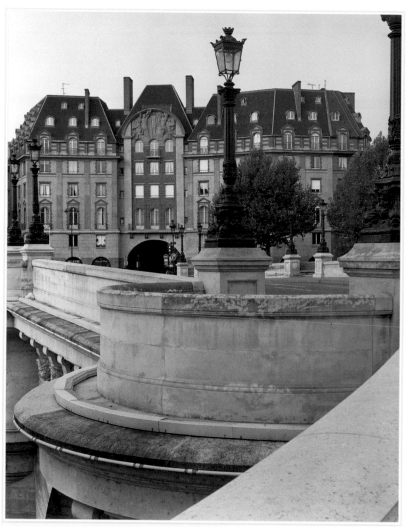

241

1–3, quai de Conti

At rue de Nevers and rue Dauphine

1930–1932, Joseph Marrast

242

Residence Université Mazet

5, RUE ANDRÉ MAZET BETWEEN RUE DAUPHINE AND RUE SAINT-ANDRÉ-DES-ARTS

2001, GEORGE MAURIOS

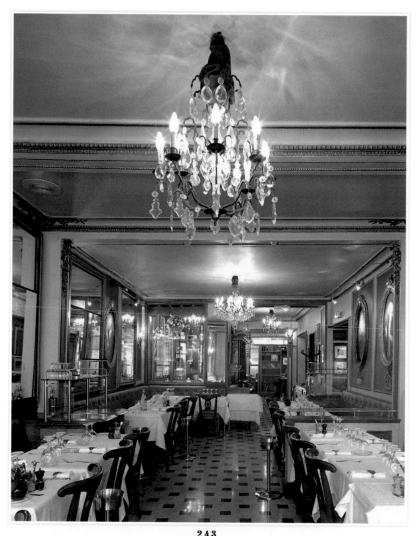

243

Le Procope

13, RUE DE L'ANCIENNE-COMÉDIE AT RUE SAINT-ANDRÉ-DES-ARTS

c.1686

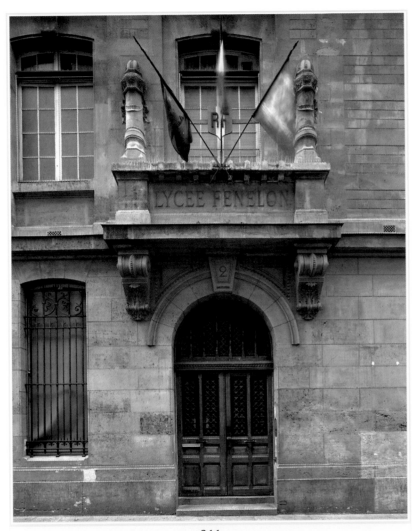

244
Lycée Fénelon

2, RUE DE L'EPERON AT RUE SAINT-ANDRÉ DES ARTS

1728; 1883–93, CHARLES LE CŒUR; 1911, ALBERT TOURNAIRE, ADDITION

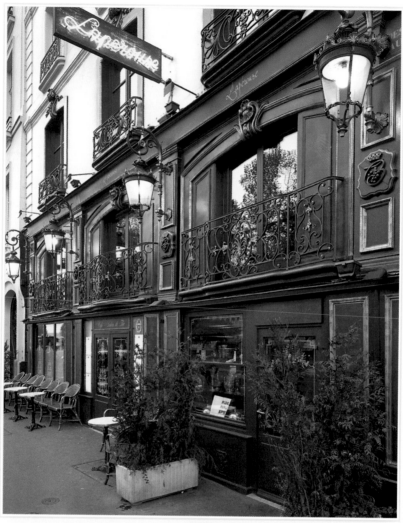

245
Lapérouse

51, QUAI DES GRANDS-AUGUSTINS AT RUE DE GRANDS-AUGUSTINS

C. 1720–30, BUILDING; C. 1850, RESTAURANT

246
Hôtel de Montholon

35, QUAI GRANDS-AUGUSTINS AT CORNER 2, RUE SÉGUIER

C. 1650; C. 1673, ADDITION

247

Hennebique building

1, RUE DANTON AT PLACE SAINT-ANDRE-DES-ARTS

1898, FRANÇOIS HENNEBIQUE, DESIGN EDOUARD ARNAUD

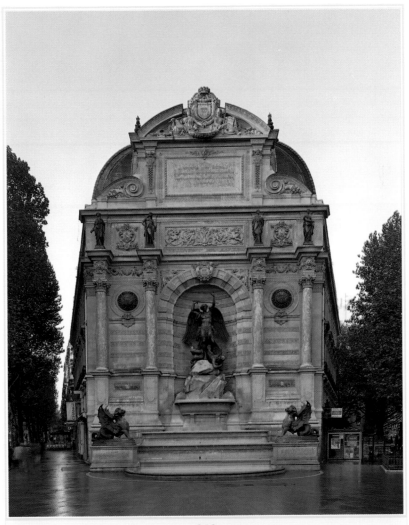

248

Fontaine Saint-Michel

PLACE SAINT-MICHEL AT PONT-SAINT-MICHEL AND BOULEVARD SAINT-MICHEL

1858–60, GABRIEL DAVIOUD

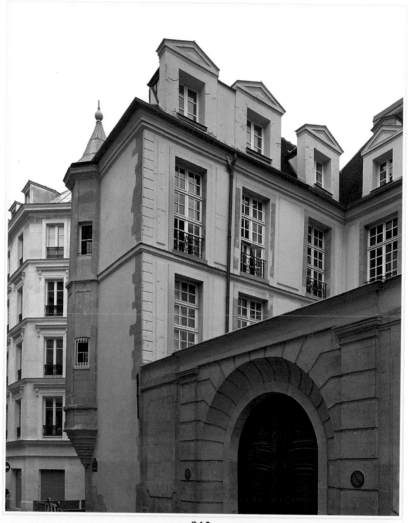

249

21, rue Hautefeuille

At rue Pierre-Sarrazin

C. SIXTEENTH CENTURY

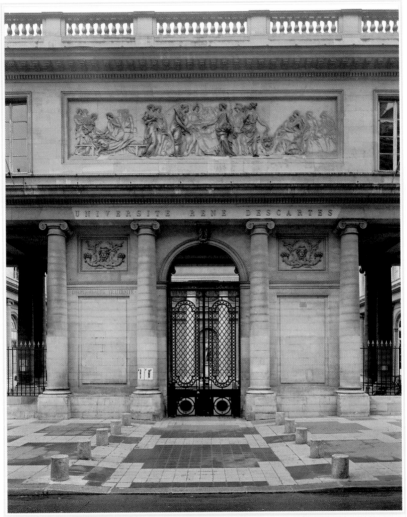

250

Université René Descartes, Faculté de Médecine

12, RUE DE L'ECOLE-DE-MÉDECINE AT BOULEVARD SAINT-GERMAIN

1776–86, JACQUES GONDOUIN;
1878–1900, LÉON GINAIN, EXTENSION OF FAÇADE ON THREE SIDES

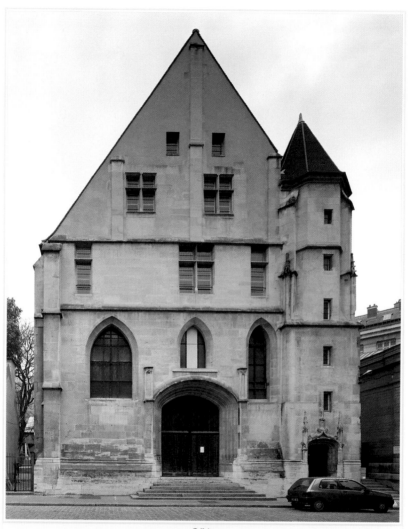

251

Refectory of the Franciscans

15, RUE DE L'ECOLE-DE-MÉDECINE AT BOULEVARD SAINT-GERMAIN

C. LATE FOURTEENTH CENTURY

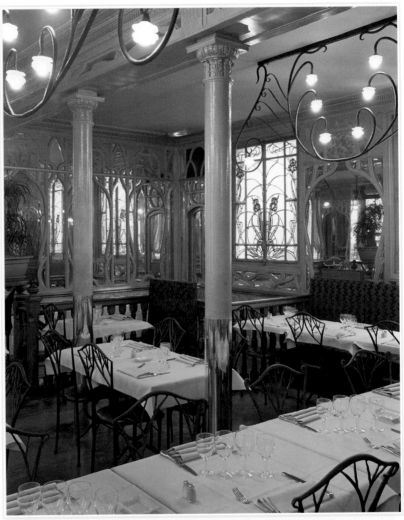

252

Bouillon Racine (Bubble Root)

3, RUE RACINE AT BOULEVARD SAINT-MICHEL

1907, J.-M. BOUVIER AND LOUIS TRÉZEL, INTERIOR DECORATION

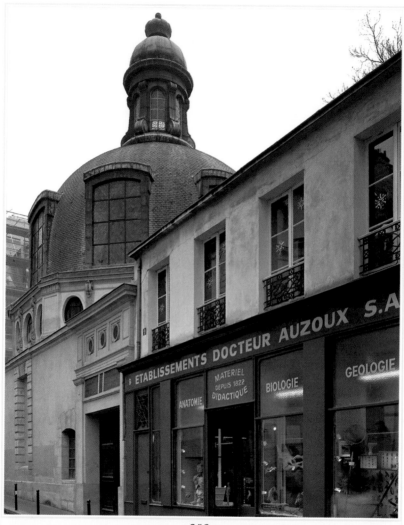

253

Université Paris 3 (Sorbonne Nouvelle)

5, RUE DE L'ECOLE-DE-MÉDECINE AT BOULEVARD SAINT-MICHEL

1691–95, CHARLES AND LOUIS JOUBERT

254
Hôtel Trianon

3, RUE VAUGIRARD

c. 1930

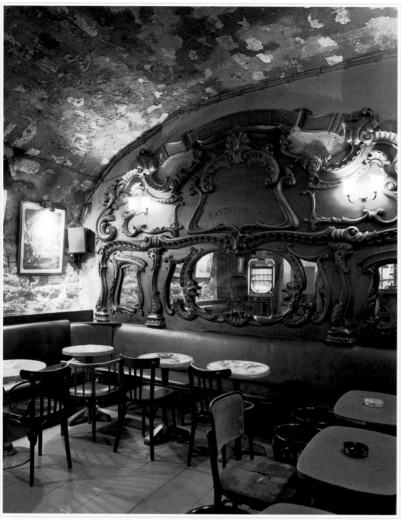

255

Le Bar Dix

10, RUE DE L'ODÉON, BETWEEN CARREFOUR DE L'ODÉON AND PLACE DE L'ODÉON

C. 1780, LOUIS DELARBRE

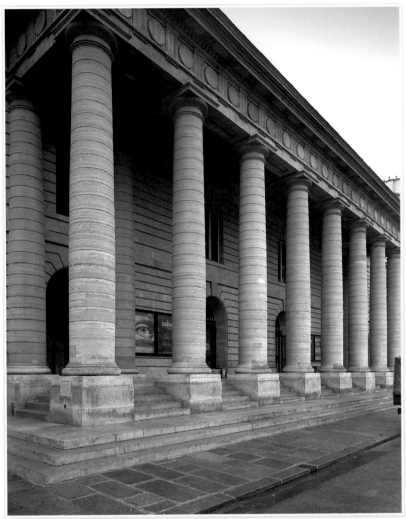

256

Théâtre de l'Odéon

PLACE DE L'ODÉON AT RUE DE L'ODÉON AND RUE RACINE

1779–82, MARIE-JOSEPH PEYRE AND CHARLES DE WAILLY; 1807, JEAN-FRANÇOIS-THÉRÈSE CHALGRIN,
REBUILT SAME STYLE; 1818, BARAGUEY, REBUILT SAME STYLE

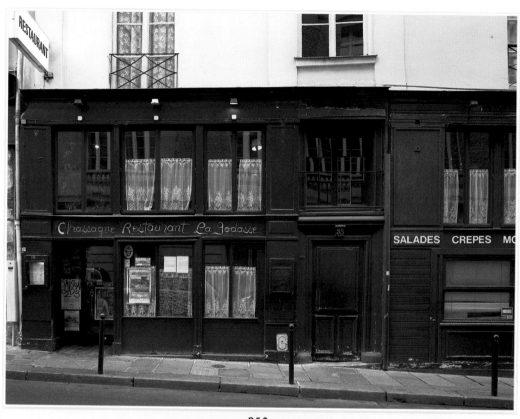

259

Restaurant La Godasse

38, RUE MONSIEUR-LE-PRINCE AT RUE VAUGIRARD

C. 18TH CENTURY BUILDING

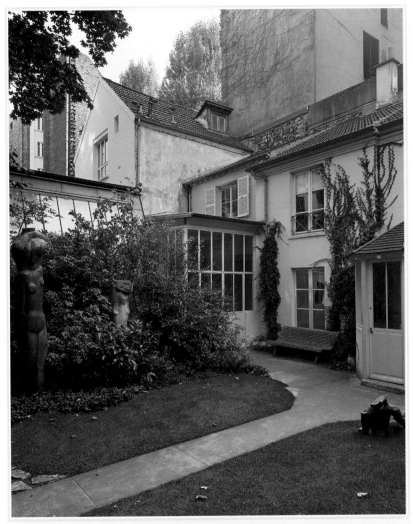

260
Musée Zadkine
100 BIS, RUE D'ASSAS AT RUE MICHELET

C. LATE NINETEENTH CENTURY

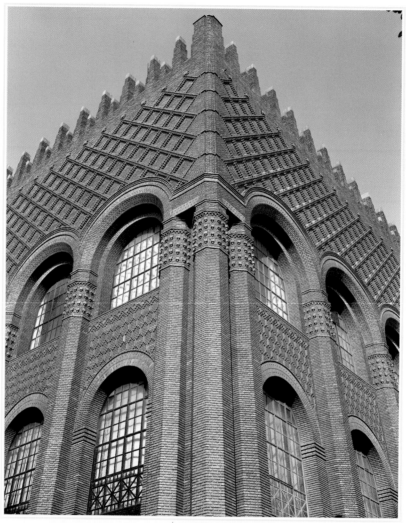

261

Institut d'Art et d'Archéologie

3, RUE MICHELET AT AVENUE DE L'OBSERVATOIRE

1927, PAUL BIGOT

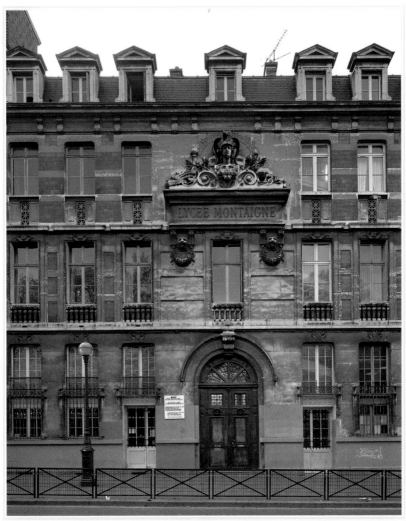

262
Lycée Montaigne

17, RUE AUGUSTE-COMTE, BETWEEN RUE D'ASSAS AND AVENUE DE L'OBSERVATOIRE

1886—90, CHARLES LE CŒUR; 1954, LUCIEN VAUGEOIS, ADDITIONS;
1997, UNDERGROUND GYMNASIUM

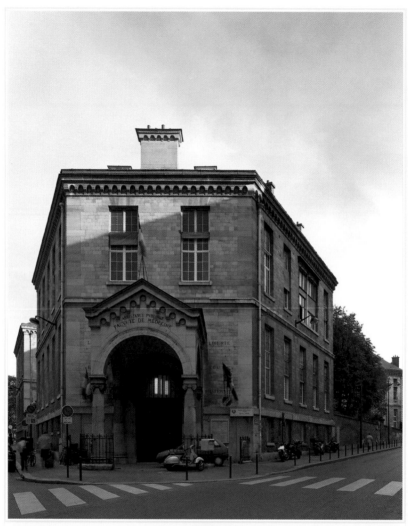

263

Hôpital Cochin

89, RUE D'ASSAS AT RUE DES CHARTREUX

1881, LÉON GINAIN

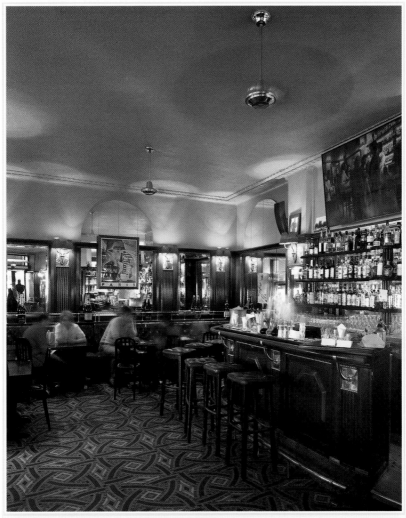

264

La Closerie des Lilas

171, BOULEVARD DU MONTPARNASSE AT BOULEVARD SAINT-MICHEL

1925, PAUL AND ALPHONSE SOLVET, BUILDING

7ᵀᴴ ARRONDISSEMENT

The ritzy 7th arrondissement has a dual personality: residential and governmental. The district boasts Musée d'Orsay, upscale antique shops, a sweeping view of the Seine from the Eiffel tower, and Napoléon's final resting place under the cupola of Hôtel des Invalides. Embassies, ministries, and government offices now occupy former aristocratic mansions in the area between the 6th arrondissement and Les Invalides, which was one of the most sought-after neighborhoods in the seventeenth century and is still home to the haute bourgeoisie. Au Bon Marché, the oldest department store in Paris and the only one on the Left Bank, caters to a tony, residential crowd. The French prime minister calls Hôtel Matignon home, and the Assemblée Nationale convenes in the Palais Bourbon at the bank of the Seine. Except on rare days when they are opened to the public, private courtyards and gardens lie hidden behind high walls and massive, closed portals. But you can picnic in the rectangular Parc du Champs de Mars while gazing at the façades of the Ecole Militaire at one end or, if you face the opposite direction, at Paris's most famous monument, the Tour Eiffel.

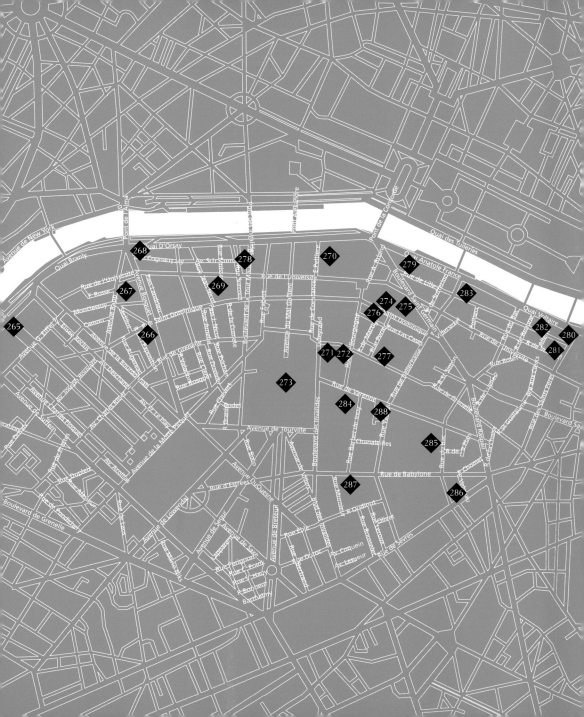

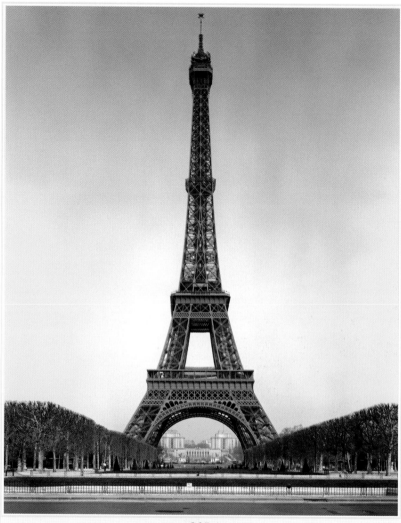

265

Eiffel Tower

CHAMP-DE-MARS, BETWEEN QUAI BRANLY AND AVENUE GUSTAVE EIFFEL

1887–89, STEPHEN SAUVESTRE (ARCHITECT), MAURICE KOECHLIN AND EMILE NOUGUIER,
(ENGINEERS), AND GUSTAVE EIFFEL (CONTRACTOR)

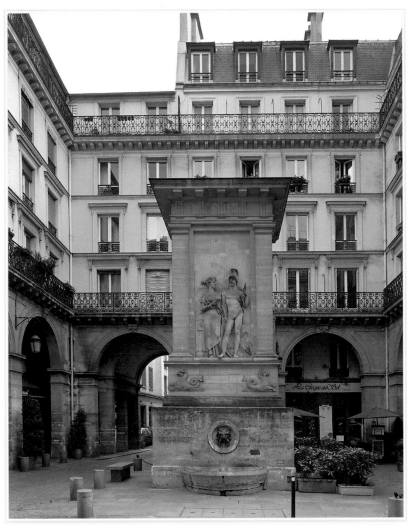

266

La Fontaine de Mars with Fontaine de Mars

129–131, RUE SAINT-DOMINIQUE AT RUE DE L'EXPOSITION

1806, NICOLAS BRALLE, FOUNTAIN; C. 1908, CAFÉ

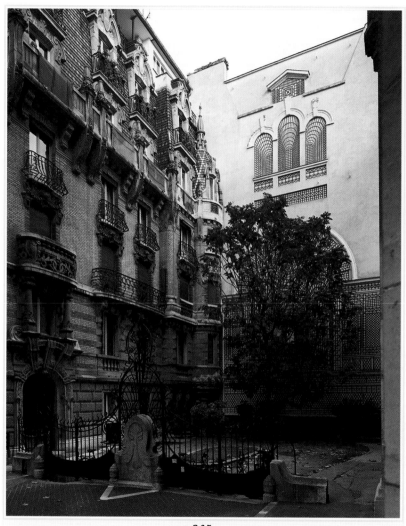

267

3, square Rapp

AT AVENUE RAPP

1899–1900, JULES LAVIROTTE

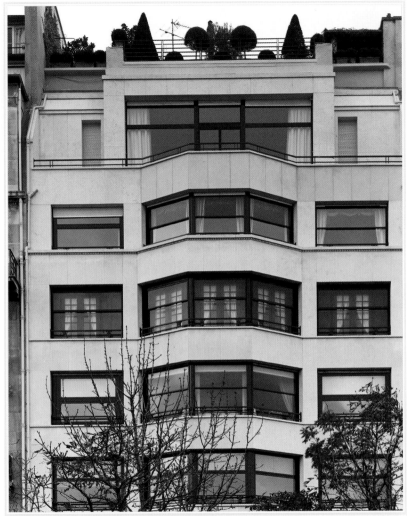

268

89, quai d'Orsay

AT PONT-DE-L'ALMA AND AVENUE BOSQUET

1929, MICHEL ROUX-SPITZ

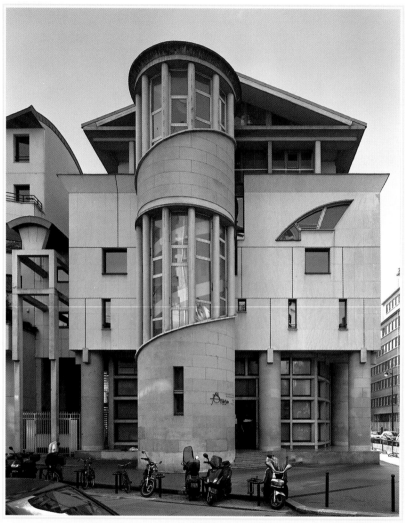

269

Conservatoire de Musique

7, RUE JEAN NICOT AT RUE DE L'UNIVERSITÉ

1984, CHRISTIAN DE PORTZAMPARC, ASSISTED BY FRÉDÉRIC BOREL

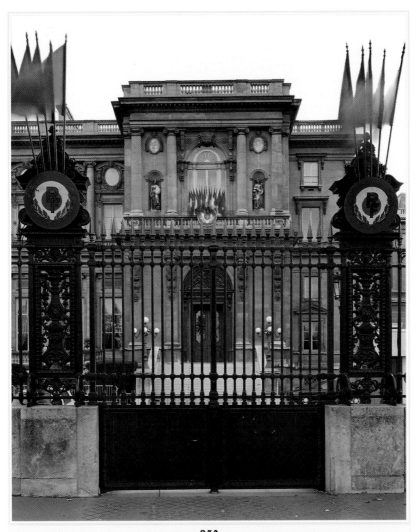

270

Ministry of Foreign Affairs

37, QUAI D'ORSAY AT RUE ROBERT ESNAULT PELTERIE

1845–56, JACQUES LACORNÉE

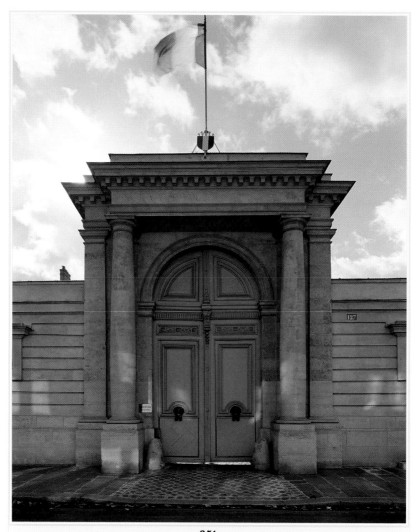

271

Hôtel du Châtelet (Ministère des Affaires Sociales, du Travail et de la Solidarité)

127, RUE DE GRENELLE AT CORNER BOULEVARD DES INVALIDES

1770–76, MATHURIN CHERPITEL

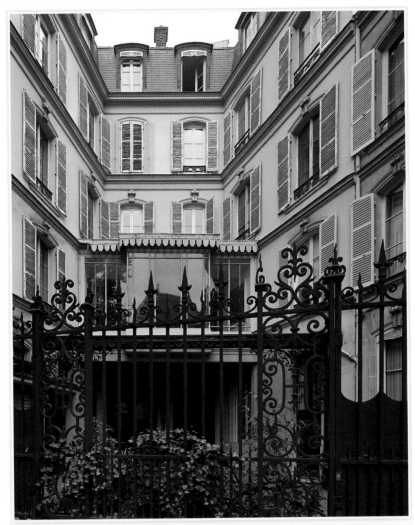

272

272, boulevard Saint-Germain

BETWEEN RUE DE LILLE AND RUE DE L'UNIVERSITÉ

c. 1840

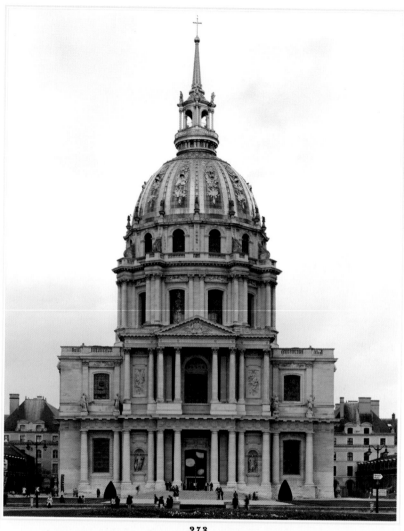

273

Hôtel des Invalides with Dome Church of the Invalides

PLACE DES INVALIDES AND PLACE VAUBAN, BETWEEN BOULEVARD DES INVALIDES AND BOULEVARD DE LA TOUR MAUBOURG

1671–78, LIBÉRAL BRUANT, MAIN BUILDING; 1676–78, JULES HARDOUIN-MANSART, SOLDIER'S CHURCH; 1677–1706, JULES HARDOUIN-MANSART, DOME CHURCH

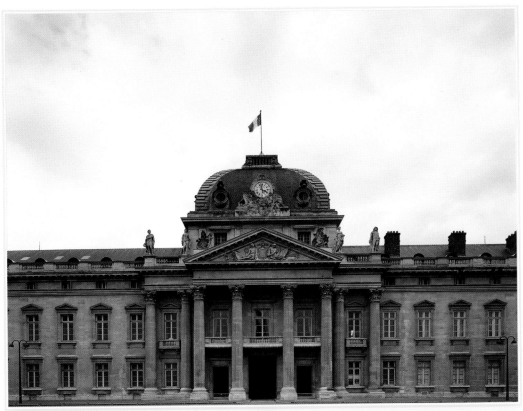

274

École Militaire

43, AVENUE DE LA MOTTE-PICQUET, BETWEEN AVENUE DE SUFFREN AND AVENUE DUQUESNE

1752–73, JACQUES-ANGE GABRIEL, INITIAL PHASE;
1780–88, ETIENNE-LOUIS BOULLÉE, THEN ALEXANDRE-THÉODORE BRONGNIART, SECOND PHASE

275

Ministère de la Défense

231, BOULEVARD SAINT-GERMAIN AT RUE DE L'UNIVERSITÉ AND RUE SAINT-DOMINIQUE

1876–77, BOULEVARD SIDE, H. BOUCHOT

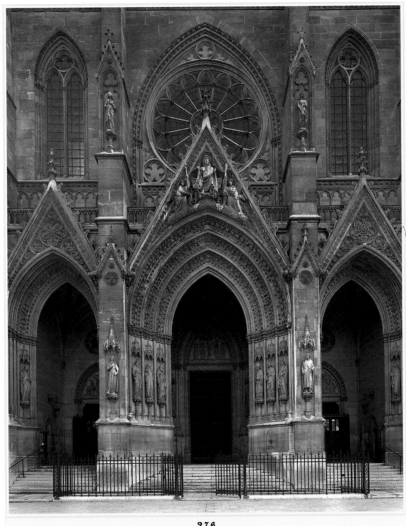

276

Église Sainte-Clotilde

12, RUE MARTIGNAC AT CORNER OF RUE LAS-CASES

1846–53, FRANÇOIS-CHRISTIAN GAU; 1853–57, THÉODORE BALLU

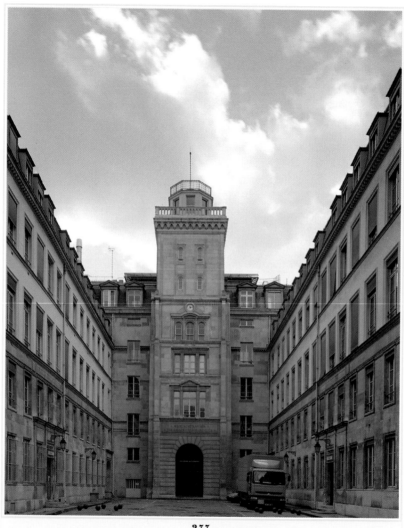

277

La Poste (Bureaux du 7ème Arrondissement)

103, RUE DE GRENELLE AT RUE CASIMIR PÉRIER

C. 1840

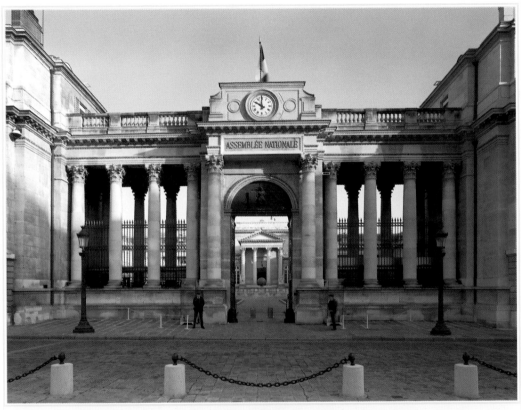

278

Palais Bourbon/Hôtel de Lassay (National Assembly)

126–128, RUE DE L'UNIVERSITÉ AT 29–35, QUAI D'ORSAY

1722, GIOVANNI GIARDINI; 1722–24, PIERRE CAILLETEAU; 1724–30, JEAN AUBERT AND JACQUES GABRIEL V; 1764, ANTOINE-MICHEL LE CARPENTIER AND
CLAUDE BILLARD DE BELLISARD, WINGS ON THE SIDES AND ON THE FRONT; 1795, JACQUES-PIERRE GISORS AND EMMANUEL-CHÉRUBIN LECONTE, HALL OF THE FIVE HUNDRED;
1806, BERNARD POYET, RIVERFRONT FAÇADE, PALAIS BOURBON; 1828, JULES DE JOLY, REMODELING; 1843, ADDITION OF ONE STORY, HÔTEL DE LASSAY

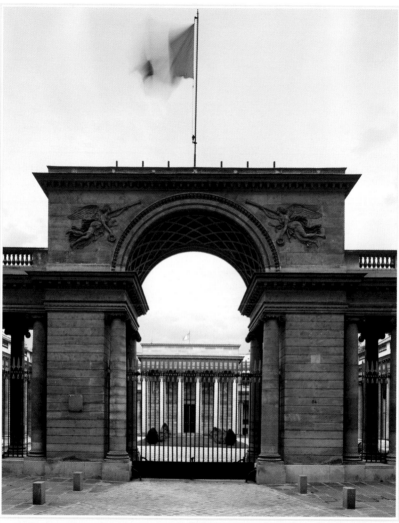

279

Hôtel de Salm (Palais de la Légion d'Honneur)

64, RUE DE LILLE AND QUAI ANATOLE-FRANCE BETWEEN RUE DE SOLFÉRINO AND RUE DE LA LÉGION D'HONNEUR

1782–87, PIERRE ROUSSEAU, ORIGINAL BUILDING; 1804, ANTOINE-FRANÇOIS PEYRE, INSIDE TRANSFORMATIONS;
1866–70, A. LEJEUNE, EXTENSION

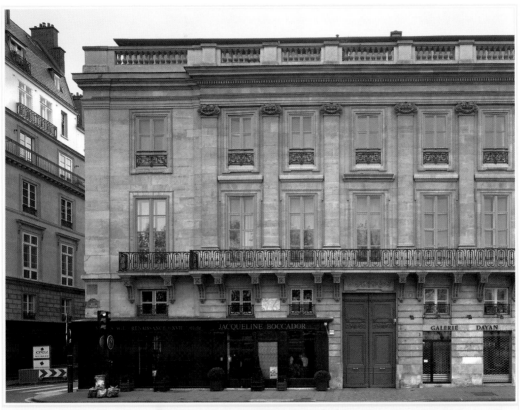

280

Hôtel de Tessé

1, QUAI VOLTAIRE AT RUE DES SAINTS-PÈRES

1765–68, PIERRE-NOËL ROUSSET AND LOUIS LE TELLIER

281

Former home of Serge Gainsbourg

5 BIS, RUE DE VERNEUIL AT RUE DES SAINTS-PÈRES

C. EIGHTEENTH CENTURY

282

Hôtel de Villette

27, QUAI VOLTAIRE AT RUE DE BEAUNE

1766–71, CHARLES DE WAILLY, INSIDE DECORATION

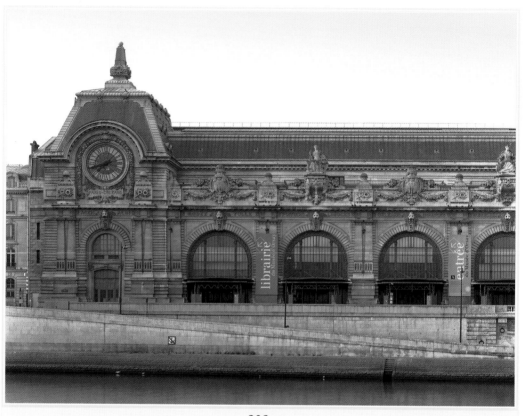

283

Musée d'Orsay

QUAI ANATOLE-FRANCE

1898–1900, VICTOR LALOUX, TRAIN STATION; 1983–86, RENAUD BARDON, PIERRE COLBOC, AND JEAN-PAUL PHILIPPON, MUSEUM; 1983–86, GAE AULENTI, INTERIOR

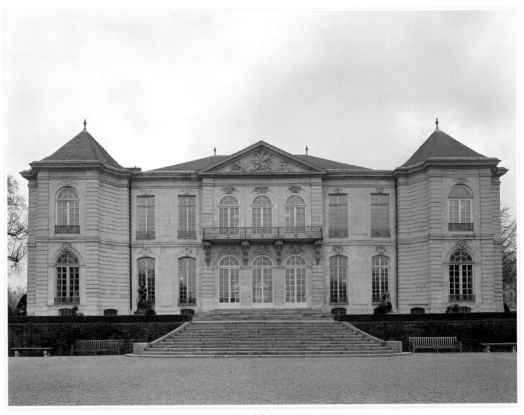

284

Musée Rodin (*Hôtel Biron*)

77, RUE DE VARENNE AT BOULEVARD DES INVALIDES

1727–30, JEAN AUBERT

285

Hôtel Montalembert

3, RUE MONTALEMBERT AT RUE DU BAC

C. 1900; 1989, INTERIOR RENOVATION

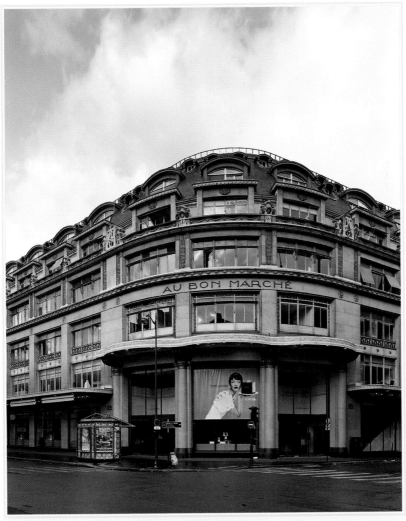

286

Au Bon Marché

22-36, RUE DE SÈVRES AT RUES VELPEAU, BABYLONE, AND DU BAC

1869–70, ALEXANDRE LAPLANCHE; 1872–74, LOUIS-CHARLES BOILEAU, PHASE ON RUE VELPEAU;
1879–87, LOUIS-CHARLES BOILEAU, RUE DE SÈVRES WITH METAL FRAME BY GUSTAVE EIFFEL;
1920–23, LOUIS-HIPPOLYTE BOILEAU, NEW STORE WEST OF RUE DU BAC

287

La Pagode (Art House Cinema)

57 BIS, RUE DE BABYLONE AT RUE MONSIEUR

1895, ALEXANDRE MARCEL; 1930, TRANSFORMED INTO A MOVIE THEATER

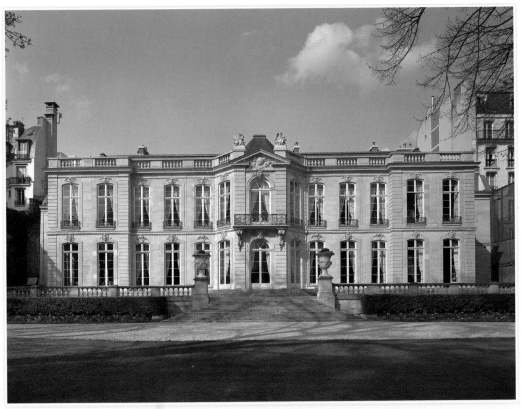

288

Hôtel de Matignon

57, RUE DE VARENNE AT RUE VANEAU

1722–23, JEAN COURTONNE; 1724, JEAN MAZIN

8ᵀᴴ Arrondissement

From the Arc de Triomphe, the 8ᵗʰ arrondissement radiates down avenue des Champs-Elysées to place de la Concorde. This vista encompasses the Grand Palais and Petit Palais as well as the U.S. Embassy and the eighteenth-century Palais de l'Elysées, home of the French president. Once lined with grand hotels, chic stores, and designer-name boutiques, and touted as the most beautiful avenue in the world, the Champs-Elysées has deteriorated into a tourist promenade throbbing with the frenzied noise of commercial establishments, movie houses, overpriced cafés, fast-food restaurants, chain stores, and congested traffic. The lower landscaped portion of the avenue below Rond Point des Champs-Elysées and avenue Montaigne is still prime strolling territory, boasting a few stylish restaurants and the fabulous Art Deco Théâtre des Champs-Elysées. However, the streets to go for genuine, high-end haute couture houses and gourmet food boutiques are avenue Montaigne, rue du Faubourg-Saint-Honoré, rue Royale, and place de la Madeleine.

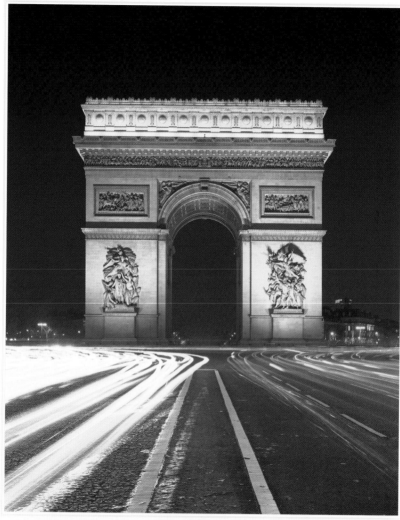

289

Arc de Triomphe

PLACE CHARLES-DE-GAULLE

1806, ARNAUD RAYMOND AND JEAN-FRANÇOIS CHALGRIN, PROJECT; 1809–11, JEAN-FRANÇOIS CHALGRIN, CONSTRUCTION;
1811–14, L. GOUST, CONTINUATION; 1825, JEAN-NICOLAS HUYOT, ENTABLATURE; 1832-36, ABAL BLOUET, ATTIC

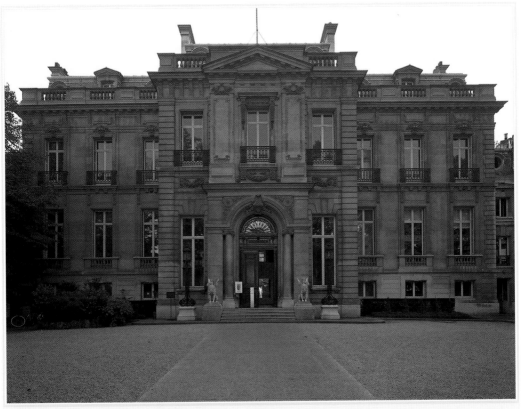

290

Hôtel Salomon de Rothschild

9–11, RUE BERRYER AT AVENUE DE FRIEDLAND (GARDEN FAÇADE SIDE)

1872–78, LÉON OHNET, JUSTIN PONSARD AFTER OHNET'S DEATH

291

Atelier

157, RUE DU FAUBOURG SAINT-HONORÉ AT BOULEVARD HAUSSMANN

C.1830; C. BEGINNING OF THE TWENTIETH CENTURY, TRANSFORMATIONS

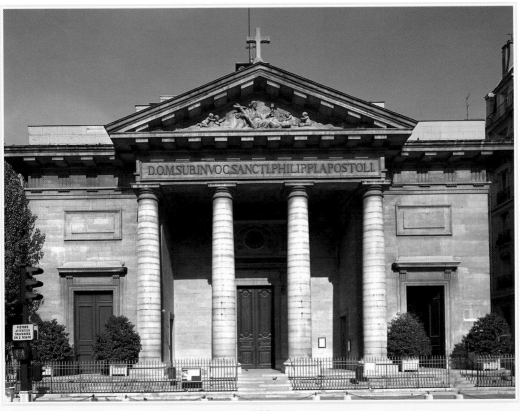

292

Église Saint-Philippe-du-Roule

154, RUE FAUBOURG-SAINT-HONORÉ AT RUE LA BOÉTIE

1774–84, JEAN-FRANÇOIS CHALGRIN; 1845, ETIENNE-HIPPOLYTE GODDE, ENLARGEMENT;
1853, VICTOR BALTARD, ADDITIONAL WORK

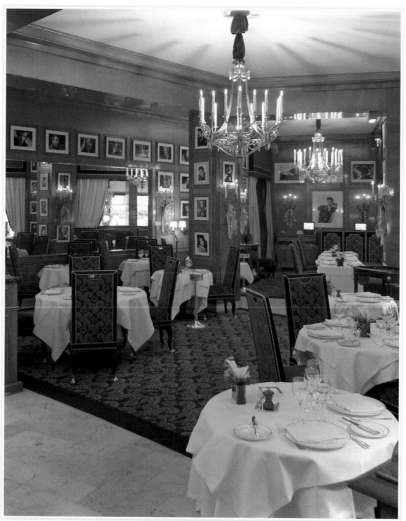

293
Fouquet's

99, AVENUE DES CHAMPS-ELYSÉES CORNER OF AVENUE GEORGE-V

1863, BUILDING; 1899, BAR; 1958, JEAN ROYÈRE, DECORATION

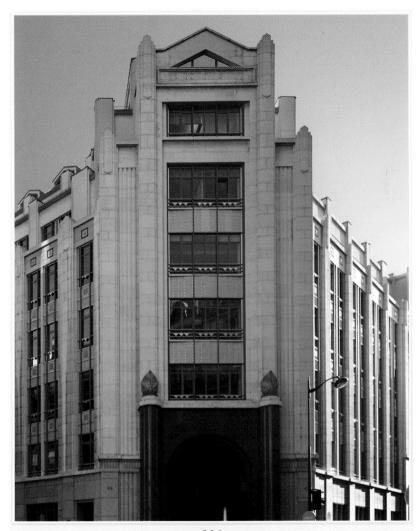

294
Shell Building

29, RUE DE BERRI AT RUE D'ARTOIS

1932, L. BECHMANN AND CHATENAY

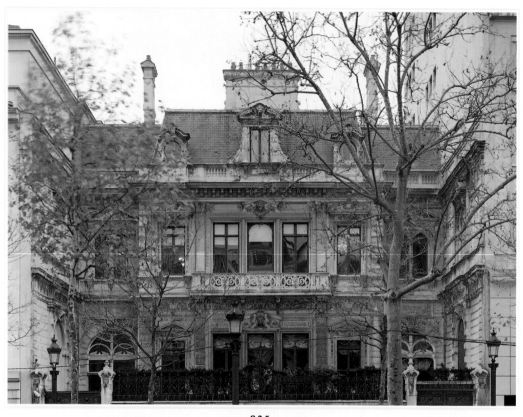

295

Hôtel de la Païva

25, AVENUE DES CHAMPS-ELYSÉES, BETWEEN RUE DE MARIGNAN AND AVENUE MONTAIGNE

1855–66, PIERRE MAUGAIN

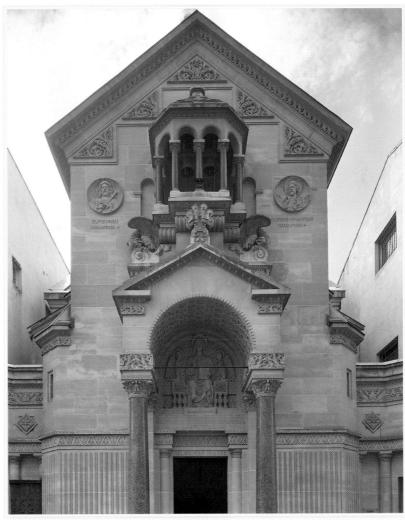

296

Armenian Church

15, RUE JEAN-GOUJON AT PLACE FRANÇOIS-I

1903, ALBERT-DÉSIRÉ GUILBERT

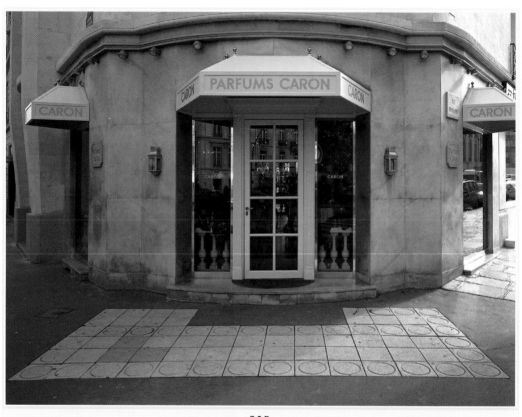

297

Parfums Caron

34, AVENUE MONTAIGNE AT RUE FRANÇOIS-I

1927, CHARLES PLUMET

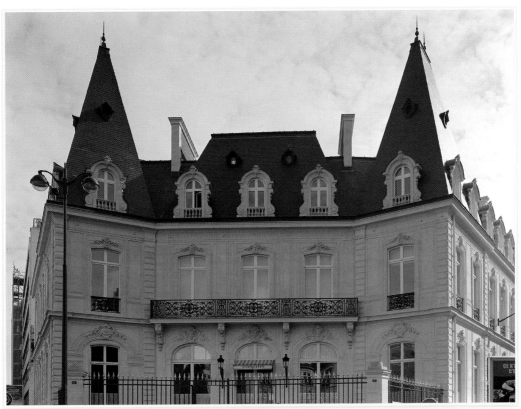

298

5, place François-Ier

PLACE FRANÇOIS-Iᴱᴿ

SECOND HALF OF THE NINETEENTH CENTURY

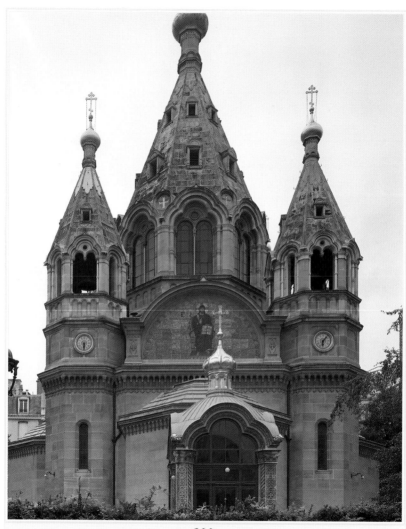

299

Saint-Alexandre-Nevski (Eglise Cathédrale Russe)

12, RUE DARU AT RUE PIERRE LE GRAND

1859–61, R. KOUZMINE AND I. STROHM

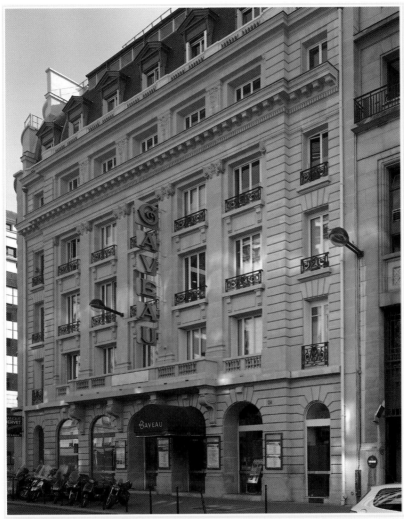

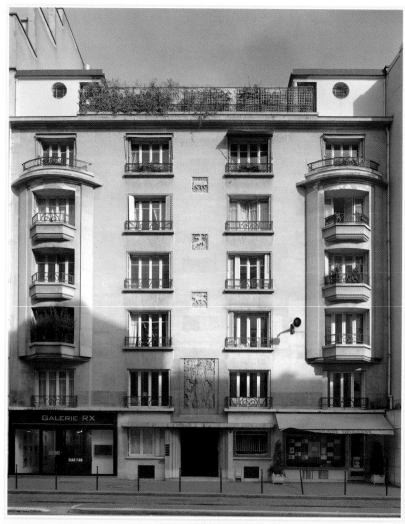

301

6, avenue Delcassé

BETWEEN RUE LA BOÉTIE AND RUE DE PENTHIÈVRE

C. 1930

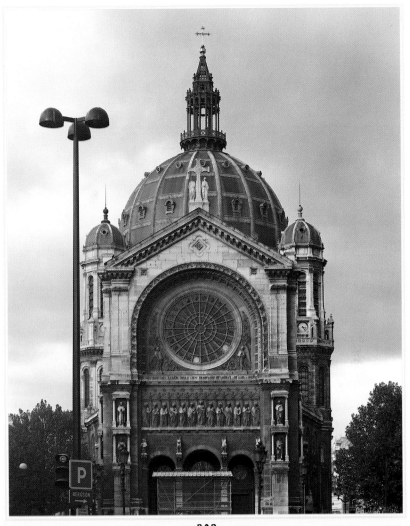

302

Église Saint-Augustin

46, BOULEVARD MALESHERBES, BETWEEN RUE DE LA BIENFAISANCE AND RUE DE LABORDE

1860–71, VICTOR BALTARD

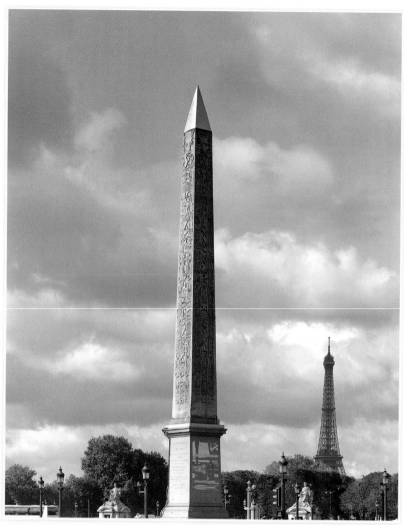

305

Obélisque de Luxor

At place de la Concorde

c. 13th century BC; 1836, chief engineer Appolinaire Le Bas

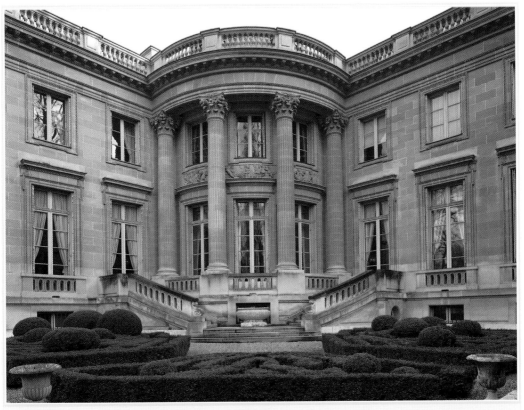

306
Musée Nissim de Camondo

61–63, RUE DE MONCEAU, BETWEEN RUE DE VÉZELAY AND RUE DE TÉHÉRAN

1911–14, RENÉ SERGENT

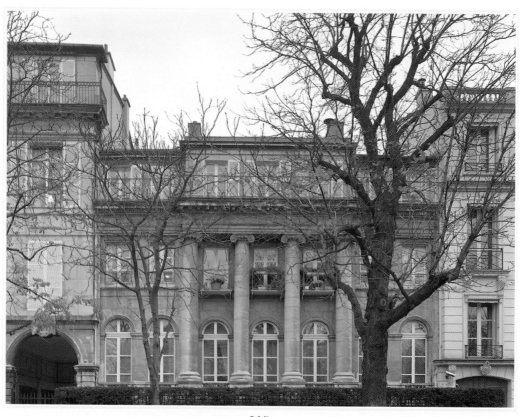

307
Hôtel d'Argenson

38, AVENUE GABRIEL AT AVENUE DE MARIGNY

1780–87, JEAN-PHILIPPE LEMOINE DE COUZON; 1840–45, JACQUES-IGNACE HITTORFF, TRANSFORMATIONS

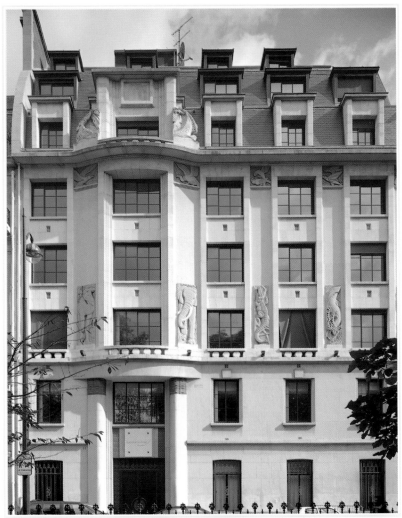

308

HypoVereinsbank

34, RUE PASQUIER

1929, PIERRE AND ALEXANDRE FOURNIER; GEORGES SAUPIQUE, SCULPTOR

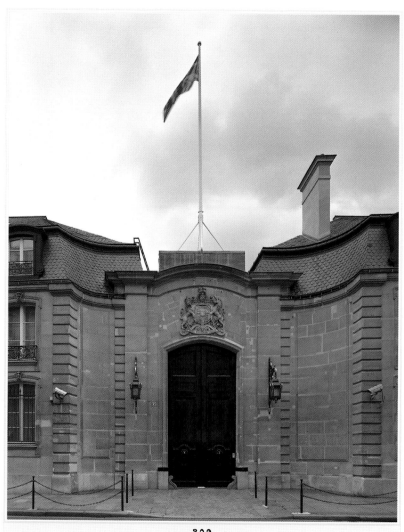

309

British Embassy

35, RUE FAUBOURG-SAINT-HONORÉ AT AVENUE GABRIEL

1720, ANTOINE MAZIN

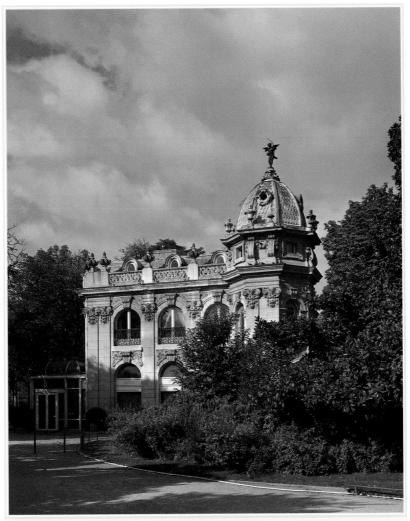

310

Le Pavillon Elysée

10, AVENUE DES CHAMPS ELYSÉES AT AVENUE DE MARIGNY AND AVENUE GABRIEL

1898, ALBERT BALLU

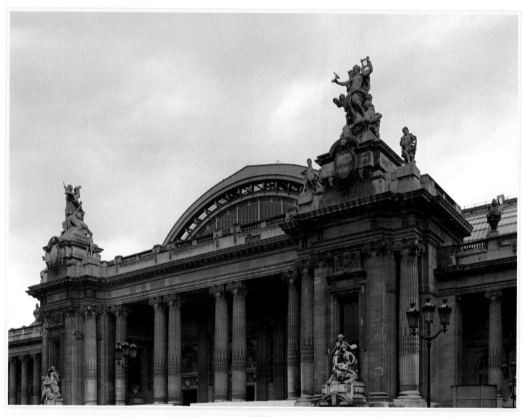

311

Grand Palais

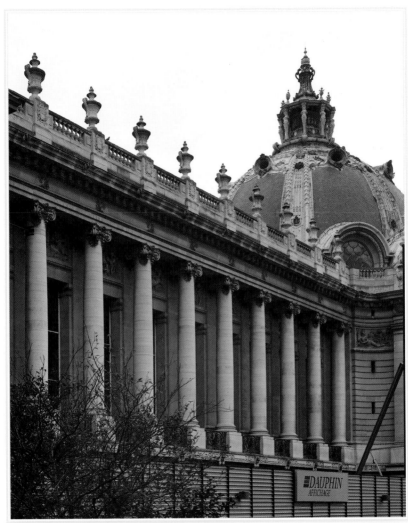

312

Petit Palais

<small>Avenue Winston-Churchill at avenue Charles-Girault</small>

1897–1900, Charles Girault

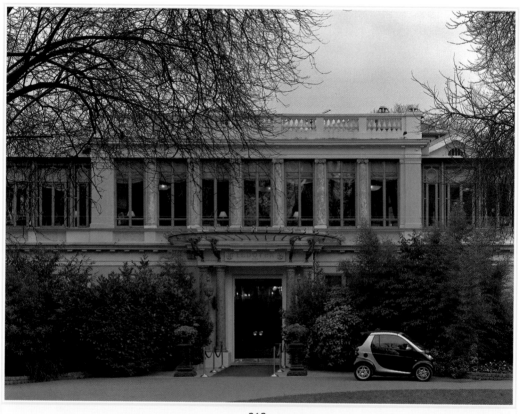

313

Pavillon Ledoyen

2, AVENUE DUTUIT IN THE CHAMPS-ELYSÉES GARDENS

C. 1730, AS AU DAUPHIN; 1848, JACQUES-IGNACE HITTORFF, REDESIGN

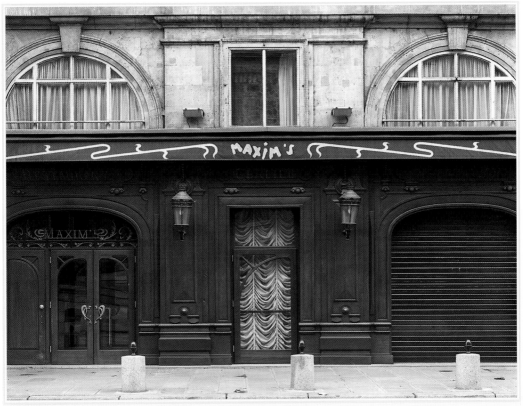

314

Maxim's

3, RUE ROYALE AT PLACE DE LA CONCORDE

1893, OPENING

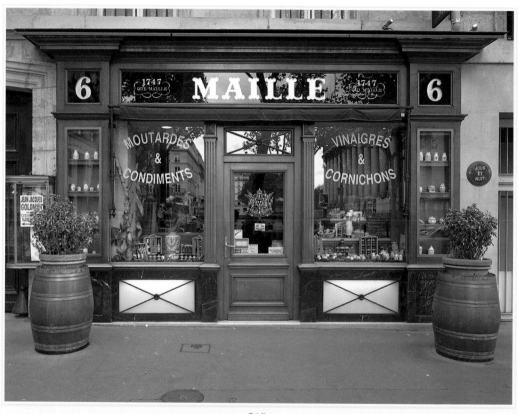

315

Maille

6, PLACE DE LA MADELEINE AT BOULEVARD DE LA MADELEINE

C. MID—NINETEENTH CENTURY, BUILDING

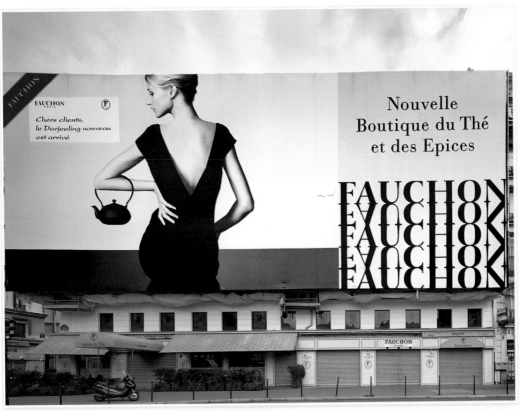

316

Fauchon

26, PLACE DE LA MADELEINE AT RUE DE SEZE AND RUE VIGNON

1829, BUILDING; C. 1886, BOTREL, ARCHITECT; LEFEBVRE, CARPENTER, SHOP FRONT

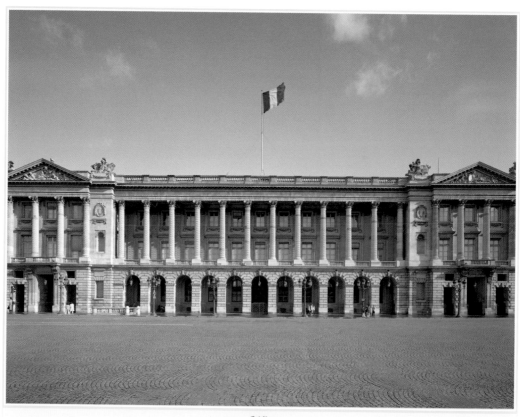

317
Hôtel Crillon

10, PLACE DE LA CONCORDE, AT RUE ROYALE

1766–75, JACQUES-ANGE GABRIEL; 1774, PIERRE-ADRIEN PÂRIS, INSIDE DECORATION;
1907, WALTER DESTAILLEURS, INSIDE RENOVATION; 1830–44, JACQUES-IGNACE HITTORFF, ALTERATIONS OF PLACE DE LA CONCORDE

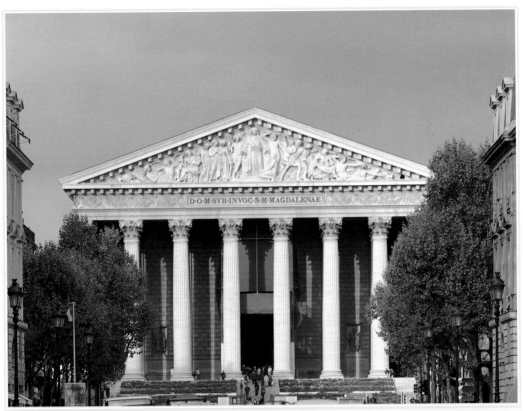

318

Église de la Madeleine

PLACE DE LA MADELEINE AT RUE ROYALE

1807–28, PIERRE VIGNON; 1828–42, JACQUES-MARIE HUVÉ

319
Paul

CORNER 55, BOULEVARD HAUSSMANN AND 35–37 RUE TRONCHET

1864, BUILDING; 1910, DECORATION STORE

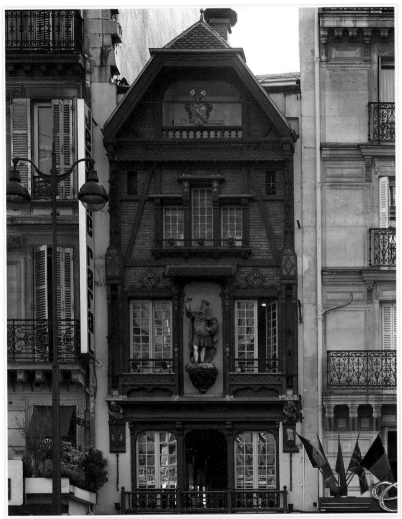

320
Mollard

115, RUE SAINT-LAZARE, BETWEEN RUE DE ROME AND RUE DU HAVRE

1884, EDOUARD NIERMANS

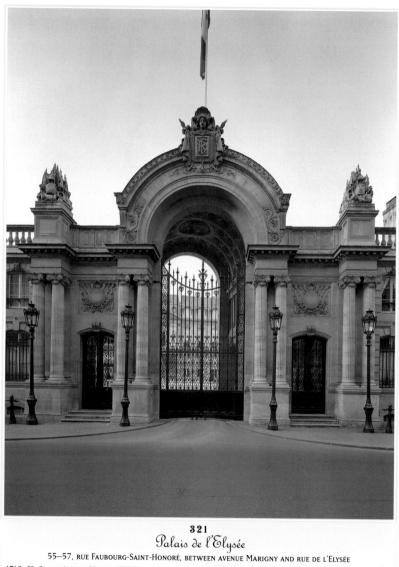

321

Palais de l'Elysée

55–57, RUE FAUBOURG-SAINT-HONORÉ, BETWEEN AVENUE MARIGNY AND RUE DE L'ELYSÉE

1718–20, CLAUDE-ARMAND MOLLET; 1753, JEAN CAILLETEAU (AKA LASSURANCE), ALTERATIONS; 1773, ETIENNE-LOUIS BOULLÉE, INSIDE ALTERATIONS, GARDEN; 1787, PIERRE-ADRIEN PÂRIS, INSIDE ALTERATIONS, GARDEN; 1805–08, BARTHÉLÉMY VIGNON, ETIENNE-CHÉRUBIN LECONTE AND JEAN-THOMAS THIBAULT, INSIDE ALTERATIONS; 1848, JOSEPH-EUGÈNE LACROIX, FAÇADE ALTERATION AND WINGS

9ᵀᴴ Arrondissement

Here's a bit of the real Paris with quaint mews and private mansions, all quietly tucked away from the average tourist. Beyond the Garnier Opéra and famous department stores Le Printemps and Galeries Lafayette, romance beckons in the village enclaves of the 9ᵗʰ arrondissement. The area above the old fortification boundary of the Grands Boulevards and below Butte Montmartre was once the countryside where, in the early nineteenth century, real estate developers created two artistic quarters: Saint-Georges and La Nouvelle Athènes. During a period that saw the revival of Greek and Egyptian styles of architecture and the rise of Romanticism, actors, writers, painters, and musicians flocked to these new neighborhoods and built lovely homes, charming squares, courtyards, and gardens. For a taste of this Romantic life, a number of former private mansions, converted now to little-known museums, are scattered around the 9th arrondissement. Just north of the Grands Boulevards border, the Folies-Bergère is a reminder of the swinging cabaret days of the nineteenth and early twentieth centuries when this district was the center of entertainment. Still popular today, the area contains clusters of great neighborhood restaurants, art galleries, other cabarets, small theaters, and the diverse and colorful market streets of rue des Martyrs and rue Cadet.

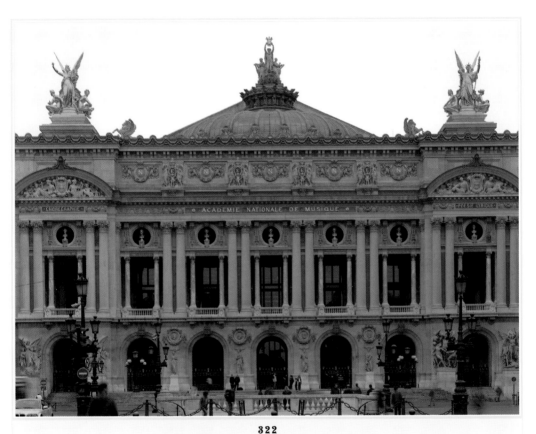

322

Théâtre National de l'Opéra Palais Garnier

PLACE DE L'OPÉRA AND PLACE DIAGHILEV, BETWEEN BOULEVARD DES CAPUCINES AND BOULEVARD HAUSSMANN

1862–75, CHARLES GARNIER

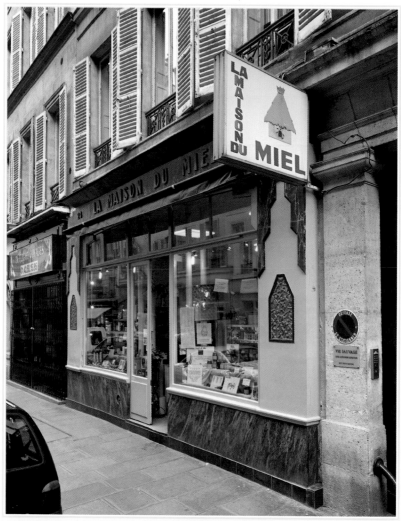

323

La Maison du Miel

24, RUE VIGNON BETWEEN RUE TRONCHET AND RUE DE SÈZE

1898, FOUNDATION; 1930, INSTALLATION AT 24, RUE VIGNON

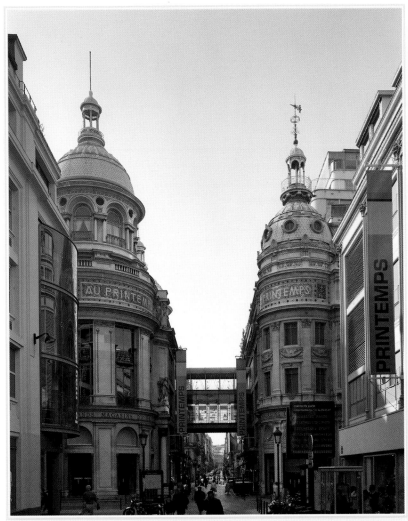

324

Le Printemps

64-70, BOULEVARD HAUSSMANN AT RUE DU HAVRE AND RUE DE PROVENCE

1865, JULES JALUZOT; 1881–85, PAUL SÉDILLE; 1905, RENÉ BINET, RENOVATION AND CENTRAL STAIRCASE; 1907–10, RÉNÉ BINET, SECOND STORE; 1912, GEORGES WYBO, EXTENSION; 1921–24, GEORGES WYBO, RECONSTRUCTION OF THE SECOND STORE

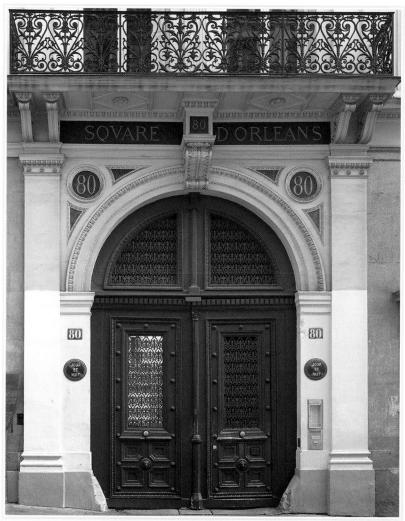

325

Square d'Orléans (Cité des Trois-Frères)

20, RUE TAITBOUT AND 80, RUE TAITBOUT

1829, EDWARD CRESY

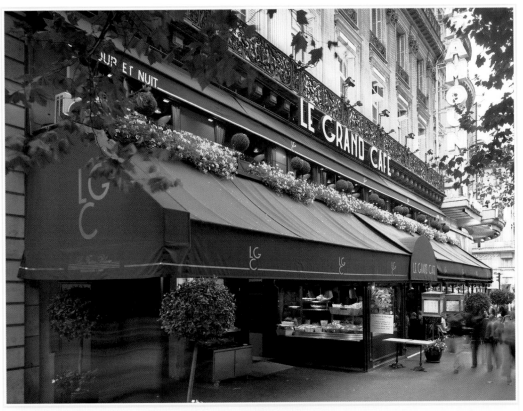

326
Le Grand Café des Capucines

4, BOULEVARD DES CAPUCINES AT RUE DE LA CHAUSSÉE D'ANTIN

c.1875

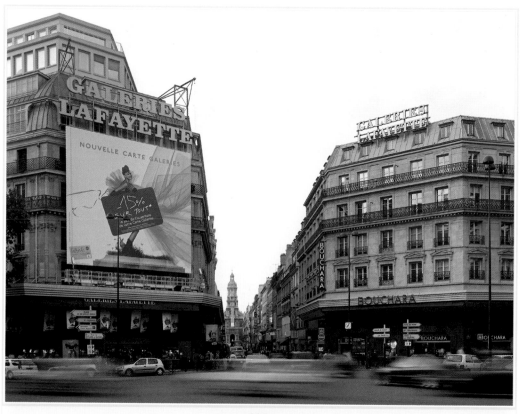

327

Galeries Lafayette

38–46, BOULEVARD HAUSSMANN AT RUE DE LA CHAUSSÉE D'ANTIN

1906–07, GEORGE CHEDANNE, FIRST PART (EXTENSION OF TWO STORIES, 1960); 1910–12, FERDINAND CHANUT, BACK SIDE

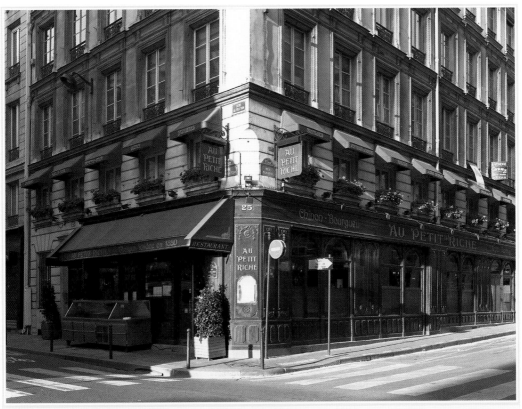

328
Au Petit Riche

25, RUE LE PELETIER AT RUE ROSSINI

1854; 1880, REBUILT; 1920, EXPANSION

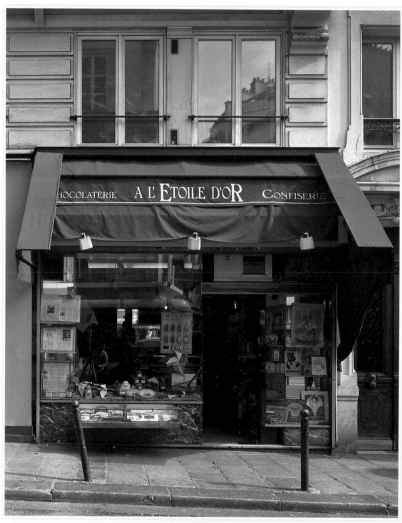

329

Former Confiserie à l'Étoile d'Or (today Confiserie Denise Acabo)

30, RUE FONTAINE AT RUE DE DOUAI

C. 1900

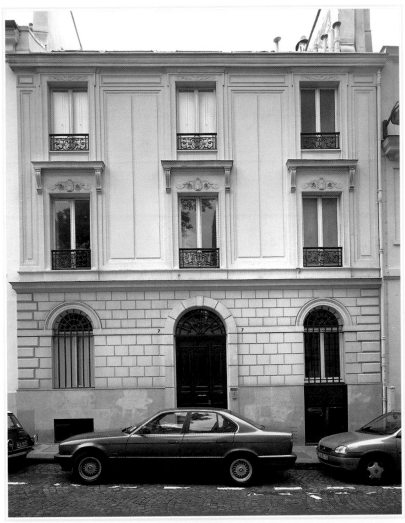

330
Delaroche House

7, RUE DE LA TOUR-DES-DAMES, BETWEEN RUE DE LA ROCHEFOUCAULD AND RUE BLANCHE

1835, AUGUSTE CONSTANTIN

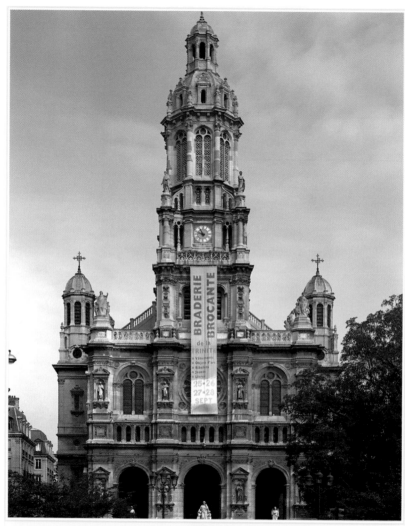

331

Eglise de-la-Trinité

PLACE D'ESTIENNE-D'ORVES, BETWEEN RUE DE CLICHY AND RUE BLANCHE

1861–67, THÉODORE BALLU

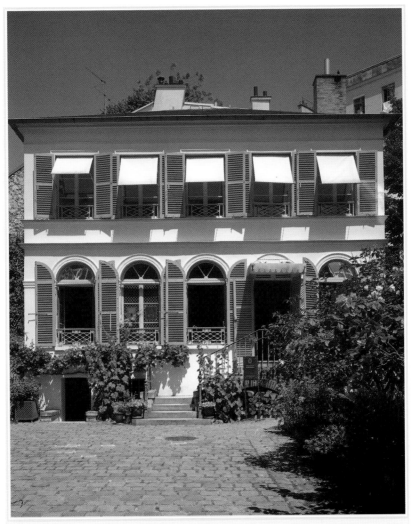

332

Musée de la Vie Romantique

16, RUE CHAPTAL AT RUE HENNER

1820

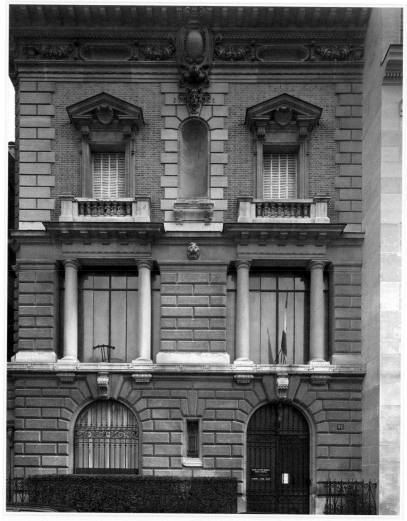

333

Musée Gustave Moreau

14, RUE DE LA ROCHEFOUCAULD AT RUE DE LA TOUR-DES-DAMES

1895, ALBERT LAFON, ADDITIONS AND FAÇADE

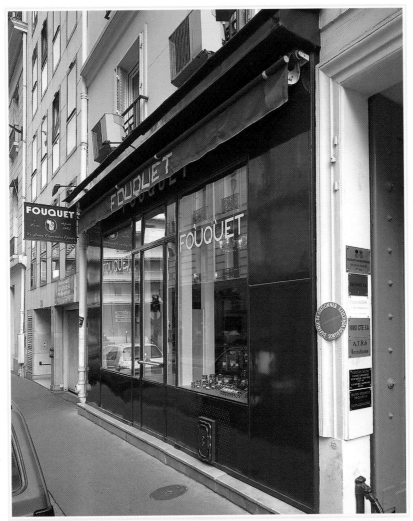

334

Fouquet

36, RUE LAFFITTE BETWEEN RUE DE PROVENCE AND RUE ROSSINI

1852, CREATION

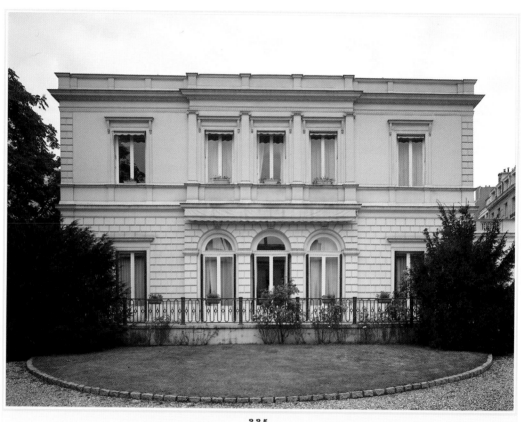

335

Hôtel de Lestapis

2, RUE DE LA TOUR-DES-DAMES AT RUE DE LA ROCHEFOUCAULD

1822—23

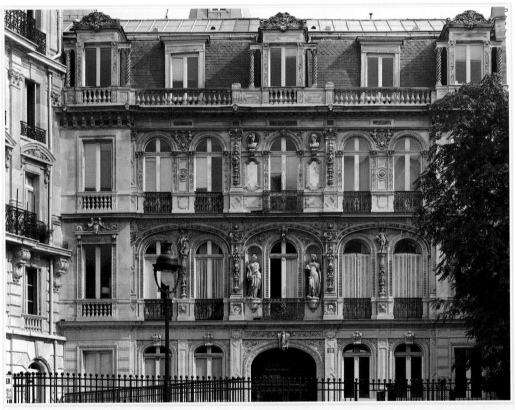

336

Place Saint-Georges apartment building

28, RUE PLACE SAINT-GEORGES AT RUE NOTRE-DAME-DE-LORETTE

1840—42, EDOUARD RENAUD

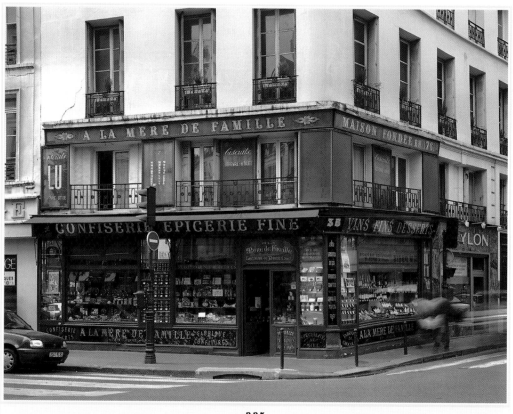

337

À la Mère de Famille

35, RUE DU FAUBOURG-MONTMARTRE CORNER OF RUE PROVENCE, RUE CADET, AND RUE RICHER

1761

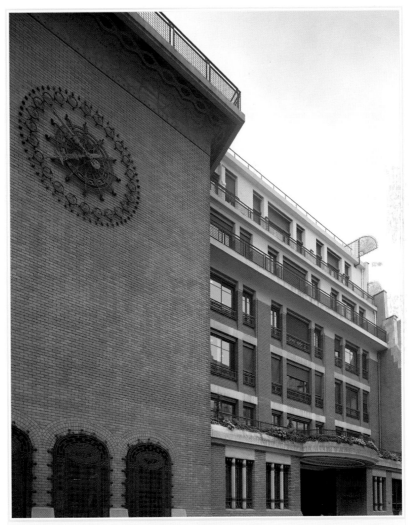

338

Centrale Téléphonique

17, RUE DU FAUBOURG-POISSONNIÈRE AT RUE BERGÈRE

1912, FRANÇOIS LE CŒUR

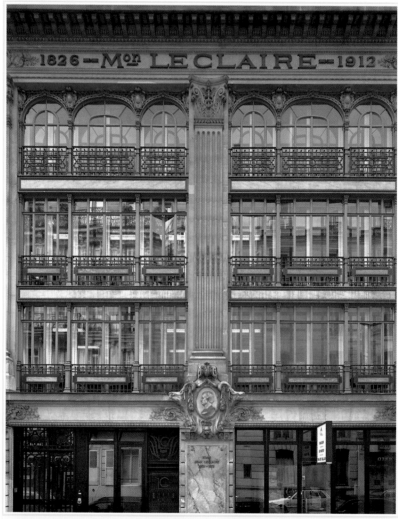

339

Maison Leclaire

25, RUE BLEUE AT RUE DE TRÉVISE

1911, HENRI BERTRAND

340

Banque Nationale de Paris

14, RUE BERGÈRE AT RUE DU CONSERVATOIRE

1878–82, EDOUARD-JULES CORROYER

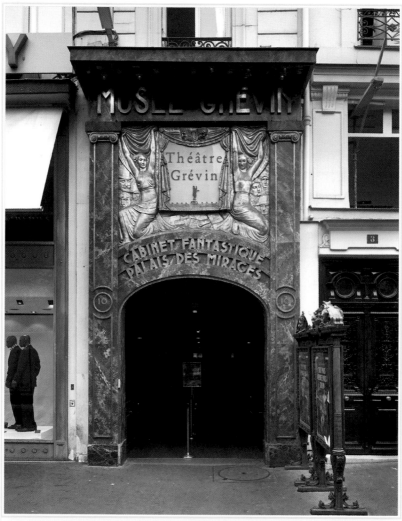

341

Musée Grévin (Wax museum)

10, BOULEVARD MONTMARTRE BETWEEN PASSAGE JOUFFROY AND RUE DU FAUBOURG-MONTMARTRE

1881, FOUNDATION OF MUSÉE GRÉVIN; 1900, ANTOINE BOURDELLE AND JULES CHÉVET, THEATER, SCULPTURES;
1906, CREATION OF PALAIS DES MIRAGES (MIRAGE/MIRROR PALACE); 2001, EXTENSIVE RENOVATION

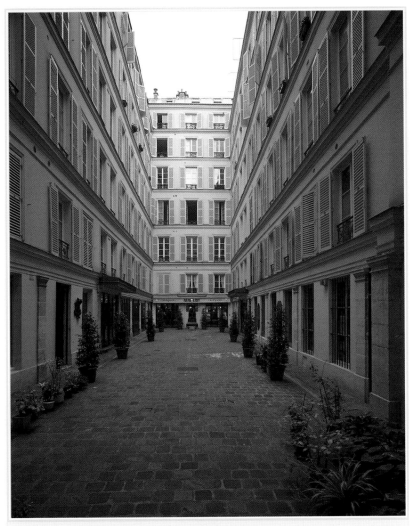

342

16, rue de la Grange-Batelière

AT RUE DROUOT

1876

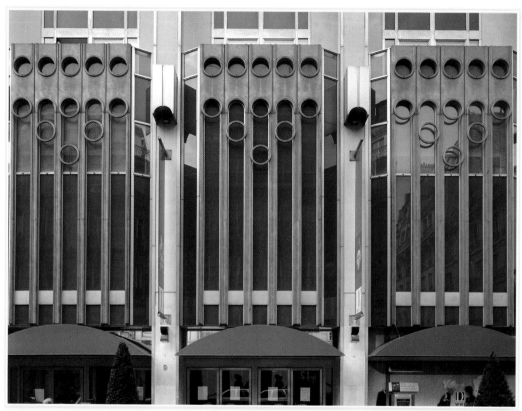

343

Hôtel des Ventes

9, RUE DROUOT ARRUE ROSSINI

1850–52 FIRST CONSTRUCTION, LEVASSEUR AND PALLARD; 1900, ADDITION;
1976, DESTROYED; 1980, JEAN-JACQUES FERNIER AND ANDRÉ BIRO

10ᵀᴴ ARRONDISSEMENT

Industrial, gray and a bit downtrodden, the 10th arrondissement is dominated by the railway stations of Gare du Nord and Gare de l'Est. With the constant motion of people coming and going, the entire district seems governed by transience. But the area is also residential, and a popular crowd fills bars, nightclubs, and restaurants. Lending a bit of romance and poetry to the heart of the arrondissement, a singular bright path flows right through the center: Canal Saint-Martin. Also, Passage Brady at the southern edge brings a bit of India to the quarter. The neighborhood west of boulevard de Magenta boasts Marché Saint Quentin, the largest covered market in Paris and one of the last original halls of iron and glass.

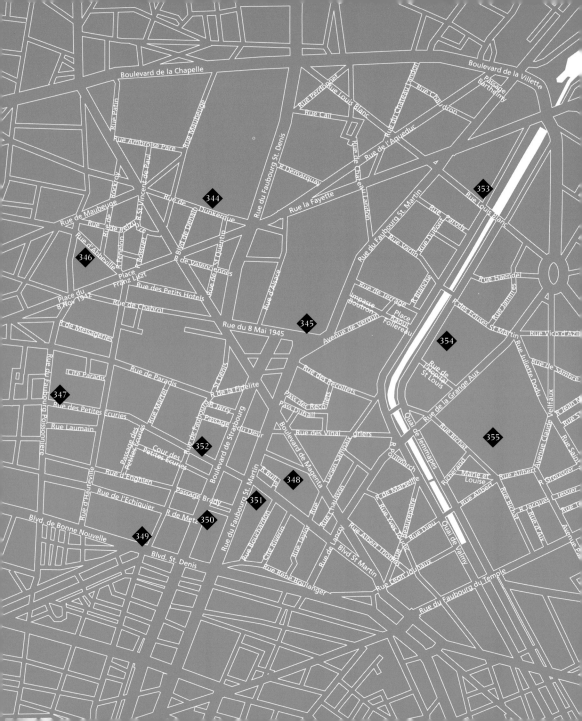

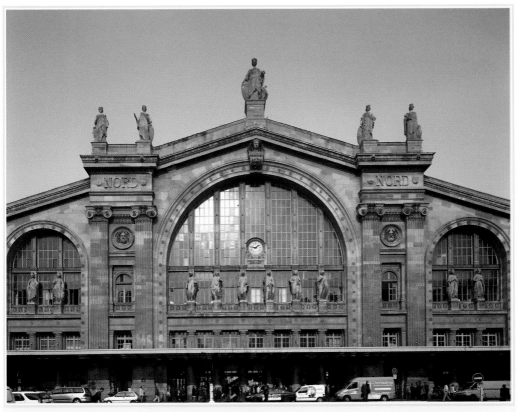

344

Gare du Nord

8, RUE DE DUNKERQUE, BETWEEN RUE DU FAUBOURG-SAINT-DENIS AND RUE DE MAUBEUGE

1861–66, JACQUES-IGNACE HITTORFF; 1993–98, JEAN-MARIE DUTHILLEUL AND JEAN-MICHEL WILMOTTE, EUROSTAR WAITING LOUNGE

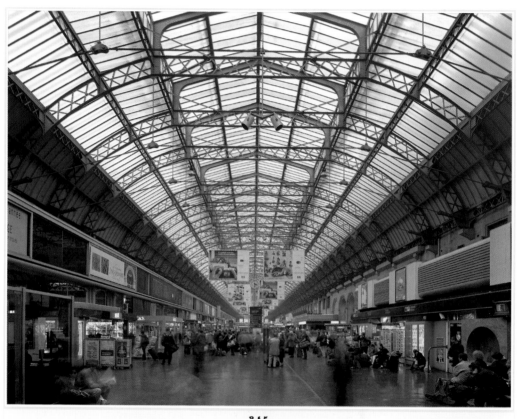

345

Gare de l'Est

PLACE DU 11-NOVEMBRE-1918 AT RUE DU 8-MAI-1945

1847–52, FRANÇOIS-ALEXANDRE DUQUESNEY; 1895-99, RENOVATIONS; 1924–31, BERTAUT, (ENGINEER), ADDITION

346

16, rue d'Abbeville

At rue du Faubourg Poissonniere

1899, Georges Massa, architect; and Alexandre Dupuy, sculptor

347

48, rue des Petites-Écuries

At rue de Faubourg-Poissonnière

c.1860

◇ 10ᵀᴴ ARRONDISSEMENT ◇

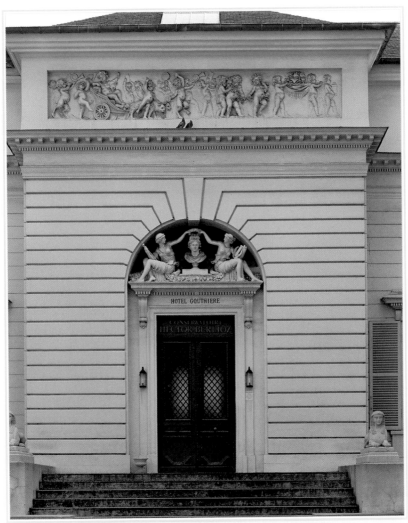

348

Hôtel Gouthière

6, RUE PIERRE-BULLET, BETWEEN RUE DU CHÂTEAU D'EAU AND CITÉ HITTORFF

1772–80, JOSEPH MÉTIVIER

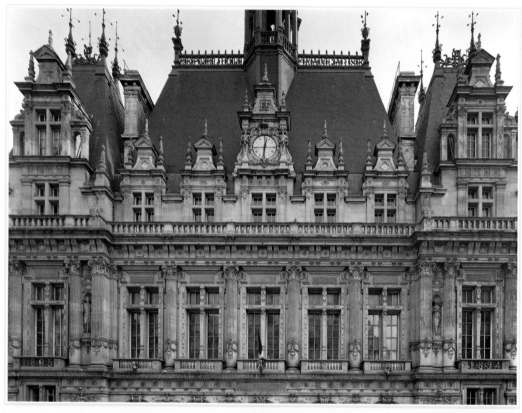

351

Mairie

76, RUE DU FAUBOURG-SAINT-MARTIN AT RUE DU CHÂTEAU D'EAU

1892—96, EUGÈNE ROUYER

352
Smallest House in Paris

39, RUE DU CHÂTEAU D'EAU AT RUE DU FAUBOURG-SAINT-MARTIN

C. BEGINNING OF THE NINETEENTH CENTURY

358

Conseil de Prud'hommes de Paris

27, RUE LOUIS BLANC AT QUAI DE VALMY

1990, JACQUES-HENRI BAJU

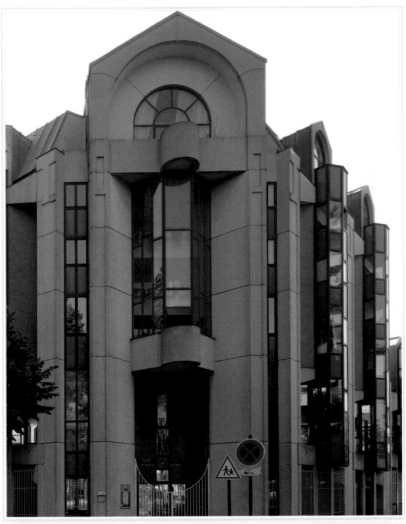

354

Foyer de Personnes Âgées et École Maternelle

126, QUAI DE JEMMAPES AT RUE DE L'HÔPITAL SAINT-LOUIS

1985, MICHEL DUPLAY

359

Église Notre-Dame-de-Bonne-Espérance

47, RUE DE LA ROQUETTE AT RUE DU COMMANDANT LAMY

1998, BRUNO LEGRAND

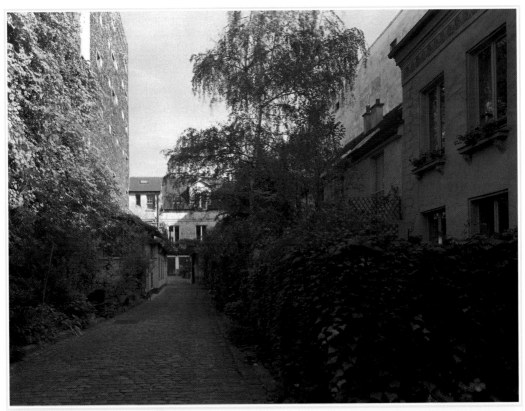

360
Cour de l'Étoile-d'Or

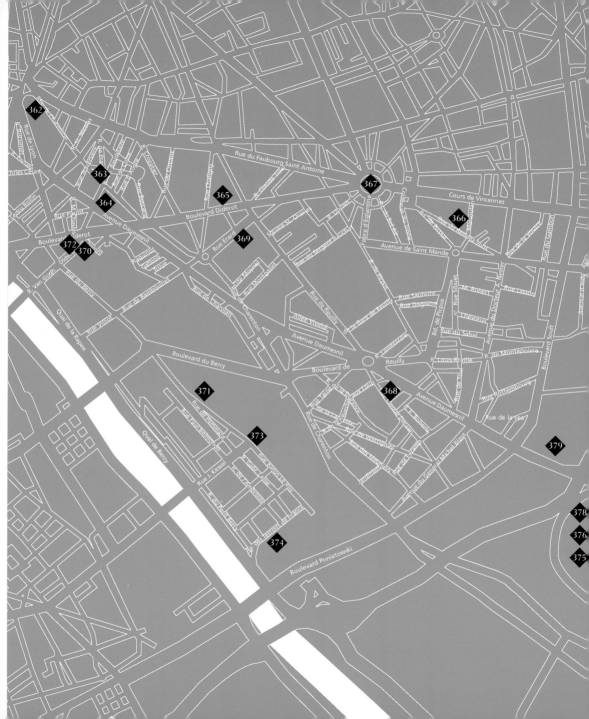

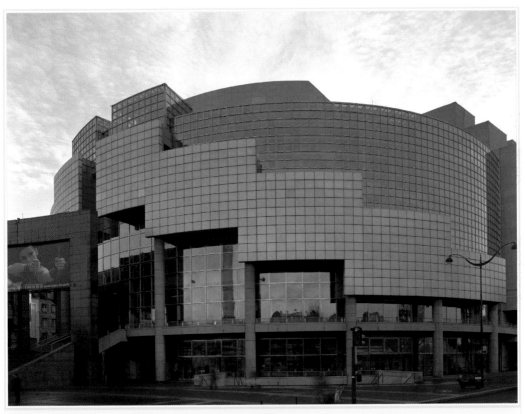

362
Opéra Bastille
26, place de la Bastille

1989, Carlos Ott

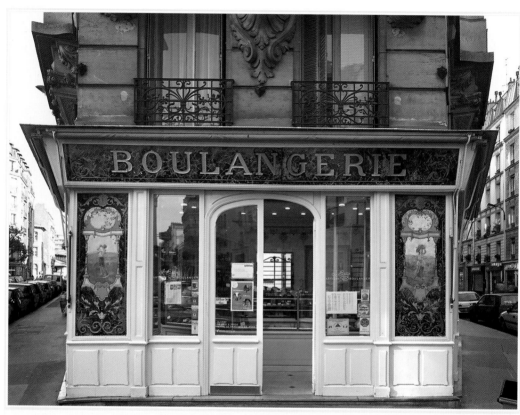

363

Jacques Bazin

85 BIS, RUE DE CHARENTON AT RUE EMILIO CASTELAR

1906, T. LUC, DECORATION

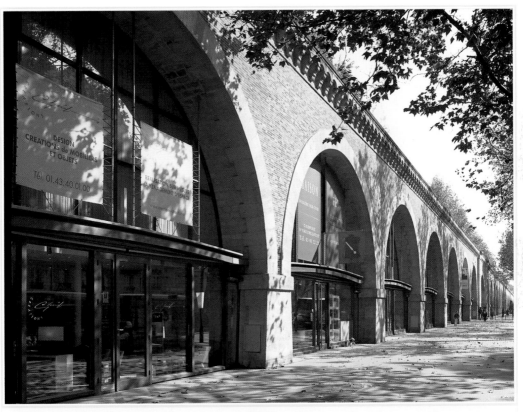

364

Le Viaduc des Arts

9–129, AVENUE DAUMESNIL

1855, CONSTRUCTION OF THE VIADUCT; 1994–95, PATRICK BERGER, RESTORATION; PHILIPPE MATHIEUX, PARK ABOVE

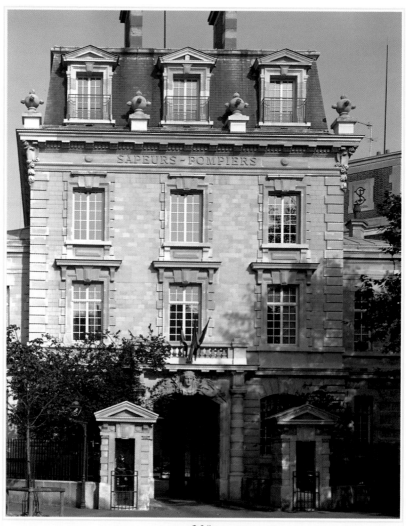

365

Caserne de Reuilly

75, BOULEVARD DIDEROT AT 26, RUE DE CHALIGNY

1885, CHARLES ROUSSI

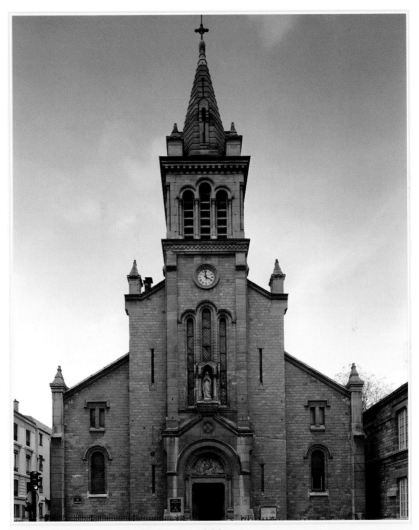

366

Église de l'Immaculée-Conception

34, RUE DU RENDEZ-VOUS AT RUE MARSOULAN

1874–75, EDOUARD DELABARRE DE BAY; 1994, INSIDE RESTORATION

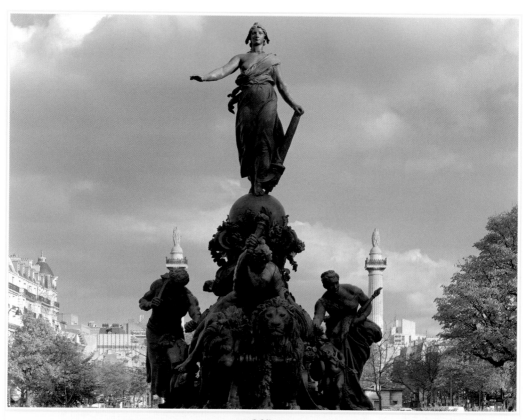

367

Place de la Nation (Tollhouse)

PLACE DE LA NATION

1785–87, CLAUDE-NICOLAS LEDOUX

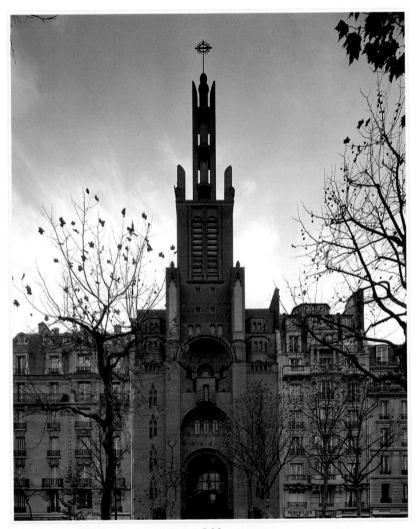

368

Église du Saint-Esprit

186, AVENUE DAUMESNIL AT RUE DE CANNEBIÈRE

1928–35, PAUL TOURNON

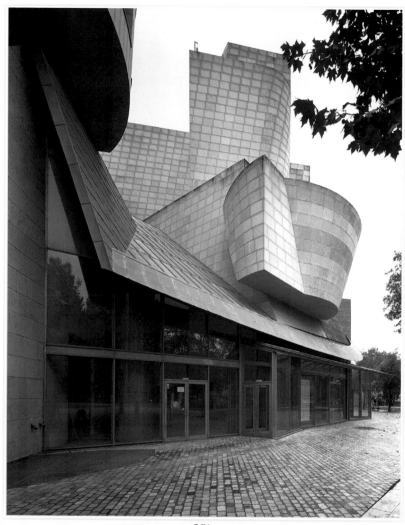

371

Former American Center

51, RUE DE BERCY

1994, FRANK GEHRY; 2003, DOMINIQUE BRARD, INTERIOR CONVERSION

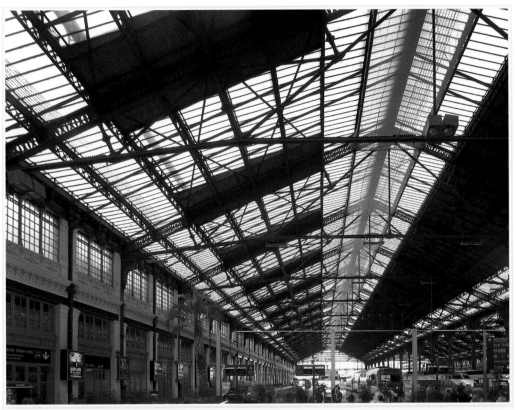

372

Gare de Lyon

20, BOULEVARD DIDEROT AT PLACE LOUIS ARMAND

1895–1902, MARIUS TOUDOIRE

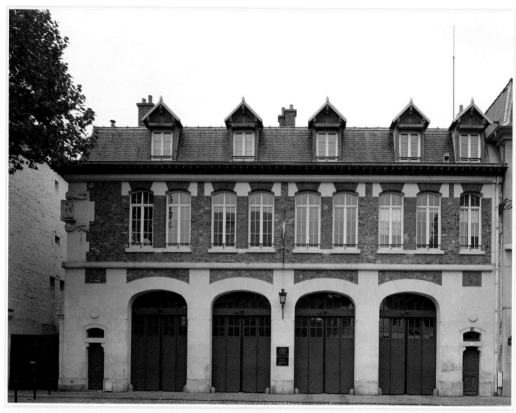

373

Firehouse

5, PLACE LACHAMBEAUDIE AT RUE DU BARON LEROY

C. 1880

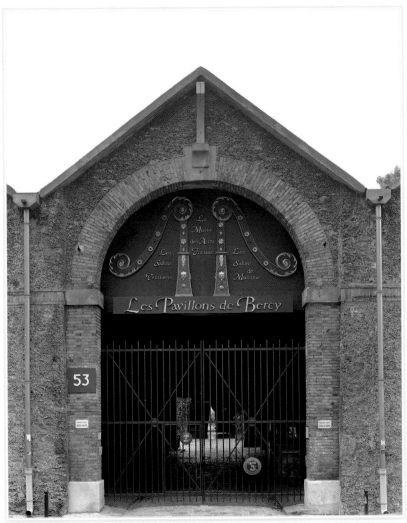

374

Pavillons de Bercy

53, avenue des Terroirs-de-France, between quai de Bercy and rue du Baron Le Roy

1886, Ernest Lheureux

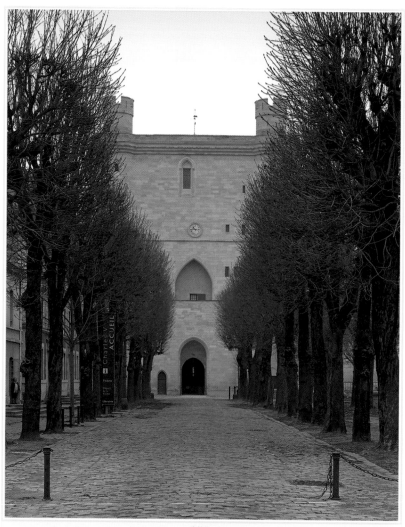

375

Enceinte du château

GROUNDS OF CHATEAU DE VINCENNES

1373—80

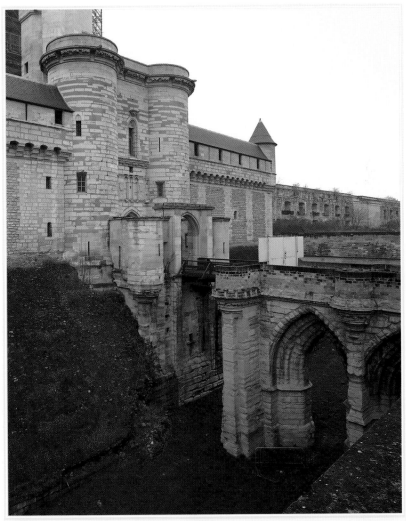

376

Donjon

GROUNDS OF CHÂTEAU DE VINCENNES

1336–70

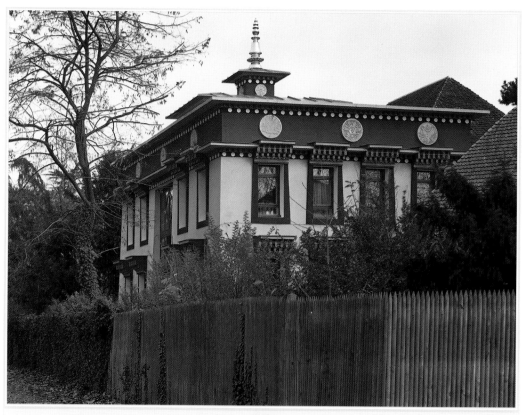

377
Institut Bouddhique

40, ROUTE DE CEINTURE DU LAC DAUMESNIL

1931, LOUIS-HIPPOLYTE BOILEAU AND LÉON CARRIÈRE

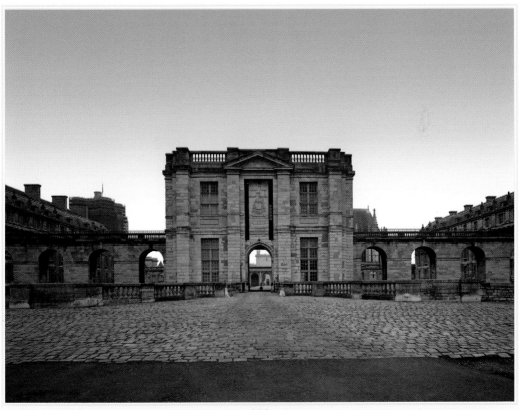

378

Château de Vincennes

AVENUE DE PARIS, VINCENNES

1336–40, PHILIPPE VI, TOWER; 1361–64, JEAN LE BON II, CONTINUATION; 1364–70, CHARLES V (THE KING WAS A BIT OF AN ARCHITECT)
AND HIS ARCHITECTS FINISHED THE TOWER; 1373–80, WALL AROUND; 1379–1552, RAYMOND DU TEMPLE, CHAPEL; 1654–58, LOUIS LE VAU,
PAVILLONS DU ROI AND DE LA REINE; 1945, JEAN- MARIE TROUVELOT, RESTORATION

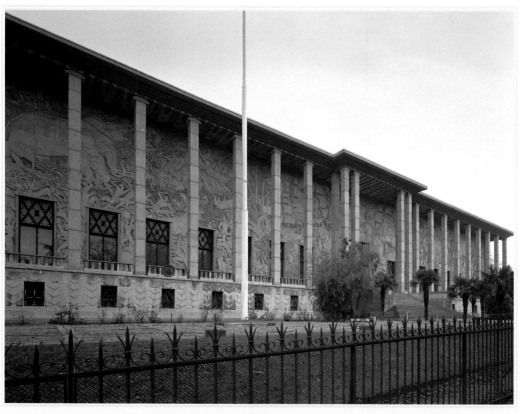

379
Musée des Arts d'Afrique et d'Océanie

293–295, avenue Daumesnil, at place Edouard Renard and avenue Armand Rousseau

1928–31, Albert Laprade and Léon Jaussely

13ᵀᴴ ARRONDISSEMENT

When Victor Hugo described this area in *Les Misérables* as ugly and sinister, it was not yet the high-rise wasteland it was to become in the 1960s and '70s. From the mid-fifteenth century, the old Gobelins dyeing workshops created tapestries for the royal court and the aristocracy, and dominated the vicinity of Place d'Italie. Although the company is still in business, their dyes and the waste from their tanneries, textile mills, breweries, and other factories severely polluted the river Bièvre, a branch of the Seine. By 1860, when the 13ᵗʰ arrondissement was annexed to the city, the entire district was quite squalid.

In a twentieth-century attempt to reinvigorate and modernize this lost district, the city paved over the river, destroyed old structures, and went on a spree of building massive apartment complexes. The area began to attract Asian immigrants and today is home to the largest "Chinatown" in Paris. Despite the clunky apartment towers, there are still pockets of cobblestone charm. Stucco houses and rambling gardens come into view on back streets where young artists have taken up residence. In an effort to revive this diverse arrondissement, city officials designated the 13ᵗʰ as the site for the high-tech Bibliothèque Nationale de France, constructed in the 1990s.

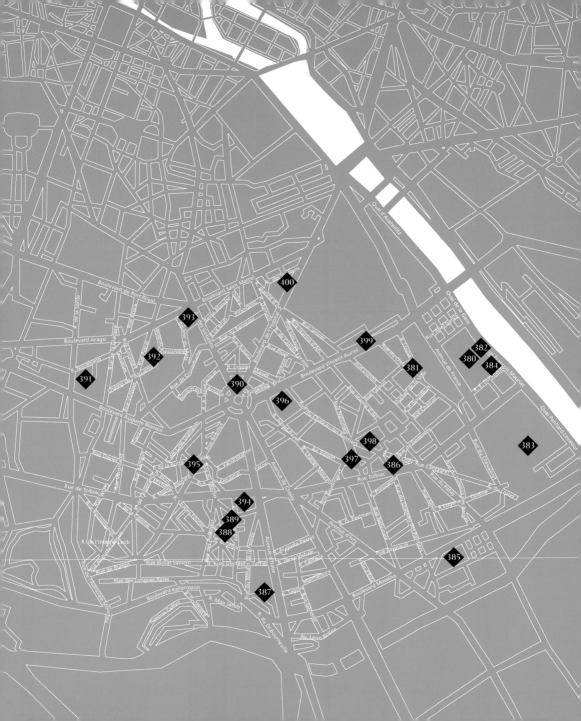

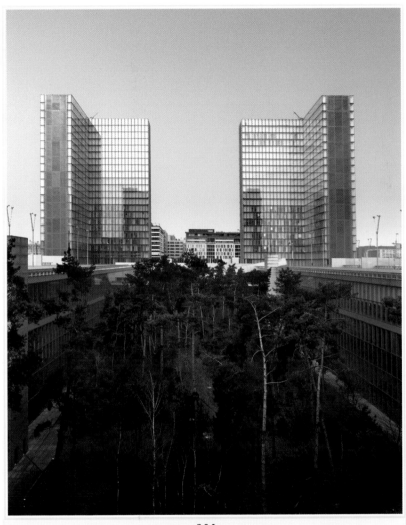

380

Bibliothèque Nationale François-Mitterrand *(Bibliothèque Nationale de France)*

11, QUAI FRANÇOIS-MAURIAC AT AVENUE DE FRANCE

1993—97, DOMINIQUE PERRAULT

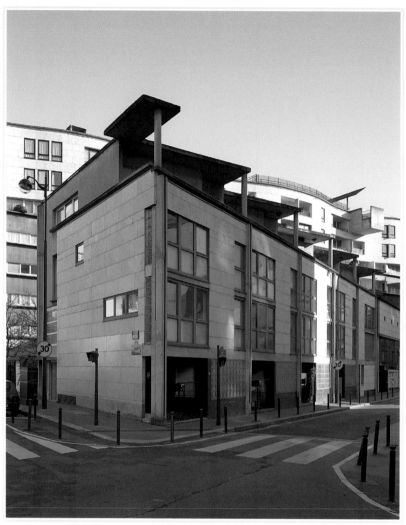

381

112, rue du Chevaleret

At 3, rue Louise Weiss

1990, Edith Girard

382

Batofar (Former lighthouse boat)

11, QUAI FRANÇOIS-MAURIAC, BETWEEN PONT DE BERCY AND PONT DE TOLBIAC

1999

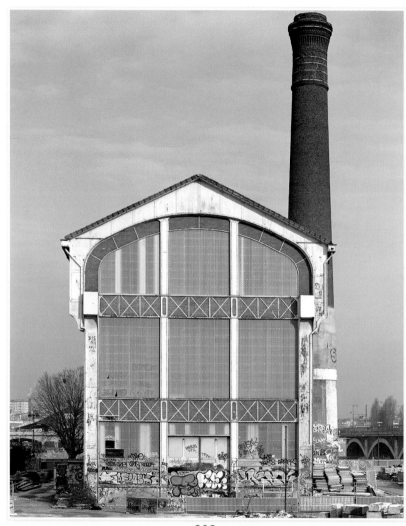

383

Distribution d'air comprimé

3–13 QUAI PANHARD-ET-LEVASSOR

1890–91, JOSEPH LECLAIR, ENGINEER

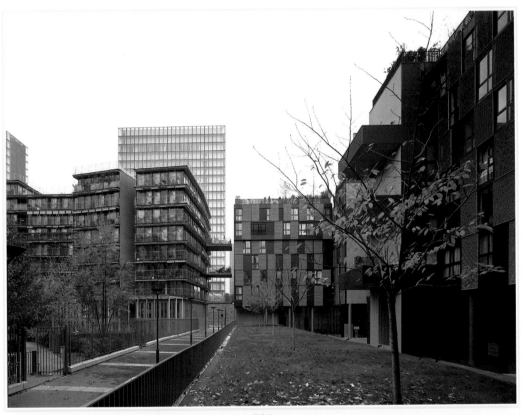

384

3, quai François Mauriac

AT RUE EMILE DURKHEIM

1997, PHILIPPE GAZEAU

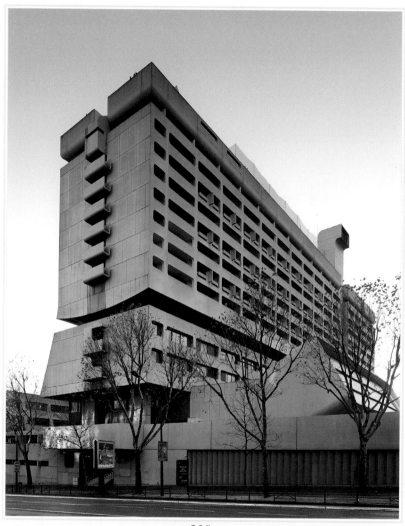

385

Caserne de Pompiers (Fire Station)

16, AVENUE BOUTROUX AND 37, BOULEVARD MASSÉNA

1971, JEAN WILLERVAL AND PRVOSLAV POPOVIC

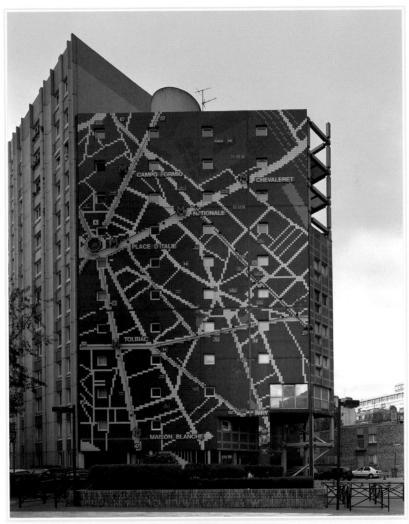

386

106, rue du Château-des-Rentiers

AT RUE JEAN-COLLY

1987, ARCHITECTURE STUDIO (M. ROBAIN, J.-F. GALMICHE, R. TISNADO AND J.-F. BONNE)

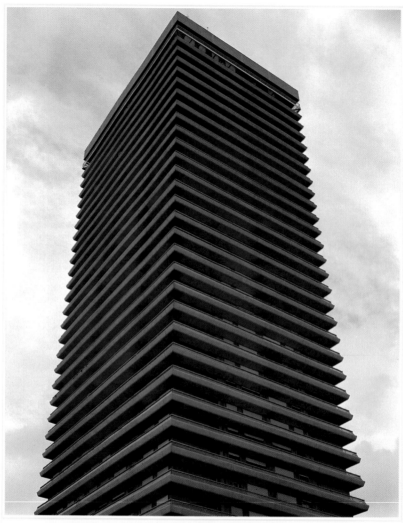

387

Tour Chambord

22, BOULEVARD KELLERMAN AT RUE DU COLONEL DOMINE

1975, MIKOL, HOLLEY AND BROWN-SARDA

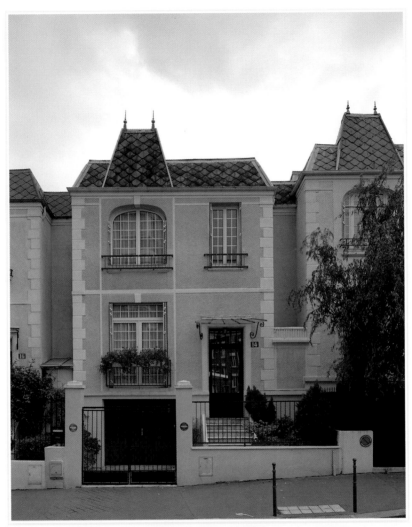

388
Rue du Docteur Leray and rue Dieulafoy

1921, Henri Trésal

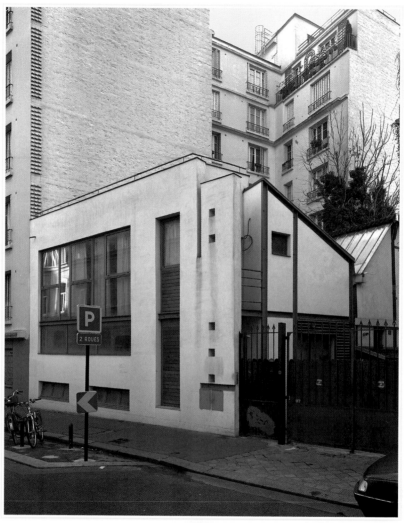

391

Cité Verte

147, RUE LÉON-MAURICE NORDMANN, BETWEEN RUE DE LA SANTÉ AND RUE DE LA GLACIÈRE

1983

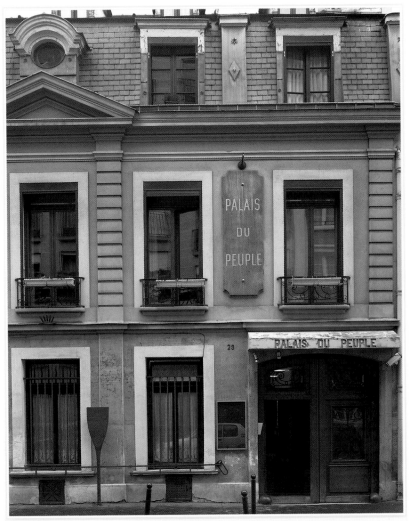

392

Armée du Salut, Palais du Peuple

29, RUE DES CORDELIÈRES AT RUE CORVISART

393

Hôtel de la Reine-Blanche

17–19, RUE DES GOBELINS AT RUE GUSTAVE-GEOFFROY AND RUE DE LA REINE-BLANCHE

SECOND HALF OF FIFTEENTH CENTURY; C. SIXTEENTH CENTURY; C. SEVENTEENTH CENTURY, EIGHTEENTH CENTURY;
2002, DOMINIQUE HERTENBERGER AND JACQUES VITRY

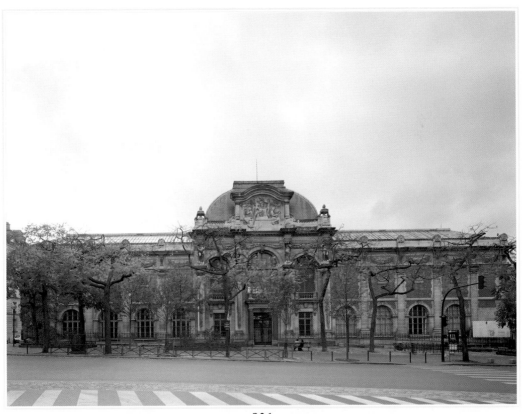

394

Gobelins Manufactory

42, AVENUE DES GOBELINS AT RUE CROULEBARBE AND RUE BERBIER-DU-METS

1447, JEAN GOBELIN, FIRST WORKSHOPS; 1607, INSTALLATION OF NEW DYER; 1662, MANUFACTURE OF GOBELINS, BY COLBERT; 1723, JACQUES GABRIEL V, CHAPEL;
1870, FRANÇOIS CHABROL, NEW CONSTRUCTION; 1894, JEAN-PAUL AUBE, NEARBY STATUE OF COLBERT;
1912–19, JEAN-CAMILLE FORMIGÉ AND LEON JAUSSELY, MUSEUM AT THE AVENUE JEAN-ANTOINE INJALBERT, CARYATIDS, AND PAUL LANDOWSKI, HIGH-RELIEF SCULPTURE

395

Piscine de la Butte-aux-Cailles *(Swimming Pool)*

5, PLACE PAUL VERLAINE AT RUE DE LA BUTTE AUX CAILLES

1924, LOUIS BONNIER AND FRANÇOIS HENNEBIQUE; 1991, JOHANNA FOURQUIER, RESTORATION

396

Immeubles cruciformes

205, BOULEVARD VINCENT-AURIOL AT 17, RUE ALBERT-BAYET

1970, A. ASCHER, G. BROWN-SARDA, D. MIKOL, AND J. CHAILLET

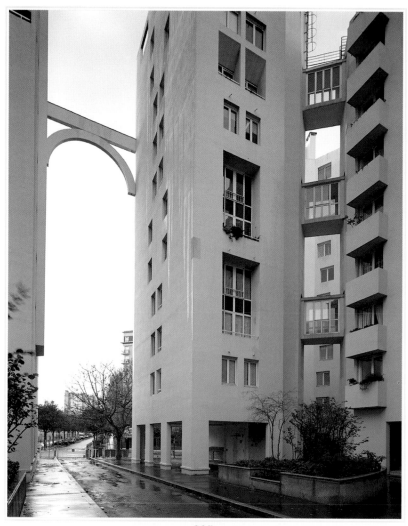

397

Rue des Hautes-Formes

BETWEEN RUE NATIONALE AND RUE BAUDRICOURT

1979, CHRISTIAN DE PORTZAMPARC AND GIORGIA BENAMO

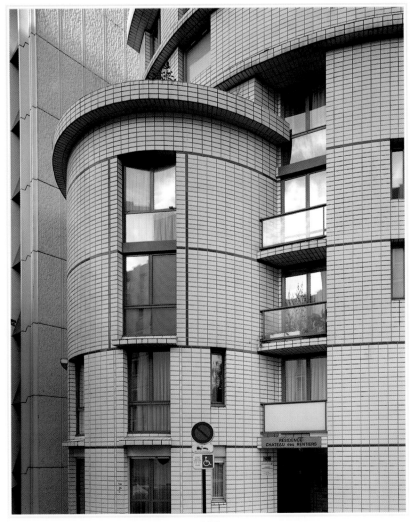

398

Foyer de Personnes Agées (Home for the Elderly)

120, RUE DU CHÂTEAU-DES-RENTIERS

1984, CHRISTIAN DE PORTZAMPARC

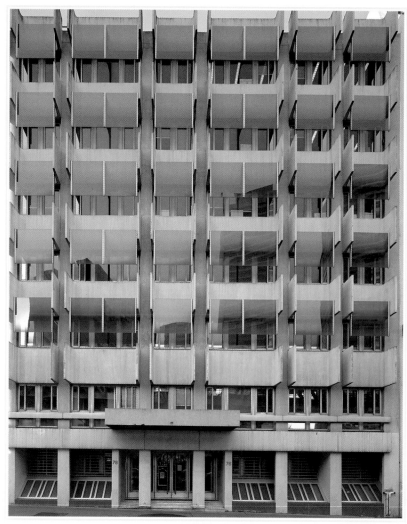

399

Immeuble d'Habitation

76–78, BOULEVARD VINCENT-AURIOL, BETWEEN RUE JENNER AND RUE BRUANT

C. 1970

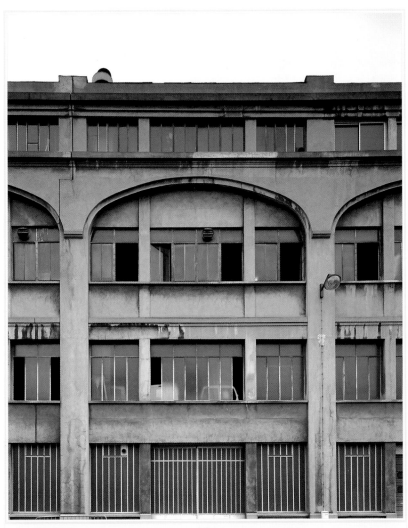

400
Ateliers de Reparation
9, RUE DES WALLONS AT BOULEVARD DE L'HÔPITAL

1919, ACHILLE CHAMPY

14ᵀᴴ ARRONDISSEMENT

Legions of artists, writers, and musicians have stirred passions in this residential quarter since the nineteenth century. The likes of Balzac and Chateaubriand gave way to Picasso, Modigliani, Man Ray, and a host of others in the early twentieth century. Now, boulevard Montparnasse stands as the quintessential symbol of this artistic and literary avant-garde scene, particularly at such notable surviving café-brasseries as La Coupole and Le Dôme. The boulevard also serves as the border to the 5th and 6th arrondissements, giving the 14th a stylish appeal by association.

Once an area of meadows and windmills, this area was incorporated into the city in 1860, when Haussmann plowed through Paris revamping its architecture. The district was largely spared that early restructuring, and remained a rural outpost with a maze of underground gypsum quarries that were later used as wine cellars for the cafés. Despite the gruesome Catacombs—where more than six million skeletons were deposited during the eighteenth century—and the Maine-Montparnasse project of 1960s that plunked a modern-day tower into the Paris skyline, the 14th arrondissement has retained a cozy, village atmosphere, with enclaves of artist studios and street markets. At the southern edge, Cité Universitaire and Parc Montsouris round out the district.

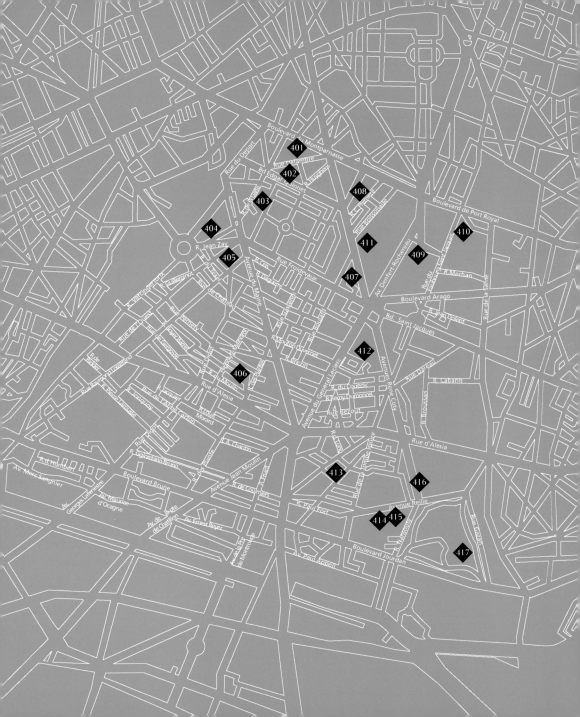

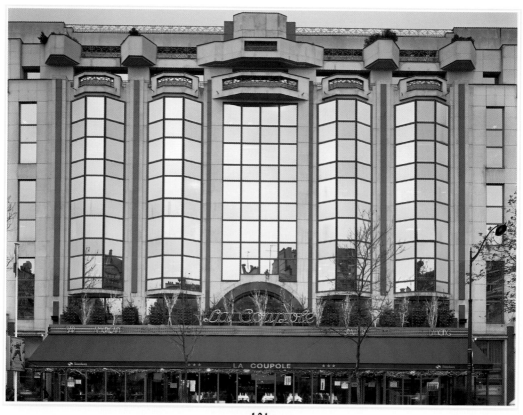

401

La Coupole

102, BOULEVARD DU MONTPARNASSE

1927, BARILLET AND LE BOUC, RESTAURANT; 1988, JEAN-LOUIS HANNEBERT, BUILDING RENOVATION

402

Café et Théâtre d'Edgar

58, BOULEVARD EDGAR-QUINET

1973, CAFÉ; 1975, THEATER

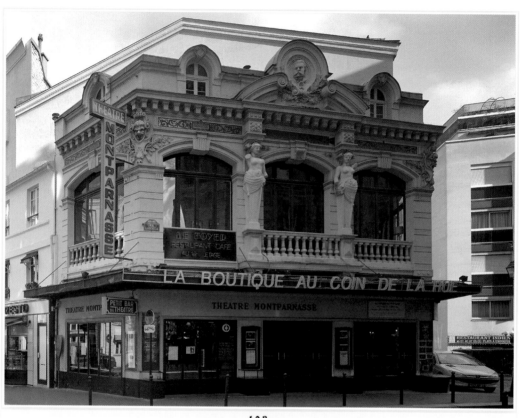

403

Théâtre Montparnasse

31, RUE DE LA GAÎTÉ AT THE CORNER OF RUE LAROCHELLE

1886, CONSTRUCTION

404

Hôtel Méridien Montparnasse

19, RUE DU COMMANDANT MOUCHOTTE AT PLACE DE LA CATALOGNE

1974, PIERRE DUFAU

407

École Spéciale d'Architecture

254–256, BOULEVARD RASPAIL AT RUE VICTOR SCHOELCHER

1805, EMILE TRELAT, ARCHITECT; 1988, CUNO BURLLMANN AND ARNAUD FOUGERAS-LAVERGNOLLE

408

31-31 Bis

31, RUE CAMPAGNE-PREMIÈRE AT BOULEVARD RASPAIL

1911, ANDRÉ ARFVIDSON

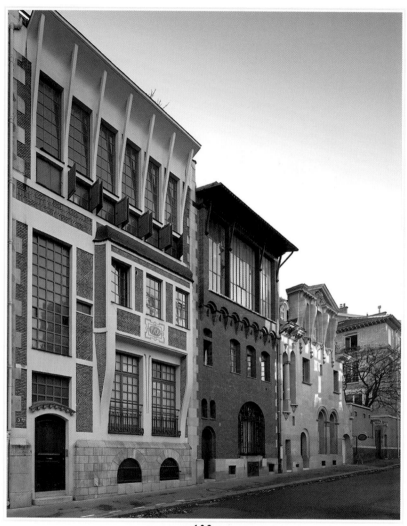

409

3–7 and 12, rue Cassini

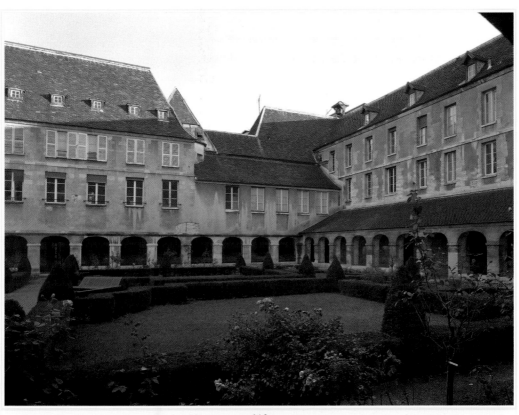

410

Abbey of Port-Royal

123–125, BOULEVARD DE PORT-ROYAL AT RUE DU FAUBOURG-SAINT-JACQUES

1648–53, ANTOINE LE PAUTRE

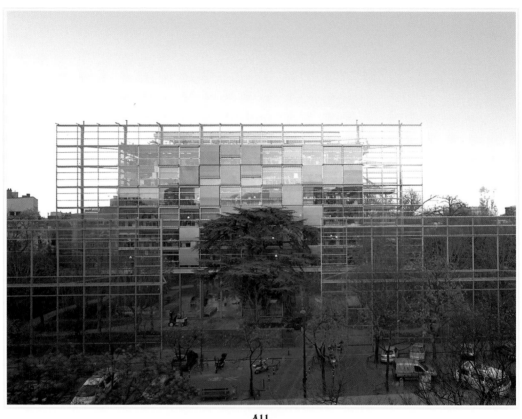

411

Fondation Cartier pour d'Art Contemporain

261, BOULEVARD RASPAIL AT RUE BOISSONADE

1992–94, JEAN NOUVEL

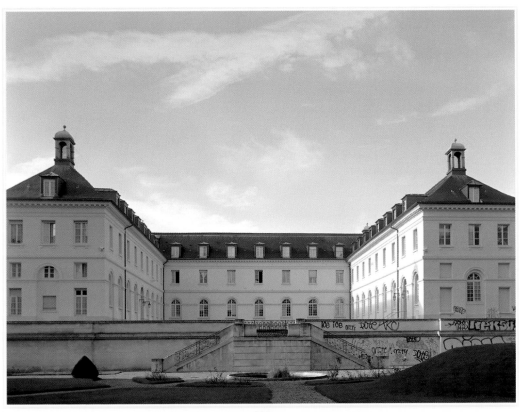

412

Hôpital La Rochefoucauld and Villa Adrienne

15, AVENUE DU GÉNÉRAL-LECLERC AT VILLA ADRIENNE

1781–83, JACQUES-DENIS ANTOINE; 1802, NICOLAS-MARIE CLAVAREAU, EXTENSION

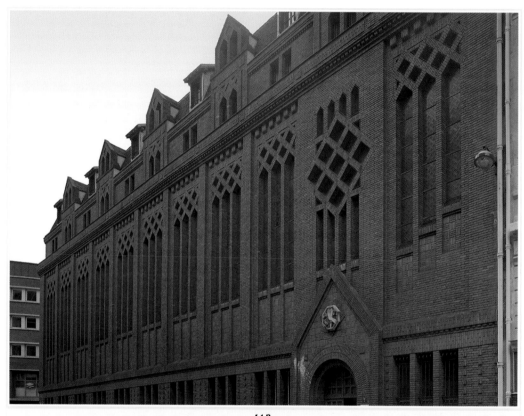

413

Couvent des Franciscains

7, RUE MARIE-ROSE AT RUE DU PÈRE CORENTIN

1930, BLAVETTE ET GÉLIS, PROJECT; 1934–38, HULOT AND GÉLIS, CONSTRUCTION

414

Ozenfant House and Atelier

53, AVENUE REILLE AT SQUARE MONTSOURIS

1922, LE CORBUSIER AND PIERRE JEANNERET; 1946, ALTERATION AT THE ROOF

415

Square Montsouris

BETWEEN AVENUE REILLE AND RUE NANSOUTY

1922, JACQUES BONNIER, ARCHITECTURAL PLANNER

416

Allée Samuel Beckett

At avenue Réne Coty

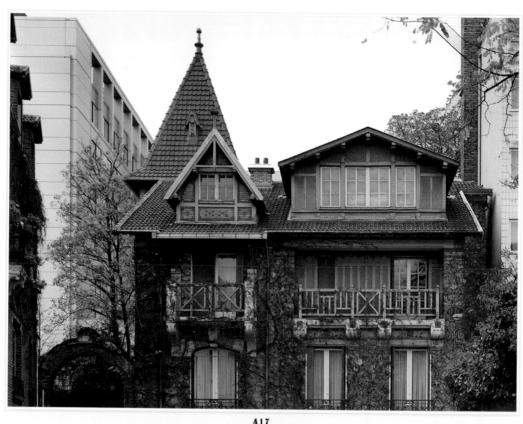

417

11, rue du Parc de Montsouris

BETWEEN AVENUE REILLE AND BOULEVARD JOURDAN

15TH ARRONDISSEMENT

In the Middle Ages, the Abbey of Saint-Germain-des-Près owned the villages of Vaugirard and Grenelle, the east and west sectors of today's 15th arrondissement. The monks tilled the productive pastures of Vaugirard, planting vineyards, but in time the less desirable Grenelle ground proved fertile for rapid factory growth. Once these factories were relegated to the suburbs, development during the 1960s left this former working-class area with a hodgepodge of old and modern architecture. One of the bright spots to replace former industry is the Parc André Citroën, located along the quai of the same name, which was built over an old auto-manufacturing plant. The construction of towers at quai de Grenelle, which has been created over landfill, contrasts with the Vaugirard quarter that benefits from its proximity to the swanky 7th arrondissement. In front of quai de Grenelle, a miniature version of the Statue of Liberty, placed at the edge of Île aux Cygnes for the 1937 World's Fair, looks west to its grand New York sister.

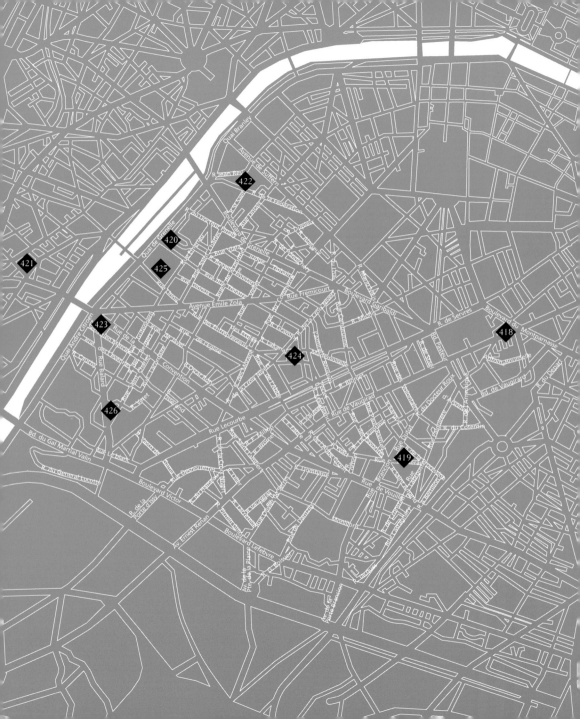

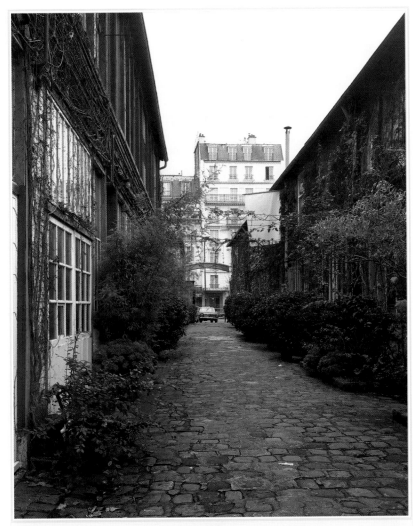

418
Musée du Montparnasse

21, AVENUE DU MAINE AT BOULEVARD DU MONTPARNASSE

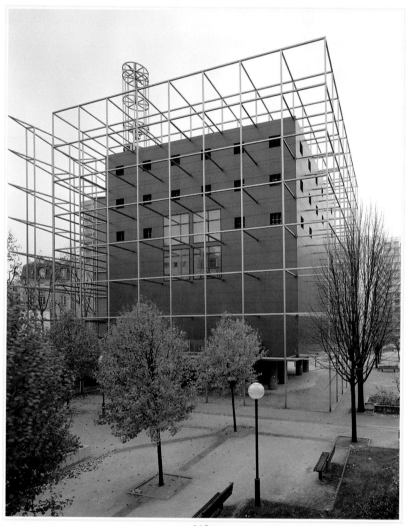

419

Notre-Dame de l'Arche d'Alliance

81, RUE D'ALLERAY

1998, ARCHITECTURE STUDIO

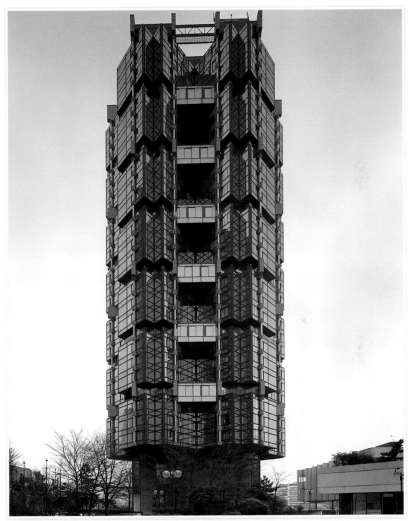

420

Tour Totem

55, QUAI DE GRENELLE, FRONT DE SEINE AT RUE DU THÉÂTRE

1978, PIERRE PARAT AND MICHEL ANDRAULT, TOWER

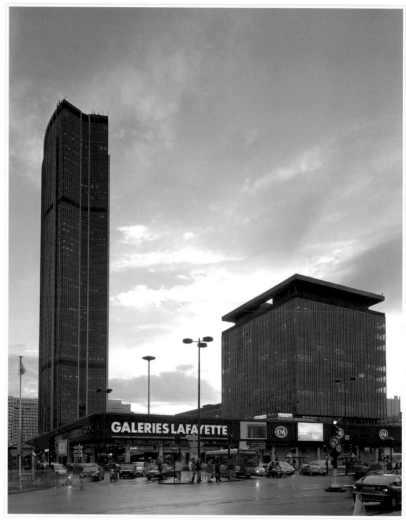

421

Tour Montparnasse

PLACE RAOUL DAUTRY/MAINE-MONTPARNASSE COMPLEX, BETWEEN RUE DU DÉPART AND RUE DE L'ARRIVÉE

1973, EUGÈNE BEAUDOUIN, URBAIN CASSAN, LOUISE DE MARIEN, AND JEAN SAUBOT

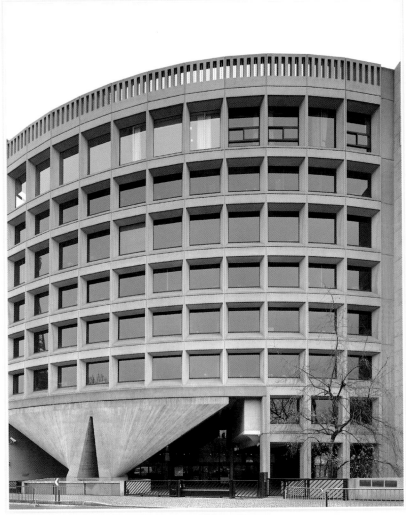

422

Ambassade d'Australie

4, RUE JEAN REY, BETWEEN PLACE DE KYOTO AND AVENUE DE SUFFREN

1973–77, HARRY SEIDLER, PETER HIRST, MARCEL BREUER, AND PIER-LUIGI NERVI

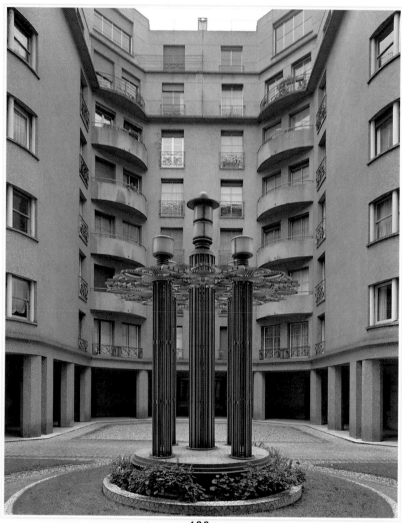

423

2–4, rue de la Convention and
7, rond-point du Pont-Mirabeau

AT RUE BALARD

1930–32, JOSEPH BASSOMPIERRE, PAUL DE RUTTÉ AND PAUL SIRVIN

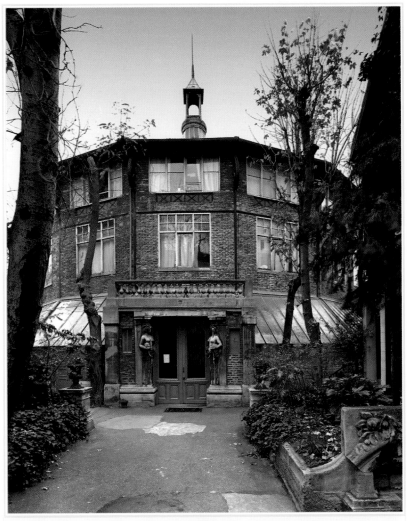

424

La Ruche

2, PASSAGE DE DANTZIG AT RUE DE DANTZIG

1900–02, GUSTAVE EIFFEL, ROTUNDA STRUCTURE

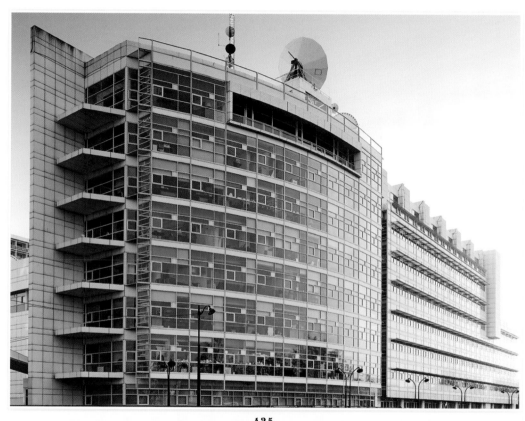

425
Siège de Canal Plus (Headquarters)

85, QUAI ANDRÉ-CITROËN AT 2, RUE DES CÉVENNES

1991–92, RICHARD MEIER

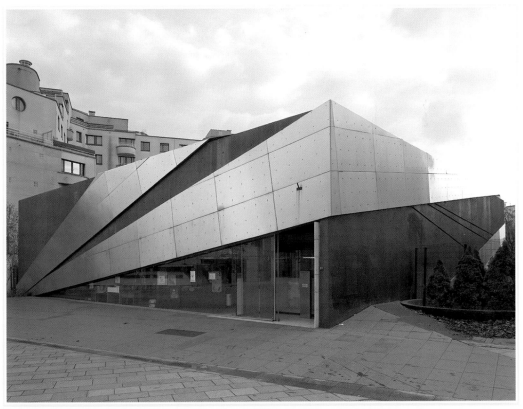

426

Bibliothèque municipale

8, RUE DE LA MONTAGNE D'AULAS/186 RUE SAINT-CHARLES

1990, FRANCK HAMMOUTÈNE

16ᵀᴴ ARRONDISSEMENT

Ooh, la, la, this is the arrondissement of wealth and luxury. If you live in the 16ᵗʰ arrondissement, you are surrounded by beautiful gardens, spacious apartments, and aristocratic sight lines from terraces. In short, this is the neighborhood of old money and new. Depending on your point of view, that's either fabulous or boring. Truth is, nothing much happens here and it's a distance from the heart of the frenetic city, save the traffic congestion around the Arc de Triomphe that stands at the arrondissement's northern perimeter. Located at the far western edge of Paris, it is bordered by the lush Bois de Boulogne, where Napoléon III hunted and carved out waterfalls, lakes, and gardens for Parisians' daytime pleasure. At night, however, in spite of the efforts by local law enforcement, these woods transform into a playground for transvestites and prostitutes. Modern influences of architects Mallet-Stevens and Le Corbusier are evident in the posh Passy quarter, where American statesman Benjamin Franklin lived for ten years. The lively but civil rue de Passy, which has a market street atmosphere, borders this sector and the southern Auteuil neighborhood. Nearby, Trocadéro at Pont d'Iéna creates a lovely vista across the Seine to the Eiffel Tower. In Auteuil, the princely sports arena and the red clay of the Roland Garros tennis stadium provide athletic entertainment.

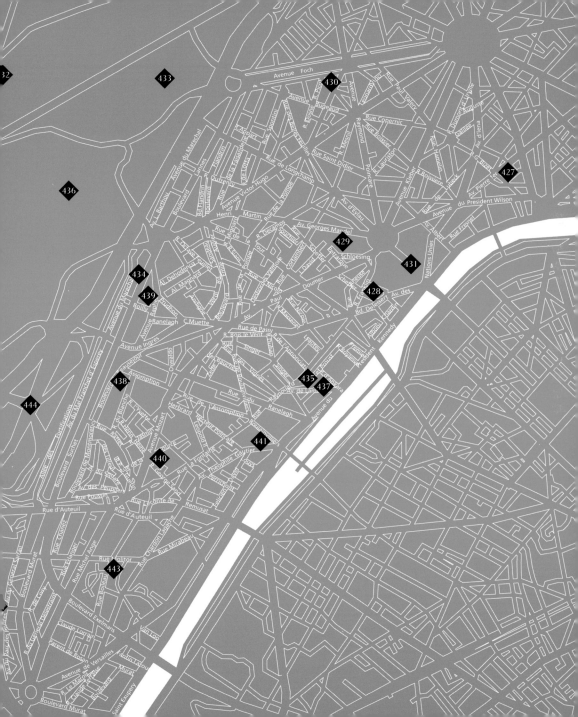

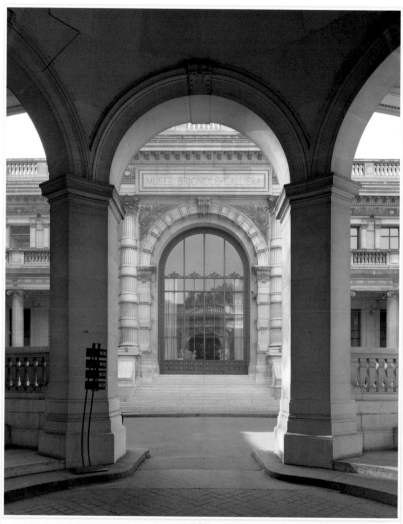

427

Musée Galliéra

10, AVENUE PIERRE-1ER-DE-SERBIE AT PLACE ROCHAMBEAU AND RUE FREYCINET

1878–94, LÉON GINAIN

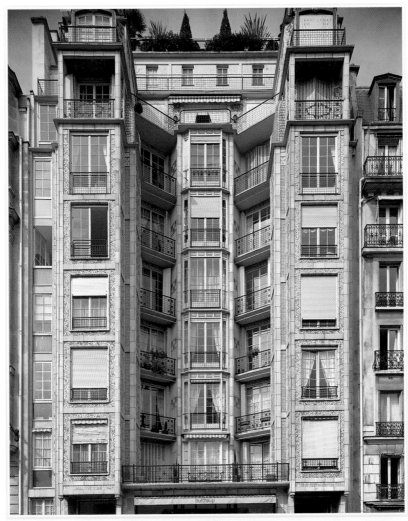

428

25 bis, rue Benjamin-Franklin

AT RUE SCHEFFER

1903–04, AUGUSTE PERRET AND GUSTAVE PERRET

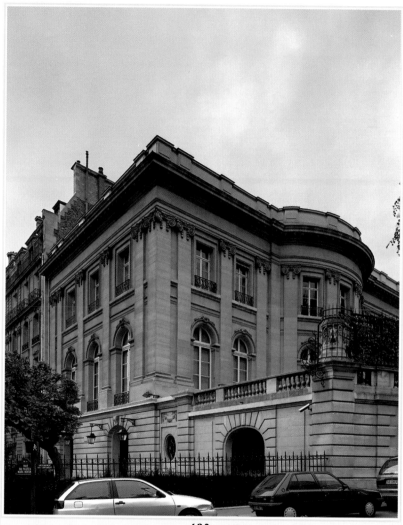

429
Fondation Singer-Polignac

43, AVENUE GEORGES-MANDEL AT RUE DU PASTEUR MARC BOEGNER

1904, HENRI GRANDPIERRE

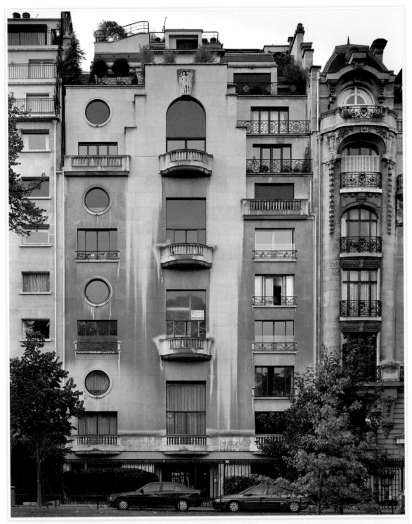

430

53, avenue Foch

At rue Picot

1939, Charles Abella

431

Palais de Chaillot *(Musée des Monuments Français/Musée de la Marine)*

One, place du Trocadéro et du 11-Novembre, at avenue de New York

1935–37, Léon Azéma, Louis-Hippolyte Boileau and Jacques Carlu

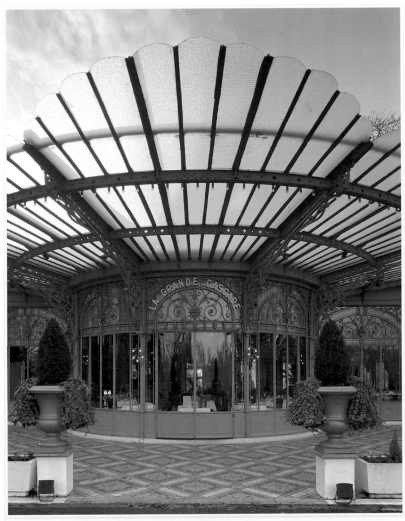

432

La Grande Cascade

ALLÉE DE LONGCHAMP, IN BOIS DE BOULOGNE

C. SECOND HALF OF THE NINETEENTH CENTURY, PAVILION; C. 1900, RESTAURANT

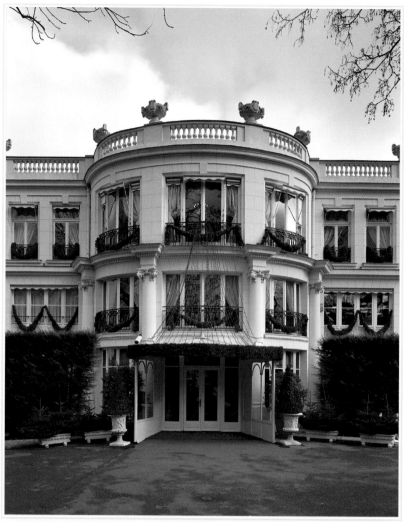

433

Le Pré Catelan

ROUTE DE SURESNES IN BOIS DE BOULOGNE

C. 1900; 1905 RESTAURANT OPENS

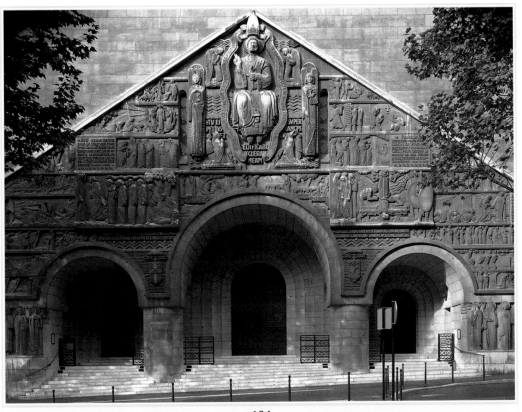

434

Église Saint-Pierre de Chaillot

33 avenue Marceau, between rue de Chaillot and avenue Pierre 1er de Serbie

1740 rebuilt, 1786 reinforced; 1931–1937, Emile Bois;
1931–1938, Emile Bois (architect); Bernard Lissalde, (architect); Henri Bouchard, (sculptor)

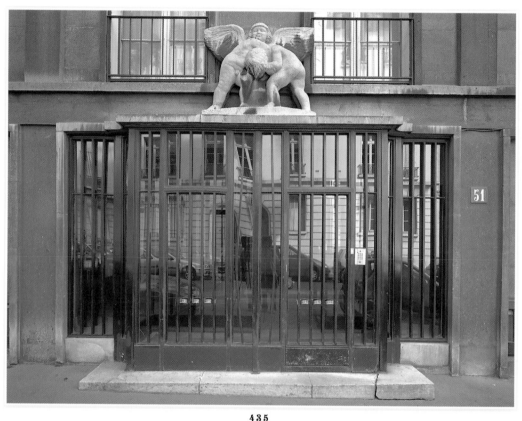

435

51–55, rue Raynouard

AT RUE BERTON

1929–32, AUGUSTE AND GUSTAVE PERRET

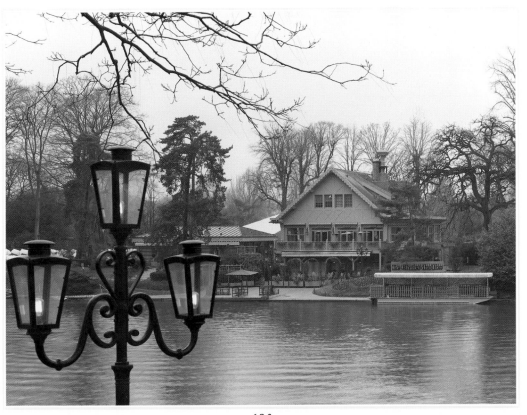

436

Le Chalet des Îles

LAC INFÉRIEUR, BOIS DE BOULOGNE

1894

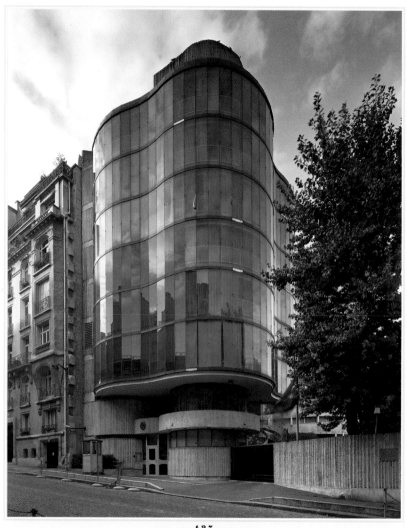

437

Ambassade de Turquie

16, AVENUE DE LAMBALLE AT RUE BRETON

1976, HENRI BEAUCLAIR, AND GRÉGORY AND SPILLMANN (ENGINEERS)

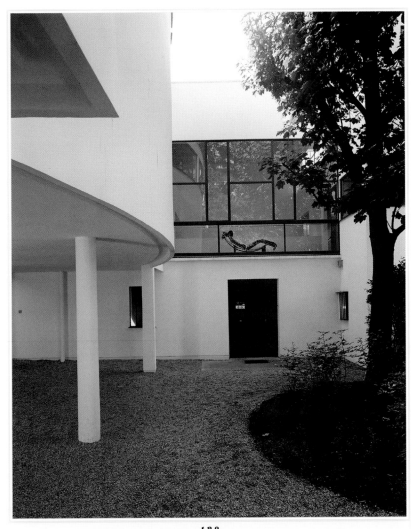

438

Villas La Roche et Jeanneret

8–10, SQUARE DU DOCTEUR-BLANCHE AT RUE DU DOCTEUR-BLANCHE

1924, LE CORBUSIER

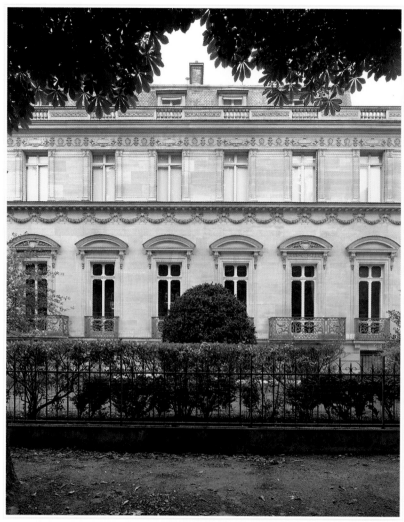

439

Musée Marmottan-Monet

2, RUE LOUIS-BOILLY AT AVENUE RAPHAËL

C. 1860, CONSTRUCTION OF THE HÔTEL; C. 1883, HEIGHTENED (RAISED EXTENSION);
C. 1913, WING AT THE STREET; C. 1970, JACQUES CARLU, PRESERVATION

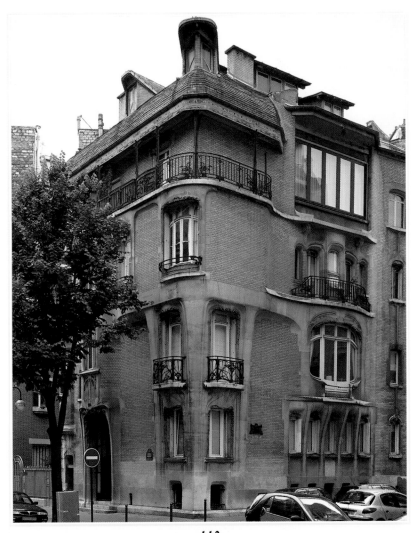

440

Hôtel Guimard

122, AVENUE MOZART AT AVENUE GEORGE SAND

1909–12, HECTOR GUIMARD

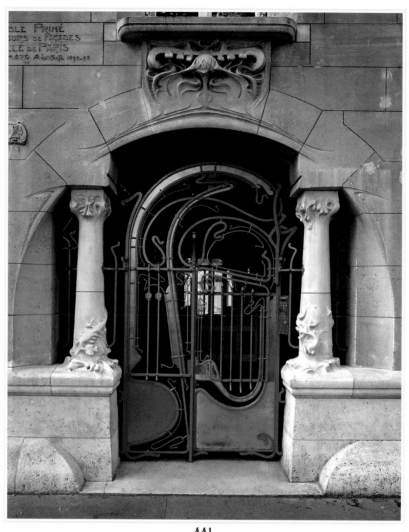

441

Castel Béranger

14–16, rue La Fontaine between rue Boulainvilliers and rue Gros

1896–98, Hector Guimard

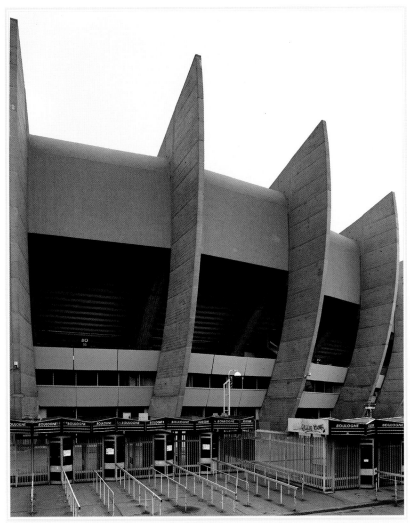

442

Le Parc des Princes

24, RUE DU COMMANDANT-GUILBAUD AT AVENUE DU PARC DES PRINCES AND RUE CLAUDE FARRÈRE

1971–72, ROGER TAILLIBERT

443

Laboratory Aérodynamique

67, RUE BOILEAU AT RUE DE MUSSET AND BOULEVARD EXELMANS

1911, GUSTAVE EIFFEL

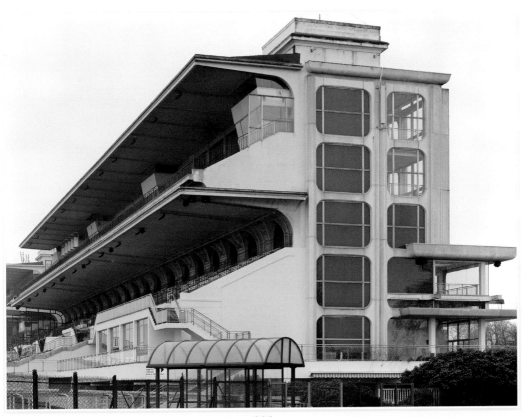

444

Hippodrome d'Auteuil

BOIS DE BOULOGNE

1873 CONSTRUCTION; 1924 REBUILT PARTLY; 1976 TRANSFORMATIONS, LIZERO, LERICHE, AND JEAN

17ᵀᴴ ARRONDISSEMENT

Divided into the villages of Ternes and Batignolles, the 17th arrondissement is a sleepy, residential area that was incorporated into Paris proper when Baron Haussmann was engineering the modernization of the city. In the second half of the nineteenth century, this area was part of that growth and creativity. The northwestern section of Ternes, next to the 16th arrondissement, developed into an upscale residential area with wide boulevards and imposing architecture, while the Batignolles section was home to city workers and the Impressionist painters.

Adjacent to the red-light district of Clichy in the 18th arrondissement, Batignolles sports an urban character. The tracks that extend from Gare Saint-Lazare slice through the narrower streets of this sector. Despite the cheap shops on boulevard Clichy, this quarter contains a few enclaves of charm: place du Docteur Félix Lobligeois, with its white chapel of Sainte-Marie-des-Batignolles; the market street of rue de Lévis; and Cité des Fleurs, which has pastel-stucco and sculpted-stone homes. The area also boasts the thriving Batignolles organic market.

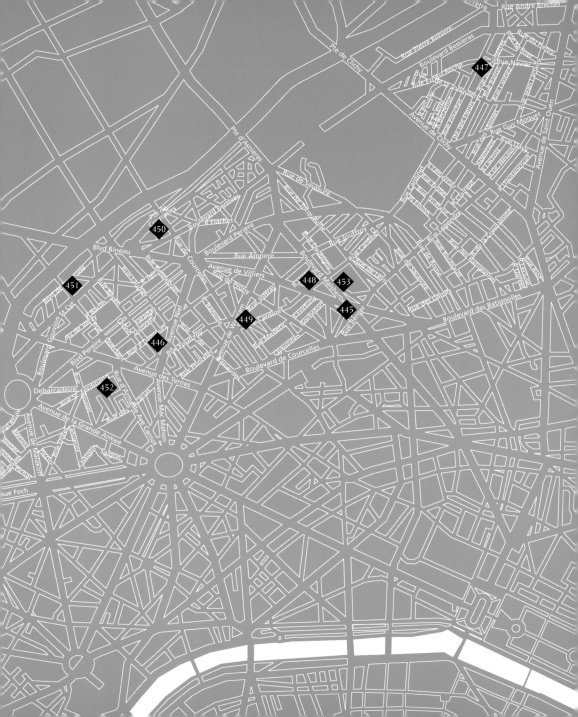

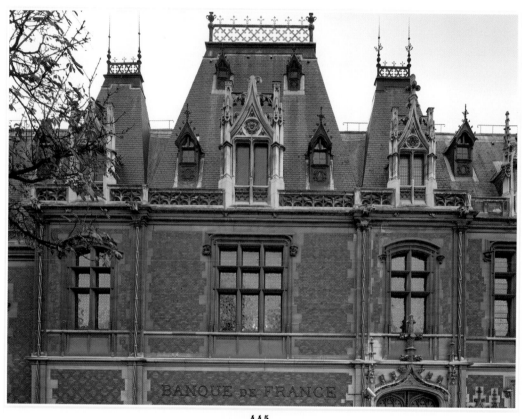

445

Hôtel Gaillard

ONE, PLACE DU GÉNÉRAL-CATROUX AT AVENUE DE VILLIERS

1878, VICTOR-JULES FÉVRIER

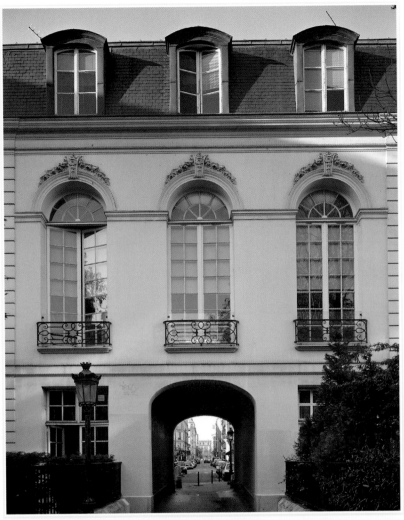

446

Château des Ternes

17—19, RUE PIERRE DEMOURS AT RUE BAYEN

1740; 1778, SAMSON-NICOLAS LENOIR, TRANSFORMATION

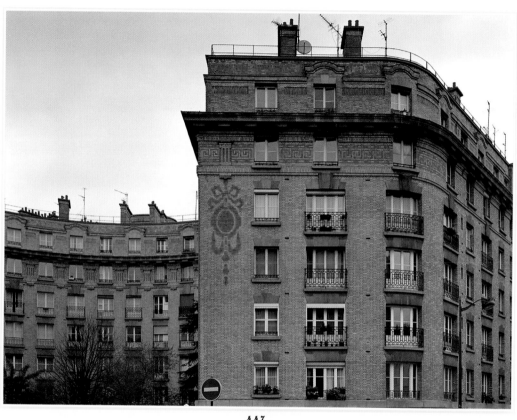

447

75, rue Pouchet

At 7 bis, rue Ernest Roche

1914–21, L. Chevallier

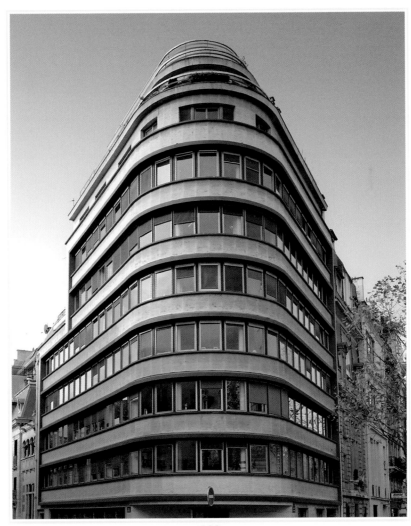

448

Immeuble Fortuny

37, RUE FORTUNY AT THE CORNER OF RUE FORTUNY AND AVENUE DE VILLIERS

1956, JEAN LEFEVRE AND JEAN CONNEHAYE

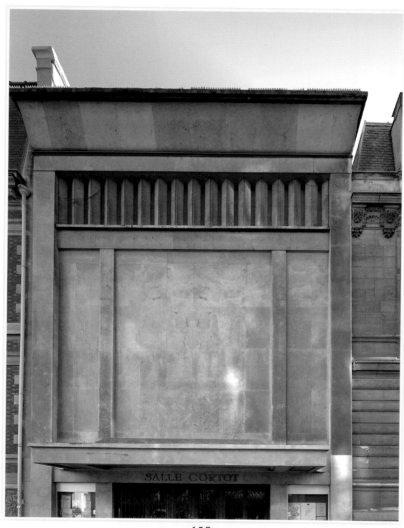

453
Ecole Normale de Musique de Paris

78, RUE CARDINET AT BOULEVARD MALESHERBES

1929, AUGUSTE AND GUSTAVE PERRET, SALLE CORTOT

18ᵀᴴ ARRONDISSEMENT

Long before the fictitious film character Amélie Poulain made Montmartre hip again, this picturesque neighborhood inspired artists of the nineteenth and early twentieth centuries. Picasso and many other painters, writers, and poets climbed the steps and made the cobblestone streets and hilly village their own community. But after inventing Cubism and Modern Art, they abandoned Butte Montmartre to the tourists who tote cameras up to record Sacré Cœur and its commanding views of Paris.

A workout to reach on foot, this spot was first discovered by the Druids. But there is more to the 18ᵗʰ arrondissement, beyond the touristy place du Tertre and place des Abbesses. The north side of the hill is quiet, with lovely residential streets, such as the tranquil cul-de-sac of Villa Leandre, the horseshoe-shaped streets of avenue Junot and rue Lepic, and the vine-covered rue des Saules. Filled with character and local color, the district stretches to include diverse neighborhoods: Markets around La Goutte d'Or and Chapelle offer a touch of north Africa, west Africa, Asia, and beyond. The calm market at rue Ordener caters to old-timers and young couples pushing strollers, while the action at the boulevard Barbès and the Marx Dormoy markets resembles the frenetic jumble of exotic lands. The 18ᵗʰ arrondissement also encompasses the famous antique and flea markets of Clignancourt and Saint-Quen. Architecturally, the old has managed to survive, even while the modern fills out the periphery.

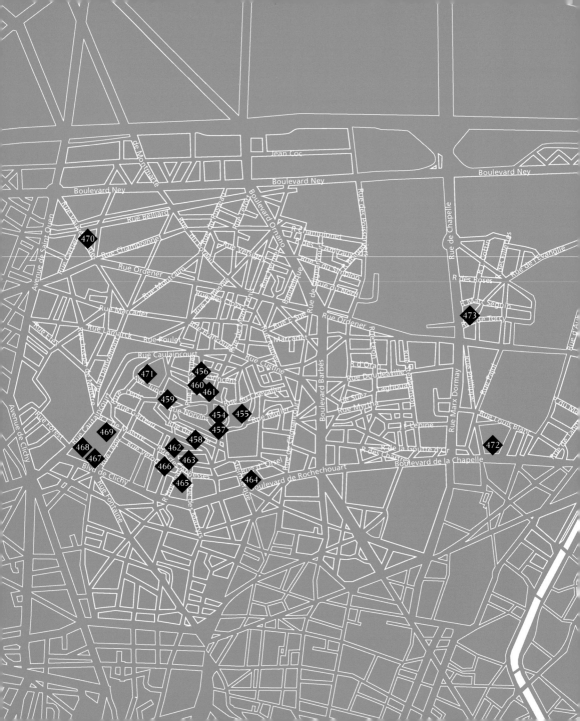

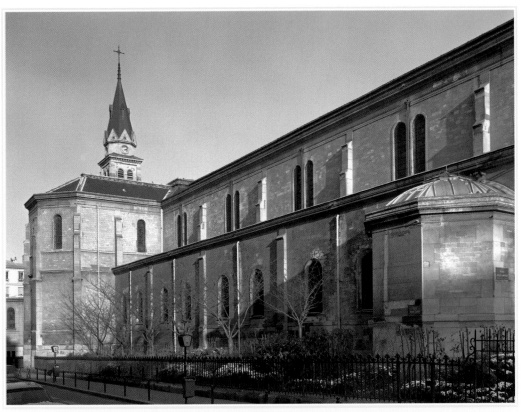

454

Église Saint-Pierre de Montmartre

2, RUE DU MONT-CENIS AT RUE NORVINS

1134–47, FIRST CONSTRUCTION; 1775, FAÇADE; 1900–05, LOUIS SAUVAGEOT

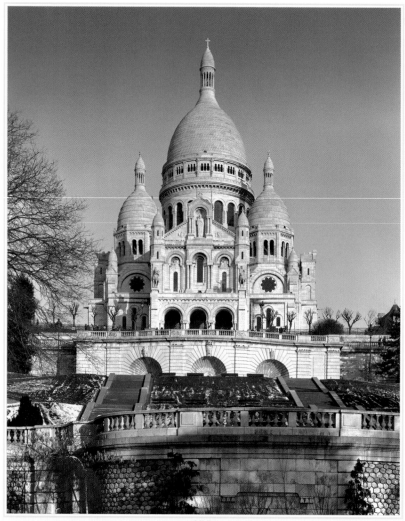

455

Basilique du Sacré-Cœur

PLACE DU SACRÉ-CŒUR AT SQUARE WILETTE

1877—84, PAUL ABADIE; 1884—1905, HERVÉ RAULINE; 1905—23, LUCIEN MAGNE, TOWER

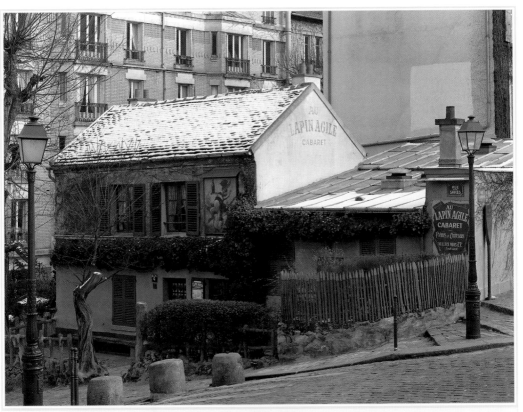

456

Au Lapin Agile

4, RUE DES SAULES AT RUE SAINT-VINCENT

C. 1860, BUILDING

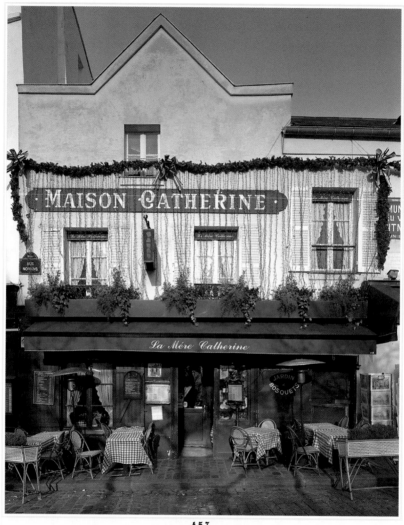

457

La Mère Catherine

6, PLACE DU TERTRE AT RUE NORVINS

1793

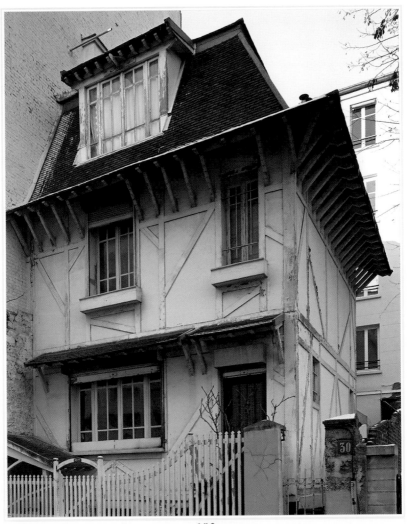

458

Maison particulière

BETWEEN PLACE JEAN-BAPTISTE CLÉMENT AND RUE DU CALVAIRE

1900

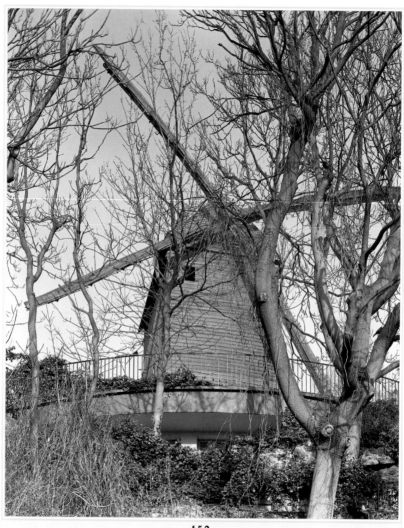

459

Moulin de la Galette

83, RUE LEPIC AT AVENUE JUNOT

C. 1620, MILL, REBUILT MANY TIMES; 1812, FARM

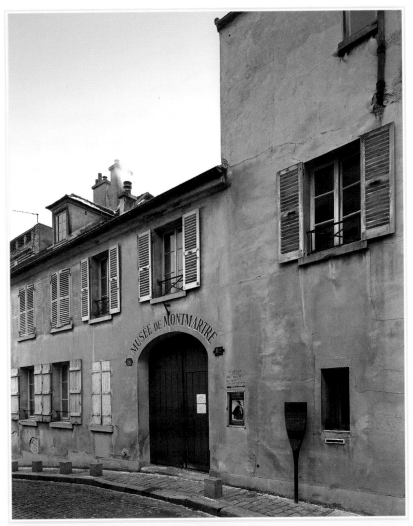

460

Musée de Montmartre

12, RUE CORTOT

C. MID—SEVENTEENTH CENTURY, HOUSE; 1922, CITY OF PARIS, RESTORATION;
1960, CREATION OF THE MUSEUM

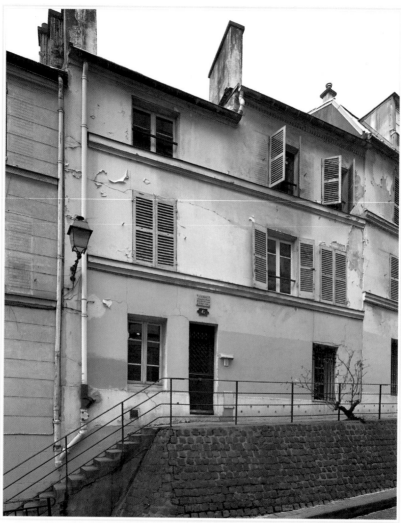

461

Musée-Placard d'Erik Satie

6, RUE CORTOT BETWEEN RUE DU MONT DENIS AND RUE DES SAULES

C. SEVENTEENTH CENTURY, THEN TRANSFORMED IN THE EIGHTEENTH CENTURY

462
Le Bateau-Lavoir

13, RUE RAVIGNAN PLACE EMILE GOUDEAU

1899, CONSTRUCTION OF WORKSHOPS; AFTER 1970, CLAUDE CHARPENTIER, REBUILT

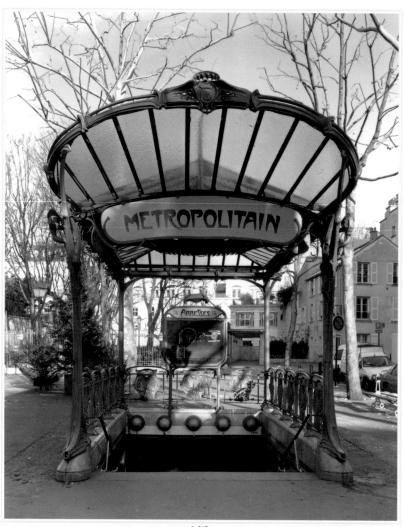

463
Abbesses Métro

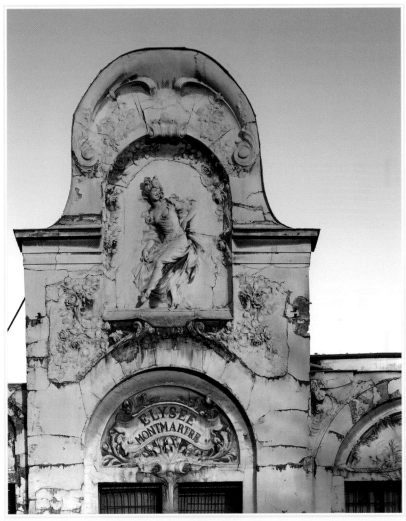

464
Elysée Montmartre

72, BOULEVARD ROCHECHOUART AT RUE STEINKERQUE

1858, DELALOT, CONSTRUCTION; 1893–97, ADDITION; 1908, RESTORATION

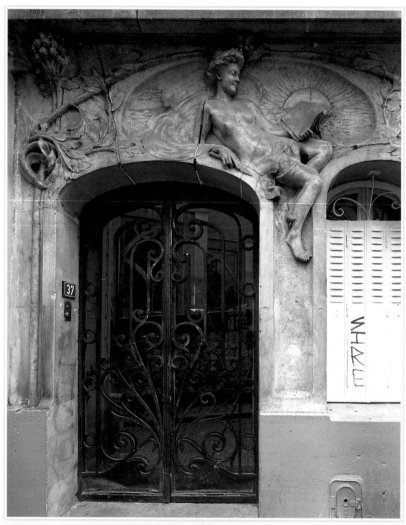

465

Théâtre-Libre de Montmartre

37, RUE ANDRÉ ANTOINE AT RUE VERRON

1887, FOUNDATION

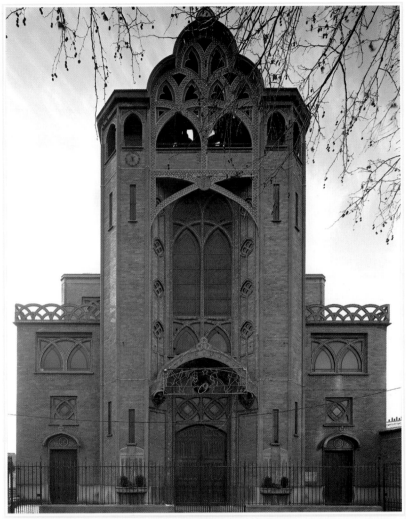

466
Église Saint-Jean-l'Évangéliste
19–21, RUE DES ABBESSES AT PLACE DES ABBESSES

1894–1904, ANATOLE DE BAUDOT

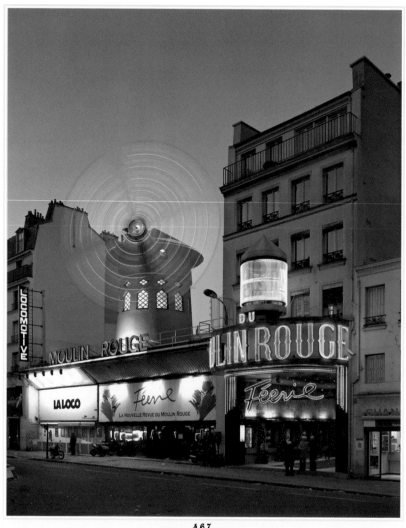

467

Moulin Rouge

82, BOULEVARD DE CLICHY AT RUE LEPIC

1889, CREATION

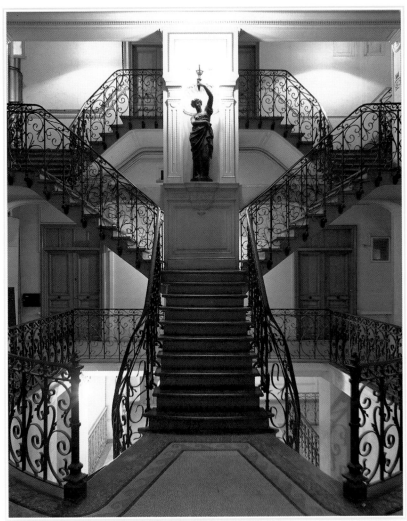

468

Villa des Arts

15, RUE HÉGÉSIPPE-MOREAU AT RUE ETIENNE JODELLE

1888–1900, HENRI CAMBON, BUILDINGS

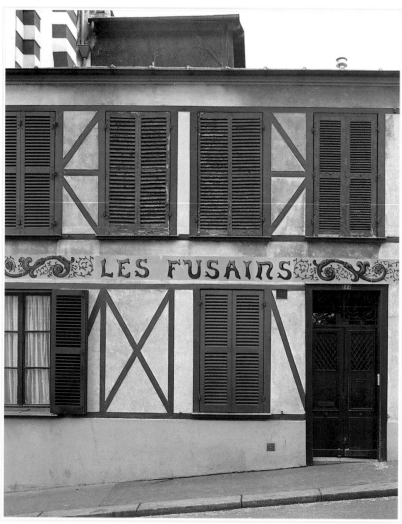

469

Villa des Fusains

22, RUE TOURLAQUE AT RUE JOSEPH DE MAISTRE

1889, BOURDEAU

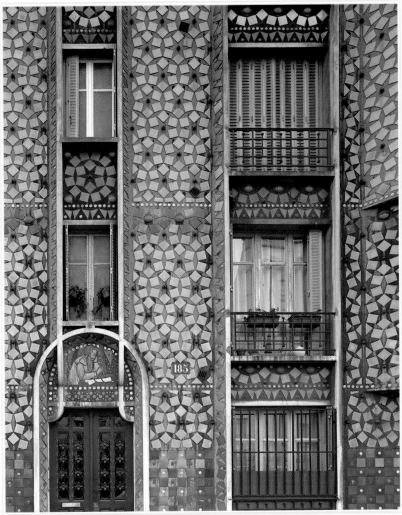

470

185, rue Belliard

AT RUE VAUVENARGUES

1913, HENRI DENEUX

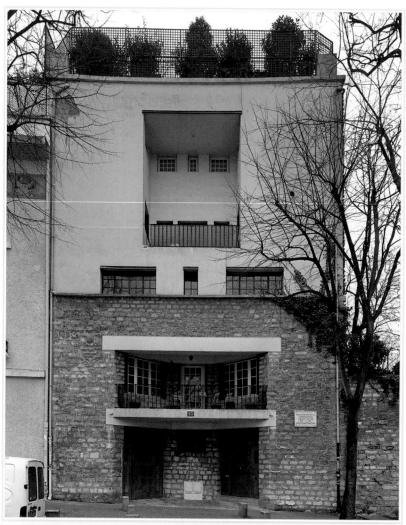

471

Maison Tzara

15, AVENUE JUNOT AT VILLA LÉANDRE

1926, ADOLF LOOS

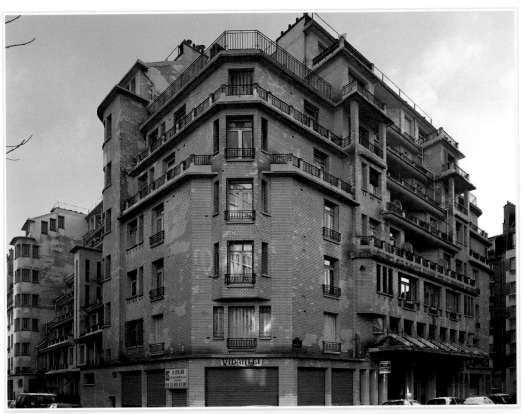

472
13, rue des Amiraux

NEAR MÉTRO SIMPLON, BETWEEN RUE DE CLIGNANCOURT AND RUE BOINOD

1922–27, HENRI SAUVAGE; 1930, SWIMMING POOL, HENRI SAUVAGE; 1982, SWIMMING POOL RECONSTRUCTION, DANIEL AND PATRICK RUBIN

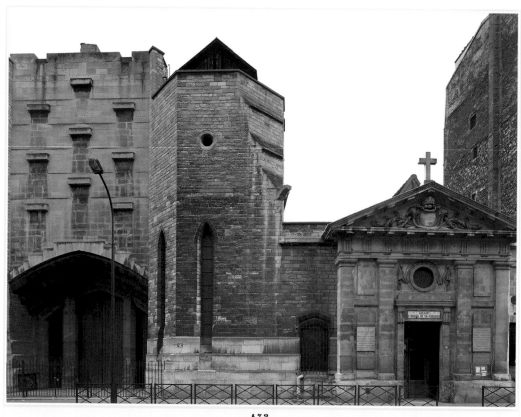

473

Saint-Denis-de-la-Chapelle with Basilica of Sainte-Jeanne-d'Arc

16, RUE DE LA CHAPELLE AT RUE DE TORCY

C. THIRTEENTH CENTURY, NAVE (CHURCH SAINT-DENIS-DE-LA-CHAPELLE); 1757, FAÇADE (CHURCH SAINT-DENIS-DE-LA-CHAPELLE);
1895, CHOIR (CHURCH SAINT-DENIS-DE-LA-CHAPELLE); 1933–54, JEAN-EMILE CLOSSON, THEN ISNARD, BASILICA

19ᵀᴴ ARRONDISSEMENT

Until the industrial nineteenth century laid waste to this once-rural hamlet outside the city walls, the river Ourcq flowed through meadowlands filled with vineyards, orchards, and fields of grain. In the early part of the nineteenth century, when Napoléon I decided to build beautiful fountains throughout Paris, the water's flow symbolizing the city's prosperity, he developed the Bassin de la Villette and the Canal de l'Ourcq, diverting the water from them to the Seine. Unfortunately, the waterways' strategic locations made them necessary conduits of the Industrial Revolution. By the time the plain of La Villette was annexed to Paris in 1860, docks and small industries had sprung up on the banks, and factories, tanneries, and refineries were dumping waste into the river, while smokestacks spewed filth into the air.

In 1867, the city's main abattoir (slaughterhouse) was located here as well. A hundred years later, the site was rejuvenated as a futuristic La Villette, with parkland, cultural venues, and museums. To the south, the magical, manmade Parc des Buttes Chaumont enchants visitors to the Buttes Chaumont quarter. Not far from the park, vine-covered mews on both sides of rue de Mouzaïa are lined with doll-sized cottages where workers used to live.

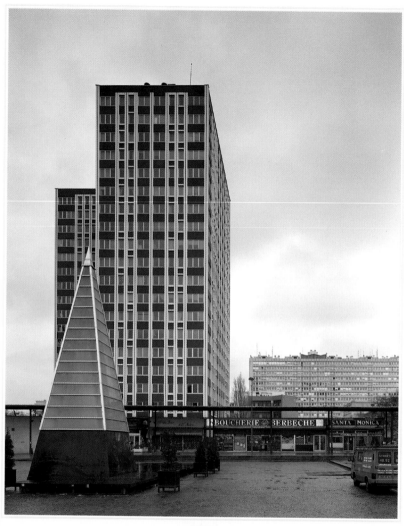

475

19, place des Fêtes

At rue de Crimée

1957, first urban planning; 1960–70, construction of the buildings;

1995–96, Bernard Huet, remodeling

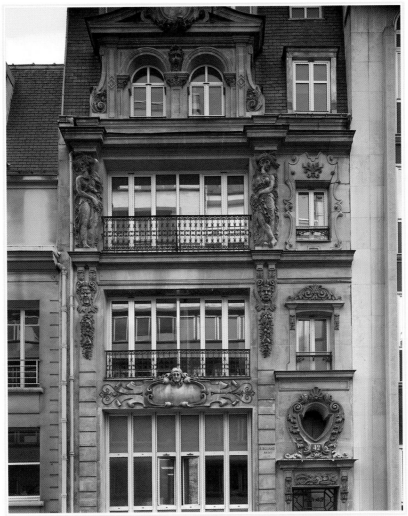

476

65–69, rue d'Hautpoul

AT RUE PETIT

c. 1890

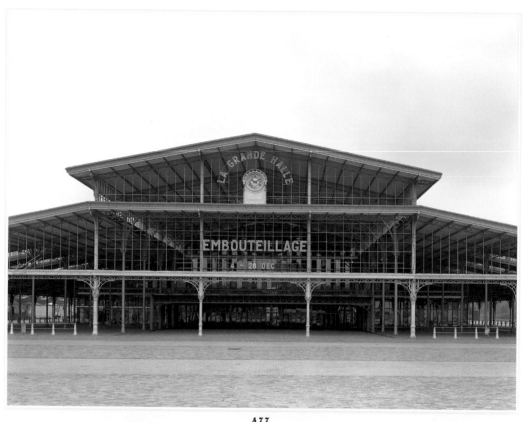

477

Grande Halle de la Villette

PLACE DE LA FONTAINE AUX LIONS IN PARC DE LA VILLETTE

1865—67, JULES DE MÉRINDOL AND LOUIS-ADOLPHE JANVIER; 1983—85, BERNARD REICHEN AND PHILIPPE ROBERT, RESTORATION

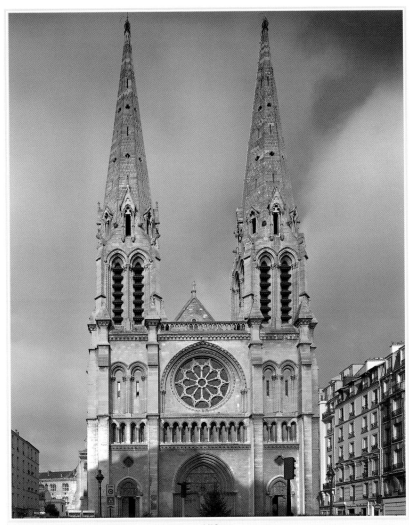

478
Église Saint-Jean-Baptiste-de-Belleville

139, RUE DE BELLEVILLE AT RUE DE PALESTINE

1854–57, JEAN-BAPTISTE LASSUS; 1857–59, TRUCHY

479

64–66, rue de Meaux

<small>At rue Armand-Carrel</small>

<small>1988–91, Renzo Piano workshop; Michel Desvigne, landscape design</small>

480

Siège du Parti Communiste Français (French Communist Party Headquarters)

2, PLACE DU COLONEL-FABIEN AT BOULEVARD DE LA VILLETTE

1965–71, OSCAR NIEMEYER, JEAN DEROCHE, PAUL CHEMETOV, JEAN TRICOT, AND JEAN PROUVÉ; 1980, OSCAR NIEMEYER, DOME

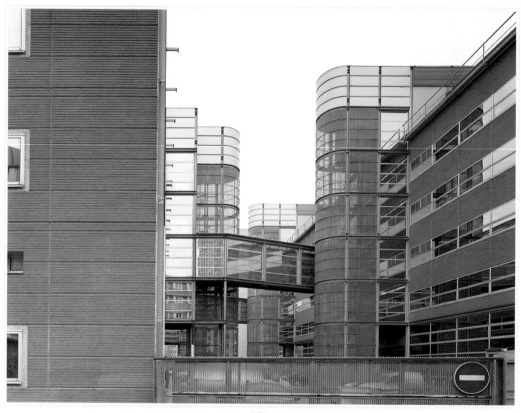

481

Hôtel industriel "Métropole 19"

138–140, RUE D'AUBERVILLIERS AT RUE RAYMOND RADIGUET

1988, JEAN-FRANÇOIS JODRY AND JEAN-PAUL VIGUIER

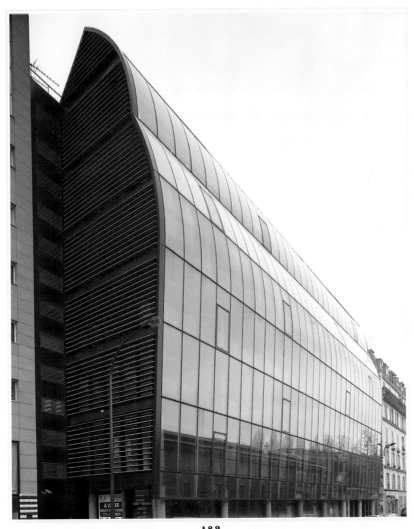

482

16, quai de la Loire

At rotunde de la Villette and avenue Jean Jaurès

1999, Philippe Gazeau

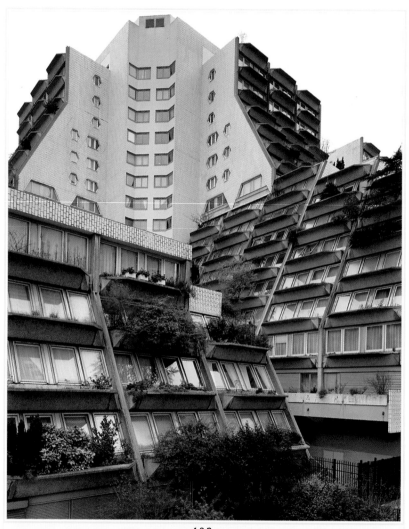

483

Les Orgues de Flandre

67–107 or 69, rue des Orgues de Flandre

1973–80, Martin S. Van Treek

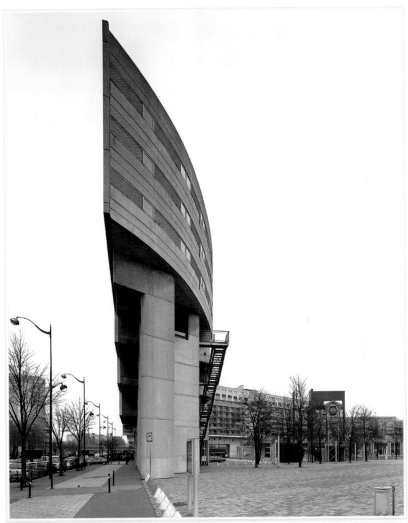

484

26–30, avenue Corentin Cariou

At quai de la Villette

1988–90, Gérard Thurnauer

20ᵀᴴ ARRONDISSEMENT

A popular and ethnically diverse neighborhood, the twentieth arrondissement is becoming the new East End, with pockets of gentrification. In a spillover from rue Oberkampf in the eleventh, the hip, the young, and the arty have moved into the areas of Ménilmontant and Belleville, mixing with the culturally diverse population. Before annexation in 1860, the hills of Ménilmontant were part of the village of Belleville, filled with workers' cottages. Maurice Chevalier and Edith Piaf rose to stardom from this working-class neighborhood. Historically, the eastern part of the city was known for its rebellions, and is still a bit of a hotbed of protest. The construction of tenements in the 1960s added to the architectural mix of high-rises, bungalows, and restored artist studios with lofts and gardens. The twentieth arrondissement also contains the famed Père-Lachaise Cemetery.

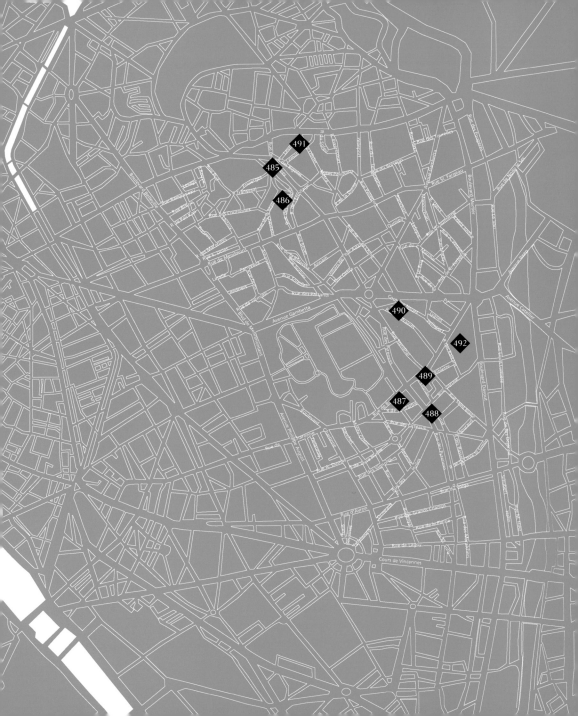

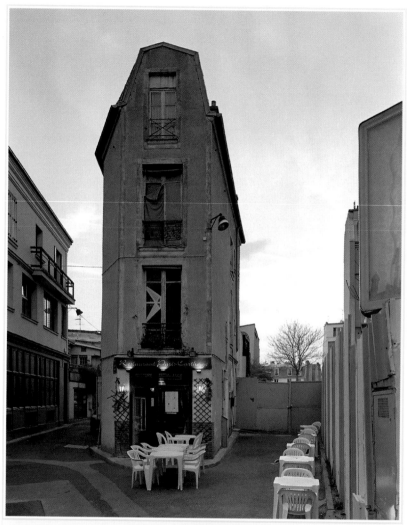

485

Paris-Carthage

4, CITÉ LEROY AT RUE DES PYRÉNÉES AND VILLA L'ERMITAGE

C. 19TH CENTURY, REBUILT SEVERAL TIMES

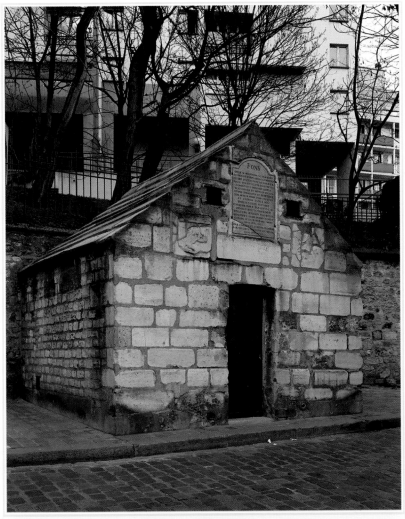

486

Regard Saint-Martin

42, RUE DES CASCADES AT RUE DE SAVIES

C. FOURTEENTH CENTURY

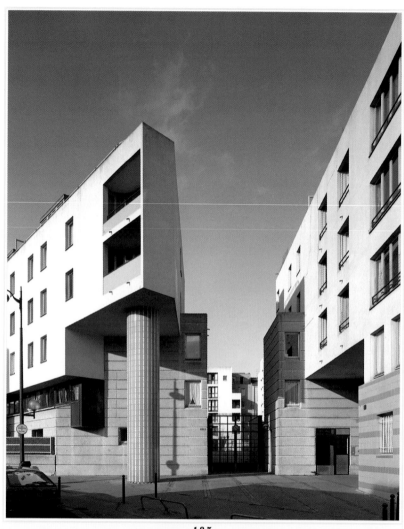

487

Logements Sociaux

11–21, RUE DE FONTARABIE AND 74, RUE DE BAGNOLET

1984–87, GEORGES MAURIOS (J. P. ASTIER COLLAB.)

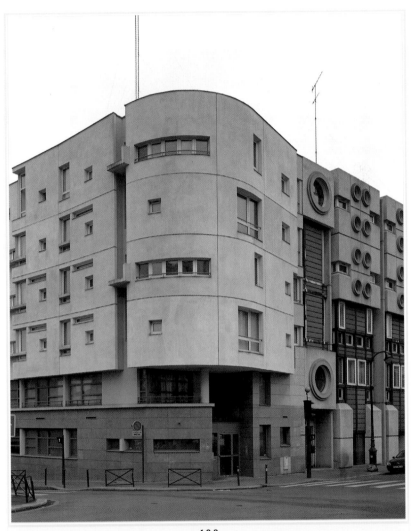

488

Musicians' homes and workshops

116, RUE DES PYRÉNÉES AT RUE VITRUVE

1986, YANN BRUNEL AND SINIKKA ROPPONEN

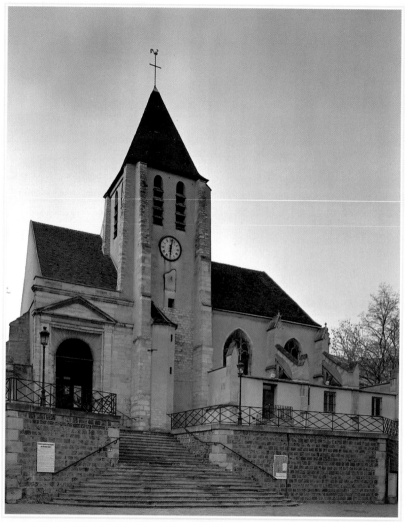

489

Saint-Germain-de-Charonne

4, PLACE SAINT-BLAISE AT RUE DE BAGNOLET AND RUE SAINT-BLAISE

C. THIRTEENTH CENTURY, TOWER; C. FIFTEENTH CENTURY, CHURCH; C. EIGHTEENTH AND NINETEENTH CENTURY,
ALTERATIONS

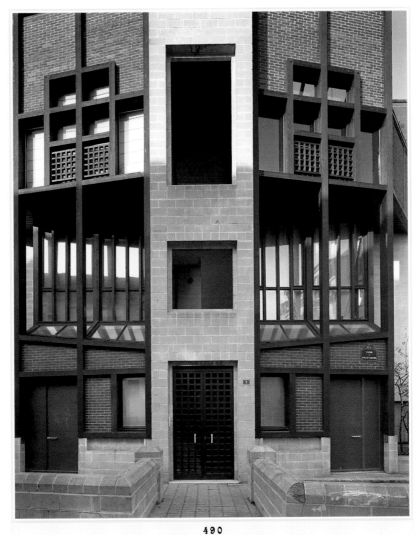

490

Ateliers des artistes

ONE, CHEMIN DU PARC DE CHARONNE AT RUE DES PRAIRIES

1982, YANN BRUNEL AND SINIKKA ROPPONEN

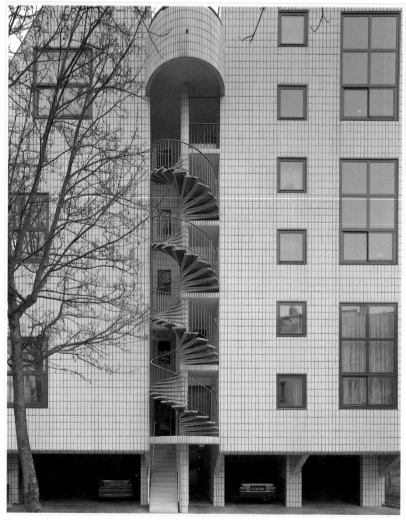

491

Ateliers d'artistes

61, RUE OLIVIER MÉTRA AT RUE LEVERT

1982, ALEX WIESENGRUN, PHILIPPE ROCCA, AND ALAIN BEAUNY

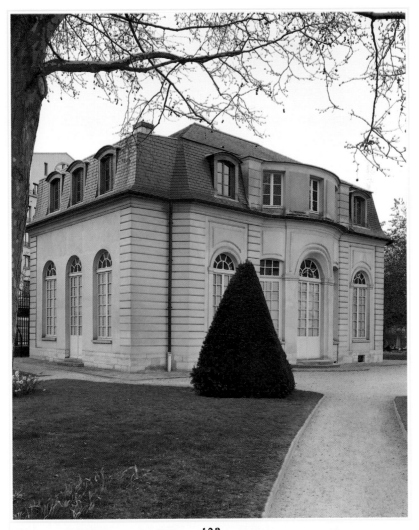

492

Pavillon de l'Ermitage

148, RUE DE BAGNOLET BORDERED BY RUE DES BALKANS, RUE VITRUVE AND BOULEVARD DAVOUT

1734, SERIN

LA DÉFENSE

In 1933, anticipating a need for new town planning, Le Corbusier along with members of an architectural group issued the Charter of Athens. This document, a major text of the Modern Movement as regarded urban planning in general, spelled out certain standards based on four themes: living (dwelling), working, recreation, and circulation. Inspired by the standards in this monograph, the town planning for La Défense called for the use of flagstone to separate pedestrians from vehicles, and for the creation of high-rises to move Paris into modern times. Instead of designing isolated towers that would have stood out in the midst of Paris's traditional stone buildings, the plan of La Défense, drawn up in 1959–60, mapped out a new 2,000-acre business district that did not offend nineteenth-century Parisian skyline that Baron Haussmann had worked so hard to achieve. And so Paris business expanded westward beyond the wealthy neighborhood in Neuilly, carving out parts of Puteaux and Courbevoie—areas with a view of the Seine, but that were just outside of Paris city limits. Nonetheless equipped with a Parisian postal code as well as metro and rail links, this business district set up shop.

This concept spanned three generations of architecture, and forty years of debate and public and private capital, before today's version of the development was realized. Even now, construction is ongoing. Although a small number of people are living in La Défense today, attempts to turn this space into a utopian residential and working property largely fell flat. Few people wanted to live in a concrete or flagstone jungle with Paris so close by. The original architects' intentions notwithstanding, the initial housing plan was abandoned in the 1970s in favor of building accommodations for business use. Today almost 3 million square meters are devoted to office spaces where over 100,000 people work, employed by 800 companies that include fourteen of the twenty largest French corporations. Thus, the new business district of Paris was born simultaneously with La Défense serving as an experimental laboratory for postmodern architecture.

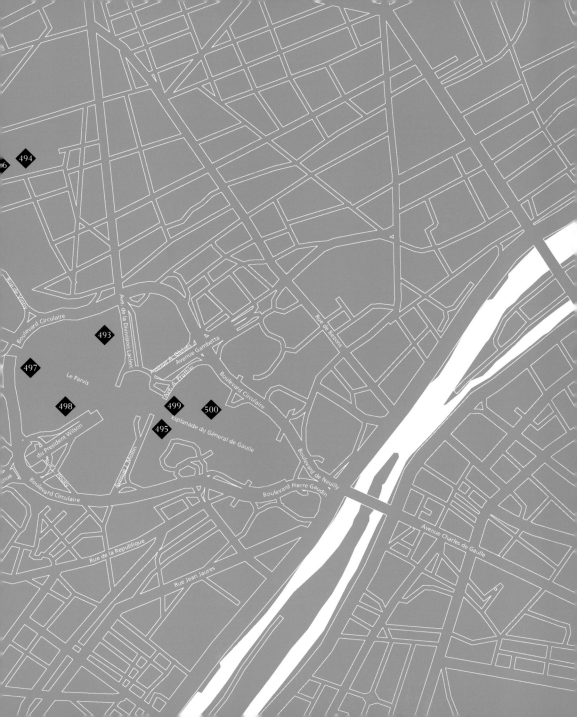

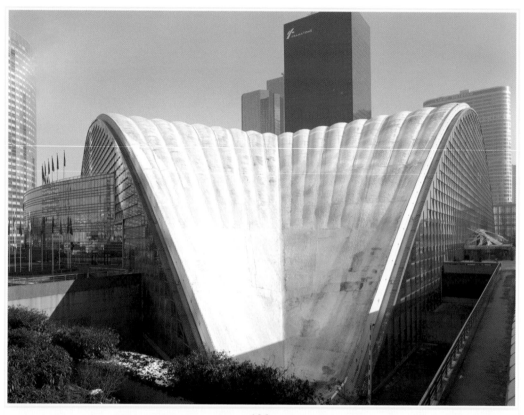

493

CNIT (National Industrial and Technical Center)

Palais des expositions (Exhibitions Palace), Parvis de la Défense Esquillan

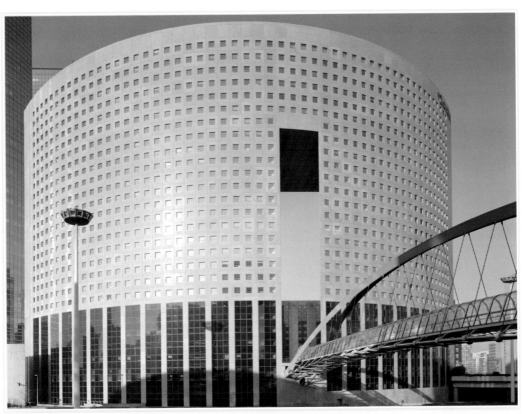

494
Tour La Pacific
QUARTIER VALMY
1992, KISO KUROKAWA

495

Cœur Défense

ESPLANADE DE LA DÉFENSE

2001, JEAN-PAUL VIGUIER

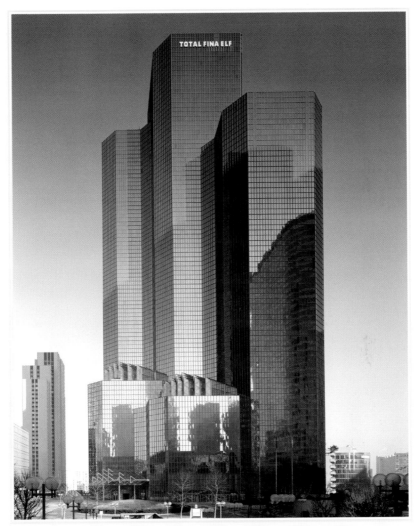

496

Tour Total Fina Elf

2, PLACE DE LA COUPOLE, OPPOSITE TOUR FRAMATOME (FORMER TOUR FIAT)

1974–85, ROGER SAUBOT AND FRANÇOIS JULLIEN

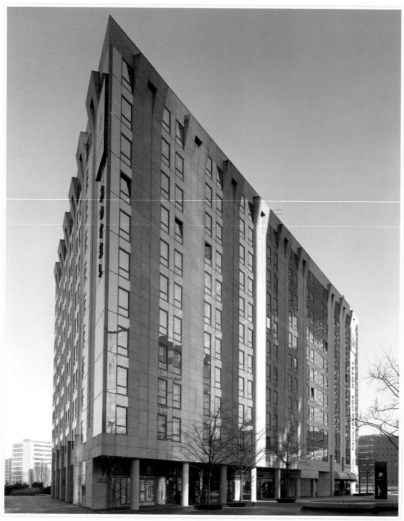

497

Hôtel Renaissance

60, Jardin de Valmy Boulevard Circulaire No. 7

1995, Pierre Parat and Michel Andrault

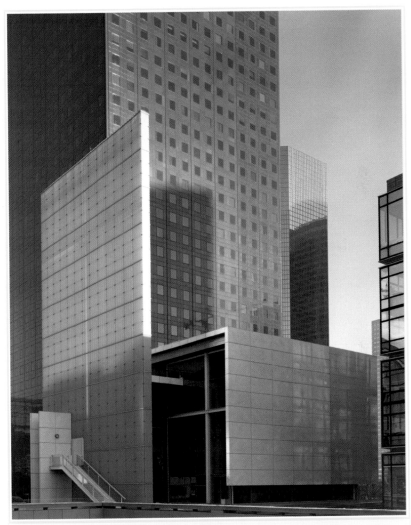

498

Église Notre-Dame-de-la-Pentecôte

<small>PARVIS DE LA DÉFENSE AT COIN EST DU CNIT AND LA DÉFENSE MAIN ESPLANADE</small>

<small>1997–2001, FRANCK HAMMOUTÈNE; 2001, PIERRE SABATIER, FURNITURE</small>

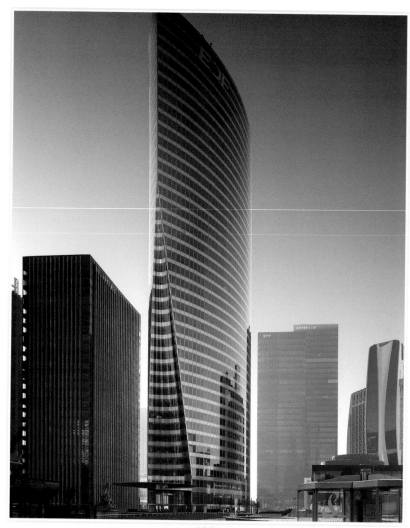

499

Tour EDF/Tour PB6 (Electricité de France)

ESPLANADE DE LA DÉFENSE

2001, PEI, COBB, FREED AND PARTNERS JEAN ROUIT, ROGER SAUBOT

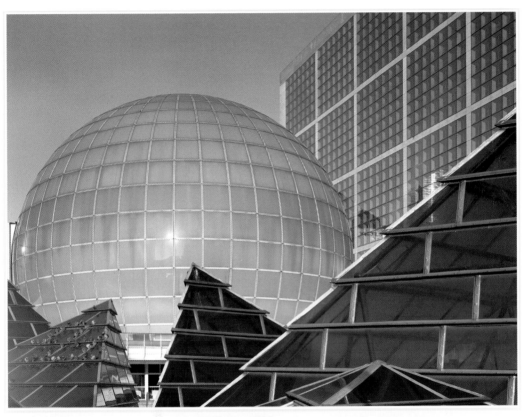

500
Dôme Imax la colline de la Défense

1, PLACE DU DÔME

1993

1
Notre-Dame de Paris

Notre-Dame soars over Île de la Cité and spans history with its stony symmetry and Gothic exuberance. Its famed flying buttresses, along the exterior of the nave, provide a means of structural support not previously realized in Gothic design and, like open wings, appear to give it weightlessness and lift. Notre-Dame became the model of religious architecture from the twelfth century. In 1163, Bishop Maurice de Sully broke ground over Roman ruins and construction began on the choir. Subsequently, Notre-Dame withstood the ravishment of the Revolution and saw the coronation of Emperor Napoléon Bonaparte and the Empress Joséphine in 1804, among many events. Thanks to a revival of Gothic style and Victor Hugo's efforts to encourage restoration, architects Viollet-le-Duc and Lassus overhauled most of the cathedral in the nineteenth century. Many of its medieval-style treasures—its interior furnishings, gargoyles, and statues, for example—are not originals, but reproductions and reinterpretations that owe their design to medieval-era drawings. On the western façade, replicas of the twenty-eight Kings of Judah statues replace their medieval originals, which the Revolutionaries decapitated in the mistaken belief that they represented the kings of France. Despite centuries of reconstruction, Notre-Dame remains a paradigm of Gothic engineering.

2
Place Dauphine

Thirty-two identical houses originally transformed this triangular plaza—wedged between the Pont-Neuf and Palais de Justice—into a fashionable center of commerce. King Henry IV commissioned these uniform stone and brick buildings in 1607 and named the space Place Dauphine, after his oldest son, the Dauphin. Over the centuries, subsequent renovations have modified the residences and changed the nature of the plaza. An area that previously bustled with trade and up-and-coming artists is now a quiet cluster of restaurants and boutiques, an ideal spot for serene strolling.

While romancing the stones, young lovers might be forgiven for nicknaming the triangular space "the vagina of Paris"—a fitting tribute nonetheless to Henry IV's vision of city modernity.

3
Palais de Justice

Once fortified by moat and drawbridge, the Palais de Justice stands on land previously occupied by Roman rulers and French kings. This medieval palace complex encompasses Sainte-Chapelle with its seventy-five-meter spire, La Conciergerie, and watchtowers. These fortifications, however, did not deter Etienne Marcel and his men from pursuing a bloody revolt inside the palace, in 1358. After Charles V witnessed the murder of his counselors, he high-tailed it to Hôtel Saint-Pol, in the Marais, and moved his residence to the Louvre. After it had been abandoned as a royal residence, the Palais de Justice became the seat of Parliament. Rebuilt after many fires and various extensions, the Palais is an accumulation of buildings from different times throughout French history. Today, multiple courts here try both civil and criminal cases.

4
La Conciergerie

A residence built by King Philippe le Bel, but abandoned in 1358–60 by Charles V, this palace—part of the Palais de Justice complex—became the seat of Parliament in 1431. Until 1914, it was a prison: During the Revolution, dungeons beneath the vaulted rooms held unfortunates awaiting trial and execution. Among its notable inmates, Robespierre, Danton, and Marie-Antoinette did time here.

5
Tribunal de Commerce

Under the direction of Napoléon III, Baron Haussmann reconfigured Paris in the mid-nineteenth century. As one of Haussmann's special projects, this building provided a place for the administrative trade courts. Both the

immense staircase and the dome are noteworthy features. The dome—initially designed for the center of the building—appears in a strange position. For Haussmann, a city perspective with points of reference on either end was critical. So he persuaded the architect to shift the dome, to align with the new boulevard Sébastopol.

6
Préfecture de Police

Until 1879, the police headquarters contained two barracks. Now, four wings surround the center court, Court of August 19, so named to honor the police force for its role during liberation in 1944. The original construction was part of Baron Haussmann's massive reconstruction plan for Île de la Cité as an administrative center for the city of Paris.

7
Sainte-Chapelle

Known as the "jewel box" for the brilliance of its stained-glass windows, La Sainte-Chapelle is a thirteenth-century treasure hidden inside the Palais de Justice. When its windows, which contain the oldest stained glass in Paris, are illuminated by sunlight, 1,134 biblical scenes glow with a depth of color seen only in expensive claret and gems. At sunset, the immense rose window depicts a scene of the Apocalypse. Stained-glass artistry reached its height in the mid-thirteenth century, at about the time Sainte-Chapelle was commissioned by King Louis IX, and these stained glass tracery windows—with delicate, radiating spokes —are typical of the Rayonnant period in Gothic design. In its original time, the expanded window surface and the reduced masonry gave this Gothic structure an impression of unusual lightness.

8 / 9
Pont-Neuf/Pont des Arts

In 1985, after ten years of study, sculptor Christo Javacheff wrapped the Pont-Neuf in cloth for two weeks as a conceptual work of monumental art. Unraveled, it now stands in its original form, linking the right and left banks as it slices across the west tip of Île de la Cité.

More than a bridge, it represents a French Renaissance symbol of reverse urban planning. Pushing Paris toward modernism, Henry IV developed Pont-Neuf as a building project between 1578 and 1607, and it immediately attracted loyal fans. Merchants, musicians, and medicine shows flocked to the bridge and it became a scene of daily entertainment. It was the first bridge built without houses on it and, as such, it opened up the river landscape of Paris. Previously invisible, the river had nonetheless been the lifeline of the city — a living and working space with houses and businesses, a dumping ground, and a harbor. With the completion of the Pont-Neuf, Parisians rediscovered the beauty of their river. The construction or expansion of other buildings such as the Louvre, the Institut de France, banks, private mansions, and various Haussmann projects followed suit, maintaining the view of the Seine. The river became a "landscape," and the Pont-Neuf, a symbol of urban revolution.

Pont des Arts opened two hundred years later, in 1803, and succeeded in replacing the Pont-Neuf as a favorite hangout. Sixty thousand spectators attended its inauguration. Creating this bridge achieved two milestones: It became the first footbridge across the Seine, and the first iron bridge. But it has required many renovations, as barges have often damaged it while trying to negotiate the close space between this bridge and the Pont-Neuf. Today, tourists, bird-feeding locals, backpackers, lovers, and other pedestrians regularly stroll across it or congregate on the bridge to watch artists at work or musicians performing *al fresco*. Most often, crowds just linger, looking up or out across the Seine to take in the breathtaking view of the Île de la Cité to the east, the Pont-Neuf and central Paris to the west, and the expanse of open sky all around.

10
One, rue des Chantres

Fernand Pouillon mixed a jumble of architectural elements to create a modern, medieval house. He

demolished the original ruin "bit by bit, [and] replaced [it] by a clever pastiche of deliberately ill-assorted architectural items, which have been both envied and admired ever since by people dreaming of a view over the Seine." Despite the self-evident pleasure in his own work, Pouillon lived here only a year. The Aga Khan took up residency next in this fake medieval wonder.

11
Hôtel-Dieu

Founded in the ninth century by Bishop Landry (later Saint-Landry) just south of Notre-Dame, the old medieval Hôtel-Dieu served for centuries as the only city hospital, taking on charity cases and caring for the ailing poor and aged. Regular overcrowding usually meant five to a bed. By the time that number dwindled to three, it was commonly said, the ill, the dying and the dead shared a bed. In the harsh winter of 1708–09, hundreds of corpses were carted off to the hospital's cemetery and buried en masse; over 2,500 infants were abandoned, most at the doorstep of Hôtel-Dieu. During Baron Haussmann's nineteenth-century civil reengineering, the Hôtel-Dieu was demolished and rebuilt on its present site.

12
Buildings on quai aux Fleurs

In 1570, Parliament ordered a conversion of the houses at quai aux Fleurs, then known as Saint-Landry Harbor, into shelters for abandoned children. At the time many institutions—Hôpital de la Trinité, Hôtel-Dieu, Hôpital des Enfants-Dieu of the Saint-Esprit—engaged in social assistance, and several were located on Île de la Cité because Notre-Dame cathedral was here. Constructed in 1769, the quai—then one of the three harbors on Île de la Cité—was rebuilt during Napoléon Bonaparte's era in neo-Classic design, as it appears today. Situated on the eastern edge of Île de la Cité, quai aux Fleurs (in addition to the property just north of Notre-Dame) is the only land on the island to belong to the 4th arrondissement—an administrative division

derived from the medieval neighborhood that had separated the western, independent royal side of the island from the church.

13
Louvre

In 1983, when President François Mitterrand commissioned I. M. Pei to create a new entrance to the Louvre, Mitterrand was following in the footsteps of French kings. During its many incarnations—former defense tower, repository of crown treasures, royal residency, artist commune, first royal library, Renaissance Palace, home to Leonardo's *Mona Lisa*, and mega-museum extraordinaire—the Louvre evolved with the times and the whims of its leaders. Since 1191, when Philippe Auguste deposited in the Louvre his bounty from the Third Crusade, treasures have amassed to fill 225 galleries and 3 main wings. Inside the museum, you'll also find the basement of Philippe Auguste's medieval castle. This ruler also built a wall that excluded the Louvre from Paris proper. But on the other side of the mall at the Carrousel-du-Louvre, you can see another wall—dating from 1358 and Charles V's reign—that pulled the Louvre inside the one that encircled Paris. Outside, Pei's geometric entrance commands your attention and invites you in. Bold and transparent, yet not without controversy, Pei's pyramid energizes the central courtyard while minimizing its visual impact on the existing historic wings. In dealing with the problem of access, Pei conceived of a large underground space illuminated by natural light, and built a 45,000-square-meter exhibition and mall area, accessed by this transparent pyramid.

14
Arc de Triomphe du Carrousel

Napoléon I commissioned this arch to celebrate his military victories in 1805. Architects Percier and Fontaine modeled their design after the Roman arch of Septimus Severus. The inscription was conceived by Napoléon himself. The bronze casting atop the arch—a Goddess of Victory

quadriga—replaced the original Venetian sculpture of Four Horses of San Marco, seized by Napoléon but later returned to Venice by the Austrians. Today, the arch stands isolated, an informal gateway to the Tuileries gardens and the Louvre. Originally, Napoléon positioned it as the triumphal courtyard entrance to the now-defunct Tuileries Palace. At the time, the triumphal arch—a symbolic threshold for returning Roman warriors—marked the successful end to military campaigns. This one is not to be confused with the Arc de Triomphe of the Champs-Elysées—a larger triumph of Napoléonic ego.

15
Musée du Jeu de Paume

As its name implies, the Jeu de Paume was used as a royal tennis court. Commissioned by Napoléon III in 1861, it was reclaimed by the state and served as a temporary exhibit space, then as a museum of contemporary French art, and, from 1947–86, as an annex to the Louvre, housing its Impressionists collection. Unfortunately, this space proved too small and inadequately ventilated, ill-serving both the artwork and the masses of visitors pressed too close to be able to appreciate the paintings' plays on light. Fortunately, the Impressionists were then moved to a better space in the renovated Musée d'Orsay. Later remodeled to have ample sky-lighting and open views of the gardens, Jeu de Paume is now used for temporary exhibitions of contemporary art.

16
Fontaine de la Croix-du-Trahoir

To French royalty, Rome was a model of modernity and wealth with its abundance of water and aqueducts. If citizens can see water, or its representation, that will mean the city is healthy and working and rich. This concept became a particularly important policy for France during the eighteenth century. Construction, replacements, copies, and restorations of fountains have sustained this tradition. This corner fountain is no exception, as it replaces one built by Jean Goujon in 1529.

Architect Soufflot borrowed his relief design of nymphs from Goujon's previous work. Fontaine de la Croix-du-Trahoir was restored 1968.

17
Saint-Germain-l'Auxerrois

From the bell tower on August 24, 1572, "Vincent," "Germain," and "Marie" heralded the Saint Bartholomew's Day Massacre of some 3,000 Huguenots. Of the three bells that rang out that night, only Marie survives. Built in the thirteenth century and remodeled in the fifteenth, Saint-Germain-l'Auxerrois was the parish church for the kings of France when they resided at the nearby Louvre. It was also a model for Claude Monet, who painted this church in 1867.

18
La Samaritaine

Founded by Ernest Cognacq and his wife Marie-Louise Jay in 1869, and notable for its stylish blend of Art Nouveau and Art Deco architectural décor, the landmark Samaritaine has one of the best views of Paris from its balcony facing the Point-Neuf. The carved relief on an old water pump, featuring the Good Samaritan offering a drink to Christ, inspired the store's name. Considered a fire hazard and closed in 2005, the building will be restructured by Japanese architecture firm SANAA to include commercial and hotel space.

19
15, rue du Louvre

Architect Blondel created this apartment complex as one of his last projects. Situated on the site of the former Hôtel des Fermes, this large complex crosses the block between rue du Louvre and rue du Bouloi with two entrances. One, flanked by two busts of Atlantis, is made of stone—a noble sign of richness—and leads you into a sizable courtyard. The other, by contrast, is composed of metal. Traveling from one side of this building to the other transports you from a nineteenth century world to old Paris streets.

20
32, rue du Louvre and 112, rue Saint-Honoré

Parisian street corners were typically "hot spots" of prestige, and so the Saint Brothers developed a tall, monumental building at this juncture to create a formidable presence. In the business of producing jute at the beginning of the twentieth century, the brothers were in competition with a British monopoly. Their company, Saint-Frères, flourished. They expanded their business and constructed this large-windowed, three-story building of metal and concrete—the latter being the trendy new building material of the period.

21
Oratoire du Louvre

The domed chevet of this chapel rises above an arched portico and is partially hidden behind a monument erected to honor Admiral Gaspard de Coligny, assassinated in 1572 during the August 24th Saint Bartholomew's Day Massacre. The gallery entrance faces rue Saint-Honoré, and the chapel's rectangular chamber on each side of the nave extends to the rue de Rivoli side of the building. The church itself served the French branch of the Oratorians, whose congregation was founded by Pierre de Bérulle in 1611.

22
Au Chien qui Fume

Parisians have a love affair with their dogs—fact born out by any glance at their city sidewalks. With equal tolerance for smoking in restaurants —despite the current smoking ban in Parisian restaurants—it's no surprise, then, to discover a restaurant named "The Dog Who Smokes." The sign features pooches in various stages of inhaling: a spaniel puffing a pipe à la Sherlock Holmes, a terrier chomping on a cigar, and a boxer dangling a cigarette in Bogey fashion. Inside, small painted panels depict other dogs in smoking poses.

23
Saint-Leu-Saint-Gilles

Like Rome, this church wasn't built in a day. In Paris, ecclesiastical construction often spanned centuries—as was the case here. Begun in 1319, this small church finally acquired aisles some two hundred years later, and a choir after an additional three hundred years. Add another two hundred years of modifications to its apse, façade, and bell towers, and voilà! Mission accomplished.

24
Théâtre du Châtelet

Two theaters flank the Fontaine du Palmier to the east and west in place du Châtelet. Commissioned by Baron Haussmann, these typical nineteenth-century buildings, with their balconies and arched windows, are almost indistinguishable except for the differences in their size and decoration. The larger of the two is the Théâtre du Châtelet. After extensive interior renovations, the old Châtelet, which had staged simple operettas, expanded its repertoire to include more ambitiously-scaled concerts and operatic productions.

25
Cador

Once the perfect tea salon for ladies who lunch, Cador caters to discriminating locals despite its tourist location next to Saint-Germain-l'Auxerrois and proximity to the Louvre. Its arched green and gold exterior leads into an elegant, chandeliered interior with scenic views. Among Parisian patisseries, window display is an art form: Meticulous care is taken to the arrangement of cookies, candies, and cakes. At Cador, it is picture-perfect. No wonder the salon has attracted loyal customers for 150 years.

26
Pharamond

When Alexandre Pharamond opened this restaurant in 1879, it became known for serving the best tripe. The second floor, with its special salons, offered great intimacy and privacy, and

discreet access was possible from the building next door. But Pharamond also took to his horse-and-buggy out on the streets of Paris, to sell his specialty—a beef stew simmering in cider. The façade of the present incarnation of this restaurant, the result of the regionalist trend of the 1930s, is a fake wooden structure that imitates the architectural style of Normandy.

27
La Potée des Halles

At the turn of the twentieth century, the glass-and-iron food pavilions at Les Halles swirled with activity. Licensed porters pushed their food carts from stall to stall, and a host of restaurants, cafés, and bistros, including la Potée des Halles, sprang up in the vicinity. Whether a household cook was planning a dinner menu or a restaurant chef sought fresh ingredients, this market was their prime source. Named for its own 1903 *potée* recipe—a hearty stew of salt pork, carrots, white beans, cabbage, and smoked sausage—La Potée pays homage to down-home French cooking and the food pavilions of Les Halles. And its interior tile murals pay tribute to the bar and coffee maidens who kept life humming along these streets.

28
Forum des Halles

The city's central markets originated here with the influx of craftsmen and traders between the tenth and twelfth centuries. As early as 1183, Philippe Auguste permitted the first fish market, and, by the 1850's, Les Halles had become a thriving marketplace with cast-iron and glass pavilions that were a marvel of engineering. Unfortunately, in 1969, bureaucratic wisdom transferred the food markets south, to Rungis, to relieve city congestion. Their replacement, a subterranean shopping mall called Forum des Halles, was an architectural disaster. In 2007, architects Patrick Berger and Jacques Anziutti won a competition to redefine the space and add a glass canopy that glows at night. Construction is due to start in 2010, but these plans are controversial because the canopy may obstruct views of Saint-Eustache.

29
Bourse de Commerce

During the late sixteenth century, when court astrologer Riggieri informed Queen Catherine de Médicis that she would die by Saint-Germain, she assumed that he meant Saint-Germain-l'Auxerrois. She promptly moved to a new residence, Hôtel Soissons—now the site of the Bourse de Commerce. In 1765, Louis XVI commissioned a grain market here, called Halle au Blé, for the commercial exchange of wheat, corn, flour, and similar commodities. The structure used to have an arch so people could see through the center to ascertain the level of food and grain in the middle. One of the first structures to use a wooden dome, it was influenced by Roman temples and their glorification of food.

30
Saint-Eustache

Although French dramatist Molière is buried in the cemetery of Saint-Joseph's church, his funeral caused quite a stir here at Saint-Eustache. Because he was an actor—then a socially unacceptable profession—the local clergy refused his confession and denied his burial on church grounds. Louis XIV interceded four days later, persuading the priests of Saint-Eustache to bury Molière at Saint-Joseph's cemetery under the cover of darkness. The second largest church after Notre-Dame, Saint-Eustache served the common folk from Les Halles as well as the great and the talented.

31
L'Escargot Montorgueil

The giant, golden snail above this restaurant's gold-lettered name and black façade entrance tells the tale. You want snails, they've got them—prepared in ways you've never dreamed of. Inside this registered historic building, a spiral staircase links two dining levels. A ceiling painting, by G.-J.-V. Clairin, that once hung in Sarah Bernhardt's dining room, now graces the entrance. In 1919, André Terrail, founder of the Georges V hotel, bought the original 1832

establishment, then called Escargot d'Or. Today, his daughter, Mrs. Saladin-Terrail, hosts customers from the worlds of arts, literature, and show business. Notables who have dined here include Charlie Chaplin, Jean Cocteau, Picasso, Salvador Dali, and Barbra Streisand.

32
Le Grand Véfour

As the oldest Parisian restaurant serving clients at its original location, Le Grand Véfour is entitled to name-drop: Napoléon and Joséphine, Victor Hugo, George Sand, and Honoré de Balzac are just a few of its diners whose names are engraved above their supposed seats. In 1820, Jean Véfour bought the Café de Chartres—the name can still be seen over the garden entrance—and renamed the restaurant after himself. Today, the resplendent and romantic Grand Véfour offers its Michelin three-star courses in a stunning setting.

33
Banque de France (former Hôtel de la Vrillière, then Hôtel de Toulouse)

Built by François Mansart for Louis Phélypaux, Lord of la Vrillière, this mansion was known for its beautiful portal and its art gallery, which housed la Vrillière's Italian collection. In 1808, the Banque de France, created by Napoléon I in 1800, moved into this building. Charles Quesnel reconstituted the Galerie Dorée with copies of the original paintings, and Raymond and Paul Balze recreated François Perrier's first ceiling.

34
Palais-Royal

Once, on sunny days at precisely noon, Parisians used to set their watches by the boom of a little cannon in the Palais-Royal gardens. This tradition had started in 1786, when a Monsieur Rousseau had fastened a magnifying glass to a small cannon he had placed in the gardens on Paris's meridian line. The attached lens would ignite the fuse. The cannon, long a subject of poetry and lithographs, stopped booming in 1914, but the ritual resumed

in 1980 when it was restored…only to be silenced again by its 1998 theft from the gardens. Today, you'll find tranquillity in the gardens and elegance within the cannon-free arcade. But this respite from the city rush belies the building's past. Built as a private home for Cardinal Richelieu, Palais-Royal was transformed multiple times by its revolving occupants. The Sun King romped on the grounds as a child. Camille Desmoulins stirred passions here on July 13, 1789, and Revolutionaries stormed the Bastille the next day. Diderot and other intellectuals argued in the vicinity. Literary denizens Colette and Cocteau waved to each other from their Palais apartment windows. Sinners and saints, chess players and prostitutes, duelers and revelers all hung out here, creating a lively atmosphere and dissonance in the gardens and arcade cafés. Today, Daniel Buren's black and white columns—a conceptual art grid—have revitalized the gardens.

35
Place des Victoires

This place royale praises the glory of the Sun King. A mounted figure of him—in his wig and, oddly, Roman attire—graces the horseshoe-shaped plaza, now home to stylish fashion houses. Marshall François d'Aubusson, the duc de la Feuillade, had this monument built at his own expense to honor his beloved Louis XIV after the Treaty of Nimwegan in 1678. The original bronze statue of the king, designed by Desjardins, was installed in 1686, but was melted down in 1792 by Revolutionaries. To commemorate the hero of the battle of Marengo, Napoléon replaced the destroyed bronze with a nude statue of General Desaix de Veygoux, which so shocked Parisians that they fenced the general out of sight. Later, during Restoration, François Joseph Bosio created the sculpture currently mounted.

36
Comédie-Française

Founded by Louis XIV near Palais-Royal, Comédie-Française inaugurated this theater in

1799 performing *Le Cid* and *L'Ecole des Maris* in a double-bill. Today, this is where one can see performances of plays by Molière, Camus, Shakespeare, and Ibsen, among others. Long past its glory days, the theater nonetheless revives tradition with historic celebrations on Bastille Day and on the February anniversary of Molière's death. It was on February 17, 1673, at the nearby Palais-Royal in Richelieu's Le Petit Cardinal Theater, that Molière, playing the hypochondriac Argan in *Malade imaginaire* (*The Imaginary Invalid*), collapsed and died onstage in mid-performance.

37
Musée de l'Orangerie

Both Musée de l'Orangerie and its opposite neighbor, Musée du Jeu de Paume, are situated near place de la Concorde. L'Orangerie—so named for its original purpose, as a greenhouse for growing oranges—was refurbished in the early twentieth century and decorated by Monet with his mural of Nymphéas. In 1984, the museum acquired the art collections of Jean and Domenica Walter, and Paul Guillaume.

38
Sloped Apartments

These apartment buildings, with identical façades, feature an arched colonnade and curved roofs. Commissioned by Napoléon I, construction began in 1802 along rue de Rivoli and continued until 1835. Originally their roofs were low and double-sloped. They frame the place de la Pyramides on three sides, looking out toward the Tuileries gardens and the Louvre. At the center stands a statue of Joan of Arc, which sculptor Emmanuel Frémiet added in 1874.

39
Eglise Saint-Roch

Jacques Lemercier conceived plans for Saint-Roch but died before Louis XIV developed this site. Lack of funding caused further delays, until Scottish financier John Law came to the city's rescue. This parish church with its column-heavy façade—built about eighty-five years after construction of the site began—represents an example of Baroque religious architecture in Paris.

40
Hôtel Ritz

The Ritz Hemingway bar, a legendary watering hole for writers, was the scene for Fitzgerald's drinking as well as the favorite of his *Tender is the Night* character Abe North. Other literary associations, from fact and fiction, include *Babylon Revisited*, *The Bridal Party*, and *News of Paris–Fifteen Years Ago*. In 1944, the story goes, Papa Hemingway, whose photos adorn his namesake bar inside Hôtel Ritz, "liberated" the Ritz with a band of thirsty soldiers, treating them to a round of ninety-three dry martinis. But long before Hemingway made the Ritz famous, Scott and Zelda Fitzgerald—along with other wealthy American patrons—took up residence here in the 1920s, when they threw lavish pre-Depression parties. A guest suite is named for Scott Fitgerald, but César Ritz renamed "Le Petit Bar" to honor his friend Ernest.

41
Hôtel Meurice

Used as Nazi headquarters during the Occupation, Hôtel Meurice has had a happier history in French cinema. In the 1966 caper, *Paris-brûle-i-il*? (*Paris is Burning*), director René Clément stoked the flames by using Hôtel Meurice as his setting ,showcasing its views of the Tuileries Gardens and the Eiffel Tower. Established elsewhere in 1817 by a Calais postmaster after the Napoléonic Wars, Hôtel Meurice moved to this location in 1835. Salvadore Dali, one of the hotel's frequent guests, used to hand out signed lithographs as tips. A recent renovation uncovered the original floor and woodwork of the hotel's bar. As directed by architects Roubert and Papamiltiades, more than 500 artisans restored its antiques, mosaics, stained glass, and friezes. In 2007, Philip Stark transformed the interior with more color and light, and the hotel is once again attracting stars.

Louis XV, until his death. During the Revolution, the chapel became national property and was destroyed. During the nineteenth century, this mansion was given a cohesive Louis Quinze style and became a national monument for its beauty.

54
Société Générale

This corner building features two symmetrical façades anchored by a clock tower. Imposing and elegant, this building is also perfectly aligned to the spirit of the times, the Belle Epoque, catching the attention of contemporaries. In *Amours Enfantines*, Jules Romain writes about life on rue Réaumur in 1908: "Its name resembles a song of *roues* (wheels) and *murailles* (high walls), a fear of buildings, to the vibrations of the *beton* (concrete) under asphalt, the hum of the subway convoy . . ." This artery capped nineteenth-century Paris with ambitious construction projects, the way the La Défense defined Paris at the end of the twentieth century.

55
40-42 rue d'Argout

Constructed on an old Parisian street that ran parallel to the former wall of Charles V, these two domestic buildings illustrate the architectural evolution of different generations. From the early part of the eighteenth century, the building on the left accommodated four stories while the adjacent building on the right maximized the same space to express an additional floor, and the last-floor balcony is typical of pre-Haussmann architecture. This corner construction—set back about two meters from the older alignment—allowed a wider street, which was preserved by chance when rue du Louvre was pierced in 1880. The connection of the two streets and these buildings reflects the architectural disruption as well as the challenge inherent in creating a city where modernity confronts history.

56
23, rue du mail

Built in the mid–nineteenth century, this site

is an important part of Erard's history: Nearby at number 13 is the first Erard townhouse, purchased by piano dealer Sébastien Erard in 1781. As business expanded, however, the company wanted to establish a greater presence in the neighborhood. Rue du Mail had been built along the fifteenth-century wall of Charles V. However, nineteenth-century regulations demanded that any subsequent constructions be set back from the street. The positioning of number 23 conforms to that ruling. Decorated with stone, this industrial building has a metal structure, which provided support for the combined weight of the pianos and harps that were assembled here.

57
Ancienne salle de concert

The piano dealer Sébastien Erard began his business in 1781 at 13, rue du Mail, where he had a home, a showroom for pianos and harps, and a concert hall. The auditorium opened onto a street that was then known then as *petit chemin herbu* (the small grassy way), but which we now know as rue Paul Lelong. The Erard reputation attracted numerous artists to this hall, including composer and pianist Franz Liszt, who lived next door on rue du Mail.

58
Hôtel de Rambouillet

As the city of Paris evolved, so did this house. Originally built for Général Nicolas de Rambouillet, seigneur de La Sablière, this residence has a side façade at rue Vide-Gousset, but faces the royal square, place des Victoires. It was transformed to fit in with this new royal place as was the mansion across the street, the now-defunct Hôtel de Pomponne, which was destroyed in the nineteenth century when rue Etienne Marcel was opened.

59
Agence France Presse

Claiming authority as the world's oldest established news agency, Agence France Presse's worldwide network gathers today's news from 165

countries and distributes it from this building to newspapers, radio, television, and other national news media. The second arrondissement, known as the financial center of the city, also carries the reputation as a center for communications, which expanded in this area as commercialism grew.

60
Café le Croissant

This nondescript nineteenth-century café distinguishes itself by its early twentieth-century history of political intrigue. A marble plaque hanging outside and a bust inside attest to its having been the scene of a political assassination. Opposed to war with Germany, socialist Jean Jaurès was murdered while dining at Café le Croissant in 1914, three days before the declaration of war.

61
118, rue de Réaumur

In his metal, glass, and stone building, architect Charles de Montarnal cleverly intermingled material, creating flourishes of Art Nouveau motifs with classic lines. He achieved a solid yet playful design with an ironwork inset bordered by stone. The result defies gravity with its weightless appearance.

62
124, rue de Réaumur

This unusual glass-and-metal building is a visual delight. Though it incorporates elements of Art Nouveau, its façade suggests a creative, futuristic vision. It is most likely the first building in Paris to eliminate traditional stone construction. Iron supports on the ground level sinuously branch outward and upward to meet a linear, riveted-metal framework, and then extend to become part of the building's narrow windows. Finally, the design reaches out three-dimensionally to bay windows supported by consoles.

63
121, rue de Réaumur

The central three floors of this metal structure are designated for commercial and industrial activity, with additional floors above for residential housing. The graceful curves and flowing lines of the bay windows on the façade give this building distinction and elegance. The complexity of decoration is intriguing, given the industrial nature of the workshops here.

64
Au Panetier

No wonder regulars line up morning and evening outside Au Panetier for their daily bread. It's hard to pass by the green-lacquered Belle Epoque façade without pausing to inhale the aroma that wafts onto the street. Inside, while you wait for one of the best baguettes in town, you can gaze at the shop's Art Nouveau tile and etched-glass interior, which features murals of exotically feathered birds. At dawn, Au Panetier bakers fill their 100-year-old, wood-fired ovens with eight different kinds of dough to create their quotidian supply of loaves. Like any decent Parisian bakery, this fin de siècle boulangerie also offers cookies, tarts, quiches, and sandwiches.

65
Chambre De Commerce

This former auction house became the headquarters of the Chamber for Paris Commerce and Industry in 1853. Inspired by Italian architecture, the building rises two stories over a rusticated ground floor on place de la Bourse. The arched entrance gives way to a main staircase. Jules Lisch constructed the courtyard addition and then extended this façade on rue Notre-Dame-des–Victoires. Based on a drawing by Eugène Grasset, Félix Gaudin created this interior stained-glass window in 1900. By 1927, the building became too small for the Chamber, which moved to the former Hôtel Potocki on avenue Friedland. Today, an annex service monitors control of gemstones from this site.

66
Le Rex

This landmark temple to the silver screen, with its atmospheric Art Deco marquee, stretches to the stars. And on December 8, 1932, 3,500 blazing lights announced its presence on the corner of boulevard Poissonière and rue Poissonière. The structure required 20,000 tons of cement, plaster, and sand, and about 1,500 tons of steel. Possibly the largest cinema in Europe when constructed, its baroque interior recalls an era when moviegoing was an experience beyond the latest film. It houses a Grand Hall and bars and foyers on three levels, and has a seating capacity of 2,750 people: 990 in the orchestra, 490 on the mezzanine level, and 1,270 in the balcony. Its monumental proportions extend to the screen, nearly sixty feet high and over forty feet wide. This gigantic screen is surpassed only by the awesome stars rotating above your head.

67
13 &15–17, rue d'Uzès

When it was constructed, rue d'Uzès replaced a beautiful hotel belonging to Claude-Nicolas Ledoux dating from 1768. Opening to the street, with a monumental portal and two triumphal columns, the entrance of its main building was flanked with statues in the style of ancient temples. After the Revolution, which frowned upon such opulence, no one could afford to maintain such property. So, the huge land parcel from rue Montmartre to rue Saint-Fiacre (250 meters long) was sold and, in 1870, textile works and printing presses moved in. Number 13 is the headquarters of a publishing group. Iconography relating to the news business and prosperity decorates the façade. The building at 15–17 is the main office of the Moniteur group, which specializes in books about construction and architecture. Its façade employs traditional motifs to symbolize abundance.

68
House of André Chénier

In 1793, a year before he was guillotined, poet André Chénier (1762–94), a forerunner of the Romantic poets, lived in this narrow, corner building, the meeting point of two streets that once bordered the wall around Paris. Falsely accused of writing in defense of tyranny, Chénier was executed three days before Robespierre's death ended the Reign of Terror. Chénier's life inspired a Victor Hugo poem and Giordano's opera Andre Chénier.

69
Ancien Hôtel Masson de Meslay

For the past two centuries, the manufacturing activities within studios in the main courtyard have damaged neighboring buildings. Nonetheless, the wonderful portal of this hotel, with its Rococo pattern, has survived quite well. The gate was shaped to help carriages ease into the courtyard from a street overcrowded with textile plants. Once inside the hotel courtyard, you'll find the ambiance of the nineteenth century, a rarity in the midst of the second arrondissement's industrial nature.

70
174 & 176, rue Saint-Denis
(Maisons a Pignon)

These gabled houses were common con-structions until the sixteenth century. Only around twenty gabled houses still exist in Paris today. These were narrow, connected, one-family homes; each gable represented a different family. A pattern of odd angles and jutting extensions mark layers of time. The ground level of these buildings accommodated commercial enterprises, above which businessmen lodged in one room, while a loft served as their stockroom.

71
Passage du Grand-Cerf

This passage derives its name from a hotelier that had stood next to it in the first part of the nineteenth century. The highest, glass-covered passage in Paris, Passage du Grand-Cerf is almost forty feet tall. Constructed on this site by an unknown architect, the arcade has a light neoclassic decoration and metal structure that covers two floors and an attic.

Restored in 1989, the *passage* connects the very hip Montorgueil quarter with the old Saint-Denis area filled with sex shops.

72
51, rue Réaumur

Distinguished by its original lantern dome, this is one of two Art Nouveau buildings constructed by food magnate Félix Potin. Today, the much-altered ground level houses a Monoprix store, but the upper portion retains the flavor of its earlier days. Its neo-Baroque style features cornices with abundant carvings of fruit garlands and caducei, and portends prosperity. Reflecting the bounty of Hermès, the god of commerce, the exterior décor is an exuberant testament to the heyday of the grand department stores.

73
10-12, rue des Petits-Carreaux

Mid-nineteenth-century manufacturing re-discovered ceramics and its esthetic application as a material to decorate interiors of commercial establishments, especially cafés. Many of these ceramic-tiled paintings depicted exotic or imaginary landscapes. Registered as a national historic landmark, the front of this building has a dilapidated wood façade with a painted ceramic sign. This one depicts a colonial scene from a foreign land: an indigenous character deferentially serving coffee to his cushion-seated Western master.

74
61-63, rue Réaumur

One of the only modern buildings on the south side of rue Réaumur, formerly rue Thévenot, this monumental building is inspired by Gothic architecture. A medieval church portal marks the entrance, and a giant clock that resembles a rosette surmounts the geminated windows. Sculptor F.-A. Jacquier decorated the building with carvings of the Four Seasons, the twelve months, and zodiac signs. An industrial textile firm still operates from the premises.

75
82-92, rue Réaumur

This imposing building stands at the site of the old department store, À Réaumur, whose builders deliberately designed a lengthy façade to maximize the visibility of the enterprise. As the first department store in the second arrondissement, the building still serves as a symbol of power within the textile industry. Its metal construction uses stone on the façade for added prestige. Today, wholesale clothing dealers operate from the premises, where multicultural accents abound along with the clothes.

76
Tour de Jean-Sans-Peur

After he ordered the assassination of his cousin, the duc Philippe d'Orléans, Jean-Sans-Peur, the duc de Bourgogne, climbed up a spiral staircase to a room in this tower that he had had the foresight to build for his own protection. Despite his precautionary measures, this tower proved a only temporary hideaway, as he was murdered eleven years later. An example of feudal architecture, the south façade and tower originally ran along the wall built by Philippe Auguste, as part of the Hôtel de Bourgogne.

77
10, rue Tiquetonne

This building is notable for its iron sign: L'Arbre à liege. One of the oldest extant signs in the city, its image of the cork tree dates from the seventeenth century. Commonly used between the thirteenth and the sixteenth centuries, these decorative devices designated the commercial trade of a building's occupant and served as a means of identifying a home address before the numbering system appeared in the eighteenth century. Ceramic signs eventually replaced the iron ones.

78
13 & 15, rue Tiquetonne

Named in the fourteenth century for Rogier de Quinquetonne, a rich baker who lived in the

neighborhood, this street follows an old route outside Philippe Auguste's ancient bulwark. Today, beautifully restored seventeenth- and eighteenth-century residences line the street. Hidden in a courtyard, the main building of number 15 has high, stone-framed windows and a triangular pediment above the dormers, elements all of the Louis Treize style.

79
Au Rocher de Cancale

In the old market days of Les Halles, rue Montorgueil was an artery along which fish merchants from the north hawked their wares to buyers from the local restaurants. The fishermen have since packed up, put their fish on ice, and now sell it south of Paris, but restaurants and merchants still spill out onto the lively rue Montorgueil, offering a wide range of seafood and its savory culinary necessities. Au Rocher de Cancale, in the same location since 1850, provides sidewalk service and, inside, its pale mustard-color walls and wooden-beamed ceiling make for cozy dining. The exterior ground-floor level is finished in a soft green and still has the original sign from 1850, while other decorative details date from the end of the nineteenth century.

80
Parti Socialiste

That a leftist political party should set up shop on this corner seems downright anachronistic, especially given the area's recent gentrification: bars, bistros, sidewalk cafés, news kiosks, fashion boutiques, and *traiteurs* spill out onto the street—all modern reminders of the legendary days of the all-night Les Halles marketplace. But the presence of the Parti Socialist expresses its long-held position that, even in this popular neighborhood, workers have traditionally earned low wages.

81
La France

Etched into the stone ledge of this building is the name of the old evening journal, La *France*. Four allegoric stone statues—two of Atlantis and two caryatids (representations of journalism and typography)—support this ledge and the balcony above it. In 1836, Emile de Girardin, a famous journalist of the nineteenth century, established a press presence in the second arrondissement with a publication called *La Presse*. In 1876, he created *La France*, a daily newspaper for the masses.

82
Galopin

With his pulse on the heart of commerce and news, Gustave Gallopin opened his brasserie in 1876 to deal makers and media types. An interior mix of French Art Nouveau and English Victorian décor sets the stage for business transactions. Colorful stained-glass panels, copper beer pumps, brass railings, and mirrors, along with black-vested and white-aproned waiters, contribute to the ambience.

83
La Tribune

A twentieth-century, metal-and-glass contraption plunked down in the midst of nineteenth-century Paris seems an anachronism. But this symbol of technology reinforces not only the continuation of journalism's role from the past to the future in reporting world events, but also the historic evidence of the press as having taken a hand—along with the financial aspect of the quarter—in shaping the character of the second arrondissement.

84
One, rue Leon Cladel

Broad windows and an imposing corner angle give this building a commanding presence on the block. Though the sides are an uneven width, it has well-balanced proportions. Typical of the nineteenth-century corner construction that marked streets, this building hovers over rue Leon Cladel and rue Montmartre. It serves as headquarters for SAEMES: Le stationnement

de la ville de Paris, a quasi-public company that operates parking facilities for the City of Paris.

85
167, rue Montmartre

Constrained by old rules, architects were slow to use modern material for apartment construction, especially in the façade. A new law in 1882, however, allowed for balcony projections of up to eighty cm (2.63 feet), thus permitting more liberty and imagination in façade design. Bay windows brought more light into apartments and became quite common, and metal was emphasized as a noble material. Architects finally had more artistic freedom of expression, as demonstrated by this building.

86
101, rue Réaumur

This elaborate building is typical of imperious nineteenth-century structures that distinguished corners. The high dome, the ornate iron balconies, and the caryatids and the other carved-stone window detailing all contribute to the impressive edifice. In addition, the massive Corinthian pilasters that create a rhythm to both sides of the façade enhance the grandeur of the construction.

87
Hôtel de Mantoue

Following the traditional French Academy route to Italy—a move started by Louis XIV to emulate what he thought was the ideal—this architect attempted an imitation of an Italian Beaux Arts model, but without much success. Formally known as Hôtel de Mantoue, this building replicates the ornamentation of the Mantoue Palace in Italy. Were it not for the placement of decorative stone statues in niches on its façade, this otherwise nondescript building would not catch your attention.

88
Passage des Princes

Though originally conceived and named to honor a brilliant businessman, Mirès, who made his fortune in the news and finance trade, this *passage* no longer honors him. In 1859, the bank of Mirès and Cie bought the old Grand Hotel des Princes and de l'Europe, an 1807 European palace at 97, rue Richelieu. They bought another building nearby to allow for the passageway and a courtyard. But, disgraced in 1861, Monsieur Mirès spent five years in prison and the *passage* was renamed. Passage des Princes marked the end to such structures' construction, at least in Paris. From 1990 and 1994, the *passage* was restored, and is today devoted to children's stores.

89
Commercial Building

This Belle Epoque structure is typical of commercial and industrial buildings constructed in the second arrondissement during the late nineteenth century. An ironwork window grid bordered by stone pays homage to the turn-of-the-century technology and the future of the Industrial Age. This building and others like it housed warehouses and studios and introduced new principles of architecture. Using metal framing created advantages in construction, obviating extra wall partitions and permitting work in open spaces with an optimal penetration of light. The iron and glass composition balances the stonework, producing a harmonious façade on the street.

90
Théâtre des Variétés

To see-and-be-seen was the entertainment in the nineteenth century, the golden age of theater. Hortense Schneider wowed them here at Théâtre des Variétés, in her 1864 performance of the leading role in Jacques Offenbach's *La Belle Hélène*, and again in 1867 as the star of his *La Grand Duchesse de Gérolstein*. This building alone must have provided theatergoers with considerable visual interest, from the play of shadows on its neoclassical, receding façade, to its imposing Doric and Ionic columns.

Maty carries on this glittering tradition.

105
Palais du Hanovre

In 1926, architect Lemaresquier, a traditionalist, collaborated with Victor Laloux, father of the Gare d'Orsay, in building one of the rare Art Deco complexes in Paris. The fluted pillars recall the giant columns of Laloux's earlier work, giving this corner building an angled rhythm that seems to undulate along both sides of the street. The building rests on the site of the former place of the pavillon du Hanovre, built by architect Chevotet in 1758 for the duc de Richelieu.

106
Crédit Lyonnais

In the late nineteenth century, banks established their presence—physically and financially—as active participants in the city's growth, especially in the second arrondissement. Inspiration for the grand style of this bank's central façade derives from the Louvre. Three mysterious fires have recently damaged part of the bank but it has since been restored.

107
4–6, rue Gaillon

This austere building, that once belonged to Prince Sulkowski, typifies a nineteenth-century transformation of an eighteenth-century building. The original eighteenth-century stories are stone, while the upper level is a nineteenth-century construct: painted plaster in a Rococo pattern. The loose stonework framing the double doorway contrasts with the iron grillwork over the ground-level windows, a later addition from the nineteenth century. The banister of the interior stairs carries through the ironwork décor of this renovation.

108
Place de la République

Slicing through a web of medieval alleyways and streets, the nineteenth-century city planning of Baron Haussmann opened up broad vistas and brought uniformity to the city. His ambition had both aesthetic and practical application: In the case of place de la République, he transformed the old crossroads of Château-d'Eau at the northeastern edge of the third arrondissement, to create speedy access to the train stations and boulevards. He also commissioned architect Legrom to develop Vérines Barracks, which provided adequate housing for the occasional troops needed to quell worker rebellion. Davioud was hired to put up a similar building opposite it, for symmetry. In 1883, the Morice brothers sculpted the giant statue of the Republic that lords over the square representing Liberty, Equality, and Fraternity. Today, following tradition, political protesters gather at place de la République as their departure point, then march to the Bastille.

109
Hôtel de Montrésor

Originally developed in the mid–seventeenth century as two adjacent residences, this property probably was remodeled about one hundred years later. A classic triangular pediment, added circa 1742, encompasses the doorway to number 54 where Claude de Bourdeille, the comte de Montrésor, lived. Iron balconies added Rococo cartouches and consoles to the façade, for a surprising contrast. The entry to number 52 remains unchanged.

110
Hôtel de Rohan

Armand-Gaston-Maximilien de Rohan Soubise—son of Prince Soubise, and then himself bishop of Strasbourg and a future cardinal—decided to build a residence around the corner from his father's home, with the help of the family architect who had designed both the Hôtel de Soubise and Hôtel de Rohan. While the courtyard façade is rather modest, the garden façade is larger and more elegant, with columns and statues. Four successive Cardinal Rohans occupied this family home.

7, rue Saint-Gilles

Reverting to tradition while introducing modern functionality, the architects deliberately created recesses, open spaces, and courtyards that were reminiscent of the Marais before Haussmann's uniform realignment of the streets. They also incorporated classic material and design elements to evoke the spirit of this ancient district. Inspired by place des Vosage, they created a deceptively simple brick façade, with a traditional, triangular-shaped pediment.

112
Hôtel d'Héroët

Until 1965, *hôtels* in the Marais quarter were routinely destroyed without regard to the district's historic significance. Most of these buildings were damaged when used for industrial purposes in the nineteenth century. Finally declared a protected quarter in the 1960s, the Marais now preserves and restores its townhouses. Almost completely reconstructed after World War II, this sixteenth-century *hôtel* barely resembles its original building, although it has retained its corner tower.

113
Musée Carnavalet

This museum houses everything from priceless treasures to the mundane: Napoléon's cradle, Proust's bedroom, Renaissance portraits, Revolutionary memorabilia. It also contains an Art Nouveau shop. Devoted to the history of the City of Paris from its origins to the present, the Musée Carnavalet divides its collection between two adjoining mansions: Hôtel de Carnavalet and Hôtel Le Peletier de Saint-Fargeau. From 1677 to 1696, Madame de Sévigné, for whom the street is named, lived in and had a salon at the Hôtel de Carnavalet. Today, that building showcases the evolution of Paris and its artifacts from prehistory to the eighteenth century. The other hotel displays the city's modern history. Around 1660, Mansart modified the façade but retained its detailed, Renaissance portal, which Lescot

probably sculpted with help from his students.

114
Hôtel de Soubise

In the days of horse-drawn carriages, this hotel accommodated guests with its recessed entry off rue des Francs-Bourgeois. Through this gate, a huge U-shaped colonnade borders Hôtel de Soubise's forecourt and leads to its stately inner façade. On the ground floor, double columns support a second level of sculptures, more paired columns, and a pediment decorated with seated sculptures on top. The original statues are the work of Robert Le Lorrain. To the left of this façade, two medieval turrets arise from the old Hôtel de Clisson, the previous *hôtel* on this site. Keeping the old, high roof behind the new one expressed family prestige. Today, the Musée de l'Histoire de France occupies the property.

115
Pharmacie des Francs Bourgeois

Inset into a simple building façade, next to the plain wooden-arched entry, this graffiti–spray-painted storefront stands in sharp contrast to the rest of the structure, adding an element of humor to an otherwise nondescript building. Pharmacie des Francs Bourgeois has changed ownership over the last two centuries, but has remained a pharmacy since 1820.

116
Hôtel d'Alméras

A grand Mannerist pediment marks the street entrance to this early seventeenth-century building. Hung above the double doors, like curtains rising on an elaborate stage setting, it presents a stately and balanced composition, opening onto a forecourt and garden. The inner building construction is brick and stone, and contains a staircase dating from the time of Henry IV.

117
Hôtel Salé (*Musée Picasso*)

Derisively dubbed "the salted *hôtel*" by Parisians after its first owner, Pierre Aubert de Fontenay,

who collected salt taxes, this magnificent mansion today houses the Picasso Museum. Fontenay was the object of royal envy as well, and ran afoul of the monarchy. He lost his luck, his fortune, and his connections when the Sun King's treasurer, Nicolas Fouquet, lost his. Fontenay died before seeing his residence completed.

118
Hôtels Particuliers *(Private Mansions)*

Voltaire once observed that the abundance of opulent *hôtels* in Paris gave Parisians a measure of comfort "unknown to our parents and not yet attained by other nations." His reference was to private middle-class homes—not guest hotels—though the terms "hotel" and "hostel" are derivative. With the rise of the bourgeoisie, moderate homes were commissioned that emulated the *hôtels particuliers*, or private mansions, of the aristocracy. Constructed in a style referred to as *entre cour et jardin*, these *hôtels*—built between an entrance courtyard and a garden—usually featured a main building and wing extensions, but could be much grander with multiple additions. Sometimes several families, as well as servants, occupied the various buildings and suites.

Depending on the monetary position of the family, the architecture of middle-class *hôtels* varied in design and in the size of the land parcel. Often, rooms were rented out to subsidize the construction. Typically, there were commercial shops on the ground floor, along with the kitchens for the homes above, and servants brought food up main and secondary stairways—a classic "upstairs-downstairs" arrangement. Over time, many of these private homes evolved into rental units, and the word "*hôtel*" began to take on its more conventional modern-day meaning. In Paris, the term has now become almost completely interchangeable, referring sometimes to an old mansion and sometimes to a temporary lodging for tourists.

Hôtels particuliers are abundant in the Marais quarter that spans the third and the fourth arrondissments. In the 1960s, when writer André Malraux was Minister of Culture under Charles de Gaulle, he not only gave Paris a facelift by washing off centuries of grime and coal soot, but he also initiated "Malraux's Law." The Marais was a chief beneficiary of this 1962 edict, which in effect declared whole districts as historic sites, not just individual buildings. Malraux's decree preserved the historic character of the district before too many *hôtels* were reduced to rubble.

119
Hôtel Le Peletier de Saint-Fargeau

Part of the Musée Carnavalet, the Hôtel Peletier de Saint-Fargeau presents the history of Paris from the Revolution to the present day. Viewed from these gardens, the pediment depicts an allegory of Time, and its orangerie features a sculpted pediment of Truth. The gardens face Square Georges-Cain, where the Musée Carnavalet has unloaded its stash of old stones and statues of historical significance.

120
Hôtel de Clisson

Olivier de Clisson, Constable of France in 1380, built a large medieval mansion on this site in the fourteenth century. In the 1550s, the duc de Guise acquired the property and hired Italian artist Nicolo dell'Abate to decorate it. Subsequent owner François de Soubise transformed the complex of which only the tower portion survives. This section, ornamented by a pointed, arched entry gate and rounded turrets, was integrated into the Hôtel de Soubise, thus perpetuating its medieval appearance.

121
Hôtel de Guénégaud
(Musée de la Chasse et de la Nature)

The City of Paris bought this dilapidated property in 1961 and leased it to Société Sommer for ninety-nine years. The society restored the residence to its former elegance. It has simple lines and a well-proportioned façade, in a severe style without decoration. The grandeur of the

place rests on its stone staircase that—supported by stone vaulting—is so light it appears aerial. The hotel's elongated windows give the house a see-through effect, visually connecting the public courtyard with the private garden.

122
Hôtel d'Hozier
Modifications and multiple ownerships often mask the original structure or alter the characteristics of Parisian homes, referred to as *hôtels*. Architect Thiriot completed this *hôtel* in the brick and stone style of Louis Treize in 1623. About a hundred years later, Denis Quirot altered the street entry. A nineteenth-century modification changed the street front with the addition of one floor. Somewhere beneath the restored surface, the original brick and stone façade from Thiriot's seventeenth-century *hôtel* lies hidden.

123
Hôtel de Montmort
Jean Habert de Montmort, whose name the hotel retains, built this seventeenth-century residence, but then Laurent Charron restructured it in the style of Louis Quinze in the mid–eighteenth century. A sculpted mask, supposedly of Charron's wife, decorates the reverse side of the grand portal on rue du Temple. This entryway gives access to two inner courtyards, one of which was a garden, probably added in 1840 along with the buildings in the second court.

124
Théâtre Libertaire de Paris Déjazet
In 1786, Théâtre Libertaire de Paris Déjazet began life as a royal tennis court for Count d'Artois. Since then, its incarnations have included bathhouse, ballroom, and follies theater. Before Haussmann demolished buildings in his town planning campaign, boulevard du Temple was a swinging area with theaters galore. Happily, the wrecking ball stopped short of this theater, which actress Virginie Déjazet acquired in 1856 and named after herself. It remains a theater.

125
Hôtel Mégret de Sérilly
The name of this hotel derives from a tax farmer, Jean-François Mégret de Serilly, who purchased it in 1786. Its original stone and brick design is in the style of Louis Treize, but the street façade is a late eighteenth-century alteration. A pediment adorned with two lions hangs over the street gatehouse entrance, and a garden façade faces rue de Thorigny.

126
Ecole Primaire Communale de Jeunes Filles
Originally, a small hotel constructed over an ancient playing field existed on this site and was sold to architect Nicholas Blondeau in 1642. It passed through several hands before Charles Bernard acquired it, and it remained in the Bernard family until 1712. By 1881, the City of Paris had purchased it and replaced the hotel with a primary grade school for young boys. The decorative façade is divided by vertical pilasters composed of stone, brick, and metal. Bands of color on the bricks accent the floor divisions, piers, and windows.

127
Musée de la Poupée
Musée de la Poupée (The Doll Museum) exhibits about 500 dolls—of various materials—from 1800 to 1919 in period settings. The growth of the doll industry coincided with the rise of commerce and the economic fortunes of the Third Republic, toward the end of the nineteenth century: Jumeau, a leading French porcelain doll manufacturer, produced about 10,000 dolls in 1878. By the turn of the century, that number exploded to about three million and included *Parisiennes* (French fashion dolls).

128
Théâtre Molière Maison de la Poésie
Jean-François Boursault-Malherbe, a former lawyer who became an actor and director of theaters in France and Italy, profited from a 1791 law that

allowed any citizen to open a public theater. He inaugurated this theater under the patronage of Molière and staged *Le Misanthrope*. The former Passage des Nourrices thus became Passage Molière. In the 1990s, the City of Paris bought the theater—in a state of total ruin by then—and rebuilt everything as it had been in the eighteenth century.

129
Théâtre de la Gaîté-Lyrique

In the glory years of grand theater, this was one of several that welcomed Jacques Offenbach's productions, and also played host to the Ballets Russes under its directorship of Sergey Diaghilev. Balanced by two linear side buildings, the theater—no longer in existence—was contained in the arched-windowed, central portion of this huge structure.

130
Fontaine de Vertbois

A remnant of the fortified wall from the priory of Saint-Martin-des-Champs, this fountain survived the Revolution. According to its inscription, it was restored along with the adjacent tower in 1882 by the state, "in accordance with the wishes of Parisian antiquarians."

131
Conservatoire National des Arts et Métiers

A tower from Saint-Martin-des-Champs—a thirteenth-century Benedictine monastery—rises from the corner of rue Saint-Martin and rue du Vertbois. When demolition loomed, Victor Hugo saved it with his words: "Demolish the tower? No! Demolish the architect? Yes!" This tower and a fountain survive as relics of the fortified wall of the former abbey.

132
Timber House

In the sixteenth century, in the interest of fire prevention, Parisian city regulations ordered the use of stone for house façades, in place of wood. This half-timbered fire hazard, once thought to be the oldest house in Paris, actually managed to survive since the seventeenth century—proof that the restrictions were regularly ignored. (Often, buildings' original wood façades were merely covered by plaster, even after the late eighteenth century, to fake compliance with the law.)

133
Marché du Temple

The marketplace of a twelfth-century Temple complex—a walled city within a city—this belonged to the Knights Templar, who derived great wealth from its activities. Philip the Fair dissolved it in 1307, but activity continued under its rotunda and arcades that housed four wooden halls known as the "Old Clothes" market. Transformed into a prison during the Revolution, the original tower on the Square du Temple for a time held captive Louis XVI and his royal family: Marie-Antoinette, the Princess, and the young Dauphin. The king remained in the tower until his execution; Marie-Antoinette stayed for a year before her transfer to the Conciergerie; the Princess was there until her exchange for Republican prisoners, and the Dauphin withered away in an isolated cell until his supposed death. In 1863, Napoléon III demolished both the rotunda and the Temple towers.

134
Musée d'Art et d'Histoire du Judaïsme
(Hôtel de Saint-Aignan/Hôtel d'Avaux)

Devoted to Jewish heritage, this museum showcases the Diaspora and features such objects as Torah scrolls and marriage certificates. Along with paintings by Chagall, Soutine, and Modigliani, it displays a wooden sukkah and furniture from an Italian synagogue. Built in 1644 for the comte d'Avaux, *surintendant* of finances for Mazarin, this townhouse has classic broad proportions, carved pilasters, a mansard roof, and courtyard gardens. Paul de Beauvilliers, duc de Saint-Aignan, acquired the hotel in 1688. In 1792, it became

a town hall where, four years later, Napoléon Bonaparte married Joséphine de Beauharnais in a civil ceremony. From 1842 onward, it declined and eventually became an investment property, with shops and craft studios at which photographer Eugène Atget photographed immigrant Jewish craftsmen. In 1986, Jacques Chirac decided to convert it to a museum of Judaism.

135
Eglise Sainte-Elisabeth

Marie de Médici founded this convent of Franciscan nuns in 1628. As happened with many other Parisian buildings, additions and alterations shaped changes in this structure over centuries. Early seventeenth-century Doric columns support an upper level of Ionic columns in a classical façade, which features four nineteenth-century statues set into niches and a pièta carved in the tympanum above the entrance. When it was originally built in the first part of the seventeenth century, the church had only one aisle; a second was added early in the nineteenth century but was destroyed during road construction mid-century. Additional modifications included construction of a nave and choir, completing this amalgam of centuries.

136
IRCAM

(Institut de Recherche et de Coordination Acoustique-Musique)
IRCAM, an acoustic music research institute created by Pierre Boulez, has the same objective as its administrative parent, the Centre Georges–Pompidou: to provide a public "window" to contemporary art. In a dual role, IRCAM promotes and supports high technology research within the industry, and it produces concerts and workshops for the public. Out of deference to nearby housing and respect for the scale of the neighborhood, the aptly named architect Piano placed most of the music studios underground, within this brick and metal annex to the Centre Georges–Pompidou.

137
Centre Georges-Pompidou

Like a shirt worn inside out, the Centre Georges-Pompidou shows its seams. In a bold and controversial move, the architects relegated all normal building infrastructure to the outside of the complex: Launch-pad–like metal scaffolding wraps around the outside of the rectangular building and provides structural support. Exposed ductwork contains the building's mechanical systems, with different colors for water, heating, electricity, and air. A great escalator enclosed in glass tubing inches up the side of the building like a caterpillar, revealing an exciting view of Paris. A meal on the rooftop is worth the trip alone. This colorful complex of external guts is itself an exhibit. Inside, you'll find twentieth-century art in the Musée National d'Art Modern on the fourth floor, a center for industrial design, a concert hall, a public library, a video shop, and TV rooms.

138
Syndicat de l'Epicerie et de l'Alimentation Générale

This austere building marks the last period of Haussmann architecture that mixed many styles to fight against homogeneity. The huge arches retain the traditional shape of commercial buildings, on this headquarters for the trade union that governs grocery and food stores. Sharing the building, Théâtre du Renard, founded in 1791, was the theater used by Jean-Jacques Rousseau's company.

139
Hôtel de Berlize

The original home was built for Guichard Faure with a main building, left wing, and an entrance on rue Pierre au Lard. In 1640, Nicolas Faure expanded it with an additional parcel of land on rue du Temple. Then, he changed the entrance to the street and built two rental houses on each side, partly to finance the project. He turned the logic of the hotel upside down: The old garden became the courtyard, and the courtyard was transformed to a garden with a new wing on its side.

140
Hôtel Le Rebours

Located near the Centre Georges-Pompidou, this stately mansion, in Louis Seize style, spreads out around a courtyard. Jean Aubery occupied the home in 1624, and then it belonged to Thierry Le Rebours. The main façade was changed in 1737, and the entire building is an accumulation of many periods. But part of the picture is missing, namely the nineteenth-century industrial occupation of the building. When the Marais was declared a historic district, those who restored it totally erased its industrial past, simply because it wasn't noble enough for them. It is virtually impossible to piece together the *hôtel's* history from that lost era.

141
Cloître des Billettes

The story goes, in the late thirteenth century, when a profaned wafer gushed forth blood on this very site, the miracle led to the construction of an expiatory chapel, la Chapelle du Miracle. Later in the fifteenth century, the convent of the Brothers of Charity occupied the premises. In 1758, the Carmelite Order of the Billettes built the current church, which became a Protestant sanctuary in 1812 and survived the Revolution with its inherited, medieval cloister intact. Completed in 1427, this late Gothic, pillared cloister is the last of its kind in Paris.

142
Ecole Maternelle

(House for the family of Jacques-Coeur)

Today, children frolic on the premises of one of the oldest brick-and-stone homes in Paris. The house, converted to a day care center, at one time belonged to the granddaughter of Jacques-Coeur, silversmith to Charles VII. (Jacques-Coeur, or perhaps his son, may have once owned it, but no records exist to verify such assumptions.) The lower portion is stone; the upper, brick, was used as a building material for the first time in the Paris. The slanted rooftop is capped with tiny dormers.

143
Notre-Dame-des-Blancs-Manteaux

Rue des Blancs-Manteaux honors religious beggars who followed Saint-Louis to Paris in 1258 and wore white mantles *(blancs-manteaux)*. The Guillemites, or brothers of Saint-Guillaume-de-Malval, who wore black robes, assumed control of the church a few decades later but not the name of the street. In the seventeenth century, the Benedictines occupied the site and built the present church, but the façade itself is a construct from the Barnabite church on Île de la Cité, which has been destroyed. In 1863, Victor Baltard relocated the façade to its current place on rue des Blancs-Manteaux, to become part of this church.

144
Hôtel Amelot de Bisseuil

In 1776, playwright Pierre-Augustin Caron de Beaumarchais threw a party here in support of the American Revolution and supplied arms to the cause, in a secretly financed deal with the Spanish and French governments. Beaumarchais also completed his famous drama *Le Mariage de Figaro* at this *hôtel*. Named for its original patron, Jean-Baptiste Amelot de Bisseuil, this magnificent Marais mansion is also referred to as the Hôtel des Ambassadeurs de Hollande, after an eighteenth-century Dutch ambassador who had resided here. Though closed to the public, the portal facing rue Vieille du Temple is visible, and worth a visit for its relief sculpture of War and Peace by Thomas Regnaudin.

145
Hôtel de Châlon-Luxembourg

Medieval weavers once plied their trade in workshops along this street. In the early seventeenth century, Guillaume Perrochel, treasurer of Paris, built this *hôtel*, then sold it in 1659 to madame Béon-Luxembourg. The elegant portal, with its scalloped stone carving featuring a lion's head, dates from this period. Converted

to apartments in the nineteenth century, the mansion is of brick-and-stone construction with a steep roof. Gabriele D'Annunzio rented the first floor between 1914 and 1915, and the *hôtel* was dubbed "the thousand *bouddhas* house" because he was crazy about small trinkets, especially Buddha statues. The Institut d'Histoire de Paris currently occupies this stately residence.

146
11–13, rue François-Miron
Among the few remaining timber-framed houses that survive in Paris today, these two restored homes recall the Middle Ages, when gabled houses faced the street. In the early sixteenth century, an edict prohibited such frontage and stipulated that plaster cover any timbered framing to minimize the potential fire hazard these homes created. Almost a century later, a new regulation mandated that stone replace the wooden façades.

147
Hair shop
This quaint hair salon, wedged into the corner on the ground level between two nondescript buildings, looks lost in time. Dwarfed by the two stone buildings, it resembles a doll's house with curving window trim and wood paneling.

148
Synagogue
Constructed from adobe stone and reinforced by a concrete structure, this synagogue for a Jewish community of Russian-Polish descent is a model of balanced and composed Art Nouveau styling. The curved rooftop gently undulates above the façade, recalling a simple temple dome, and mimics the wave-line of the portal below. Playing with shadow and light, the slender horizontal lines add dimension to the façade, while the narrow, top-rounded, double windows resemble the shape of the stone tablets from Sinai.

149
Hôtel d'Aumont

In 1957, the City of Paris restored this building. This magnificent façade is visible from rue Nonnains-d'Hyères. François Mansart originally decorated the home for Michel-Antoine Scarron, and then his son-in-law, duc Antoine d'Aumont, mayor of Paris, moved in and remodeled it in 1657 with décor enhancements by Charles Le Brun. The Le Brun ceiling still survives.

150
Hammam Saint-Paul *(Turkish baths)*
In 1856, the Société des Israélites polonais de la loi rabbinique occupied this place; next, a *hammam*. From Polish Jews to Turkish baths, the strange destiny for this nineteenth-century building awaited yet another odd turn: a luxury shop opened here in 1991.

151
Place des Vosges
Place des Vosges, known as place Royale in the seventeenth century, was a favorite spot to determine one's fate by the sword. Celebrations of a more noble cause also graced this royal place. In 1612, the double wedding of King Louis XIII to Anne of Austria, and of his sister Elizabeth to Philip IV of Spain, inaugurated this open-air square—the oldest of its kind in Paris. As first conceived in 1605 during the reign of Henry IV, its façade borders an open-air square on all sides, anchored by the King's Pavilion (*Pavillon du Roi*) on the south end and the Queen's Pavilion (*Pavillon de la Reine*) on the north side. The resultant uniformity has survived to this day even through turbulent times, though the Revolutionaries melted the square's original Louis XIII statue.

152
Hôtel de Lamoignon
In a determined effort to enforce his ban on dueling in place des Vosges (then place Royale) in 1626, Cardinal Richelieu ordered the execution of two who defied his orders, and promptly displayed their severed heads and bodies in the main hall of Hôtel d'Angoulême. Originally built for Diane

de France, duchesse d'Angoulême, it became Hôtel de Lamoignon in 1688 when president of the parliament of Paris, Chrétien-François de Lamoignon, resided there. Additions and remodeled wings have altered the mansion since its early owners occupied it. The overhanging turret on the corner dates from 1624, and the decorative portal featuring two putti dates from 1718. The City of Paris acquired this building in 1928, but restored it only in the 1960s in order to house the Bibliothèque Historique de la Ville de Paris, the history library of Paris.

153
Saint-Paul–Saint-Louis

The name of this church derives from a double dedication: first, to Saint-Louis and second, to Saint-Paul. Originally conceived in 1627 as a monastery for the Jesuits, the church honored Saint-Louis alone. In 1797, the nearby church of Saint-Paul was demolished, but in 1802 its clock replaced the elliptical window in the center of the façade of Eglise Saint-Louis, which thus acquired its additional name. It was modeled after the layout of Gesù in Rome, from which it borrowed the domed structure then used for the first time in Paris. The façade directly replicates that of the very Parisian church, Saint-Gervais, with its three levels, Corinthian columns, and niches with statues.

154
Wall fragment of Philippe Auguste

Running seventy meters along the rue des Jardins-Saint-Paul, this is the largest existing relic of the wall erected to protect Paris while Philippe Auguste gallivanted off to the Crusades. Composed of two sides of freestone, with a mixture of sand and rubble filling the empty spaces, the remains of this enclosure were often preserved and concealed behind various courtyards and workshops around Paris. Today, the buildings of the antique village of Saint-Paul are on one side of this particular fragment, while a ground surface used for sports and a children's play space occupy the other side.

155
Lycée Charlemagne

Originally built as a Jesuit monastery, this building lodged novice monks as they completed their studies. It became a school site in 1802 when Napoléon I granted the buildings to Lycée Charlemagne. Noteworthy features include its interior seventeenth-century staircase and the Giovanni Gherardini fresco, *The Apotheosis of Saint Louis*, which adorns the cupola. The Lycée Charlemagne is part of the current church of the Saint-Paul–Saint-Louis complex.

156
Hôtel de Sens
(Bibliothèque-Mediathèque Forney)

On July 28, 1830, a stray cannonball pierced the eastern façade of Hôtel de Sens, lodging itself permanently in the wall. Built originally for the archbishops of Sens in the thirteenth century, this *hôtel* was remodeled completely by Archbishop Tristan de Salazar. The building has seen many more changes since but its façade still has the cannonball.

157
14, quai des Célestins

Inspired by the peaceful courtyard of the nearby place des Vosges, architect Cesari refurbished this building to serve as warehouses for the Samaritaine department store. In trying to recreate the scale of traditional neighborhood residences, Cesari subdivided the building into five small sections, between which he positioned large, recessed bay windows. Floodlit and tiled, the inner courtyard space has a quiet ambience but with the odd sensation of being inside an aquarium.

158
Hôtel de La Cossaye

This mid–seventeenth-century building has a rather plain façade and is typical of the layers created by centuries of construction and transformation. When the kings moved from Île

de la Cité, they resided near this site in the royal mansion, Hôtel Saint-Pol. After Catherine de Médici's husband, King Henry II, died accidentally in a jousting tournament nearby, she moved away and it became a regular neighborhood.

159
Ecole Massillon *(Gratry annex)*

The development of the Massillon religious school on nearby quai des Célestins necessitated an annex for boarders. Canon Pradel, the school's director, hired architects Bouzy and Giraud to design this dormitory. Because of its proximity to the river, the architects built the entire structure, except for the roof, out of concrete. They covered the façade with a hard, clear pink stone called Serrigny. The corner rises in the shape of a severe, rectangular tower as a reflection of the studious atmosphere inside.

160
Hôtel de Sully

After the first owner squandered his gambling fortune, his creditor, the duc de Sully, minister to Henry IV, assumed control of this house. In his mid-seventies when he moved into this mansion, the duc de Sully, also known as Maximilien de Béthune, marquis de Rosny, had a rousing good time here, as did his heirs. The old duke loved dancing with young women of ill-repute under the arcades of Place Royale, now the nearby Place des Vosges, while he accommodated his young wife and her lovers by building them separate apartments within this residence. His daughter, the duchesse de Rohan, fooled around here, too, and had an illegitimate son. A century later, Voltaire challenged the then-prince de Rohan who lived here to a duel, but Rohan had Voltaire thrown in prison instead. Today, the Caisse Nationale des Monuments Historiques occupies the building and maintains the history of Hôtel de Sully as well as the cultural heritage of France. Their restoration preserves the original building configuration between the court and garden. The horseshoe-shaped *hôtel* consists of a main building

with an entry court framed by two identical wings and a garden with a former orangerie. Allegorical sculptures of the Four Seasons adorn the façades of the main building, and the Four Elements—Fire, Earth, Air, and Water—are divided into pairs to decorate the two wings. The carvings, no doubt, were favorites of Sully's for their year-round entertainment value.

161
Brasserie Bofinger

This quintessential Alsatian brasserie is the genuine article from the Belle Epoque. Bofinger is famous as both the oldest brasserie in the city and, its website claims, the first Parisian restaurant to serve draft beer on tap. Inside, under a colossal stained-glass cupola, made by Néret and Royer, turn-of-the-century–attired waiters serve up enormous seafood platters and other traditional dishes such as onion soup, classic *choucroute*, and crème brûlée.

162
Bibliothèque de l'Arsenal

In the sixteenth century, the Royal Arsenal, where cannons were made, controlled an area from the banks of the Seine to the Bastille. This remaining portion of the arsenal served as a residence before being converted to a library. Originally, the duc de Sully lived here as the grand master of the artillery; then architect Boffrand enlarged it for a new grand master, the duc de Maine. In 1755, the Guard of the Arsenal, Voyer d'Argenson, established the library.

163
Housing for Republican Guard

Designed by architect Bouvard, these buildings house 450 men—three groups each of 150—of the Garde républicaine. Bouvard's polychromatic brick façade created a decorative wall pattern, and his use of metal to tighten the brick walls was an unusual construction technique, considering hard stone was then the norm. For the late twentieth-century restoration, Yves Lion respected the original design and added modern extensions using contemporary material.

centuries despite its limited religious teachings in Latin. In fact, until the Revolution, the Sorbonne's curriculum was restricted to theology, leaving the teaching of humanism to the College de France from the Renaissance. In 1626, Cardinal Richelieu commissioned architect Lemercier to expand and rebuild the Sorbonne. Today, the chapel, with its street and courtyard façades, is the only surviving portion from that period.

175
Ecole élémentaire

Between 1870 and 1914, three hundred schools were constructed in Paris to support the growing demand from the immigrant, working population. The minister of education established new building regulations: rooms had to be well-lit from one side and buildings had to be raised sixty centimeters above the ground and constructed of brick and tile. Thus it was easy to recognize these buildings with their stone foundations, the well-marked ground level of two materials, the large windows, and the use of brick and stone for the lintels and frames.

176
Hôtel and Musée de Cluny

One of the oldest, secular monuments in Paris, this Gothic mansion—once home to the affluent abbot of Cluny—is like a charming castle from a fairy tale. Its spires and arcades, winding staircases and stained-glass windows, courtyard gargoyles and story-telling tapestries virtually celebrate Paris of the Middle Ages. The six-paneled *Lady and the Unicorn*—the most famous of the woven tapestries—is an allegorical work upon the six senses.

177
Shakespeare & Co.

At the address of 12, rue de l'Odeon, Sylvia Beach first published James Joyce's *Ulysses* and used to welcome Hemingway and other writers into her home and the original bookshop called Shakespeare & Co. She would often give them

books and extend credit to them. Though this bookshop on rue de la Bûcherie is not the real McCoy, it is legendary in its own right. Named for Sylvia Beach's Shakespeare & Co, this one sits on the bank of the Seine, and is crammed with new and used books.

178
Eglise Saint-Julien-le-Pauvre

According to legend and prophesy, Julien killed his parents and fled, but he devoted his life to the poor and helped a beggar cross the Seine. Unbeknownst to Julien, the pauper was Christ in disguise who ultimately redeemed Julien. The site where they crossed the river became the location of the church, Saint-Julien-le-Pauvre, just opposite from the Square René Viviani. Several earlier chapels existed here, prior to this small, rustic twelfth-century church, one of the three oldest in Paris.

179
27-39, rue Galande

In Roman times, when Île de la Cité was Paris, and Paris (founded by the Parisii boat people) was known as Lutetia, this now-picturesque street followed the Roman route that linked Lyons to Lutetia. First developed in 1202, the current road, though reconstructed over time, retains the essence of old Paris with its charming sixteenth- and seventeenth-century houses that have narrow façades and a few gables.

180
Hôtel de Nesmond

This building dates to the thirteenth century, when the abbey Saint-Victor developed this plot of land for a medieval house called l'hôtel du pain (the bread hotel). The owner, the grand panetier, baked bread for the royal court of King Philippe the Fair. In 1643, Charlotte de Fourcy sold it to François Théodore de Nesmond, president of the parliament and the attendant of the Prince of Condé. Nesmond acquired additional plots of land and increased the garden's size. In 1847,

it became a distillery, but a violent explosion in 1885 severely damaged it. Behind walls and a closed gate, a sober seventeenth-century building still stands, the oldest portion of which is the gate and two pavilions on each side that probably date from the sixteenth century.

181
Saint-Sévérin

The small square next to Saint-Sévérin church contains a bizarre, Gothic sight: An arched corridor with pointed roofs curves around the square. Built in the late fifteenth century around the church's cemetery, this medieval arcade served as a charnel house—a repository for communal remains. High-ranking corpses were buried beneath the corridor, while the laity was dumped under the open spaces. Later, in the seventeenth century, when the arches were redesigned and closed off by stained glass, the clergy held meetings there, and a few resided above the arches.

182
Paris Mosque

A traditional Moorish minaret rises from this complex, evoking North Africa and the Muslim world. The architects designed the center court-yard and prayer hall to have a border of arched columns, and a marble patio and fountain. To achieve a faithful interpretation of Middle Eastern décor, they brought in artisans and craftsmen from participating countries to decorate the mosque with tiles, mosaics, and marble. This collaboration between the French government and several Muslim countries respects the three traditional components of Islamic architecture: religion, culture, and commerce.

183
La Tour d'Argent

Famous for this spectacular view above the Seine of Notre-Dame, La Tour d'Argent also stakes its reputation on history and legend. From Napoleon III to Balzac, from the Maharajah of Kashmir to FDR and Charlie Chaplin, aristocrats and notables from all ages and countries have dined here. In 1600, duels were fought over tables and during the reign of Louis XIV, guests from the Sun King's court came from Versailles to dine here on ox prepared 30 different ways. Supposedly, the fork was invented on this spot, in a sixteenth-century inn. Later, in 1789, the Revolutionaries sacked the restaurant that stood here and, when it opened again, it drew literary and political crowds with its specialty: a duck dish called "*canard au sang*." Since 1890, close to one million ducks have met a delectable fate in this recipe. Half that many bottles of wine (500,000) are stored in ancient wine cellars beneath the restaurant.

184
Parisienne de Distribution d'Électricité

Now boarded up, this anachronistic building on a quiet street was once a substation that supplied power to the Gobelins quarter. Composed of metal, brick, and glass, the facade features the industrial characteristic of a riveted metal framework. Iron bars define the long, triple windows, and a thin, brick border surmounts arched windows at the ground level.

185
Refectory of the Bernardine Monks

Boulevard construction, demolition, ownership transfer, and various efforts at remodeling have conspired to destroy most of what was the Bernardine College at this site. Only the refectory remains. Founded in 1244 by the Abbot of Clairvaux, an Englishman named Etienne de Lexington, the order lost its mandate to the Citeaux Abbey in 1320. Reconstruction occurred periodically due to regular flooding and a first-floor fire in 1698. In the 1800s, only the papal living quarters survived the new construction on rue de Poissy and boulevard Saint-Germain, when the remaining buildings were demolished. Subsequently, from 1845 to 1993, the refectory has transitioned from being a street-lamp oil shop, the archives for the City of Paris, and a home for the Frères des Ecoles Chrétiennes, to serving as a fire station.

186
Maison de la Mutualité

The Art Deco corner entrance of this stone building leads to numerous meeting rooms, lecture halls, and Restaurant La Fontaine Saint-Victor. Built on the former site of the Séminaire of the Saint-Nicolas-du-Chardonnet Church, it was intended as a gathering place for insurance societies. Later, its grand lecture room accommodated large crowds for political meetings. The windows and balconies, flanked by four columns, lend a rhythm to the façade and extend over two stories above the bold, fan-shaped, corner entrance.

187
Chapel of the Collège de Beauvais

This chapel is the only surviving structure of the Collège de Dormans-Beauvais. The college's other buildings were destroyed in 1881. Today, this simple church, with its pointed roof and tall steeple, serves a Romanian Orthodox congregation. Of note is the 1926 mosaic above the entry.

188
École Sainte-Geneviève

The strange double doorway—an entry-over-an-entry—is the result of street reconfiguration in 1685. Just after the completion of this building, the street was lowered by several feet, requiring the installation of a new doorway below the original. The ground floor thus became the main level of the building. A chapel on this level contains the tomb of the Stuart king James II, who died in 1701 while in exile from England at Saint-Germain-en-Laye. Female students receive training here today to prepare for higher education.

189
Presbytery of Saint-Etienne-du-Mont

Compared to his father's turbulent life, Louis le Pieux, duc d'Orleans, desired a peaceful life of learning. So he built this stately mansion, devoted to the abbey of Sainte-Geneviève, and retired here. He studied Greek, Hebrew, and Syrian, and collected botanical and mineral specimens. His pavilion also contained a library, a chemical and natural science laboratory, and a medal collection (since 1787, in l'Ermitage). Today, his home serves as a presbytery for the clergy of Saint-Etienne-du-Mont nearby at place Sainte-Geneviève.

190
Bibliothèque Sainte-Geneviève

The names of 810 writers and scientists are etched into the stone façade of this library. And preserved within are thousands of manuscripts rescued during the Revolution by scientist Alexandre-Guy Pingré from Sainte-Geneviève abbey, now the Henri IV high school. In another stunning achievement for the age, architect Labrouste constructed this library, which predated and influenced the famous ironwork of Les Halles market pavilions, the railway stations, and particularly the National Library.

191
House of Lepas-Dubuisson

Above the arched entryway, an elaborately carved and curvy console dominates the façade of this eighteenth-century townhouse and supports a lovely wrought-iron balcony. Typically, then as now, the ground floor was reserved for commercial space while the upper levels were converted to living quarters. Currently, a cultural bookstore occupies the ground level, with apartments above.

192
Institut de Biologie

Inspired by contemporary Dutch architecture of the period, this building's interlocking planes suggest Cubist influences, but it veers from that tradition by having a brick construction rather than a simple white façade. An academic committee oversaw the development plans; and, therefore, the building design incorporated about fifty different laboratories. One was sunk thirty-six feet below ground, to keep a constant temperature.

193
Former Ecole Polytechnique

Over two hundred years old, this state-supported institution of higher learning is the most prestigious engineering Grande Ecole in France. It first occupied the premises here in 1838, but relocated in 1976; and this building now houses the Ministry of Research and Technology, and other government offices. The former college courtyards have, in part, become a public garden with a reflecting pool and a delightful walkway that links rue Descartes to rue du Cardinal-Lemoine.

194
Eglise Saint-Etienne-du-Mont

A Gothic structure with a Renaissance façade makes this building unique. The last rood screen, or stone choir, in Paris is preserved in near-perfect condition inside this church. Before pulpits existed, rood screens provided a place to read the Gospel. This screen dates from 1541, and Beaucorps designed it to leave the nave fully visible. Also noteworthy within the interior of the church are the 1630 organ case, the pulpit, the winged female sculpture, and the elaborate spiral balustrade.

195
Panthéon

In 1744, a seriously ill Louis XV prayed to Sainte-Geneviève for his recovery, vowing to build a church dedicated to her. He lived and commissioned a church with a dome and portico in monumental Gothic style. During the Revolution, the Panthéon became the resting place for great men of France. The inscription over the pediment reads: *Aux Grands Hommes La Patrie Reconnaissante*. The building swung back to its church roots when Napoléon I ruled; it then reverted to being a national monument during the regime of Louis-Philippe, who commissioned the patriotic sculpture in the pediment.

196
Studio des Ursulines

On this tiny street in the Latin Quarter, actors Armand Tallier and Laurence Myrga opened the first theater for French avant-garde films on January 21, 1926. Among those in attendance were Man Ray, Fernand Leger, and André Breton. *Et voila*, the art-house cinema was born. In the 1960s, Truffaut shot a scene here, when he directed *Jules et Jim*. The interior, renovated in 1996, has Dolby sound and seating for 100, plus a balcony.

197
Maison de Facchetti

Italian painter Eldi Gueri created this wild country scene on the façade of a former butcher shop, Maison de Facchetti, in 1929. Between the two windows of the mezzanine, he painted four pastoral panels over sheet metal advertising the butcher's wares. Inspired by Italian renaissance, Gueri then depicted deer and wild boar on an ochre background surmounted by an unrestrained floral and fauna pattern. This freewheeling plant motif fills the façade as well as the gables, providing a unique setting in this popular neighborhood known for political agitation as well as an abundance of food.

198
33-35, Rue Censier

Smoky glass balconies provide the only visual break to the repetitive frontage of these interlinking apartment blocks. The residents of this boring, prefab complex, however, have a lovely view across the angled street, overlooking a small patch of green and toward more interesting Haussmann stone apartments.

199
8, rue Scipion

This street was named for Scipion Sardini, a Tuscan, who came to France in Catherine de Médicis' entourage with nothing, but piled up a fortune while here. All the homes on this tranquil, residential street have slate roofs and nearly

identical flat, tan façades with shabby shutters and peeling white paint. Across from the old Hôtel de Scipion Sardini, which is now the Hôpital Sainte-Marthe, the surprise is the little, terra-cotta tiled-roof annex and the tiny court.

200
The Abbey Bookshop
Originally called rue des Escrivains when scribes copied manuscripts here, this road derives its current name from parchment merchants who worked along the street until the late fifteenth century, when a paper shortage from China jeopardized their business. The book trade continued to thrive on this street, however, throughout the seventeenth century. Today, this tall, narrow building, constructed in Rococo style for coin exchange controller Claude Dubuisson, houses the Abbey Bookshop—a Canadian-owned English- and French-language bookstore.

201
Le Champo
Close to the Sorbonne, this art-house cinema first opened in 1938 by cinéphile Roger Joly. After a fire destroyed the interior, Joly—with the aid of an engineer and optical experts—devised an ingenious system of projection using a periscopic device. With a projection room situated lower than the screen, this mirrored system still functions today, perhaps the only one Europe.

202
Le Cinéma du Panthéon
Founded in 1907 with Jean-Paul Sartre and Jacques Prévert in attendance, Le Cinéma du Panthéon distinguishes itself in the Latin Quarter as the oldest surviving movie house in Paris. It was the first, in 1930, to show films in their original English-language format without dubbing, thrilling English and American communities in Paris. Now, the theater holds meet-the-director sessions and functions as an art-house cinema, screening little-known-artists' and foreign films. The façade, with its fixed camera, is wedged between two higher buildings and seems to resist time.

203
Institut Curie
Resting on a foundation of gravel, this hospital entrance leads through a courtyard entry, to a series of connected buildings and odd shaped portals. The frontage of the reflective glass grid is repeated on the back façade of the buildings, which are linked by a tubular walkway. The random patterning created by these windows on this façade prompts imagination: The curious position of the open windows suggests a face with wide eyes. The street is aptly named for microbiologist Louis Thuillier, a student and collaborator of Louis Pasteur.

204
Institut du Monde Arabe
A split façade—the northern one glass, the southern one aluminum—creates a dynamic cultural center reflective of Middle-Eastern art. Like the aperture of a camera lens, mechanized panels on the photosensitive windows regulate the intensity of light in the building, while the aluminum varies the shadows, thus producing a lattice-screen effect reminiscent of early Muslim architecture. A central patio is a quiet oasis between the sliced façade, while the rooftop patio features a restaurant and a stunning view of Paris across the Seine to Notre-Dame. This building was an Arab-French collaboration under President Mitterand, in which architects from nineteen Arab countries participated.

205
Palais du Luxembourg
In 1616, Salomon de Brosse designed the Palais Luxembourg to indulge the whim of Marie de Médicis, widow of Henri IV and the mother of the future Louis XIII. She wanted a mansion reminiscent of the Pitti Palace, her former palatial home in Florence, Italy. While the stone rustication indeed resembles that of her Italian palace, the grand proportions, the simplicity and the classic *entre cours et jardin* styling of the building are all French sensibilities. She also commissioned Peter

Paul Rubens to create a series of paintings, now in the Louvre, on the cycle of her life. In 1630, during the Day of the Dupes uprising against her, she fled this palace, never to return. In the next century, the Revolution confiscated it to use as a prison. Since 1852, it has served the Senate, and today the adjacent Musée du Luxembourg shows temporary exhibits. Two unadorned pavilions flank the main building and its courtyard, and Doric and Ionic columns support the austere façade. What it lacks in façade ornamentation, it gains in location: situated at the north end of Luxembourg gardens, it commands one of the most beautiful pieces of real estate in Paris. With its tennis courts, *jeux de boules*, tree-lined paths, beautiful gardens, pony rides, toy boats, and plenty of people-watching positions, this is definitely a democratic park, original intentions notwithstanding.

206
La Maison de Poupée

Just across from Luxembourg Gardens, this tall, white apartment complex has a forest green, ground-floor façade. Occupying the premises is a shop that buys and sells antique dolls. The building itself only just predates the architectural changes and developments of Haussmann's civil engineering. Its cut-off corners are typical of other regulations that came about between Louis-Philippe's reign and the Second Empire. The structure has five levels, plus one added probably at the turn of the last century.

207
27, rue de Fleurus

Between 1903 and 1937, Gertrude Stein lived here with Alice B. Toklas and held court with writers and artists. Her large, ground-floor apartment welcomed Hemingway, a frequent visitor whom she took under her tutelage. As he recalls in *A Moveable Feast*, he and his wife " . . . loved the big studio with the great paintings. It was like one of the best rooms in the finest museum except there was a big fireplace and it was warm and comfortable and they gave you good things to eat . . ."

208
Building Félix Potin

Bulging with the beauty of sensuous shapes, flowing curves, and carved balconies, this former headquarters of the Félix Potin grocery chain, founded in 1844, towers with elegance and grace ten stories over rue de Rennes. Art Nouveau flourishes abound on the building as it undulates from the corner down both sides of the street. Decorative mosaics scattered on the façade announce, in Art Nouveau cursive, the former store's provisions and services. Individually, some translate to read, "tea, cocoas, buffets, pastry making, biscuits, chocolates, baptisms, coffee, fish of sea, and fresh water." The name of Félix Potin can also be found inscribed in the three oculi of the corner bell tower. The building is occupied today by the Tati chain.

209
Hôtel de Marsilly

Architect Bonnot built this eighteenth-century hotel for himself. Of particular interest is the portal with a Rococo cartouche above which Bonnot mounted a cornice balanced by two ornamental stone vases that offset a window. This window mimics the shape of the entry and is capped with a partial pediment that extends the façade. On the upper level, two decorative, oval windows flank the central rectangular one.

210
Hôtel de Choiseul-Praslin

This classic mansion recalls the pre–Industrial Revolution days when this quarter was in the countryside. But that rural setting did not last for long, as the city expanded quickly. Built in the early eighteenth century for the Countess de Choiseul, this *hôtel* has well-balanced proportions. Though its unadorned windows show only slight variations and its central pediment contains no decorative sculpture, the structure is beautiful in its simplicity.

211
Musée Hébert

This eighteenth-century building houses the watercolors, paintings, drawings, and decorative arts of Ernest Hébert (1817–1908), a late nineteenth-century artist. Hébert studied in Rome under Ingres at the Academy of France, and used luminous colors to render his landscapes of the countryside, peasant scenes, and portraits. He was commissioned to enhance the apse of the Pantheon during the Third Republic. The building, a composite of styles from its adjacent structures, was the former Hôtel de Montmorency-Bours, also known as the Petit Hôtel de Montmorency to distinguish it from the home he owned next door. Old plaques on the façade feature street names, and a statue of the Madonna can be found on the corner.

212
Embassy of Mali

This is the former residence of the comte de Montmorency-Bours who, like most aristocrats, owned many homes though usually in different locations. This one is adjacent to another of his mansions, the current Musée Hébert, known in the count's time as Petit Hôtel de Montmorency. He named this own home Grand Hôtel de Montmorency, to avoid confusion. A small triangular pediment crowns the central portion of this eighteenth-century façade, which is also decorated with a Rococo balcony, ironwork, and patterns created by the horizontal rustication at the base. Although the upper story reflects the same style, it is probably a nineteenth-century addition.

213
95, rue Vaugirard

This charming building, which contains offices and artists' workshops, mingles eclectic styles: brick-and-stone in a Louis Treize manner, some neo-Gothic patterning, and a Jules Verne–type bay window jutting vertically over the street and positioned as if to scout for oncoming enemies. Perhaps it is a metaphor for the artist-residents who might be attempting to break through the rigidity of society with their art.

214
96, rue Notre-Dame-des-Champs

At the edge of modernity, this building is typical of architecture between the wars. Halfway between tradition and modern construction, a layer of fine brickwork conceals the concrete frame of the apartments. The façade on boulevard Montparnasse recalls traditional principles while the side facing rue Notre-Dame-des-Champs leans more toward the future. In a daring move and to gain more sunlight, architect Madeline placed the traditional courtyard along the road and curved the façade around it, setting large glass windows at each corner. He achieved a vertical emphasis with a central staircase that is enclosed by glass panels and capped with a rotunda. The exaggerated chimneys add to the impression of architecture rising to new heights of expression.

215
La Rotonde

In the heyday of literary café life in the sixth arrondissement, La Rotonde was one of the big four anchoring the Montparnasse neighborhood. Always in competition, these restaurants drew intellectuals from the political arena as well as the arts. The first owner, Libion, harbored Russian political exiles, including Trotsky and Lenin. Such international artists as Picasso, Modigliani, Derain, and Max Jacob were also among the patrons. Legend has it that the Dadists came to blows here, over what they perceived to be the owner's strict policies and general intolerance. Simone de Beauvoir was born upstairs in this building in 1908. Hemingway was a habitué, and his character Jake Barnes in *The Sun Also Rises* complained that taxi drivers in the Left Bank "always take you to the Rotonde" no matter which café you wanted to visit in Montparnasse. Once upon a time, La Rotonde offered one of the best places to people-watch.

216
Hôtel Lutétia

A Left Bank landmark, Hôtel Lutétia figures in the 1974 Louis Malle film, *Damage*, as the Art Deco location for decadent glamour and trysting between Jeremy Irons and Juliette Binoche. In real life, this magnificent combination Art Nouveau and early Art Deco hotel has also attracted the famous and infamous. Pablo Picasso, Henri Matisse, and Henry James all chose to stay at this hotel. And, during Occupation, the Nazis set up Gestapo headquarters here.

217
Lucernaire Forum
Taking over a closed factory in 1968, Christian Guillochet and Luce Berthommé created a theater open to all artistic endeavors in a dead section of Montparnasse. Seven years later, a real estate developer took control of the property and expelled them. A new cultural forum opened here with broader ambitions and eventual support from the Ministry of Culture. In 1984, Lucernaire Forum received official recognition with the label, National Center of Art and Essai, for the creative work it still undertakes.

218
Mairie
When the architects began erecting this town hall in 1848, it was constructed in two parts, the first of which was actually in the eleventh arrondissement. Its original façade, facing Saint-Sulpice, was built on the site of Hôtel de Charost. Its central pavilion formed the *l'avant-corps* (the front part) of the present main building. Twenty-eight years later, in 1886, architect Ginain expanded the building toward rue de Madame and rue Mezières.

219
Newsstand
The first kiosks were created by Haussmann back in the latter nineteenth century. Since then, several different models have been designed to service the public. Often located at subway entrances, these newsstands open like small

books each day to service Parisians and tourists. This particular, forest green kiosk dates from around 1960, and stands in front of a massive building from the early twentieth century. The convex domed construction of the stand mimics the shape of the repeating bay windows of the building's façade.

220
Eglise Saint-Sulpice
A parish church stood here in the twelfth century. Over time, a mismatched structure grew, the church compensating for this lack of unity in design and style with its imposing proportions: Ordered sets of Doric and Ionic columns support two successive levels, above which a balustrade borders a terrace.

221
Hôtel de Sourdéac
This impressive seventeenth-century home sports an unusual façade of Ionic pilasters with scroll-style ornamentation. Shaped like spiraling ram horns, the Ionic capitals support an entablature with a small, triangular pediment above the central portal.

222
Former Seminary of Saint-Sulpice
(Ministry of Finance)
In the early nineteenth century, the construction of place Saint-Sulpice destroyed a seminary that had belonged to Saint-Sulpice church. The state partially paid for another building opposite the square, which architect Godde designed in a neoclassical style with additional influences from Italian palaces. Seminarians used this building until a 1905 decree separated church and state. Today the Ministry of Finance occupies the premises.

223
Hôtel de Beaumarchais
Constructed by owner Charles Testu, this private mansion passed along to his heirs and, in 1710, to Counselor Augé. Its wrought-iron balconies contain the initials "A. C." From 1763 to 1776,

writer Beaumarchais lived here. During this period, he was married for the second time and wrote the dramas, *Eugénie*, *Les Deux Amis*, and the famous *Le Barbier de Séville*. During the late 1800s this was also known as Hôtel du Mercure de France, when it served as the home of a newspaper called *Mercure de France*.

224
Hôtel de Brancas

The Institut Français d'Architecture owns this former residence. Built in the early eighteenth century, its street façade features an entry pediment surmounted by the allegoric figures of Justice and Prudence. Prior to its current occupant, the Paris-based Institut Tessin—named for the seventeenth-century Francophile architect of Swedish origin—occupied the building.

225
Polidor

Opened as a *crémerie* in 1845 near the Sorbonne, Polidor served bohemian students for mere pennies. By 1890, it had evolved into a bistro, but retained its simple menu, affordable prices, antique mirrors, and old tiles. Between 1902 and 1903, James Joyce dined at this restaurant when money from his literary reviews arrived from Dublin. The bistro also attracted nineteenth-century writers Verlaine and Rimbaud, twentieth century author Richard Wright, and numerous others in the arts.

226
Institut National du Patrimoine
(Ancien cercle des Libraires)

This building is composed of two types of stone. Its design features an angled pavilion, a rotunda, and two wings. Above a simple ground floor, decorative windows open out to a balcony. A bronze attribution crowning the central door indicates its original mission as le Cercle des Libraires—a member association and union that brought together varied professionals to protect mutual interests and private properties. Between 1877 and 1879 this group built their headquarters

à aspect de palais (in the style of a palatial mansion) in an attractive space owned by Charles Garnier (architect of l'Opéra), employing his plans for the design. Part of the completed space was then rented to engravers and printers. After the building was remodeled in 1992, the Ecole Nationale du Patrimonie—the historic monument division of the Ministry of Culture—moved in.

227
Marché Saint-Germain

Annual fairs were encouraged by both the clergy and royalty for their economic potential. Inaugurated in the fifteenth century, the Saint-Germain Fair was on the Church's grounds, and continued until end of the nineteenth century. A permanent covered market with a double-tiered roof was built nearby in 1511. Damaged by fire in 1762, it was redesigned on the square as an arched structure. Rebuilt on this same site in the late twentieth century, from the outside the current covered shopping arcade resembles the early nineteenth-century Saint-Germain marketplace. However, inside, brand-name chain stores and other modern shops, and other contemporary facilities occupy the retail space; and it is only the overall structure of the interior that bears even a faint reminder of the medieval fairs of long ago.

228
Eglise Saint-Germain-des-Prés

Originally built in the mid–sixth century and known then as Sainte-Croix-Saint-Vincent, most of this structure dates from the eleventh and twelfth centuries, thereby qualifying Saint-Germain-des-Prés as the oldest church in Paris. Overall, it combines Romanesque and Gothic features: Its nave, transepts, and three bell towers reveal Roman origins, while its flying buttresses and stained glass owe their style to Gothic influences. It became Saint-Germain-des-Prés after Germain, the Bishop of Paris, was buried there.

229
Brasserie Lipp

Alsatian refugees Léonard Lipp and his wife Flo (Florderer) left their province when France lost Alsace to the Germans in the 1870 Franco-Prussian War. They resettled in Paris, where they opened this eatery. Originally, they named their brasserie Edges of the Rhine, but customers habitually referred to it by the name of the owners, and that stuck. Its Belle Epoque interior features exotic ceramic designs by Leon Fargue. In 1920, Marcellin Cazes bought the restaurant, expanded it, and, in 1958, received the Legion of Honor for having the best literary salon in Paris. Literary and theater groups still meet here. Its celebrity past includes writers Thornton Wilder, Antoine de Saint-Exupéry, and Hemingway, of course.

230
Café de Flore
Jean-Paul Sartre wrote that, during World War II, he and Simone de Beauvoir "more or less set up house in the Flore." These two lovers and fellow philosophers wrote volumes here, using the café's marble-top tables as desks and its sawdust-burning stove for warmth. Even when air-raid alarms sounded, they pretended to leave, but then continued writing upstairs. De Beauvoir wrote *The Mandarins* here, and parts of her journal, *The Second Sex*, as well. Picasso and Chagall exchanged political views and matchbook doodles. Apollinaire and his group founded their magazine, *Les Soirées de Paris*, at this café, and André Breton and his Surrealist buddies alternated between this and its rival café, Les Deux Magots.

231
Hôtel Bel Ami
In the Middle Ages, a door in the middle of one of the halls that used to be on this site provided access to the Saint-Germain-des-Prés abbey. Allegedly, in the twelfth century, Pope Alexander III himself passed through the door in this manner to enter the abbey. Now, Bel Ami occupies two renovated buildings: a typically austere construction from the eighteenth century and an industrial workshop structure from the nineteenth century. Today's

minimalist building originally housed a printing press that produced documents for the Assemblée Nationale. Designer Grace-Leo Andrieu, the same woman who remodeled the Montalembert Hotel, recently completed an interior renovation.

232
Rue de l'Abbaye
This quiet street is just around the corner from the bustling Saint-Germain-des-Pres Place with its historic Abbey. Established in 1800, the street was named rue de la Paix (Peace) from 1802 to 1809, then renamed Neuve-de-l'Abbaye until 1815, when it assumed its current name. Although shops fill the ground level of these buildings today, doorways at the crossroads of numbers 1, 2, and 2 bis once led to the main courtyard of the Abbey. In the 18ᵗʰ century, administrative houses for the bailiffs, civil and criminal judges, and police force were situated at the angle of these streets. Across the street, Charles de Bourbon, the abbot of Saint-Germain-des-Prés, originally occupied a palace at #3.

233
Ladurée
In 1862, when Louis Ernest Ladurée opened a bakery around the thriving commercial district of the Madeleine on the Right Bank, he probably never anticipated that his name would one day cross the Seine. Ladurée's breads and Viennese pastries were so successful, he opened a *salon de thé* in 1890 so ladies could lunch discreetly. A hundred years later, Francis and David Holder bought the period restaurant and began expanding. Their Ladurée tearoom in the heart of the Saint-Germain-des-Prés district on the Left Bank occupies a former antique shop, opened in 1947 by Madeleine Castaing, which had its own history of famous clientele, such as Chagall, Modigliani, and Soutine. Inspired by the Castaing's interior décor, designer Rodriguez blended neoclassical elements with the Second Empire style to create the feeling that one is dining in an elegant private home.

234
Grande Masse des Beaux-Arts

This corner building juts out onto the street like a rounded glass luxury liner. Its mostly-window exterior curving around the corner gives weightlessness to the large and weighty structure. The large rooms inside face north and the horizontal windows allow good light on every drawing table, contributing to the building's function as an architectural school. Situated at a corner, the place also seemed ideal for mischievous students who had a reputation for pelting pedestrians below with water bombs.

235
22, Passage Dauphine

This brick house, in Louis Treize Revival style, crosses the former site of part of Philippe Auguste's wall, which ran parallel to rue Mazarine. Constructed between 1190 and 1220 to protect the city from invaders, this rampart crops up in the oddest places today. It is usually hidden by newer construction. Different portions have been well-preserved thoughout the centuries, however, because houses leaned up against them.

236
Restaurant Vagenende

A Belle Epoque atmosphere pervades this Saint-Germain-des-Prés brasserie, preserved in the splendor of its Art Nouveau styling: carved arabesque woodwork, beveled mirrors, and painted-glass landscapes. Opened in 1904 by Edouard and Camille Chartier, brothers and founders of the Chartier chain of Bouillon ("Bubble") restaurants, this site quickly became a popular gathering place. In the 1920s, the Vagenende family took over the premises, and ran it for more than fifty years until 1966.

237
Le Buci

Rue Dauphine is the first example of a regulated street developed by Henri IV to generate a modern city face. Buildings had to adhere to height and stone frontage requirements. The strategic site and shape of this building placed at the corner was perfect to express monumental architecture that would become a model for Parisian apartment buildings until the time of Haussmann in the nineteenth century. On the other side of rue Dauphine, the same architect reused his model with identical characteristics. Its crossing shaped like the prow of a boat, the building rests on a solid base level surrounded by a balcony, and a heavy cornice crowns the building and hides the roof. By its position and shape, this building, one of the most beautiful of its time, is reminiscent of the Flatiron Building in New York City.

238
Monnaie de Paris

Majestic when illuminated at night from the vantage of Pont-Neuf, the Monnaie de Paris commands your attention across the Seine. Before architect Antoine won a contest to design this building, the Mint—one of the oldest French institutions dating back to Charles the Bald in 864—had had successive homes. Louis XV selected this site on the Left Bank, for the Mint to replace the former Hôtel de Conti. Under Louis XV, this neoclassical monument became the Royal Mint. Antoine designed the building to stand at the widest portion of the Seine facing the Louvre. He created offices on the riverfront, and workshops in the rear. The 117-meter building sports a neoclassical central façade of five arches surmounted by six Ionic pillars that support an entablature containing six allegorical statues: *Prudence, Abundance, Fortitude, Justice, Peace, and Commerce.* The building is now a coin museum.

239
Institut de France

Impressive by day but an exhilarating sight at night, this Baroque building features a central domed chapel overlooking the Seine. Inside, beneath the dome, the mausoleum of Cardinal Mazarin rests once again—having lost its place temporarily during the Revolution. Before he

died, Mazarin established a grant in his will to fund the construction of the College des Quatre Nations, designed to educate noble students from the four foreign regions that France had recently acquired: Alsace (from Germany), Artois (from Flanders), Piedmont (from Italy), and Roussillon (from Spain). During the 1790s, this building was one of many to be confiscated and transformed into prisons. Among hundreds of others, Dr. Guillotin, of guillotine fame, occupied a cell here. In 1805, Napoléon converted the building back to being a seat of learning, and the chapel became an assembly hall.

240
Ecole des Beaux-Arts

The aristocratic patronage of the arts in the 6th arrondissement led to the eventual creation of this art school complex. When Henry IV disavowed his first wife, Marguerite de Valois, she set up housekeeping across the Seine in a mansion she had built for herself. In 1608, she founded the convent of the Petits-Augustins for the Augustinian monks and constructed, on her estate, a church and chapel known as the Chapelle des Louanges. Its dome is the oldest in Paris. The Revolution closed down the convent and used it to deposit artwork in 1791, with Alexander-André Lenoir as its guardian. He converted it into a museum, the Musée des Monuments Français. In 1816, the museum was closed, renovated, and transformed into the Ecole des Beaux-Arts.

241
1–3, quai de Conti

The arch at rue de Nevers opens onto one of the narrowest streets in Paris and ends at a remnant of Philippe Auguste's twelfth-century fortification wall. The buildings on either side of the arch overlook the Seine and the Île de la Cité. Their construction in brick and stone visually matched the buildings originally at Place Dauphine on Île de la Cité. This view from Pont-Neuf suggests the problems this project created for city authorities because the architecture had to respect the site

of Pont-Neuf, rue Dauphine, and the riverbank alongside it. As an extension of Pont-Neuf on the Left Bank, rue Dauphine is one of the first real urban planning projects in Parisian history thanks to Henry IV who, in the beginning of the seventeenth century, first tried to impose homogeneous buildings of the same height and stone facades on a straight street. This final project is an interpretation of seventeenth-century classical architecture with a stone base level, monumental pilasters, brick at the central portion and at the upper level of the façade, and a steep roof.

242
Residence Université Mazet

Part of the University Mazet, this modern building resembles a three-dimensional grid. These upper levels are reserved housing for university students who often experience difficulty in finding places to live due to the high demand for rental units in Paris. The modern materials, metal and painted zinc, fit well in this historic neighborhood, thanks to the building's simple proportions.

243
Le Procope

Francesco Procopio dei Coltelli had the prescience to anticipate coffee's universal appeal, and introduced Parisians to the exotic beverage when he opened Le Procope. It was also possibly the first café in Paris to serve sherbet. With a three-hundred-year history, Paris's oldest café bills itself as the "*Le Rendez-vous des Arts et des Lettres,*" and Diderot and d'Alembert, who conceived the *Encyclopédie* here, Voltaire, Rousseau, Beaumarchais, Marat, and Danton wandered in now and then, among others.

244
Lycée Fénelon

Ten years of reconstruction work by architect Charles Le Cœur transformed this eighteenth-century mansion into Paris's first all-girls school. Previously known as Hôtel Villayer and Chateauvieux, the building was conserved in part,

retaining its beautiful stairway as well as some original salon and bedroom décor. The street façades are reconstructions, and the old courtyard became a recreation space, but the courtyard façades correspond to the conserved building.

245
Lapérouse
In 1766, Limonadier (soft drink manufacturer to the King) Lefèvre purchased an eighteenth century private home facing the Seine. Today, its dark wood façade with gold trim and Louis XV balconies glows at night from chandelier light on the upper levels where Lefèvre established private dining rooms in the former servants' quarters. In 1840, Jules Lapérouse took over and soon his clients used these petits salons for other business arrangements. Proust and Colette dined here, as well as Robert Louis Stevenson, Hugo, Thackeray, Maupassant, and Dumas.

246
Hôtel de Montholon
In 1740, printer François Didot resided here. Despite the symmetry seemingly created by the series of pediments, the building's charm derives from the irregular composition produced by the placement of the entrance on the right side. Two slightly different piers—one with carved horizontal lines and the other without—flank the entry gate. Dormers also cross the roof adding a horizontal balance. The building typifies a time of research in French Renaissance architecture when vertical lines were still directing the shape of a building.

247
Hennebique building
Engineer François Hennebique, father of the reinforced concrete building in Paris, created this striking Art Nouveau building. Hennebique, who began his career as a stonemason, started experimenting with the properties of concrete. Discovering that it was preferable to iron because it permitted expansion, he devised a system to fix its reinforcement in place and patented the method in 1892. This geometric building marks one of the first applications of his method.

248
Fontaine Saint-Michel
A colossal statue of the archangel Michael (Saint-Michel) crushes the Devil, vanquishing evil and welcoming you to the Rive Gauche. One of the most impressive fountains in Paris, this one occupies the entire end wall of a building, gushing water at the juncture of Pont-Saint-Michel, quai Saint-Michel, quai des Grands Augustins, boulevard Saint-Michel, and place Saint-André-des-Arts. Francisque-Joseph Duret designed the energetic archangel at the center of the fountain.

249
21, rue Hautefeuille
This tower survives on a small stretch of street between rue de l'Ecole-de-Médecine and boulevard Saint-Germain. One of the few existant corner turrets in Paris, this one dates from the sixteenth century, and the octagonal shape of its charming tower makes this even a rarer sight. Beneath the surface lie the remains of an old Jewish cemetery dating from the twelfth and thirteenth centuries, before Philippe Auguste and later Philip the Fair each confiscated the area and expelled the Jews.

250
Université René Descartes, Faculté de Médecine
At one time, surgeons were members of the same fraternal society as barbers. This strange union lasted 100 years, when the education of surgeons was finally merged with that of medical doctors. This led to the founding, in 1794, of l'Ecole de Santé (School of Health), which Napoléon I rechristened the Faculté de Médecine. This neoclassical building has an inner court whose amphitheater contains Corinthian columns, a pediment, and a half dome.

251
Refectory of the Franciscans

This refectory is all that survives from a Franciscan monastery founded in the thirteenth century, but destroyed in 1802. The merry monks abandoned their monastery just before the Revolution. Taken over by Revolutionary leader Camille Desmoulins, it became the headquarters for radical thinkers. It was a gathering of like minds here on July 14, 1791, that called for the deposition of the king. Today, the large ground floor hall is a venue for temporary exhibitions.

252
Bouillon Racine (Bubble Root)

This registered historic French monument has been faithfully and painstakingly restored to its original Art Nouveau splendor from the days when George Sand had once lived in the same building. From the crystal façade to the floor mosaic and floral ceiling of tile and glass, the refitting and replicating that was accomplished in 1996 by Belgian brewers has restored this Latin Quarter restaurant to the way it looked in the early twentieth-century.

253
Université Paris 3 (Sorbonne Nouvelle)

When built in the late seventeenth century, this amphitheater was used for training surgeons. At the time until the Revolution, surgery and medicine were separate and rival professions. So, medicine had its own amphitheater in the 5th arrondissement. The schools of Surgery and Medicine merged in 1794, but surgery moved to a new location earlier, and this amphitheater became a drawing school in 1775. Today, the University of Paris uses it for its modern language institute.

254
Hôtel Trianon

This tall and elegant building, Hôtel Trianon, stands at the corner of rues Monsieur-Le-Prince and Vaugirard. Elements of its sleek Art Deco façade are evident on one side and on the balcony portion. The hotel now serves as a conference center for seminars and meetings.

255
Le Bar Dix

Occupying ground level of this eighteenth-century stone building, a maroon-painted façade identifies this hip dive with the name "Bar" and the number "10" scrawled discreetly across the front. Inside, Art Nouveau posters claim the décor, a jukebox plays Guns n' Roses as well as Pachelbel's Canon, and an expat crowd drinks sangria and hangs with the French hipsters.

256
Théâtre de l'Odéon

After Molière's death, the Comédie-Française had to relinquish their theater at Palais Royal. Louis XVI promised to construct a new venue for them— the largest in Paris capable of seating an audience of almost 2,000—and acquired the former Hôtel de Condé on this site for that purpose. In 1784, Beaumarchais premiered his *Mariage of Figaro* in the sumptuous interior of this theater, which is a neoclassical gem. The architects achieved a harmonious setting for their Greco-Roman theater by constructing buildings on either side of the plaza, to create visual balance. Approached from rue de l'Odéon, the building itself seems set upon a stage.

257
Ecole Supérieure des Mines

Situated at the southeast corner of Luxembourg Gardens, this school has several façades: a typical, three-floor structure with a mansard roof fronts boulevard Saint-Michel; a former orangerie with large, arched windows and multiple panes repeat along the side of rue Auguste Comte; and one short façade faces the lovely Luxembourg Gardens. On the boulevard side, the building's arched, rusticated entry with a small curved pediment provides the only character to this otherwise unadorned building.

258
Lycée Saint-Louis

A small second-century amphitheater—the architectural remains of the early Roman settlement Oppidum Lutetia—lies beneath the Lycée Saint-Louis. While above ground, the Lycée functions as a public college. This classic building with multiple façades on different streets has a rusticated lower level with brick construction above. A curved façade fronts its entrance on boulevard Saint-Michel.

259
Restaurant La Godasse

Situated around the block from the Sorbonne, this historic corner building has a solid stone foundation on one side and painted wood on the other. White lace curtains dangle daintily from the windows, but this French bistro whose name means "old worn shoe," serves up hearty grilled steaks to match its rustic interior and exposed-beam ceiling.

260
Musée Zadkine

Russian sculptor Ossip Zadkine lived and worked in this house with his wife, painter Valentine Prax, from 1928 until his death in 1967. Hidden behind an alley, not far from Luxembourg Gardens, a small sculpture garden remains just as Zadkine had arranged it. In her book, *Avec Zadkine, Souvenirs de Notre Vie*, Prax describes her memory of her husband in his garden: "There in the open air, Zadkine shaped the granite and the stone of Pollinay, as well as the hardest woods. He gave the impression of being a worker, with his suit of gray velvet and his brown suede cap. He also wore big glasses to protect his eyes from the shards of wood and granite." His former home is now a museum.

261
Institut d'Art et d'Archéologie

A concrete pastiche of architectural styles, periods, and ethnic influences, this wondrous red brick building seems incongruous in its location near Luxembourg Gardens. Reminiscent of Moorish design, its lower level frieze also recalls the Roman origins of the Parthenon. Head of l'Ecole des Beaux-Arts, architect Bigot studied the buildings of the past, and was more interested in the restoration and history of architecture than in designing new buildings. Perhaps as a reaction to the Modernist Movement that he opposed, Bigot created this monument to eclectic traditions. But its anachronistic presence also expresses its function as an institute for art and archeology.

262
Lycée Montaigne

Situated at the southern end of Luxembourg gardens, this school enjoys a coveted location in the 6th arrondissement. A large vestibule opens to a winter garden that extends the traditional *cour d'honneur* (main courtyard). Architect Le Cœur incorporated classrooms and dormitories on the upper floors, allowing for day and boarding students. Inaugurated in 1885 as Le Petit Lycée Saint-Louis-le-Grand with connections to another school nearby on rue Saint-Jacques, it became independent in 1891 and was renamed Lycée Montaigne. An all-boys school until 1912, when girls joined the younger classes, it went completely coed in 1957.

263
Hôpital Cochin

Physician Tarnier was the first to recommend isolating pregnant women within medical facilities instead of placing them in highly infectious general wards. So, this building became a maternity hospital with seventy-four beds when inaugurated; it eventually expanded to hold 240 beds. In 1897, it became known as Hôpital Tarnier. This massive structure has multiple austere façades but a distinguished entrance: Surmounted by a triangular, scalloped cornice and supported by Ionic columns, the arched portal provides a drive-up entryway that juts out with character from these otherwise somber blocks of stone. Hôpital Tarnier is now a dermatology clinic and a treatment center for pain.

264
La Closerie des Lilas

One of the legendary literary cafés of the 1920s, this restaurant actually started out as a country inn during the days when stagecoach travelers stopped here on their route from Paris to Fontainebleu and Orléans. Long before Hemingway made it his neighborhood café, nineteenth-century writers, poets, and artists gravitated here. Brass markers inside testify to famous folk who frequented the establishment back then; they include Baudelaire, Verlaine, Balzac, and Chateaubriand. A photograph of the bar also verifies the twentieth-century presence of Man Ray, Apollinaire, Picasso, and Lenin, in addition to poet Paul Fort, and novelists James Joyce, John Dos Passos, and F. Scott Fitzgerald. After World War II, La Closerie was home to the Symbolists, the Dadaists, and the Surrealists. Today, a current crop of Montparnasse intellectuals mingle inside the dark, mosaic-floored café.

265
Eiffel Tower

This marvel of late nineteenth-century engineering stretches more than 1,000 feet above the skyline—the equivalent of more than three and a half football fields stacked vertically—and was the tallest building of its time. Composed of 7,300 tons of wrought iron and 2.5 million rivets, it was assembled from over 18,000 prefabricated parts, as if from some giant-scale Erector set. Horrified intellectuals dubbed it the "awful tower," a "truly tragic street lamp," a "belfry skeleton," and a "hole-riddled suppository," but several had the audacity to think it grand. On opening day, a broken elevator forced Gustave Eiffel and selected bureaucrats to hoof it up the tower's interior stairs. Most stopped before reaching the summit, but Eiffel hiked the full 1,665 steps to the top, where he and whatever hardy officials accompanied him there hoisted a flag, thus inaugurating the structure. Eiffel encouraged its use as an experimental scientific site and as a radio broadcast tower, in hopes of

ensuring its survival past its originally intended twenty years, and the strategy worked: Today, the high platform continues to support various antennae including those used for television. Protected from oxidation with several layers of paint, the tower is repainted every seven years by a team of twenty-five painters. Variations in the façade color toward the top give the paint the appearance of a uniform coating against the sky. Originally conceived for the 1889 World Exposition, this graceful "Iron Lady" has remained the quintessential symbol of Paris.

266
La Fontaine de Mars

Sculpted by Pierre Beauvallet, the figures of Mars and Hygeia—god of war and goddess of health—adorn this fountain; hence, the name of both the fountain and its adjacent café. Napoléon originally commissioned the fountain for a military hospital on the site. Some hundred years later, the fin de siècle café opened its doors to serve traditional cuisine amidst typical French ambience. The restaurant was renovated in 2007 and a red-checked motif adorns everything from the curtains and cane chairs to the wrappers around the complementary chocolate squares served with a café creme.

267
3, square Rapp

Built by the same architect who created the nearby Lycée Italien Léonard-de-Vinci and a residential building on avenue Rapp, this apartment house shows the full extent of Lavirotte's enthusiasm for Art Nouveau design. Lavirotte's elaborate façade features highly decorative windows and an ebullient turret.

268
89, quai d'Orsay

In his design of these luxury apartments, Michel Roux-Spitz created what he termed a "French balance" between classic style and modern elements. To fulfill his vision, he framed the building with concrete, but then hid this skeleton beneath a façade of traditional white Hauteville

king. Oversized Ionic pillars support two interior levels, and a simple balustrade trims and hides the roof. The *hôtel's* former eighteenth-century grand salon (living room), covered by carved wooden paneling, has been removed for display in New York City's Metropolitan Museum of Art.

281
Former home of Serge Gainsbourg
Whitewashed by city authorities, the scribblings on the former home of celebrity bad boy Serge Gainsbourg come from his adoring fans. From the 1960s until the 1980s, the words and public antics of this singer, songwriter, actor, and provocateur shocked and pleased audiences. When he died in 1991, his home became a cult attraction. Although the building is periodically "whitewashed," Gainsbourg's cult followers return frequently to write messages anew.

282
Hôtel de Villette
After having moved outside of Paris in political exile, Voltaire returned to this quai in 1778, when he was eighty-four. Marquis Charles-Michel de Villette gave him a quiet courtyard room in Hôtel de Villette, where Voltaire received hundreds of admiring visitors, including Benjamin Franklin. The marquis honored him by replacing the "quai des Théatins" street sign with one that read "quai Voltaire," but the police removed it. In 1791, after Voltaire's death, the marquise initiated the official name change.

283
Musée d'Orsay
Musée d'Orsay started life as the railroad station, Gare d'Orsay, which itself emerged from the ruins of Palais d'Orsay, burned down during the 1871 Commune. In 1898, architect Laloux gave the train station metal framework, but wrapped the terminal's exterior in classical limestone. For the interior, he designed a north lobby, a domed vestibule, and a central, grand iron-and-glass vaulted complex.

284

Musée Rodin *(Hôtel Biron)*
Abraham Peyrenc de Moras hired architect Aubert to design this detached masterpiece of *rocaille* (loose stone) architecture on 7.4 acres. In 1753, the maréchal de Biron bought the residence, and completely transformed the property into one of loveliest parks in Paris. The duc de Lauzun inherited the estate, but he was guillotined during the Revolution, despite being a hero in the American War of Independence. Jean Cocteau, Henri Matisse, and Isadora Duncan worked here and, in 1908, sculptor Auguste Rodin rented the ground floor.

285
Hôtel Montalembert
When Grace Leo-Andrieu and her husband, Stephane, renovated this mansion in 1989, it became one of the first contemporary luxury hotels in Paris and attained a five-star rating. Respecting the elegant architecture of the original building, their renovation successfully integrated modern innovations with history, encompassing restoration of the antiques collection that came with the mansion. Christian Liaigre designed the fifty-six guest rooms whose rich detailing is offered in two styles, consistent with the owners' blending of old and new: Guests can opt for high-tech décor, with modern lighting and chrome appointments, or can select a room with traditional, inlaid wooden furnishings.

286
Au Bon Marché
In 1852, Aristide Boucicaut opened just a small store and sold hosiery there. When this store proved popular, Boucicaut invested his profits, expanded, and developed Au Bon Marché, the first department store in Paris—and the only major one on the Left Bank. An innovative merchant, Boucicaut offered "delivery to homes as far as a horse [could] travel in Paris," and "free delivery by train for any order over twenty-five francs."

287
La Pagode (Art House Cinema)

In 1895, Monsieur Morin wanted to give Madame Morin a gift. As *japonisme* was then the rage in Paris—thanks in part to the Impressionists—he, naturally, built her a pagoda. Shipped in pieces from the Far East, reassembled in Paris, and plunked down in the midst of a residential district, this carved temple trumped the all-things-Japanese craze with its stone figures of dragons and lions and Buddhas and birds. In 1931, it was converted to an art house cinema.

288
Hôtel de Matignon

For this palatial mansion, architect Courtonne created a garden façade that was wider than its forecourt side—a model other aristocratic townhouses subsequently copied. The hotel owes its name to the comte de Thorigny, Jacques de Matignon, who purchased it during its construction. Since 1810, various statesman, diplomats, and politicians have lived here. Statesman Talleyrand occupied the premises in 1810. The Austrian-Hungarian embassy took it over between 1888 and 1914; and, in 1935, it was purchased by the state. Since 1958, the prime minister has resided here.

289
Arc de Triomphe

Emperor Napoléon commissioned this imposing arch in 1806 to glorify the military victories of France's Grande Armée in 1792, but he didn't live to see its completion. Thirty years in the making, the arch was finally completed fifteen years after his death. Plunked down at the top of the Champs-Elysées, this colossal and classic monument—inspired by Rome's Arch of Janus—stands as a witness to history: Mourners passed through it to view Victor Hugo in his coffin in 1885. After World War I, returning soldiers marched beneath the arch in celebration, and it became the site of the Tomb of the Unknown Soldier.

Later, Nazi soldiers also stomped through it defiantly, during their occupation of Paris. Its Napoléonic purpose all but forgotten, in our own time the Arc de Triomphe is ceremoniously remembered as a memorial to all who died in World War I: Each evening at six p.m., the dashing French military reignite the flame at its top, in a tradition begun in 1929. On clear evenings, tourists crowd the observation deck to take in this ritual, as well as for one of the finest 360-degree views of Paris at dusk.

290
Hôtel Salomon de Rothschild

A hundred years after financier Nicolas Beaujon created a home here, Baroness Salomon de Rothschild built a classic mansion in Second Empire style on the site. In 1922, she bequeathed it to the State. Today, the Fondation Nationale des Arts Graphiques et Plastiques and Christie's Education Paris school share this grand residence.

291
Atelier

In a city filled with stone buildings and only a few areas of green parks, courtyards such as this one, branching off a main street, are gems. Small, private gardens are often hidden just behind buildings and beyond doors. Designed to bring more light into apartments, courtyards also once served functional purposes, such as a place for the care of horses and for staff-run repair shops. As part of an evolutionary process, many of these workshops were eventually converted to artist studios.

292
Eglise Saint-Philippe-du-Roule

Beautiful eighteenth-century mansions and chic ready-to-wear houses line rue Faubourg-Saint-Honoré today. When this road was first used, it was chiefly known as leading to the village of Roule. This eighteenth-century church, named for Saint-Philippe of Roule, evokes the

Obélisque that graces the center of Place de la Concorde. The 23-meter (75 feet) high, 230-ton monument, a gift to Charles X from Mohammed Ali, Viceroy of Egypt in 1829, had originally marked the entrance to the Amon Temple of Luxor, and is over 3,300 years old. Its transport to Paris took more than two years and required the construction of a special boat. By the time it arrived in Paris, Louis Phillipe was king. Hieroglyphs in gold along the sides of the Obélisque proclaim the great deeds of Pharoahs Ramses II and Ramses III, while images on its pedestal depict its journey to France. Its landmark position was arranged by Jacob Ignaz Hittorff who installed two fountains and refurbished the statues that surround it, representing France's largest cities: Lille, Lyon, Marseilles, Rouen, Nantes, Strasbourg, Brest, and Bordeaux. Prior to this, the square, initially known as Place Louis XV, celebrated the king with an equestrian statue. Revolutionaries later toppled the statue, installing a guillotine where Louis XVI and Marie Antoinette perished. Following other transformations and name changes, Paris's first and largest open-air square was again renamed, and the Obélisque—the oldest monument in Paris—replaced the guillotine.

306
Musée Nissim de Camondo

This spectacular mansion—home to the eighteenth-century art collection of the de Camondo family—tells the tragic tale of a transplanted Turkish Jew who became a French patriot. Comte Moïse de Camondo replaced another building that had been on this site since 1866, with a copy of the eighteenth-century Petit Trianon of Versailles. In 1935, he bequeathed this house and gardens, along with his entire collection of art and furnishings, to the Union des Arts Decoratifs—with the stipulation that the name of the museum must honor his son Nissim, who had been killed fighting for France during World War I. During World War II, the Vichy government forgot this act of patriotism and sent the de Camondo family to Auschwitz.

307
Hôtel d'Argenson

In the eighteenth century, the aristocracy had a fondness for placing mansions along the border of the Champs-Elysées. The widow of the marquis d'Argenson was among those who commissioned a residence here. Overlooking the gardens of the Champs-Elysées, this hôtel was itself an impressive sight, for its neoclassic proportions. Its layout of gardens surrounding the house demonstrates a British influence in the use of the property.

308
HypoVereinsbank

For the former Financial French and Colonial Society, eclectic architect Fournier used this corner site to shape a monumental building that expressed France's perspective of the African continent. Resting on a high base level, the piers between the windows of the three stories above are decorated with patterns of colored marble, enamel from Venice, and mosaics. Animal scenes of camel, elephant, shark, ibex, and fishing create a naïve expression of the exoticism of former French colonies rather than a true cultural understanding. Business was preeminent, and this building served as prime advertising about the continent.

309
British Embassy

In 1870, when the Prussians besieged Paris, the British Embassy converted one of its wings to a maternity ward to prevent eventual conscription of its subjects into the French army. Somerset Maugham—whose father worked at the Embassy—was one of the babies born there. Originally known as Hôtel Béthune-Charost, when architect Mazin built it in 1720 for Paul-François Béthune-Charost, this beautiful eighteenth-century mansion became the property of the British Government in 1814.

310
Le Pavillon Elysée

Created for wealthy patrons of the 1900 World's

Fair, this former pavilion is set in the gardens of the Champs Elysées and was once known as Pavilion Paillard, after the original owner. Architect Ballu designed the structure in Louis Seize shape and style with a stage, a rotunda, and a turret. Sculpted heads crown the pilasters around the façade, and, above the gilded tower dome, Jules Blanchard installed his graceful cast-iron statuette of a winged cupid. Remodeled in 2003, it is now part of the Lenôtre chain of gourmet restaurants and known for its luxury gastronomy.

311
Grand Palais

From an aerial perspective, this enormous building appears to rest on the lower Champs-Elysées like a giant airplane upon a runway, with the Petit Palais as its nose. Its massive stone façade—over twice the length of a football field—stretches down avenue Winston-Churchill, and the dome at its peak measures 144 feet from ground level. Monumental quadrigas, sculpted by Georges Récipon, surmount the side entrances. Unlike other palaces built for members of the aristocracy, the Grand Palais—constructed for the 1900 Universal Exposition—honored art, and as such became a showcase for emerging artists. Since 1937, the Grand Palais has allocated its southern portion for use as Le Palais de la Découverte, a science museum and planetarium dedicated to scientific discovery.

312
Petit Palais

Built for the 1900 Universal Exposition, the Petit Palais, along with the Grand Palais, replaced a gigantic structure from the 1855 World's Fair. Architect Girault designed both as temples to art and culture. But unlike the Grand Palais, built for the display of changing exhibitions, the Petit Palais was intended from the start to be a permanent museum. It is organized around a semi-circular courtyard garden and its impressive facade—grand porch, ionic columns, and dome—resembles the Invalides on the other side of the Seine.

313
Pavillon Ledoyen

After the original owner, whose last name the restaurant still bears, sold his café, architect Hittorff, who redesigned the lower gardens of the Champs-Elysées and rebuilt fashionable restaurants there, moved this one to its present location. The restaurant has drawn such personages as Napoléon, and writers Guy de Maupassant and Henry James, all of whom were equally attracted by its sumptuous cuisine and verdant surroundings. Other patrons have included Edgar Degas and Edouard Manet.

314
Maxim's

Early in the twentieth century, Maxim's became a celebrity haunt and continued to attract the famous to its glitzy Belle Epoque interior. Originally started by Maxime Gaillard, subsequent owners added their own flourishes: Eugene Cornuché helped develop Maxim's legend crafting its art nouveau image, and his placement of courtesans in the windows didn't exactly hurt business. In the 1980s, restaurant was sold to fashion designer Pierre Cardin who transformed it into an Art Nouveau museum and authentic 1900 cabaret.

315
Maille

In 1747, Antoine Maille, a vinegar distiller and mustard manufacturer, opened a shop on Saint-André-des-Arts, and supplied mustards and vinegars to the royal courts of Europe. Legend has it that Madame de Pompadour would commission his aniseed vinegar by the barrel. World famous for its Dijon mustard, packaged in a squat jar with a black label, this wood-trimmed gourmet shop opened on the prestigious place de la Madeleine in 1999, carrying on the condiment tradition started in the eighteenth century.

316
Fauchon

Auguste Fauchon originally hawked his produce

from a pushcart on the place de la Madeleine, alongside the flower merchants. From those humble beginnings, he rose to found the now-famous Parisian luxury food enterprise. Patrons can *emporter* (take out) their order, or sample their selections in a more leisurely fashion in either Fauchon's original tea salon or in their 1924 restaurant.

empire collapsed, the pagan temple reverted to its religious roots. Anchoring rue Royale on an axis with place de la Concorde, this building's location makes it a favorite place of worship for Parisians, despite its missing parts. The neoclassical church has also been host to famous funerals, including Chopin's in 1887, Joséphine Baker's in 1975, and Marlene Dietrich's in 1992.

317
Hôtel Crillon

From the glory of the king to the public execution of his grandson, this site's name has changed with the prevailing political winds, from place de Louis-XV to place de la Révolution and finally place de la Concorde. Hôtel Crillon, on the west side, was home to wealthy, elite expatriates like F. Scott Fitzgerald in the 1920s and was also a famous site for historic and cultural affairs: The British and Americans used it during World War I; preliminary work on the Versailles Treaty occurred here; Presidents Woodrow Wilson and Dwight Eisenhower stayed here; Germans used it as headquarters during World War II; and in postwar years, it was a gathering place for such celebrities as Orson Welles and Jacqueline Kennedy Onassis. Inside the Hotel Crillon's columnar and arched façade, silk brocaded furniture, tapestries, elaborate chandeliers, and sculpture create a mood of elegance. A wrap-around terrace on the top floor gives guests of the "Bernstein" suite a lovely view of Paris and the Eiffel Tower. As Leonard was a frequent guest in the elegant wood-paneled suite, one of his pianos still graces the living salon.

318
Eglise de la Madeleine

Napoléon I sought to build a *temple à la gloire*—a monument to the glory of his armies—and scouted around for a location. He settled on the site of a medieval parish church that had been transformed into one dedicated to Madelaine, but the Revolution interrupted construction. The temple was left without a dome or bell tower. When Napoléon's

319
Paul

This famous bakery—founded in 1889 in Lille in the north of France by Charlemagne Mayot and his wife—replaced a store established in 1864 that specialized in the sale of ivory objects. Inspired by the Louis Seize, the marble decoration of the current frontage dates from 1910; it features two bronze heads of elephants, and two of tortoises. In 1953, new owners acquired a bakery from the family of Paul and their name remained; the owner's son expanded the manufacturing side of the business and opened an industrial *boulangerie* in 1965. In 1972, he installed the first bakery to have a furnace within view of customers; and in the late 1980s, he added to the original range of breads, tea service and pastries.

320
Mollard

Although Edouard Niermans was Dutch by birth, he adopted France as his home and became the architectural darling of Parisian society. With a formal richness created by mixing paintings, sculptures, stained glass artistry, and Art Nouveau styling, Niermans's work generally catered to parvenus. The original frontage with columns and mosaics has disappeared, but the interior of polychromatic marble, figurative mosaics, and ceramic paintings remains intact. The ceiling depictions in raised gold mosaic with scenes of eating and drinking, recall the establishment's origin as a bar in 1865 by Mr. and Mrs. Mollard, whose Art Nouveau brasserie flourishes today, despite its current fast food occupant at the ground level.

321
Palais de l'Elysée

Originally known as Hôtel d'Evreux for its first owner, comte d'Evreux, this palatial mansion became the official residence of France's president in 1873. At the northern edge of the Champs-Elysées gardens, its arched entryway opens onto a large, classical courtyard. Prior to State ownership, illustrious residents occupied the premises: Madame de Pompadour, the building's second owner; Napoléon Bonaparte, who abdicated here in 1815; and Napoleon III.

322
Théâtre National de l'Opéra
Palais Garnier

"Now would I have a book where I might see all
characters and planets of the heavens, that
I might know their motions and dispositions."
—Faust.

On May 20, 1896, as if in answer to Faust's query, a performance of Gounod's *Faust* came to a terrifying halt as l'Opéra's chandelier suddenly came crashing down, killing one woman and injuring other members of the audience. This night at the opera inspired Gaston Leroux's novel, *Le Fantôme de l'Opéra*, which in turn became the source for movie and musical spinoffs that, while recreating the tragedy of its chandelier, also celebrated the splendor of this building's interior. In 1860, Charles Garnier won a city competition for his grandiose design with statues and pillars of marble and colored stones, anchored in a huge quadrangular space. Parisian society, led by Napoléon III, who initiated the project, flaunted its finery here amidst the grandeur Garnier created specifically for that purpose. The satin and marble interior matches the opulence of the exterior and dazzles the eye with its magnificent foyer and stairway, and its restored auditorium features a seven-ton crystal chandelier and a Marc Chagall ceiling painting. Today, this unrestrained, eclectic monument to the Second Empire shines in gilded glory at the end of avenue de l'Opéra.

323
La Maison du Miel

Like a honeycomb that attracts its share of bees, historic gourmet shops swarm around place de la Madeleine. Located just at the border of the 8th and 9th arrondissements, near place de la Madeleine, La Maison du Miel is a honey of a store amid other shops that specialize in offerings for the epicure. Espousing the health and nutritional value of honey, this store has dispensed the golden nectar since 1898.

324
Le Printemps

Classified in 1975 as a Parisian historic landmark, this department store stands elegantly in a neighborhood of aristocratic townhouses. The Printemps name, inscribed in the multi-colored tiles above the entrance, almost dances off the grand corner façade, which features cast-iron columns, large bay windows, Renaissance domes, and an Art Nouveau copula added in 1923. in 2006, the store underwent a major renovation.

325
Square d'Orléans (Cité des Trois-Frères)

In the 1830s, English architect Cresy designed square d'Orléans on property previously owned by actress Mademoiselle Mars. And the square attracted writers, singers, musicians, artists, and actors. Lovers George Sand and Frédéric Chopin lived here, though in separate homes. Opera singer/composer Pauline Viardot owned a house on this square as well, and Berlioz and Liszt listened to music in pianist Pierre-Joseph-Guillaume Zimmerman's house.

326
Le Grand Café des Capucines

On December 28, 1895, a few dozen cus-tomers of Le Grand Café Capucines paid one franc each to witness cinematic history: The Lumière brothers—pioneers in French cinema—showed their first documentary in the café's Salon Indien downstairs. Today, if you are looking for a late-night stimulant, Le Grand Café Capucines would

be your cup of tea, so to speak. Even without a film to keep you awake, it's easy to spend the entire night just looking at its lavish Belle Epoque interior of painted tile murals, exotic statues, and stained-glass ceilings. This all-night café has provided nourishment for late-night theatergoers and party-hoppers since its opening on the Grands Boulevards more than a century ago.

327
Galeries Lafayette
Only slightly younger than its rival, Le Printemps, just down the boulevard, Galleries Lafayette department store compensates for its less-than-grand façade with a lavish Art Deco interior and a glorious, neo-Byzantine stained-glass cupola. Its awesome height measures almost 110 feet. And from the department store terrace, you can catch an exceptional view of Paris.

328
Au Petit Riche
In the mid–nineteenth century, while its cousin, the Café Riche restaurant, served the wealthy and the talented, this small bistro catered to the backstage crews who attended to the functioning of the nearby l'Opéra and the theaters on the Grands Boulevards. It was gutted by the Fire of 1873, which consumed the old opera house and other buildings that included the original Au Petit Riche. But, in 1880, the restaurant reopened and still serves traditional fare.

329
Former Confiserie à l'Etoile d'Or
(today Confiserie Denise Acabo)
Just down the street from Le Moulin Rouge and a short distance from the Butte Montmartre, this old-fashioned candy store may have helped to satisfy the sweet tooth of many an artist in its original day: Toulouse-Lautrec and Degas both lived on rue Fontaine in the neighborhood, where many other artists also lived at one time. Not much has changed—including the interior décor and the offerings—since this shop opened its doors more than 100 years ago.

330
Delaroche House
The homes in the La Nouvelle Athènes quarter, which encompassed rues de Tour-des-Dames, La Rochefoucauld, and Saint-Lazare, were inspired by the then-trendiness of Greek culture among people in the arts. Many of the architects for this district were trained in the neoclassical style of Percier, an architect to Napoléon. In 1822, artist Paul Delaroche moved into this particular house, right next door to painter Horace Vernet, who lived at number 5.

331
Eglise de-la-Trinité
Religious architecture took an odd turn here, with an eclectic jumble of styles, predominantly neo-Gothic and French Renaissance. The elaborately detailed façade of this towering structure causes the church to resemble a parliamentary building rather more than a house of worship. In front of its monumental porch, three statues personify Faith, Hope, and Charity.

332
Musée de la Vie Romantique
A tree-lined path reveals a garden hideaway where, in 1830, at the edge of the rural Nouvelle-Athènes quarter, Dutch painter Ary Scheffer settled with his family for almost thirty years. In this secluded setting, his ochre-painted, Italian-style home became a Friday-night gathering place for such luminaries of the Romantic Period as George Sand, Franz Liszt, and Frédéric Chopin, among others. Today, the museum recalls those times, with its careful restoration of his home and garden, and of one of his studios.

333
Musée Gustave Moreau
Crammed wall-to-wall with painter Gustave Moreau's symbolic and phantasmagorical paintings and sketches, this townhouse-style mansion is both the painter's former home and a meticulously planned memorial to his own life's

work. Moreau, known as a "writer's painter," bequeathed his house and estate, including hundreds of unfinished works, to the French state, in 1898. The double-decker studio and upper two levels that he had added to the original structure, became a museum in 1902.

334
Fouquet

For 150 years, five generations of the same family (Chambeau-Mimard) have enticed Parisians with sweet indulgences: chocolates, bonbons, caramels, and other assorted candies. The artful window display on rue Laffitte beckons you to sample a treat, still prepared by hand with meticulous care, and using original nineteenth-century recipes. Purchases are weighed and wrapped with the same attention to detail as had been given when painter Claude Monet satisfied his craving for bonbons here.

335
Hôtel de Lestapis

Much of the property development in La Nouvelle Athènes quarter initially occurred on the south side of its most desirable street, rue de la Tour-des-Dames. Hôtel de Lestapis—built in the same period though not part of the original layout—was placed on the opposite side of the street, allowing its wealthy residents to look out upon some of the hottest new façades in town.

336
Place Saint-Georges apartment building

Inspired by French Renaissance architecture, this elaborate building became the prestigious apartment address for those with expensive tastes. The marquise de Païva temporarily resided here while her multi-millionaire lover built her a residence on the Champs-Elysées. In the mid–nineteenth century, most rental apartments favored simplicity of style; for this particular one, however, architect Renaud deliberately created a sumptuous design that resembled a private mansion, to attract wealthy tenants.

337
À la Mère de Famille

Peering into the green-painted, glass façade of this *confiserie* is like a trip to the distant past, when kids rolled hoops down the streets, and wore bows and sailor outfits. Vintage tins, apothecary jars, boxes, baskets, and burlap sacks spill over with marzipan biscuits, cookies and crackers, bonbons and spiced breads, chocolates and caramels, colorful liqueurs, honeys, and confitures. All this and more, in this old-fashioned store.

338
Centrale Téléphonique

Widely criticized when it was built, this powerful structure houses the telephone exchange. Architect Le Cœur, an early pioneer of modern architecture, created a monumental building covered by bricks, focusing upon function, with little regard to aesthetics. Nonetheless, he deserves special mention for the former entrance (no longer in use) that was crowned by a marquee formed by a block of glass.

339
Maison Leclaire

This beautiful, industrial building from the early twentieth century, is the creation of architect Henri Bertrand, who devised the framework's fine, high stone pilasters that split the façade in two parts. The Cochi brothers created the building's decorative sculptures. Originally used as a wallpaper workshop for the company of Maison Leclaire, founded in 1826, this glass-and-metal building now warehouses surgical and dental supplies, behind its large, iron-framed windows.

340
Banque Nationale de Paris

In the late nineteenth century, banks competed with each other to win clients and subliminally influence them, by means of prestigious, over-the-top buildings. A firm's headquarters particularly needed to signal wealth and inspire confidence. A large, sculpted figure graces the triple-arched entrance of this building, and two

other sculptures flank its triangular pediment. The architect purposely centered this entrance on an axis with rue Rougemont, to maximize its visibility and leave a lasting impression.

341
Musée Grévin (Wax museum)
Elvis rocks, Marilyn's dress flares up around her thighs, and the Three Musketeers duel, while Gandhi treads barefoot, with stick in hand. Musée Grévin presents these wax figures amid spectacular Gothic and Baroque displays that lead to unexpected encounters as visitors travel through time, history, and culture. Assisted by sculptor and costume designer Alfred Grévin and investor Gabriel Thomas, founder Arthur Meyer created the first representation of the famous "plastic journal" for the Grévin wax museum, opened on June 5, 1882.

342
16, rue de la Grange-Batelière
In the mid–nineteenth century, this area attracted fine-arts galleries. Around the corner, on rue Drouot, the famous nineteenth-century auction house Hôtel Drouot still operates, albeit in a retro-style building. In 1876, the Impressionists—rejected by traditional salons—defected from the mainstream and first showed their unheralded masterpieces on rue Peletier, a few streets away. The bistro within this courtyard opened the same year that the Impressionists scandalized the art world.

343
Hôtel des Ventes
The architects of this retrofitted auction house—a redesign of the famous nineteenth-century Hôtel Drouot, the oldest auction house in the world—attempted to create, in their words, "a surrealistic reinterpretation of Haussmann." Inspired by fin de siècle lantern-like windows and macramé curtains, they retained the building's genuine window frames from 1856, while using molded aluminum panels for the façade, to achieve their desired affect. Unfortunately, the entire massive

building resembles a metal accordion, with its fan-like folds extending down both sides of the street. Believed to be innovative in the 1970s, this building appears merely dated, rather than serving as an example of successful cohesive design incorporating the old and new.

344
Gare du Nord
The early nineteenth century brought to the 10th arrondissement a wave of industrial development, which in turn necessitated expanded railroad facilities. In 1864, Gare du Nord became the gateway to and from the north. Its impressive, triple-arched stone façade, with double Ionic pillars, is adorned with sculpted statues of nine European cities and twelve French destinations.

345
Gare de l'Est
This station received such an onslaught of travelers and industrial workers that it was enlarged several times between 1877 and 1931. Ironically, this increased space gave it the ability to send a hundred thousand French to their death during World War I; and to deport Jews east to concentration camps during World War II. In that latter regard, Gare de l'Est was a prime center for deportation because it connected with the Drancy and Bobigny stations.

346
16, rue d'Abbeville
Two ornate, sculpted groups of scantily draped women adorn this façade and jut out over the street. This exuberance of Art Nouveau style was created during the period when rue d'Abbeville was extended to the rue du Faubourg Poissonnière five years earlier. It is similar to the adjacent Number 14, constructed in metal with almost identical decoration. Both express the liberation of the architects of the time.

347

48, rue des Petites-Écuries

A travel agency now occupies this former mansion, which originally combined a workshop on the ground level and first floor, with a bourgeois apartment on the second story. Dark Art Nouveau sculptures of Atlas flank the entrance and support a wrought-iron balcony that identifies the apartment. The symmetrical composition of the façade creates a triangle that makes the building appear taller than it is.

348
Hôtel Gouthière

This severe, neoclassic, eighteenth-century mansion belonged to a goldsmith named Gouthière. Unfortunately, Madame du Barry, last mistress to Louis XV, owed him a sizeable debt that she reneged on, leaving him unable to pay for this *hôtel* he had commissioned. After the Revolution, du Barry's estate became the property of the State, and Gouthière sued; but subsequent attempts to recover the debt through the courts were unsuccessful.

349
Porte Saint-Denis

Looming at the crossroads of the Grands Boulevards, this monumental arch celebrated Louis XIV's triumph in the Rhine campaigns. François Girardon sculpted two allegories above the central arch: *The Capture of Maastricht* on the north side, and *The Crossing of the Rhine* on the south side.

350
19, boulevard de Strasbourg

A branch of the BNP Paribas Bank occupies these late Art Nouveau premises. Covered by a colorful pattern in enamel, this concrete structure has Doric pilasters at its entrance. A grooved construction wraps around the lower level, grounding the bank with elegance and stature. Above, several extended bay windows and carved balconies heighten the building, giving it lift and character.

351

Mairie

Demonstrating pretentious attention to ornament, architect Eugène Rouyer designed this late–nineteenth-century town hall with carving on the façade from the ground level to the roof. Having lost in the competition to renovate the Hôtel de Ville, Rouyer recreated a reasonable facsimile for this, one of the more remarkable town halls in Paris. This one is a perfect illustration of neo-Gothic architecture, with a high roof and peaked chimney that stretches toward the sky.

352
Smallest House in Paris

A family argument led to the construction of this tiny, two-story house, wedged into a space that previously provided a walkway between rues du Château d'Eau and du Faubourg-Saint-Denis. Heirs to this alley could not settle their dispute and so the owner blocked access to the property by building there. Looking more like a makeshift playhouse than a real home, it nonetheless contains a ground-floor workshop and a room on the second level. Two tall buildings on either side dwarf the little structure that measures just under 4 feet wide x 16.5 feet high.

353
Conseil de Prud'hommes de Paris

In a deliberate effort to create a building with a duality of purpose, architect Baju developed a breakaway design for the tribunal that resolves professional disputes. His use of gray-blue marble and a base of green granite gives the building grounding and represents the institution's durability. In contrast with these solid materials, a huge glass façade slants to the sky, emphasizing the building's monumental status while suggesting openness to the public. Behind the reflective glass shield, each department of this judiciary bureau works independently, and has its own balcony with visibility to the street. Playing with the spatial relationships of angles and planes, Baju designed a building that suggests justice will

be meted out with expansive vision.

354
Foyer de Personnes Âgées et Ecole Maternelle

Composed of glass, concrete, pink brick, and gray-blue zinc, this building contains both an old-age home and an elementary school. Architect Duplay attempted to create a monumental building in proportion to the surrounding canal by putting a contemporary twist on traditional Haussmann architecture. But many of the canal buildings were constructed before Haussmann, and Duplay's design doesn't resemble these buildings despite his intentions. Reinterpreting the conventional bay windows typical of nineteenth-century Paris, Duplay developed studio apartments on one side, for the elderly; and glass houses on a another, to be used as classrooms. The massive building is a repetitive structure that resembles a church from the front. Fortunately, the canal setting gives the residents and students a lovely view to the outside.

355
Hôpital Saint-Louis

When outbreaks of the plague threatened the city in the early seventeenth century and overwhelmed the general hospital, contaminating its other patients, Henry IV wanted to quarantine those who were infected. So he ordered the construction of another hospital away from the center of the city, to demonstrate his command over the epidemic. Contained within a square court and enclosed by a wall with four corner pavilions, the brick and stone cloister-like construction was intended to keep personnel in and to thus confine the contagion, isolating illness pavilion by pavilion.

356
Colonne de Juillet (July Column)

Working-class discontent reached its peak on July 14, 1789, when Revolutionaries stormed the Bastille, liberated seven prisoners, and demolished the fortress. Earlier worker riots in the spring had caused disruptions, but liberating the Bastille was a major victory. Long a symbol of oppression, the stronghold occupied the site of the current place de la Bastille. Charles V built the fortification there between 1370 and 1372 as a defense for both the city and his residence at Hôtel Saint-Pol; in the fifteenth century, Louis XI transformed the fort into a prison. The destruction of the Bastille symbolized an end to the monarchy and the overreaching power of the church. Topped by the dainty, golden-winged "Spirit of Liberty," a graceful Colonne de Juillet (July Column) now stands at the center of place de la Bastille as a reminder of those heady days of freedom.

357
Logements Sociaux

This apartment building was erected on the site of the old Petite Roquette prison. Architects Kalisz and Bernard deliberately planned the building around the park to take advantage of the setting. They divided the building into small units in a U-shape; and offer open areas of greenery, with several designated, small playspaces for children. The building's features include façades that have cascading terraces—some covered, others left open facing the park.

358
Eglise Saint-Ambroise

Inspired by Romanesque and Gothic models, architect Ballu combined those two styles in his design for Saint-Ambroise church. Tall, twin, squared-and-spired turrets anchor a central, Gothic entrance whose three arches support a balustrade. The gabled nave—vaulted by diagonal ribbing for more light, and pierced by a rose window—juts out above the entrance giving the church balanced proportion.

359
Eglise Notre-Dame-de-Bonne-Espérance

This monumental church presents a hierarchy in its façades. The main entrance plays with

both traditional symbols and modernism on the side facing the rue de la Roquette. Alluding to Roman and Gothic influences in Parisian churches, two towers frame this façade. At the entrance a glass wall catches the light, and the window frames create a rhythm that fits with this popular neighborhood. The absence of decoration, except for the blue stone that covers the building, gives the church a commonplace ambience.

360
Cour de l'Etoile-d'Or

Imagine, if you will, a time in the not-too-distant past…and a place where there were country roads and the hum of carpentry workshops instead of rushing cars and congested streets, a place where the digital world did not exist and you measured the hours of the day by the length of shadows. Go ahead, push back the heavy wood door at 75, rue du Faubourg-Saint-Antoine and step into this world. As you venture down a long cobblestone alley, you may not hear the clip-clop of horses' hooves, but birds sing, insects chirp, and an occasional cat slinks by. The passageway leads to open sky, garden walls overflowing with ivy, and country cottages. Etched on the far wall is a 1751 sundial. And you've just entered the Faubourg— the outskirts of Paris, a working-class area so named because it had been countryside—a "false burg" —outside the city proper.

Cour de l'Etoile-d'Or, one of the many hidden pockets off of rue du Faubourg-Saint-Antoine, was once known for its woodworking ateliers, and the houses here date from the mid-seventeenth century. In the past, if you wandered into the Faubourg, you would see craftsmen tapping, sanding, and gluing amid piled-up sawdust and armchairs hung drying in the open air. Having deteriorated into slums over the years, many of these workshops are being renovated by owners who have uncovered their original wood beams and ancient cellars. It's not the Twilight Zone, but "l'Etoile d'Or," which means "golden star," is still a kind of never-never land—a country treasure in the midst of a world rushing by.

361
Cirque d'Hiver *(Winter Circus)*

Two sculpted equestrians mark the entrance to this circular pavilion and recall the glory days of the circus that had performed here during the Second Empire. Built as the counterpart to the Cirque on the Champs-Elysées and originally named Cirque Napoléon, this one planned to seat 4,000 spectators, but fire regulations limited the number to fewer than 2,000. Decorative friezes encircle the façade, and interior murals, added in the 1920s, depict famous circus figures, such as Charlie Chaplin and the Fratellinis.

362
Opéra Bastille

As a world-famous symbol of class struggle and freedom, the place de la Bastille has seen a variety of buildings since Revolutionaries stormed the prison and overthrew the monarchy in 1789. In keeping with its historical location, the Opéra Bastille was intended as un *opéra populaire*, a people's opera, welcoming the general public, not just the elite. Thus, architect Ott designed a functional building in which to introduce opera to an audience unfamiliar with this art form. Accordingly, he chose to deemphasize any grandiosity associated with such buildings, in favor of creating a worker's atmosphere replete with shopping, entertainment, and its own metro station—essentially marrying goods and services to art. The stepped exterior façade recalls a traditional opera stairway, and the large square arch over the entry stairs embraces ceremony, while yet encouraging the informal gathering of masses on its steps. Ott also downplayed the interior, by dividing the building into functional proportions. Overall, the architect chose to go with the accessible rather than the awesome—a fitting tribute to the place that symbolized workers' desire for a democratic society. Of course, what the Parisians today may think of this controversial structure is another matter entirely, as it has become just as bourgeois as any other opera house in the city.

363
Jacques Bazin
This *boulangerie* occupies the ground floor of a lovely corner building from the turn of the twentieth century. The corner of this late-Haussmann building, composed of stone, bulges with Art Nouveau carving and wrought-iron flourishes, topped by a sensuous pediment. Like many buildings in Paris that mark street corners, this one recalls the prow of a ship proudly viewing Paris from its deck. The bakery beckons with painted-glass panels of harvest scenes.

364
Le Viaduc des Arts
From 1855 until 1969 this viaduct carried train passengers along Daumesnil Avenue between the garden of Reuilly and the Bastille. When service ended, the viaduct's beautiful arched structure and its eight meter (26.3 feet) high promenade above were preserved. Constructed of brick and stone, its 72 broad arches span a length of 1,020 meters (3,346.5 feet). The restoration included converting the space under the arches to artist showrooms, workshops, and galleries. The elevated pedestrian promenade features a paved pathway bordered by plane trees.

365
Caserne de Reuilly
This neoclassical fire station was the first of its kind in Paris to accommodate horse-drawn vehicles for fire equipment. Above this nineteenth century entrance sculptor Louis-Oscar Roty carved the portal keystone of a female head sporting a fire helmet surrounded by a fire hose and cords.

366
Eglise de l'Immaculée-Conception
Abbot Olmer commissioned the construction of this church in 1874. Influenced by Roman style, its architect created an arched portal featuring a scene of the Virgin and Jesus in its tympanum, and a reproduction of a statue of the Virgin that exists in the cave of Lourdes, in the niche above. An octagonal spire with lanterns completes the upper level.

367
Place de la Nation (Tollhouse)
Previously known as place du Trône, this site originally honored royalty, but its name shifted with political tides. The Barrière du Trône survives as one of four tollhouses in the Wall of the Farmers General, a tax revenue collection barrier for goods entering the city at different points.

368
Eglise du Saint-Esprit
To coincide with the Colonial Exposition of 1931, religious authorities decided to build a memorial church dedicated to the missionaries who pioneered colonialism. Drawing inspiration from Sainte-Sophie at Constantinople, Tournon created this church. The reinforced-concrete façade, made by François Hennebique and covered by brick, sports twelve arches for the twelve prophets and twelve apostles. The bell tower, the highest in Paris, soars eighty-five meters (279 feet) to the heavens.

369
11–19, rue Erard
Like stacks of interlocking Lego blocks, this apartment complex is an interconnected and dependent layering of separate buildings. Unlike other city projects, this one did not depend on integrating the new with the old. Instead, the architects razed the old and created a three-tower housing unit that consists of multiple dwellings linked together by bridges. With its interplay of recesses and balcony extensions, the buildings give the impression of individual houses piled atop each other.

370
Le Train Bleu
This celebrated restaurant made its debut at the turn of the last century, feeding the appetites of sophisticated rail passengers on the Paris-Lyon-Marseille line in the glamorous days of steam engines. The restaurant name derives from that of a rapid train that used to travel to la Côte

d'Azur. Classified as a historic monument in 1972, this Belle Epoque dining hall on the mezzanine in Gare de Lyon train station still shines, with its glittering chandeliers and brass trim. If the staircase doesn't sweep you away, the interior décor whose 41 paintings depict its namesake's southern destinations will: Marseille, Monaco, and Villefranche among others..

371
Cinémathèque Française Musée du Cinéma
Like Matisse with a pair of scissors, Gehry created a three-dimensional collage in his design for this building. This exuberant mélange of light shafts and sculpted shapes faces the park, while the street façade respects the building line of rue de Bercy. Gehry also made some concessions on material, using stone so it would not offend a Parisian sensibility. The former American Cultural Center featured activities to foster understanding between French and American cultures. This sculptural building—Paris's only Gehry-designed structure—closed in 1996 for lack of funding, just two years after opening. Since 2005, it now houses Paris's national cinema center—part museum, library, and theater— celebrating the history of film.

372
Gare de Lyon
Although the exterior of the building belies its function as a train station, this interior view leaves no doubt that passengers will find their destination. This perspective highlights the industrial glass-and-metal canopy that opens up the station with airiness and extends its lengthy corridor. Extremely light and wide, it was also a "temple" dedicated to modernity at that time. While gothic churches were designed to elevate the soul, the train station represented a new direction: movement, speed, and communication.

373
Firehouse
This austere, monumental firehouse expresses the role of a state institution organized to serve

and protect. Rationalist architecture, typical of the period, is seen in the heavy stone ground level that houses the trucks and equipment. Above, the shared spaces and offices are built in meulière, the traditional stone of Paris. Like schools of the same era, this building was designed according to fixed standards of measurement, material, and shape.

374
Pavillons de Bercy
In the seventeenth and eighteenth centuries, the aristocracy owned country homes in the Bercy quarter, where natural vineyards proliferated. As the Industrial Revolution, wrought changes, the area experienced a growth of shipping and warehousing industries and transformed into a wine warehouse district. By the end of the nineteenth century, with the help of rail transportation, the Bercy quarter flourished with the addition of a wine market, open-air taverns, and entertainment along the Seine. It was a bustling neighborhood, with red-tile-roofed buildings and tree-lined streets. The old plane trees, preserved by ecologists, are still here, but the thriving market is long gone. Nonetheless, in a revitalization effort, the area of Pavillons de Bercy is attracting new customers to its wine bars and shops.

375
Enceinte du château
Conceived by Charles V, this medieval fortress provided residences for close relations of the king and members of his inner council. The construction of the external enclosure was one of the largest medieval building sites. Its immense proportions, covering more than one kilometer in length, included enormous walls flanked by towers and surrounded by moats. Charles V imagined the grounds of Vincennes as a closed world sheltering the elite of the kingdom.

376
Donjon
Looking much the same as it did when built in the fourteenth century, this tower—the highest of its

kind in Europe, an imposing 52 meters (170 feet) above ground—stood guard over the Château de Vincennes complex. Perhaps this medieval tower (one of the few that survives intact, others being nineteenth-century reconstructions) owes its existence to durable construction: Its angles are flanked by turrets, each 6.6 meters in diameter, with walls 3.2 meters thick.

377
Institut Bouddhique

Zen-like in the heart of the woods, this Buddhist Center stands on the site of the former French Togo and Cameroon pavilions from the Colonial Exposition of 1931. Inspired by palaces from the regions of Bamoun and Bamileké, in Cameroon, it is one of the six pavilions that remain from that time. In 1977, it was converted to a space dedicated to Buddha. Its symbolic details enhance the spiritual quality of the Tibetan temple. A large statue of Buddha, sculpted by Mozes, graces the interior.

378
Château de Vincennes

The origins of this square go back to a destroyed château dating back to the reign of Philippe Auguste between 1180 and 1223. The current château survives from the Valois dynasty of Philippe VI, Jean le Bon II, and Charles V, who all used it as a royal residence. In 1610, Marie de Médicis, wife of Henri IV, added the Pavillon du Roi (king's pavilion) that architect Louis Le Vau later expanded. In 1658, he also built the Pavillon de la Reine (queen's pavilion), as well as a south and north portico to keep things symmetrical. At various times during the seventeenth century, when royalty was not living here, the château doubled as a prison surrounded by a moat.

379
Musée des Arts d'Afrique et d'Océanie

Formally called the Palais de la France d'outre-mer, this stately, neoclassic stone building was conceived as a monument to celebrate the French colonial empire for the 1931 Colonial Exposition.

At the time, the classic building drew criticism from the Modern Movement, which viewed a revival of neoclassical architectural as backward thinking. In 1987, it became a registered, historic monument. Its peristyle main façade and bas-reliefs depict cultures from the French colonies. Multiple artists worked on the project, including Alfred Janniot who sculpted the façade's "stone tapestry" of the civilizations then under French rule. In 1960, writer André Malraux, then France's Minister of Cultural Affairs, initiated plans to convert it to the Museum of African and Oceanic Arts. It now houses collections from north and sub-Saharan Africa as well as the South Pacific.

380
Bibliothèque Nationale François-Mitterrand (Bibliothèque Nationale de France)

Four giant L-shaped towers, meant to recall open books, rise from the corners of a vast underground platform—the new foundation of the French National Library. Long suffering from a serious shortage of space, Bibliothèque Nationale de France moved the majority of its holdings to this location, from the old library on rue de Richelieu. The last of president François Mitterrand's *grands projets*, its architectural designer was chosen in a formal competition. Dominique Perrault won the contract in 1989. Reading rooms overlook a central patio whose greenery brings a bit of warmth to this imposing, controversial space, which academicians and the media alike criticized as a "Disneyland of reading." Nonetheless, Mitterand's successor, President Chirac, inaugurated the building in December 1996 and named it Bibliothèque Nationale François-Mitterrand.

381
112, rue du Chevaleret

Developed at an acute right angle on a triangular piece of corner property, this project was an effort to revive the feel of the old 13th arrondissement. In the background, taller buildings rise like a wall above and behind the foreground of three levels of artists studios. Constructed in white-plastered

concrete, these buildings seem durable, yet bland and uniform—the opposite atmosphere one would expect for artistic endeavors.

382
Batofar (Former lighthouse boat)
Floating at the dock between the Le Parc de Bercy and Bibliothèque Nationale to its east and west, and the bridges to the north and south, this former lighthouse ship—moored on the Irish coast between 1957 and 1975—was refitted with a second (night) life as a music venue and bar. In warm weather, revelers drift to the bar on the deck and to dine on its heated terrace overhanging the Seine. But this trendy nightclub also keeps the crowds packed onto its dance floor below.

383
Distribution d'air comprimé
Function followed form in this building: The external aesthetics include double, diagonal box-trusses and pillars, creating a pattern that suggests the industrial nature of this working factory, which was responsible for the workings of public clocks, elevators, and other technological equipment. The main clock on the façade controlled the other clocks in the building. Today, this building is the only metal structure that remains of the four original structures on this site.

384
3, quai François Mauriac
Part of the city's biggest redevelopment project to transform a neighborhood, this apartment complex has a prime location along the Seine. Architect Gazeau created separated units, each with suspended terraces and multiple views of the river. A white façade with wooden latticework overlooks the Seine. Recesses on the upper level look like stadium box seats offering a choice view. The entire composition on the river side appears to float above a seemingly disconnected white base.

385
Caserne de Pompiers (Fire Station)
Using reinforced concrete to create a building that resembles a ship, the architects launched shapes that diverge from the straight line. The building's rounded ends, which break from the monotony of traditional, linear buildings, give this fire station a unique presence in the city. In addition to its modern shape, the social aspect of combining attractive living quarters above a functional fire station was an innovative notion. The architects positioned the apartments to allow firemen quick access to their vehicles and equipment: The residential spaces are located directly above the garage level, with poles that permit the firemen to slide down to their trucks in twenty seconds. In the lower building are recreational facilities serving the residents of the fire station.

386
106, rue du Château-des-Rentiers
Challenged to build on street corners and other leftover patches of real estate, the Architecture Studio laid out this structure on less than 100 square meters (only about 325 square feet). An odd piece of metal—emphasized by the sharp slant of the roof—protrudes from the building. It turns out that the innovative architects incorporated the construction's scaffolding crane right into the building's design, definitely giving new dimension to the term "scrap metal."

387
Tour Chambord
The sales promotion brochure for Tour Chambord dubbed its tower "Renaissance," to lure customers to this residential building. They chose a sixteenth-century astrolabe—a tool that guided seafaring voyages toward grand discoveries—as the tower's symbol, hoping to convince tenants that living here would be an exciting adventure. Otherwise known as "block C3, Italy-Kellermann operation," the project tried to present a luxuriant image. Today, the tower stands alone and its car garage remains unfinished.

388
Rue du Docteur Leray and rue Dieulafoy
Colorful, attached townhouses, each with a unique

character, line these streets. Architect Trésal took out a patent for his design of these homes that, though small, were sophisticated and comfortable, each featuring its own bathroom, bedrooms, courtyard, garden, and car park. Developed with private capital, the project accomplishes a look that is close to the appearance that this arrondissement once had: small, individual houses for workers, rather than large and impersonal apartment buildings.

389
1, 2 bis, rue du Docteur Lucas Championnière
Comparing this picturesque house with the high-rise urban development after World War II presents a surreal contrast. This house was part of a new neighborhood, planned in 1911, that let each owner choose his own architect. Although the subdivision is consistent, the façades are all different, achieving an overall effect of a small-town neighborhood.

390
Eglise Saint-Marcel
In 1966, Daniel Michelin created a new church on the site of a former nineteenth-century one. Almost thirty years later, Michelin's son, Jean, built a new steeple for the church, and gave it a facelift, by means of a colored glass construction that hides his father's original façade. Square glass blocks shape the overall façade into a triangle, and the texture of its surface reinforces the design with a repetitive triangular motif. With the addition of this glass façade, the building now aligns with the street.

391
Cité Verte
Previously owned by a religious community, this property was redeveloped as artist studios in the late 1970s and early '80s. Occasionally graffiti-scrawled, the white façades are otherwise unadorned. The angled, sky-lighted roofs and large window frontage provide ample light for working in a space somewhat sheltered from the

tumult of the city. As many artists live in the 13ᵗʰ arrondissement, this project follows workshop tradition, creating a small-scale space on a short dead-end street, in contrast to large commercial buildings commissioned by private businessmen.

392
Armée du Salut, Palais du Peuple
Founded in 1881, this organization, similar to the Salvation Army, originally constructed a hotel here in 1912 for indigent men. In 1926, Princess Edmond de Polignac, of the Singer sewing family fortune, arranged a renovation and had gardens added that enhanced and opened the space. Today, lace curtains hang in the windows and the façade features a pediment surmounted by an oculus and a slate-roof attic. A wooden door with minimal wrought iron opens onto a beige and brown brick corridor with tile flooring that leads to the interior court and housing. This classical façade hides one of Le Corbusier's buildings designed in 1926 for the social institution.

393
Hôtel de la Reine-Blanche
This picturesque medieval building, with a spire and cantilevered timbered extension over the archway, bears a name for which history has no record. Though nicknamed "the House of the White Queen," no White Queen ever lived there. It is, however, near a street called rue de la Reine-Blanche (White Queen). This building appears to have been built by the sixteenth-century Gobelin family of dyers, to use as a dyeing workshop, and it may have also been used as a tannery during the late nineteenth century. This house is a mix of architectural styles from various centuries.

394
Gobelins Manufactory
Known as the "scarlet dyer" in the mid-fifteenth century, Jean Gobelin begat a dynasty of dyers. By the seventeenth century, their workshops had become the Gobelins Manufactory, famous for its

tapestries rather than its dyes. It was here, in the 1660s, that Colbert built a factory that produced royal furnishings and tapestries.

395
Piscine de la Butte-aux-Cailles
(Swimming Pool)
Constructed on the site of a hot-water artesian well, this swimming pool complex represents opposing directions in its design inspiration. Architect Bonner juxtaposed the modern behind the traditional—an innovative concept for its day —in a single building that appears to be composed of two separate units. A modified Art Nouveau façade of red brick is paired with an interior façade of reinforced concrete that rises above it—a dramatic splash of modernity behind the cover of tradition.

396
Immeubles cruciformes
This giant cruciform in white overlooks place d'Italie, itself a crossroads between the old and the new in the 13ᵗʰ arrondissement. Identical grading of reinforced concrete composes the façade of this building, which has 340 residential units. The complex looms against the skyline as part of the architecture that was to define the postwar decades.

397
Rue des Hautes-Formes
With towering elegance, this housing project signaled a turning point in Parisian architecture. These eight low-rise buildings—interlinked at each third level by accessible galleries and tempered by the window design—achieve lightness, and provide open space for thought and comfort. Portzamparc's interplay of light and proportions helped bring an end to two decades of austere, cookie-cutter high-rise development in the 13ᵗʰ arrondissement.

398
Foyer de Personnes Âgées *(Home for the Elderly)*
This building—a home for the elderly—marks a transition in the chaotic urban planning to affect Paris in the 1960s and '70s. With its smooth, curved surface, it serves as a literal as well as psychological bridge between two older, disconnected, impersonal buildings. De Portzamparc designed this project at a lower, more accessible level than its neighboring towers, creating it on a more intimate, human scale, not only for its architectural healing power, but also for its residents' comfort.

399
Immeuble d'Habitation
In the 1970s, architects favored the technique of using prefabricated material, usually concrete or metal, because it made construction easy and inexpensive. The tendency, however, often created buildings that were boring and too systematic. This entire façade is treated without hierarchy, and the shape of the prefabricated module seems a very aggressive facing to the outside.

400
Ateliers de Reparation
This building survives as a prime example of a bygone era: It housed early-twentieth-century industrial workshops whose industries essentially defined the 13ᵗʰ arrondissement. The use of the then-new material, reinforced concrete, created a façade that demonstrated the ability of the material to support and shape the third level arches, while illustrating its potential and versatility within the interior as well. The internal posts of concrete offered a vast floor surface that facilitated the use of machinery.

401
La Coupole
In 1927, René Lafon and Ernest Fraux, former managers of Le Dôme café, bought an old coal shop and lumberyard on this site, and converted 1,000 square meters of it into what was then the largest brasserie in Paris. Josephine Baker performed in its famed basement dance hall; Hemingway, Henry Miller, Anaïs Nin, and Samuel Beckett also came here. The Art Deco style brasserie was restored in 1988 to its former glory: Thirty-

three large square columns support a high ceiling covered with a cupola of glass flagstones.

402
Théâtre d'Edgar
Founded in 1975 by Alain Mallet, the Théâtre d'Edgar is devoted to newly discovered authors, directors, and actors. This tiny space accommodates just seventy participants in its workshop, and has seating for only eighty in the theater, but it is an essential venue for exploring the theatricals not performed elsewhere. The café and the theater also represent a cultural activity source for the Montparnasse district, providing a gathering place, children's spectacles, and courses for theatrical study.

403
Théâtre Montparnasse
Originally outside the city boundary, this theater was built on the site of a former theater called La Nouvelle Troupe Comique du Mont-Parnasse. Performing semi-professional productions derived from commedia dell'arte theatricals since 1817, the company entertained a working-class audience who brought in their dinner while they watched the show. The theater's prestige rose in 1888, under the directorship of André Antoine. Today, its programming—under the direction of Myriam Feune de Colombi, former member of the Comédie-Française—is as eclectic as its façade.

404
Hôtel Méridien Montparnasse
The site of this hotel was once home to Gauguin, in the 1890s. He lived here with his Indonesian mistress, Annah la Javanaise. A glass entry door that he painted with a tropical scene was destroyed in transport, and the whole area was torn down for urban development. In 1974, Hôtel Méridien replaced a Sheraton hotel that had stood on this spot. Composed of white-painted steel plates and aluminum-framed windows over a concrete skeleton, this skyscraper rises to a dramatic height of 116 meters (377 feet).

405
Artist Ateliers
Two central bay windows and several large-scale picture windows provide ample light for these artist studios and residences. Architect Molinié created the façade as part of the City of Paris's contest of frontages in 1913. Beneath the ledge on the upper level, a frieze of yellow ivy on a brown base wraps around the building, in a process of mural decoration called *sgraffito*.

406
39, rue Hippolyte Maindron
At the turn of the last century, a Monsieur Machin developed inexpensive huts and artists' workshops at the corner of rue du Moulin-Vert. In 1927, sculptor Alberto Giacometti and his brother Diego settled into one of these residences, number 46, rue Hippolyte Maindron, although it offered few comforts—just a small stove with coal, a gas burner, and a tap in the corridor. They intended to stay a short while, but lived here for thirty-nine years, until Alberto died. Situated near the sculptor's former workshop, this odd little house has been redecorated in Art Nouveau style. This quiet street is named for another sculptor, Etienne Hippolyte Maindron who created the marble statue of Velléda in Luxembourg Gardens..

407
Ecole Spéciale d'Architecture
These buildings house an independent school of architecture, founded in 1805 by engineer émile Trélat as a reaction to the Beaux Arts tradition that, for a long time, had dominated architectural education in France. At the only private school of architecture in Paris, students fully participate in the collective administration of the school. Architect Robert Mallet-Stevens, who built the homes on rue Mallet-Stevens, both studied and taught here. Other celebrity architects who have taught at ESA include Auguste Perret, Henri Prost, Paul Virilio, and Christian de Portzamparc, architect of Cité de la Musique and winner of the 1994 Pritzker Prize.

408
31-31 Bis, rue Campagne -Première

Ceramic detailing gives this industrial façade charm and helped the architect win an award for its frontage in 1911 from the Town of Paris. The sandstone tiling by ceramist Alexandre Bigot covers this reinforced concrete duplex of twenty workshops with residences. The three-dimensional floral elements add geometric patterning to the piers and around the window borders.

409
3-7 and 12, rue Cassini

Named for the four generations of astronomers who lived here, the street was also home to Honoré de Balzac, between 1828 and 1835. Painter Lucien Simon lived in the brick and reinforced-concrete building at number 3; architect Süe also created a neo-Gothic brick dwelling for artist Jean-Paul Laurens, and a classical-style house for painter Czernikowski. In 1930, architect Abella designed the overhanging structure, which boasts bay windows and a tower that encases a spiral stairway.

410
Abbey of Port-Royal

The origins of this cloister date to 1626, when it was the Cistercian abbey of Port-Royal des Champs, in the Chevreuse Valley. (Its roots date back even further, to 1204, but Mother Angelica, Marie-Jacqueline Arnaud, was responsible for major changes to the structure.) This abbey became home to a seventeenth-century reform movement known as Jansenism. As a center for intellectual religious thinking, it attracted the best and the brightest of the day: Pascal, Racine, and the Arnauds. In 1656, Pascal wrote *Provinciales*, in defense of Jansenism; and later, when his sister miraculously recovered here, he wrote *Pensées*, his apology for Christianity. The cloister was converted to a prison during the Revolution and then into a nursing home until, in 1812, it became a maternity hospital. The present hospital complex on this site includes the abbey's original cloister and chapel.

411
Fondation Cartier pour d'Art Contemporain

Architect Nouvel designed this glass and steel structure where Chateaubriand once lived, using parallel glass panels in succession, opening the space to imagination. The building's transparency both reflects and links the garden below with the sky above, creating a synergy between the two. In 1823, when Chateaubriand lived on the property, he planted a cedar tree here, which still grows on the premises, fostering a natural, organic connection with the contemporary art environment.

412
Hôpital La Rochefoucauld and Villa Adrienne

Initially called the Maison Royale de Santé, Hôpital La Rochefoucauld was the former Royal Nursing Home for poor veterans, clergy officers, and government officials with no means of support. It stands next to the nineteenth-century Villa Adrienne. Composed of brick and stone, the private and provincial homes of Villa Adrienne border on a large, rectangular site where quiet prevails in the midst of this bustling arrondissement.

413
Couvent des Franciscains

Constructed around a large, square courtyard, this convent has two distinct buildings: The public section contains the chapel, the visitors' room, and a conference room; the other structure houses the convent itself. The chapel is of brick construction with a slate roof and a square tower above the choir. Stained glass windows fill the sanctuary with high colors, and seven small chapels in the back are each lit by three bays.

414
Ozenfant House and Atelier

With the construction of this house and studio, painter Amédée Ozenfant claimed to be Le Corbusier's first French client. With his cousin, Pierre Jeanneret, as his design partner, Le Corbusier conceived of a studio roof composed

of tilted glass panels. They designed an exterior spiral staircase flowing out from the stucco façade which gave an additional sense of open space; and large horizontal openings and bay windows infused the painter's studio with constant light.

415
Square Montsouris

Just off of the eastern edge of Parc Montsouris, charming row houses and studios line this curved, quaint road. Surrounded by lush vegetation, each home exhibits artistic and eclectic features. Skylights, gardens, and flower boxes mark the street and others nearby. The romance of this villa atmosphere among the ivy and wisteria and lilac drew artists and architects to these hideaway homes. Architects Guggenbühl and Le Corbusier designed resi-dences here, and artist George Braque lived one block away.

416
Allée Samuel Beckett

Residential buildings of all shapes, sizes, and material line both sides of avenue Réne Coty. Allée Samuel Beckett, named for the Irish playwright, is the flat, central divide of the avenue. Roller-bladers, bikers, and children with foot-pedaled scooters maneuver past strollers and dog-walkers on this tree- and bush-lined, paved walkway. With cars streaming by on either side, it's not quiet, but it does provide unhindered pedestrian access to the lovely and serene Parc Montsouris just down the street.

417
11, rue du Parc de Montsouris

This private residence anchors the turn of a U-shaped, cobblestone street. Slightly unkempt and overgrown with vines, the façade features rusticated stone, wooden trimming, and tiled gables. An arched stone entry leads to a private garden where a large, seated classic sculpture rests in a stone alcove.

418
Musée du Montparnasse et le Chemin du Montparnasse

In 1901, Joseph Roux inherited this property and, recycling material from the 1900 Exposition Universelle, built about thirty ateliers and artisan workshops. Off the cobblestone passageway, hidden by overgrown greenery, the Musée du Montparnasse provides the neighborhood with a local venue for the arts that recalls the days and nights of the Modern Art and intellectual diversity.

419
Notre-Dame de l'Arche d'Alliance

The external, cube-like shape of this church conceals its internal frame of a pyramid. At the top, thicker inside walls form meeting rooms and lodging for two priests. Conceived as a structure for contemporary worship, it was the first church built in Paris since the construction of Saint-Eloi in 1968. Twelve stone columns sunk twenty meters into a former quarry signify the twelve apostles, and raise the church above ground level. A stainless-steel screen provides for display of sculpture and paintings.

420
Tour Totem

Attached to a visible concrete column, square window blocks overhang the pedestrian walkway at ground level and almost appear as if they could rotate like a windmill. The blocks, grouped as units of three, hang off this circular tower at forty-five degree angles to allow a full view of the Seine. These luxury apartments have tight security measures in place, as they are occupied primarily by citizens of the Gulf States.

421
Tour Montparnasse

Like the Eiffel Tower, this high-rise is visible from nearly every vantage point in the city; and, as in the early days of the Eiffel Tower, controversy loomed over its construction. For ten years, in fact, the

project was mired in political-aesthetic debates that resulted in drastic modifications to the original plan. Unlike the Eiffel Tower, it has never become an endearing landmark of which countless souvenirs are bought. Rising 690 feet high, fifty-seven stories above street level, this glass-curtained office building pierces the skyline of Paris as a towering example of the mediocrity of the 1960s Maine-Montparnasse urban redevelopment project. But its commanding view over the city from the top floor is one of the best in Paris.

422
Ambassade d'Australie
Built as two curved buildings, the embassy looks like a piece of sculpture, with openings that allow the play of light and shadow. The arc of the façades imitates the nearby Palais Chaillot, and permits a comprehensive view of the Eiffel Tower and the Seine. Pier-Luigi Nervi designed the ground-level entrance columns.

423
2-4, rue de la Convention and 7, rond-point du Pont-Mirabeau
This apartment building, erected between the wars, was also caught between tradition and modernity. The composition, however, recycled broken tiles for the façade, a compromise solution between traditional stone and modern concrete. Partially influenced by the technology of transportation design, the shape of the building evokes aerodynamic curves. The corner at 7, rond-point du Pont-Mirabeau is particularly interesting with its inside curve that increases the height of the façade.

424
La Ruche
Fernand Léger was among the first residents of this honeycomb of artist ateliers created by sculptor Alfred Boucher. Others who pollinated here in the early years of the twentieth century included Modigliani, Chagall, Zadkine, Archipenko, Soutine, and writers Cendrars, and Apollinaire. Having acquired the wine rotunda from the 1900 Exposition Universelle, sculptor Boucher rebuilt it on passage de Dantzig and created La Ruche (The Beehive) for painters and sculptors of little means. Now a historic landmark, it continues to house artists.

425
Siège de Canal Plus (Headquarters)
For the headquarters of this television station, New York architect Richard Meier separated the functions of administration and production. The convex, transparent glass façade showcases the managerial offices that overlook the river at quai André-Citroën. Connected to this building by a glass atrium, the lower perpendicular structure holds the TV studios and production facilities, while offering their workers views of Parc André-Citroën. White-enameled paneling covers the enclosed production workshops.

426
Bibliothèque municipale
Composed of black concrete affixed with metal and glass, this isolated object invites inspection. Like the slits in a knight's helmet, the narrow glass openings on the façade reveal activity within, but the library space inside appears independent of the exterior: Light from a fifteen-meter cone on the roof is diffused through a glass column, and defines an interior space whose unlikely indoor garden sits at the center of an open reading room.

427
Musée Galliéra
The duchesse de Galliera waited sixteen years for architect Ginain to finish this Italian Renaissance–style mansion to house her art collection. But, when the city of Genoa inherited her collection, the city of Paris converted it to the Musée de la Mode de la Ville de Paris (Museum of Fashion). Dedicated to fashion and the history of costume, the museum includes clothing and accessories from the eighteenth century to the present. Of note are the three statues under the arches symbolizing Sculpture, Architecture, and Painting.

428
25 bis, rue Benjamin-Franklin
Unlike traditional apartment buildings, this one rests solely on its concrete posts and has no interior supporting walls, thus allowing tenants to create their own room partitions. As is a feature of the Gothic architecture he admired, Auguste Perret left the concrete framework of the building exposed, decorating it only with glazed tile, which gave it a weatherproof coating. The floral Art Nouveau tile design is the work of ceramist Alexandre Bigot.

429
Fondation Singer-Polignac
Built by Winnaretta Singer, aka princesse Edmond de Polignac, this stately stone mansion is the last of the neoclassical buildings constructed on avenue George Mandel. The princesse—of the Singer sewing machine family—received at her home many personalities from the world of arts and culture: Manet, Monet, Proust, Colette, Cocteau, Stravinsky, and Debussy, among others. This mansion became the Singer-Polignac foundation in 1928, devoted to music, culture, and science.

430
53, avenue Foch
A student of the Ecole des Beaux-Arts and winner of the Premier Grand Prix de Rome, architect Abella is virtually unknown today. He did most of his work in Limoges and Morocco, and this building, designed between the wars, is one of only three that he built in Paris. The porthole windows and the absence of decoration reflect moderate concessions to modernism, but the overall look he achieves with his concrete façade borrows from neoclassicism, as can be seen in the monumental curved balcony shape.

431
Palais de Chaillot
Situated on Chaillot hill, on the site of the old Trocadéro, this twentieth-century palace overlooks the Seine from the bank opposite the Eiffel Tower. Erected on the axis of Trocadéro-Montparnasse to coincide with the 1937 Exposition held there, the project was originally intended as a monumental entrance to the fair. The architects designed the horizontal complex with open space, in the interest of creating a broad sightline. The building houses multiple museums and theaters in two neoclassic structures that share a vast, open terrace.

432
La Grande Cascade
For nineteenth-century Parisians, leisure walking was the see-and-be-seen entertainment of the day, and La Grande Cascade (the great waterfall) in Bois de Boulogne drew its share of strollers, thanks to Napoléon III and Baron Haussmann, who cleared ninety-five kilometers of paths, adding lakes, islands, waterfalls, ponds, and an artesian well. For his visits to the Bois de Boulogne, the emperor reserved for his own use a small pavilion at the base of La Grande Cascade. For the 1900 World's Fair, this pavillon became La Grande Cascade restaurant. Despite its artificial rush of water, the great waterfall opposite its namesake still attracts diners as much for the view as the food.

433
Le Pré Catelan
Horseback riders still ride the paths of Bois de Boulogne, but the days are past when they paused at a half-timber house for fresh milk. Instead, next to the old cottage, this stately building houses Le Pré Catalan, which serves more formal fare in the elegant, wooded setting. Now part of the Lenôtre restaurant group, Le Pré Catelan's interior salons and verdant grounds, adorned with sculptures by Badin, are as sumptuous as its cuisine. Considered a chic dining experience at the turn-of-the-century, it still projects style and inspires writers.

434
Eglise Saint-Pierre de Chaillot
Triple Roman arches supported by huge columns

mark the principle entrance and lead to the church complex, which is composed of three parts: a bell tower, a low church and crypt, and the primary church. Both the low church and the high church take the form of a Greek cross with Byzantine influences: The framework—covered with white stone —is concrete, the modern material that allowed the construction of various angles and shapes.

435
51–55, rue Raynouard

For this building, August Perret designed a traditional structure to use as his own office space and apartment. For the façade, he chose to replicate traditionally shaped stone blocks. Similarly, the entire building shows restraint, featuring classical proportions and traditional, vertical windows. The architect's one overt concession to modern times was his innovative use of glass as a lighting source for the concrete spiral staircase.

436
Le Chalet des Îles

Here, you can ferry back to the nineteenth century for a bite to eat, or row your own boat over Lac Inférieur for a pastoral repast. Situated on a thin island strip on Lac Inférieur, this idyllic restaurant was originally built as a Swiss chalet for Empress Eugenia by Napoleon III. It was taken apart, transported by train, and reassembled here on Ile du Lac Inférieur. Its natural ambience, amid trees and water is an artificial construct of Napoléon III's crew of engineers, who poured concrete into a pit and piped in artesian well water from about thirty miles away. Nonetheless, the serene setting attracts diners, who take in the artful view from beneath the cover of umbrellas. In the past, regular rowers on the lake included Marcel Proust and Emile Zola.

437
Ambassade de Turquie

Three quiet, interlocking cylinders made it possible to position this ultramodern building on a triangular

space between an eighteenth-century townhouse and Balzac's former home. The central concrete pillars support the overhanging stories, and leave ground-floor space for an opening to the building's underground garage. In creating this structure, architect Beauclair had several challenges before him: He could not displace any of the preserved trees—he had to leave a clear view from the garden; and, he needed to fit his modern creation into an otherwise bourgeois neighborhood. Using simple white concrete and slightly tinted glass, he designed an unobtrusive building.

438
Villas La Roche et Jeanneret

Although Le Corbusier's intention was to create an entire row of his buildings along this street, his deal with the developers fell through and he designed only two of the homes here: Villa La Roche for his friend, a banker named La Roche; and villa Jeanneret for his brother (Le Corbusier was born Charles-Edouard Jeanneret). In later years, Le Corbusier developed his five canons of architecture, and here, in his design for Villa La Roche, he applied for the first time two of those five important features for a house: roof terraces and full-length windows. He organized the interior with promenades, partitions, walkways, and platforms. The frontages and roofs of the villa are registered as historic landmarks.

439
Musée Marmottan-Monet

In 1966, Claude Monet's son Michel donated his father's paintings and the property at Giverny to this museum, which added "Monet" to the name of Musée Marmottan. The donation filled out its already significant collection of works by Manet, Monet, Pissarro, Sisley and Renoir. Originally the old hunting lodge of the Christophe Edmond Kellermann, Duke of Valmy, this mansion, which overlooks the gardens of Ranelagh, was purchased as a home by Jules Marmottan in 1882. In 1934, the mansion, its art collections, and a library in Boulogne officially became the museum.

440
Hôtel Guimard

Architect Guimard built this private mansion to have all the curves and trim and ironwork flourishes characteristic of what became known as the "Guimard style" of Art Nouveau design. His architectural firm occupied the ground floor, and he also incorporated into the building studio space for his wife, Adeline Oppenheim, who was a painter. She unsuccessfully attempted to donate the house to the State in 1947. The mansion was finally protected in 1964.

441
Castel Béranger

Painter Paul Signac, who lived here in the late 1890s, called this the "Eccentric House." Other neighbors referred to it as the "Crazy House" or "Devil's House," because of design elements on the façade, which featured—among other strange detailing—caricatures of the architect's face in the ironwork of the balconies. The quirkiness notwithstanding, this building won design awards in 1898 and 1901. Though the entry gates and balconies exhibit the curving lines of Art Nouveau, the façade decoration is more abstract, and the interplay of shapes becomes distinctly modern. Not only did Guimard use an eclectic range of materials—brick, ceramics, stone, sandstone—but his window designs also contain a diversity of proportions.

442
Parc des Princes

Using 6,000 tons of steel and 60,000 cubic meters of concrete, architect Taillibert suspended this stadium from fifty self-supporting, prefabricated consoles. His objective was to seat 48,000 sports spectators without obscuring anyone's view with posts or other structural obstacles. Thus, the bracketing sustains both the tiered seating and a hood of cantilevered-roof that protects the seating area. Originally a wooded area west of the capital, and reserved for the princely recreations from which it derives its name, this site was also once a center for the scientific study of the anatomical movements of men and horses in motion along a track. In 1897, a new track staged cycle-racing. Then, from 1932, professional soccer teams played matches here, and a stadium hosted the World Cup in 1938. Today, the track is home to the French soccer team, Paris-Saint-Germain.

443
Laboratory Aérodynamique

Gustave Eiffel created this sleek building, one of the first aerodynamic laboratories in the world, as the place in which to do his own research. Framed in metal, this simple hangar contained Eiffel's technical equipment, including measuring and testing devices. In 1920, he opened the laboratory for use by aeronautical engineering departments and industries. Since 1997, the space has been used to test the aerodynamics of planes, cars, and buildings.

444
Hippodrome d'Auteuil

As a young writer in Paris, newly married with a child, Ernest Hemingway was one of many fans addicted to this and other historic racetracks. Following the lead of the Hippodrome de Longchamp, established in 1855 during the fun-loving days of Napoléon III, also in the Bois de Boulogne, this stadium attracted fans with steeplechases, obstacle courses, and promenades. Originally opened in 1873, it was rebuilt in 1924 and then, about fifty years later, the architects Lizero, Leriche, and Jean extended the former construction using white concrete for the structure and stainless steel for the windows frames. The addition now accommodates 8,600 people whereas the original allowed for only 3,600. Although avid horseracing fans gather here from early March to late December, the space is also used for antique fairs and rock concerts.

445
Hôtel Gaillard

Inspired by the castles of Blois and Gien in Loire, architect Février designed this house for Emile Gaillard, the Director of the Bank of France. In addition to gables, dormers with carved Gs, sixteenth-century paneling, sculpture, and opulent furnishings, the architect assured his immortality and that of his patron's with statues above the entrance: One resembles the banker carrying a money bag; the other contains a square featuring the architect's likeness. Gaillard died in 1904 and the Bank of France acquired the manor house in 1919, making necessary modifications to transform the residence into a bank, but not significantly altering the basic structure. They used the water buildup in the basement as the first line of security for their vault, and rumor had it that crocodiles protected the safe-deposit stash at night.

446
Château des Ternes

This mansion rests on the site of a fifteenth-century farm and fortification, in what was then the countryside, outside the limits of an old property called Roule. In mid-century, a gazebo was built here for the Queen to allow her to watch the nearby horse races. Mirey de Pomponne, treasurer-secretary to the king, acquired the property and replaced it with a château in 1740. Over the years, other owners enlarged it with additions. In 1778, architect Lenoir acquired the property and divided it into salable units. To facilitate access to the development, he created a new street, now called rue Bayen, which runs right through the building under an arch. After many modifications, the Chateau now appears a mere shadow of its former grandeur: Its eighteenth-century façades, an entry, and a few relics are the only reminders of its past. Today, it accommodates town hall services, a restaurant, and housing for the elderly.

447
75, rue Pouchet

Like a giant armchair, this U-shaped complex of public housing, built at the old city wall, welcomed the growing population at the turn of the last century. Organized around a large courtyard that allowed circulation of air and light, the building is composed of brick, with decorative detailing and a stone foundation that conformed to architecture of the time. A neoclassical frieze breaks up the building's uniformity. Patterned in green, it drapes the façade like a garland, an expression of the city limit before the *périphérique* (freeway).

448
Immeuble Fortuny

This building, which curves around the corner that connects to avenue de Villiers, is a prime example of constructions belonging to the Modern Movement, in its emphasis upon reinforced concrete. Internal posts, held by pre-stressed slab, give the building a clean appearance on its façade, without betraying any visible support of the structure. Built on the entire lot and partially on the ledge of the construction alignment, the building exudes an exceptional density.

449
132, rue de Courcelles

This Art Nouveau building sports an unusual, monumental dome with oculi, the front of which peers out at the corner like the eye of a giant Cyclops. Artist Henri Bouchard produced the sculpted stone façade, and Léon Binet adorned it with Art Nouveau flourishes. Binet, who specialized in vegetal patterns, created at the top angle this leaf-and-branch design, which appears to grow out of the building.

450
Eglise Sainte-Odile

A strange, disproportionate tower, seventy-two meters (236 feet) high, zooms above this Byzantine-inspired church as if to challenge the fates—raising a finger to the powers that be, or perhaps to modernism, which the church frowned upon. With its domed copulas and looming bell tower, oddly called futuristic by some, the church recalls the ancient fortifications built in this area.

451
42, boulevard Gouvion Saint-Cyr

Distinguished by three vertical "pilasters" of stone that separate the balconies at each story, this Art Deco building is a monument at heart: Carved and curving balconies add to the feeling that the architect invested the exterior of the building with an importance beyond its interior function as an otherwise average apartment building. It is, however, quite a slender building that was meant to conform to the uniformity of the neighborhood.

452
Eglise Saint-Ferdinand

This Catholic church, which replaced an earlier church on the site, from the side appears to be a rather quiet, severe stone edifice, but its angled façade brings an imposing presence to the street corner. Composed as a triptych, this façade features bas-relief carving above the triple-arched entry, which rises to a multi-arched bell tower. The building is styled in a Roman-Byzantine fashion with cupolas. Its frescoes, created in the 1940s, illustrate the sacraments, in particular the life of the saints, and the Eucharistic rite in the choir section. In the 1990s, workers refitted the chorus with a new organ and an installation of the Way of the Cross in stone mosaic.

453
Ecole Normale de Musique de Paris / La Salle Cortote

Established in 1919 by pianist Alfred Cortot and his partner, Auguste Mangeot, this music institution earned an international reputation for its celebrity students and for the quality of its teaching faculty, whose instructors included Igor Stravinsky, Pablo Casals, and Arthur Honegger. In 1924, the school moved to this former private mansion, built in 1881 for the Rozard family by the architect Léopold Cochet. Its interior décor features decorative art from the end of the nineteenth century. Protected from demolition in 1965 and registered as a historic landmark, the concert hall, known as Salle Cortot, occupies the site of the mansion's former stables. This wood-paneled room, an Art Deco *chef-d'oeuvre* designed by the Perret brothers, resonates with an acoustic quality Cortot equated to that of "a Stradivarius." Students in this school train in classical music, theory, orchestra conducting, and composition.

454
Eglise Saint-Pierre de Montmartre

From early Celt and Roman deification, through Norman invasions, to Christian worship, this site has undergone both religious and architectural transformation for almost 2,000 years. Four marble pillars remain from the time of the Romans, when they dedicated a temple here to Mercury. This Romanesque-influenced building is one of the three oldest churches in Paris. Because of its elevated position, the structure has also served a secular purpose: as an early telecommunications center. In 1794, Claude Chappe used the apse as a tower from which to send telegraph transmissions, successfully relaying a signal between Paris and Lille. As recently as 1980, sculptor Gismondi added three bronze doors depicting Saint-Denis, Saint-Pierre, and the Virgin.

455
Basilique du Sacré-Cœur

As the Eiffel tower represents Paris to the outside world, so is Sacré-Cœur the quintessential visual symbol of Montmartre. The site of this church was sacred long before Saint-Denis lost his head, picked it up, rinsed it off at a fountain, and carried it downhill. Tourists have long made the pilgrimage up the Butte, the highest of Paris's seven hills, to visit Sacré-Coeur. Dismissed by some as a whimsical plaything at best, a ridiculous wedding cake at worst, Sacré-Cœur's cluster of white onion domes illuminate the night sky like a sugar-coated northern beacon. Resembling a Russian Orthodox church or a mosque more than a Catholic basilica, this legendary Roman-Byzantine–style structure actually cleans itself. Built from local stone that releases white calcite whenever it rains, the church gets brighter and whiter with each drop that falls.

456
Au Lapin Agile

In 1875, after painter-caricaturist André Gill created a sign of a rabbit jumping out of a saucepan (*lapin à gill*) holding a bottle of wine, the original name *Le Lapin à Gill* evolved into Lapin Agile. This favorite haunt of Modigliani, Picasso, Apollinaire, and others, became the site of an artistic hoax: In 1910, critic Dorgelès, no fan of Cubism, tied paintbrushes to the tail of Lolo, the cabaret-owner's donkey. Lolo swished over a large canvas. The resultant masterpiece, *Soleil sur l'Adriatique*, was accepted into the modern art exposition.

457
La Mère Catherine

A sea of crisp, red-checkered tablecloths wow you upon entering—along with the words that Danton scrawled across the wall in 1793: "*Buvons et mangeons, car demain nous mourrons*" ("Let's drink and eat, because tomorrow we will die"). Likely, Danton and his disciples believed in that motto as a perfect description for the clientele of this café and the times they lived in. This restaurant was founded by Catherine Lemoine during the French Revolution.

458
Maison particulière

This funny little house appears lost in the big city. It's either a vestige or fake vestige of the old neighborhood. Composed of wood framing and brick, this picturesque house, in need of repair, might have been built by someone who wanted to add charm to his environment, perhaps an artist who had his studio above and a small, precious garden behind the gate.

459
Moulin de la Galette

In the seventeenth century, vineyards and windmills dotted the landscape of Montmartre. This historic windmill was one of around thirty that milled flour for the locals. A clever miller at this *moulin* (windmill) decided to cook up *galettes* (flat cakes or pancakes), to serve to his customers while they waited for their ground flour, hence the name, *Moulin de la Galette* (Pancake Windmill). Capitalizing on a good idea, he added wine to his popular menu, and the windmill became a place to go for rollicking good times. This windmill, known as Blute-fin, is one of two surviving windmills on Butte Montmartre; the other is Radet. Situated above the restaurant, the two mills comprise the Moulin de la Galette, made famous by various artists, notably Renoir and Van Gogh.

460
Musée de Montmartre

Situated on the last remaining vineyard in Paris, this museum, founded in 1960, occupies the former home of Claude de la Rose, known as Rose de Rosimond, an actor in Molière's troupe who died on stage while performing in *Le Malade Imaginaire* (as did Molière himself). When Rosimond lived here in the 1680s, Montmartre was not yet part of Paris. In the latter half of the nineteenth century, various artists used this house as both living quarters and ateliers. While working here, Renoir painted *Le Moulin de la Galette*. Today, the museum's collection of posters, period sketches, photographs, and manuscripts document the history of Montmartre.

461
Musée Erik Satie

From 1890 to 1898, composer Erik Satie lived in this nondescript building in a room so tiny he called it "a closet." In 1893, he conducted an intense love affair with painter and model Suzanne Valadon, who lived next door. Supposedly, on January 14, 1893, the very night their liaison began, Satie proposed marriage to Valadon; and he wrote passionate letters about her "exquisite eyes, gentle hands, and tiny feet." Valadon dumped the obsessed musician after six months. One of the world's smallest museums, Satie's house contains little beyond his art collection.

462
Le Bateau-Lavoir

Painters gravitated to this rundown, one-story

building called Bateau-Lavoir (laundry boat or washhouse) in the 1890s, most of them settling in between 1902 and 1904. Picasso who, like Hemingway, seems to have turned up everywhere in Paris, moved in and worked here from 1904 until 1909, and retained a workshop here until 1912. This was also home or hang-out to Georges Braque, Henri Matisse, Otto Freundlich, Juan Gris, and Herbin (with whom Picasso shared a studio).

463
Abbesses Métro

The subway transportation system came late to Paris, following those already constructed in the 1860s and '70s in London, Berlin, New York, and Vienna. By 1895, when Paris was ready to relieve city congestion and join the underground movement, it did so with a flourish thanks to Hector Guimard. At the beginning of the twentieth century, Guimard, Art Nouveau architect par excellence, began installing covered Métropolitain entryways around the city. From 1900 until 1913, he created 141 entrances. Ranging from simple designs to elaborate works of art, they all demonstrate the curving, organic style of Art Nouveau. Eventually regarded as obsolete, however, many of Guimard's original coverings have been dismantled and distributed elsewhere. The Museum of Modern Art in New York City acquired his masterwork from the Bastille metro. Fortunately, Guimard's artistry still covers a few stations: Châtelet in the 1st arrondissement, Port Dauphine in the 16th, and Abbesses in the 18th. Constructed in 1900, the Abbesses' ornamentation was initially located at the Hôtel de Ville metro station.

464
Elysée Montmartre

Since 1807, this former area of the Bal de l'Élysée-Montmartre (a popular music hall) has seen its share of political and cultural history, from providing housing for Revolutionary heroes to being a site of protests against potential bans on exotic dancers. Here, in the midst of Pigalle,

the legendary center of nightlife, dance halls, sex shops, and cabarets, Guy de Maupassant chose this particular building as the setting for his short story, "The Mask." Despite a fire that ravaged the premises in 1900, this music hall, with a minimal yet electric interior, still plays on. Except in August when it's closed, eclectic sounds from Reggae and Indie to hip-hop and heavy metal music resonate here, along with the occasional strains of accordion. This versatile venue seeks out new talent and also presents fashion shows, festivals, and movies.

465
Théâtre-Libre de Montmartre

André Antoine—theater innovator, director, manager, and critic in the late nineteenth and early twentieth century, and for whom the street is named—originally founded this theater at another location in 1897, as the Théâtre Antoine. He produced avant-garde productions for ten years, directing plays of Zola and contemporary German, Russian, and Scandinavian playwrights. He advocated naturalistic theater in opposition to what was then advocated by the Paris Conservatory. Théâtre-Libre (Free Theater) de Montmartre became a model for experimental productions elsewhere in Europe and in the United States.

466
Énglise Saint-Jean-l'Évangéliste

Architect Baudot's personal preference for Gothic architecture notwithstanding, he created the first church in Paris to be made of reinforced concrete. Construction took ten years to complete, and the church was almost demolished before it was finished because authorities did not understand the properties of that new material called concrete. In the end, Baudot applied a layer of brick over the concrete skeleton of his neo-Gothic creation. Unexceptional stained-glass panels fill most of the windows and small vaulted openings. The high vaulting, however, gives the acoustics a special quality and makes a church visit worth a trip.

467
Moulin Rouge

The red windmill sails aren't the only hot items twirling here. Leggy and scantily clad cancan girls kick up their gams in Paris tradition inside the Moulin Rouge (Red Windmill). Although the legendary cabaret—founded by a butcher named Charles Zidler, and his partner, Joseph Oller—opened to great fanfare during the 1889 World Exposition and centenary of the French Revolution, its fame owes a tremendous debt to artist Toulouse-Lautrec who brought it world attention with his posters that depicted its dancers and frolicking customers. In a transitional period between wars and centuries, Parisian society enjoyed cultural expansion and a brief fling with gaiety, carefree thought, and joie de vivre. This vitality expressed itself in various artistic forms, including the emerging sex industry, of which the dancing girls of the Moulin Rouge became symbolic.

468
Villa des Arts

Henri Cambon designed this arts community, a cul-de-sac near the Montmartre cemetery, using leftovers from the World's Fair and recycled material from construction sites. Once completed, light flowed into about sixty studios, and the villa's wrought-iron gate, with the name Villa des Arts pierced above, swung open to celebrity artists: Paul Cézanne, Raoul Dufy, and Paul Signac were among those who made the area famous. It remained an attractive artistic neighborhood well into the twentieth century.

469
Villa des Fusains

Famous artists gravitated to this street, as they did to other areas in Montmartre. Vincent Van Gogh and his brother Théo shared a place at 54, rue Tourlaque. This shady nook of thirty artists' ateliers drew Renoir, Bonnard, and Derain, as well as others. If they didn't live here, they routinely visited one another. Picasso, who lived nearby for a time, was a regular to these studios. Behind the entrance to this artist villa, scattered sculptures decorate the gardens.

470
185, rue Belliard

Using the technology of concrete, architect Deneux, who planned this complex for himself, developed the building's structure, then applied a weatherproof layer of ceramic to the façade. He prefigured the Modern Movement by about a decade, with his bold design of a flat roof to which he added a tiered garden terrace. This construction was so well-planned and executed that the waterproofing has never needed maintenance.

471
Maison Tzara

Like a Dadaist painter, Austrian architect Loos attacked the conventional standards of aesthetics. Here, he chose commonplace materials—brick and plaster—to create a harmonious entity. By placing heavy, dark masonry-work at the base, he achieved a balance of lightness with white plaster on the upper half. White beams underline the recessed base and emphasize its solid grounding, while the upper balcony recess resembles a large picture window that provides additional light.

472
13, rue des Amiraux

Architect Sauvage turned this entire site into a vertical *cité-jardin* (city garden). His stadium-like gradations—almost the size of the apartments themselves—allowed ample room for terraces. Sauvage—the founder of a society for affordable housing—wanted to develop a living space that symbolized health. His graduated layers opened up space for the natural flow of light and air.

473
Saint-Denis-de-la-Chapelle with Basilica of Sainte-Jeanne-d'Arc

In 1920, Pope Benoit XV canonized Joan of Arc, who came to pray here in 1429, and he allowed

the construction of a church dedicated to her adjacent to Saint-Denis. The first church on the right, called Saint-Denis-de-la-Chapelle, is at number 16 and was built earlier. The new basilica was supposed to resemble a medieval castle from Sainte-Jeanne's time.

474
La Géode

As part of the science museum, La Cité des Sciences et de l'Industrie, this cinema-in-the-round sits in the center of a reflecting pool. Surrounding the viewer with sound on a vast spherical screen, architect Fainsilber used stainless-steel mirrors to create the façade of his sphere—6,500 triangular pieces closely fitted to within a millimeter. The basic form, a "geodesic dome," was inspired by the work of Buckminster Fuller, who pioneered the structure as a super-efficient use of light, space, and energy.

475
19, place des Fêtes

A time-traveler from 100 years ago would never recognize place des Fêtes today. Gone are the nineteenth-century circular kiosk and verdant park, replaced by a modern pyramid sculpture surrounded by high-rises of the twentieth century. Despite the brutality of 1960s urban planning, a colorful market still exists at place des Fêtes three days a week, setting up in the shadow of the apartment buildings. This neighborhood today is a melting pot of nationalities and immigrants drawn to Paris for new opportunities.

476
65–69, rue d'Hautpoul

Despite its modernism, this office and apartment building adheres to a tradition of Parisian hierarchy in the façade: The ground level is well defined, and the historical height of the cornice is 15.6 meters. It is marked by a horizontal line above, in which a dark color distinguishes the attic and roof. Covered by granite, the façade is punctuated by a rhythm of two large, vertical bay windows.

477
Grande Halle de la Villette

The Grand Halle, now used for exhibitions and trade fairs, once housed a livestock market, conveniently located near the old La Villette slaughterhouse. Contained within the renovated Parc de la Villette—conceived as a futuristic city for twenty-first century activities—the Grand Halle is as stunning as it is huge. This former covered market sits under an enormous roof that rests on slender cast-iron columns, and its glass-and-metal skylight gables allow natural light to flood in.

478
Eglise Saint-Jean-Baptiste-de-Belleville

During the Revolution, the church lost its autonomy, and its properties became nationalized until the separation of church and state in 1905. Throughout the nineteenth century, church construction was thus the domain of the State, which sought to create a style that would promote a unifying identity for a French national church. To accomplish this, it revived the Gothic style of twelfth-century Paris. Jean-Baptiste Lassus, who worked on the renovation of Sainte-Chapel, Notre-Dame, and Saint-Germain-l'Auxerrois, was one of the "diocesan architects" who took part in this movement. He modeled Saint-Jean-Baptiste-de-Belleville on buildings from the period 1150–1250.

479
64–66, rue de Meaux

Architect Piano combines good architecture with socially responsible public housing, proving they are not mutually exclusive. He researched and drew inspiration from this area, traditionally filled with workshops boasting a wood-and-brick framework. He then adapted this architecture, using modern technology and a restrained budget, to produce four apartment blocks composed of bricks plus baked clay tiles innovatively hooked onto the façade.

480
Siège du Parti Communiste Français
(French Communist Party Headquarters)

A diehard communist, Brazilian architect Niemeyer created this worker's house for free, and dedicated it to a world without injustice or prejudice—what he hoped the French Communist Party represented. Set back from the place du Colonel-Fabien to allow open space around the square, a strange dome rises in front of a massive, curved building. The semi-buried, white dome holds the Central Committee's meeting room, which was added in 1980.

481
Hôtel industriel "Métropole 19"

As a practical matter, an internal street cuts through this industrial site: This clever concept facilitates deliveries and the movement of maintenance equipment without disrupting busy city streets. While the private road is concealed from passersby, the window façade on rue d'Aubervilliers—in an attempt to enliven the main street—gives pedestrians a full view of the daily activities within the building. Also visible are the elevators, which run inside rounded columns composed of a galvanized-metal casing.

482
16, quai de la Loire

Le Monde, one of the influencial French newspapers, operates behind this dark, glass façade. The building stands out from its neightbors with its swollen belly, as if it had drained the Bassin de La Villette that it faces. In front, the broad glass wall reflects the never-ending movement of the sky. Within the area's uniform environment, architect Gazeau respected Parisian scale and structure by the use of traditional stories, but gave his building a clear identity with its unusual and dynamic shape.

483
Les Orgues de Flandre

These futuristic buildings appear to be conversing with one another, as well as defying gravity. Architect Van Treek developed an optical device similar to the medical endoscope, which allowed architects to determine what a pedestrian would view from ground level, and to design exteriors accordingly. His concept for this structure was to move the stories away from each other, to create more open and inviting space inside, while the curves suggest a sense of protection.

484
26–30, avenue Corentin Cariou

Situated at the northern edge of Paris, this building is at the confluence of the freeways, the railways, the subway station, and a parking lot. On one side, it is also a main access to the park of the Cité des Sciences et de l'Industrie. The architectural challenge was to develop housing with the intimacy of a neighborhood, while simultaneously protecting it from the aggression of sound from all those competing transport structures. Architect Thurnauer's solution was to erect a high wall at the avenue and the freeway, to block the din from the back section, which has lower proportions. Cube-shaped "villas" stack above a portico, creating a pedestrian street that leads to a quiet place where background noise is already forgotten.

485
Paris-Carthage

Located at the triangular juncture of two narrow, cobblestone alleys, Paris-Carthage is an exotic gem with an interior décor of hand-painted tiling. Although the building itself is somewhat shabby, poured concrete without external decoration, the ground floor restaurant serves up Tunisian specialties such as couscous combinations in colorful earthenware. As a neighborhood restaurant, it seems to fit the tree-shaded ambience of villa l'Ermitage with its private gardens, overgrown ivy and wisteria, and its quaint, vine-carved, iron lampposts.

486
Regard Saint-Martin

This area, known as Belleville once flowed with an abundance of water, as the street name implies. Before the Industrial Revolution laid waste to this section, it was idyllic, with springs and vineyards. An aqueduct with various water stations along

its route supplied the local communities. Regard Saint-Martin served as one of the water inspection chambers between 1583–1613, supplied by la Fontaine de Savies, a local spring used by the monks of Saint-Martin-des-Champs.

487
Logements Sociaux

Like a monumental gateway, this development attempts to reinvent an urban area. A powerful column exerts a solid presence as it supports the overhanging volume and marks the entrance to a semi-public courtyard. Creating a pedestrian walkway between rue de Fontarabie and rue de Bagnolet, the interior complex is open and inviting. The wide blocks of windows and low rise of the building enhance the openness of the development even as the building rises sharply to eight stories on the right side.

488
Musicians' homes and workshops

The architects who set out to create in Paris the first residential units and studios specifically designed for musicians eschewed traditional office and housing developments in favor of an allegory to music, creating a structure in which symbolic images play everywhere on the façade. The black and white window framing builds vertical movement like a piano keyboard laid on its side, while the upper portion gives the building horizontal tone. The large, round windows resemble the ends of trumpets; the small windows, the notes of a score; and the concrete elements running horizontally along the top level, the frets on the neck of a guitar. Shaped like a concrete bunker, the structure contains soundproofed, flexible workshop space.

489
Saint-Germain-de-Charonne

Until 1860, this picturesque church and church-yard lay outside the city limits and, therefore, was unaffected by an 1804 law that would have forced its parish cemetery to close. The entrance faces south, and looks down the

hill at the quaint, cobblestoned rue Saint-Blaise. The church's name derives from a legend about the Bishop of Auxerre, the future Saint-Germain.

490
Ateliers des artistes

Designed by two architects who live in Finland, this is one of the few contemporary buildings constructed of wood—assembled in only four days. To accomplish their task, the architects used a prefabricated structure of steam-treated and laminated beams. The rest of the composition combines stone for the staircases and brick as a filler. The second-floor corner element is an unusual shape, and is the only indicator that the building is in fact situated on a corner. The overall design was meant to convey a sense of historical ateliers.

491
Ateliers d'artistes

Designing this building to accommodate six artists' studios, the architects imagined the space as a three-dimensional abstract composition on a flat, empty canvas. The façade of the building has a smooth, austere coat of tiling and the tinted windows are flush with the façade. The graphic quality of the building is punctuated with an exterior, spiral staircase that breaks the skin of the building and adds a dynamic energy to the otherwise silent shell.

492
Pavillon de l'Ermitage

As early as the seventeenh century and later in the eighteenth century, aristocratic families purchased and sold country homes in this quarter. The fresh air and beautiful surroundings drew the Sun King's aunt, the duchess d'Orléans, to the neighborhood. In 1763, Philippe d'Orléans bought the adjacent grounds, divided it up, and sold off parcels. One of the buyers, a royalist, hatched a scheme on this property to save the king and queen from the Revolutionary guillotine, but to no avail. Pavillon de l'Ermitage is all that

survives of the country estates from those days. Today, this eighteenth-century pavilion is part of Hospice Debrousse Foundation, and the City of Paris maintains the park and gardens.

493
Palais des Expositions du CNIT
(National Industrial and Technical Center)

A major technical feat for its time, this exhibition center has the largest concrete vaulting in the world. The architects developed a 22,500-square-meter structure on the triangular site. Its 230-meter wingspan, assembled piece by piece, rests on three support points that are interlinked with steel cables to prevent collapse. Jean Prouvé designed the curtainwall façades, also considered a technical achievement.

494
Tour La Pacific

Kiso Kurokawa sat on the jury that chose architect von Spreckelsen for La Grande Arche, so it is no surprise that the crescent-shaped Pacific tower would bear a close relationship to the Arch, as a gateway symbol. The split in the tower opens out towards the Valmy district and recalls the *Chu Mon*, a symbolic gateway for the tea ceremony. The curved concrete façade is reminiscent of European masonry architecture, while its flat, curtainwall frontage, composed of steel and translucent plastic, resembles a shoji screen.

495
Cœur Défense

One of the third generation office towers built in La Défense, this building replaced the 1960s Esso tower—one of the first of earlier structures to be demolished here. Architect Viguier wanted to construct an extremely slim structure. He configured two curved twin towers of forty levels, one set back slightly from the other. Three lower constructions, similarly curved, are connected to the twin towers by a vast canopy-covered atrium. These lower parts contain technical and common commercial space.

496
Tour Total Fina Elf

Tour Elf, built in 1985, is eleven years younger than its older brother, Tour Framatome, built in 1974. The architects are the same but, though the buildings have the same height (180 meters) and capacity (100,000 square meters of office space), they are not twins. Inspired by Kubrick's 2001, *A Space Odyssey*, the black monolithic Tour Framatome was built at the time when social and economic crisis hit La Défense. The architects designed the Framatome tower to emphasize the monumental environment of La Défense. In contrast, Tour Elf, a third-generation building, is much more sophisticated and self-assured.

497
Hôtel Renaissance

Situated in the center of La Défense business district, at the site of the Grande Arche, this triangular ten-floor building features 331 elegant rooms with many amenities. This hotel is across from the Société Général Tower.

498
Eglise Notre-Dame-de-la-Pentecôte

With extremely modest dimensions compared to its neighbors and just a cross to identify its function, this atypical church stresses reflection and meditation. To achieve this quietude, architect Hamoutène devised a sanctuary of simple volume using the effects of scale, material, and lighting as his tools. Inspired by the first Christian communities, Hamoutène organized the layout of the church by surrounding the alter and the pulpit with the congregation on three sides. This active, modern parish tunes in to the preoccupations and the everyday life of those working in La Défense by organizing conferences, debates, and study groups on themes such as working conditions and terrorism.

499

𝒯our EDF/𝒯our PB6

(Électricité de France)

This sleek, postmodern building pyramids up from a circular awning entrance to an angular, conical tower. The simplicity of this design emphasizes purity of form as the mildly reflective glass façades curve gently to a height of forty stories. The architects developed this structure with the employee in mind, creating private and flexible office space while achieving lower maintenance costs for a building that contains 700,000 square feet of offices, over half of which the building co-owner Électricité de France occupies. It also includes a conference center, restaurants, and a sports facility. This twenty-first-century glass tower is typical of the most recent generation of energy-saving buildings developed in La Défense.

500
Dôme Imax de la Défense

Conceived to put the audience in the driver's seat, so to speak, this dome was originally built with a hemispheric screen of 1,144 square meters and a 180° angle of vision with inclined chairs that gave viewers the sensation of being in the midst of action. The Dôme Imax complex also included an antique car museum. Despite the proximity to the adjacent shopping mall "Quatre-temps," both the museum and the Dôme Imax proved economically unwise and went bankrupt in November 2000. Parts of the automobile collection were auctioned off and the Imax theater has been converted to a normal cinema. Yann Kersalé, who created the lighting for Bastille Opera, also devised the night light of the dome.